Eudora Welty's Fiction and Photography

Eudora Welty's
Fiction and Photography

The Body of the Other Woman

HARRIET POLLACK

The University of Georgia Press *Athens*

© 2016 by the University of Georgia Press
Athens, Georgia 30602
www.ugapress.org
All rights reserved
Set in Sabon MT Pro by Graphic Composition, Inc.,
 Bogart, Georgia
Printed and bound by Thomson-Shore
The paper in this book meets the guidelines for permanence and durability
of the Committee on Production Guidelines for Book Longevity of the Council
on Library Resources.

Most University of Georgia Press titles are available from popular e-book vendors.

Printed in the United States of America

20 19 18 17 16 C 5 4 3 2 1

Library of Congress Cataloging-in-Publication Data

Names: Pollack, Harriet, author.
Title: Eudora Welty's fiction and photography : the body of the other woman /
 Harriet Pollack.
Description: Athens : The University of Georgia Press, 2016. | Series: The New
 Southern Studies | Includes bibliographical references and index.
Identifiers: LCCN 2015037371 | ISBN 9780820348704 (hardcover : alk. paper)
Subjects: LCSH: Welty, Eudora, 1909–2001—Criticism and interpretation. | Welty,
 Eudora, 1909–2001—Knowledge—Photography. | Women and literature—
 Southern States—History—20th century. | Photography, Artistic—History.
Classification: LCC PS3545.E6 Z845 2016 | DDC 813/.52—dc23 LC record available at
 http://lccn.loc.gov/2015037371

Contents

Acknowledgments

Every book has a history. I write to thank the large number of people who have been important to the production of this study of Eudora Welty.

I begin with Professor Alan Howard, University of Virginia, who introduced me to Welty's work in a memorable course on southern literature, which inspired my dissertation and, beyond that, my career. I also remember three far-flung individuals, now lost, who in various ways brought me to this book. My one-time classmate Karen Tidmarsh, who eventually became the beloved dean of Bryn Mawr College, introduced me to Eudora Welty the woman with an invitation to join a dinner party at the college where Welty had taught. Ruth Vande Kieft, the author of the first book on Eudora Welty, after serving as a reviewer for my first article, invited me to visit her at her home in the Poconos to talk about Welty's fiction, an arrangement that we happily continued with monthly sojourns in the last two years of Ruth's life. And Patricia Yaeger, University of Michigan, published *Dirt and Desire: Reconstructing Southern Women's Writing, 1930–1990*, which made a significant contribution to both the fields of southern and Welty studies and to my work here.

This particular book project began in a conversation with Nancy Grayson, then an editor at the University of Georgia Press, who heard me deliver a paper in Chapel Hill and asked if there was more on the topic. Nancy left her position at the press before I completed this book, but I have not forgotten either our conversations or the friendship that developed as we discussed it.

Bucknell University's Dean's Office; the Bucknell Center for the Study of Race, Ethnicity and Gender (CSREG); and the Bucknell Department of English provided critical funding for research travel to both Mississippi and New York, for archival fees, and for conference and use fees, supporting this ven-

ture at many stages. I especially want to thank Associate Dean Ann Tlusty and CSREG director Susan Reed for their dedicated sponsorship.

At the Mississippi Department of Archives and History (MDAH), the Welty Collection's director, Forrest Galey, and Special Collections archivist Betty Uzman answered my every question and request with warmth, enthusiasm, and insight. Working with them has made long-distance archival labor a pleasure: they have my high opinion and gratitude. The Welty Collection that they oversee, catalog, tend, and preserve is unsurpassed in its value to scholars as is their exceptional work in shaping it. I also thank Julie Dees in the MDAH electronic archives, who made fresh scans of Welty's photographs for this book.

I am indebted to Tal Nadan, a reference archivist in the Brooke Russell Astor Reading Room of the New York Public Library, for her kind facilitation when making available the Russell and Volkening Papers.

Without the support of Mary Alice Welty White, Eudora Welty's niece and executor, and Robert McQuilkin at Lippincott, Massie, McQuilkin (the most recent bearer of the Russell and Volkening mantle), this project would not have happened; I greatly appreciate their cooperation and assistance, especially their permission to discuss Welty's unpublished stories and correspondence and to reprint her photographs. I am also especially grateful to Michael Robinson, Louisiana State University, for his permission to discuss and reprint lines from Eudora Welty's letters to John Robinson and from John Robinson's unpublished manuscripts. I particularly appreciate the part Michael Robinson played in preserving these materials.

Arranging for the many images supplementing this book was no easy task, and I thank all those who helped me to track and arrange permissions, including Rebecca Sullivan, the rights specialist at Ohio State University Press; Michael Lange, the collections and information access coordinator at the Oakland Museum of California; Cheryl Ferguson, an archival assistant at Tuskegee University Archives; and Jordan Stepp, the intellectual property manager at the University of Georgia Press.

I am extremely grateful to the colleagues who read my entire manuscript at various stages of its development: Katherine Henninger, Rebecca Mark, David McWhirter, and the anonymous readers for the University of Georgia Press. Their comments and criticisms have made this a better book, and their encouragement has been inestimable. I am likewise thankful for the input of Suzanne Marrs, who read sections of the manuscript and with whom I have shared decades of creative and, in this case, foundational Welty conversations. I extend my appreciation for early readings and other assistance to a number of extraordinary students who worked with me at various stages of the book's development, especially Nick Salvo, who contributed so much in its final stages; Jacob Agner (now a Welty scholar himself), who read parts of

the manuscript in progress; and Louie Land and Maggie O'Brien, who read drafts and aided with all of the laborious everyday tasks related to a book's early stages of production.

At the University of Georgia Press, I thank my editors, Walter Biggins, who stepped into the project with warmth, grace, and enthusiasm; and John D. Joerschke, who shepherded it through the production stages. I greatly appreciate the subtle elegance and major contribution of my outstanding copyeditor, Merryl A. Sloane, who made this a better book. Thanks too to Erin K. New, art director, who acted as book designer.

I want also to thank my Welty colleagues, friends all, who have been a constant source of pleasure in the field and who have in so many ways nurtured my progress with this book. In addition to those who read it, I owe a debt to Suzan Harrison, whom I have seen too rarely in recent years, but whose interests, so close to my own, have stimulated mine, and to Barbara Ladd, whose friendship I enjoy and whose scholarship I appreciate. I also extend my appreciation to Geraldine Chouard, Susan Donaldson, Julia Eichelberger, Sarah Ford, Michael Kreyling, Pearl McHaney, Donnie McMahand, Daniele Pitavy-Souques, Peggy Prenshaw, Peter Schmidt, Annette Trefzer, Dawn Trouard, Lois Welch, and Sally Wolff. Thanks too to my departmental colleagues Meenakshi Ponnuswami and Michael Drexler for their collaboration in our shared daily academic work, which sustains the teacher-scholar model.

Finally, I thank the members of my family for their long support of my work and for graciously accepting the effects of my writing schedule on our shared lives. I thank my husband, Marc Schloss, for his heroic patience, steady encouragement, and always reliable aid. And I thank my amazing and greatly loved children, Lauren and David Schloss, who keep me aware that work is not the only matter of importance, nor the only way to be creative.

Preface
On Accidental Education and Reading the Body

I first came to Eudora Welty's fiction as a graduate student reading for, and teaching in, an undergraduate survey course on southern literature at the University of Virginia, but I came to the significance of the body and its symbolic capacities earlier and quite by accident.

When I was an undergraduate taking courses at Haverford College, my professor of anthropology, provoked when most of his students had not read the assignment for that day, sent us all away to write a ten-page précis of Mary Douglas's *Purity and Danger: An Analysis of the Concepts of Pollution and Taboo*. That unplanned assignment had consequences that neither my irritated but much respected professor nor I could have predicted. Its first consequence was that I canceled plans with the young man who is now my husband but suggested he read the book too, because it was smart. Its second consequence was that he read the book, and though he had never taken a course in anthropology, he soon set out to become a cultural anthropologist (an example of how a book can change a life or, in this case, two lives). His unpredictable decision made anthropology my second field of study for a time as the two of us read each other's books and then shared the experience of fieldwork in Senegal. But the third consequence, most relevant to this book, came when I focused my own research on southern literature and found I had my key to the field in the seventh chapter of Douglas's book, a statement that in due course I will try to make clear.

Douglas makes two points in her chapter 7. The first is that cultures almost everywhere use the symbolic body to express in microcosm notions central to the social body, the body politic. She writes: "[T]he body is a model which can stand for any bounded system. . . . What is being carved in human flesh is an image of society" (116). As she and southern literature both make abundantly clear, bodies matter. Rules of social order are written on flesh, figura-

tively and literally, a fact particularly evident in U.S. history and literature, textual spaces thick with traumatic recollections of bodies transported, displaced, guarded, sold, brutalized, protected, restrained, and punished. Think from Douglas's lines to the ritually disciplined black male bodies in southern history and literature—lynched for allegedly threatening the white woman's symbolic and restricted body. The asserted "purity" of the white woman's corporeal self has embodied the inviolability of a cultural class and caste system. Lynching protected against a threat not to white women but to the prevailing cultural order. One can see in this single palpable example how state politics are written in the rules, rituals, and conventions regulating bodies, as well as how I came to match Douglas's work to my interest in the literature of the South. In the symbolism of any community's conventions and taboos about bodies, central cultural metaphors are being articulated.

Also in chapter 7, Douglas writes specifically of how cultural ideas about cleanliness and defilement, purity and pollution, express notions of dangers or threats to a society's conceptual order. This is social organization imposed on disorderly nature, and although Douglas might not stress the point, this is a social order imposed in service to a power structure. In short, the body's "boundaries . . . represent any boundaries which are threatened or precarious" (Douglas 116). Douglas additionally details how ideas about defilement generally express "four kinds of social pollution [that] seem worth distinguishing." To make this passage of theory more quickly concrete and relevant, read it while thinking of the boundaries of the class and caste system of the South during Reconstruction: "The first [pollution threatened] is danger pressing on external boundaries; the second, danger from transgressing the internal lines of the system; the third, danger in the margins of the lines. The fourth is danger from internal contradiction, when some of the basic postulates are denied by other basic postulates, so that at certain points the system seems to be at war with itself." In these cases, "the symbolism of the body's boundaries is used . . . to express danger to community boundaries" (122).

For me, this passage holds a key to the cultural ideas about the gendered and raced bodies in twentieth-century southern culture and literature, in the context of an apartheid society riddled with vulnerabilities and internal contradictions. Teaching southern literature, I first thought from each of Douglas's four points analyzing threats of pollution to specific plots of "dangerous" and therefore endangered bodies in Faulkner's storylines. The punished and lynched body of Will Mayes in "Dry September" is a recognizable result of pressure on class and caste boundaries; the "fallen monument" of Emily Grierson's body in "A Rose for Emily" memorializes her transgression of "the internal lines" and the rules and regulations marking caste and class; the castrated, category-defying body of Joe Christmas in *Light in August* models the danger of hybridity blurring "the margins of the lines"; and Tomey's drowned

body in *Go Down, Moses* floats in the dangerous cultural space of "internal contradiction, when . . . basic postulates are denied by other basic postulates, so that at certain points the system seems to be at war with itself." This war of contradiction is evident in the inconsistencies between abstract ideals of honor, chivalry, and family value held and yet denied by another basic postulate: the concrete practices of owning slave bodies, including those of family members. Just as clearly, another internal contradiction is staged on Caddy's reprimanded but pivotal body in *The Sound and the Fury*: the young woman is reduced to powerlessness and yet paradoxically wields overriding power, which has been granted to her symbolic body.

Following this fruitful connection while teaching courses on body and culture in southern literature and photography, I read Patricia Yaeger's newly published *Dirt and Desire* (2000) with quite the same respect Douglas's work had produced in me, but also with an eerie shock of recognition. I realized that Yaeger read Douglas as I had, and had applied the insight to her own countertheory of southern literature, emphasizing the works of black and white women as well as ideas about the body. Yaeger's articulation and extension confirmed and helpfully further defined the links I had been following, and she even read a scene of what I am now calling "female exposure" from Welty's work. I am grateful for and indebted to Yaeger's parallel work. More recently, while I was in the last stages of finishing this book, Jay Watson's *Reading for the Body: The Recalcitrant Materiality of Southern Fiction, 1893–1985* (2012) was published in the same series this book now appears in. Watson also found bodies, literal and symbolic, to be the material of southern literature ("the story of the U.S. south [is] in large part the story of its bodies"; 27), and then he directly called for my book: "one can easily imagine a place for Flannery O'Connor, James Weldon Johnson, Erskine Caldwell, Harriette Arnow, Eudora Welty, Linda Hogan, Alice Walker, or John Kennedy Toole in a study" about reading the body (26). I note his invigorating invitation with the recognition that I have had his predicted Welty chapter long under way.

Written on the Symbolic Body

Reading the Pattern of the Other Woman

In so many of Eudora Welty's fictions a woman's body is exposed, seen, scrutinized, spread, remarked, or commented on. This book explores the puzzle of this repetition. Although the image of female exposure has been noted sporadically, the force and the implications of its repetition as it runs through Welty's fiction and photography have not been appreciated. Her attention to bodies such as Lily Daw's, the bather's in "A Memory," Phoenix Jackson's in "The Worn Path," Jenny Lockhart's in "At the Landing," Virgie Rainey's in "June Recital," Easter's in "Moon Lake," Ruby Gaddy's in "The Demonstrators," and Fay Chisom's in *The Optimist's Daughter*, as well as those of the women she photographed early in her career, make her interest evident. These bodies, among many more discussed in this book, all fit the model of the "other woman," even though the implications of their disparate uses may at first seem various and ambiguous. Their exposure is related to Welty's modernism. Unlike twentieth-century male writers, such as Eliot, Pound, Fitzgerald, and Faulkner, who figure the modern as loss, and more like alternative modernists such as Hurston and Ellison, who write from outside the white male point of view, Welty explores the modern as a body of possibility.

With this pattern of attention to the body of the other woman, Welty's fiction enters southern literature's recurrent traumatic intersection between issues of class, gender construction, and race—all written on symbolic bodies. A prototypical Welty plot pairs a sheltered young "lady" and an "othered" body—usually underclass in Welty, but at times foreign or black. In her "girl stories," a Weltian genre I define and discuss in chapter 1, the sheltered female body is protected, reticent, muted, without direct speech. In opposition, the othered body is disturbingly exposed and expressive, though possibly grotesque. The bodies are paired, and the focalizing girl character is fascinated

by the other, who is seen as transgressive and "making a spectacle of herself," a phrase I will return to in due course. If, throughout southern literature, signifying bodies communicate class and caste ideas of social purity, certain bodies are by their "nature" transgressive. Welty's fictions attend to, adapt, tailor, parody, and transform this semiotic.

The Body of Woman as Historical Situation: Tracing Theories of the Body

As groundwork for my readings of the body of the other woman in Welty, I want to introduce several aspects of theory concerning the relationship between body and culture. As suggested in my preface, anthropology in the work of Mary Douglas (but also, for example, in work by Victor Turner, Clifford Geertz, and T. O. Beidelman) demonstrates that symbolic bodies are vehicles bearing cultural and social meanings, and other theoreticians, such as the sociologist Pierre Bourdieu and the philosopher Michel Foucault, have argued that the body is then prone to become a direct locus of social control.

In his masterwork, *Discipline and Punish*, Foucault outlines the disciplinary practices that produce "docile bodies" (138). Foucault's analysis is stunning in its explanatory power and applicability when he clarifies how the social codes governing the symbolic cultural body are internalized to become the source of self-regulated discipline. Foucault illustrates this through analogy with the panopticon, Jeremy Bentham's 1791 model of a circular prison in which the cell windows face a watchtower where a single supervisor is understood to be. In this well-known and influential analogy, the *impression* of being seen through the lens of regulatory expectation produces perpetual self-surveillance and self-consciousness, a self-discipline that has at its center the prisoner's acceptance and enactment of the role of enforcer.

While Foucault had no particular interest in connecting his insight specifically to the story of the disciplined female body, Sandra Lee Bartky in "Foucault, Femininity, and the Modernization of Patriarchal Power" extends Foucault's analysis to the regulation of the socially controlled and constructed feminine. Bartky writes, "[E]ach becomes to himself his own jailer. . . . the tight, disciplinary control of the body has gotten a hold on the mind as well" (131). Bartky emphasizes women's self-restriction of "manner and movement"; she finds evidence of that self-control in the German photographer Marianne Wex's series of over two thousand photographs that document "differences in typical masculine and feminine body posture." In Wex's photographic record, women consistently sit in public spaces folded in on themselves, "arms close to the body, hands folded . . . in . . . laps, toes pointing straight ahead or turned inward, and legs pressed together." They "take up little space," their eyes averted or downcast when "under scrutiny," while men are expansive, typically situating themselves in "what Wex calls the proffer-

ing position . . . with legs thrown wide apart, crotch visible . . . hand resting comfortably on an open, spread thigh" (Bartky 135).

Taking up and transforming this same point, the feminist philosopher Susan Bordo has helpfully argued the connection between the body as "a powerful symbolic form, a surface on which the central rules, hierarchies, and even metaphysical commitments of a culture are inscribed," and "the concrete language" of the living body disciplined to express culture, that is, the body as experienced. She explains, "Banally, through table manners and toilet habits, through seemingly trivial routines, rules, and practices, culture is 'made body'" (165). The discourse and meanings written on the body express in microcosm the discursive meanings of the macrocosm, and "macrocosm" can and should be read as the dominant culture, the state, social structure, economic class, racial hierarchy, power structure, and so on: in other words, variably, as contexts warrant.

I understand the body as expressing collective social ideas, and its discipline as both public and personal. This observation underpins my discussion of the provocative and rule-breaking body of the other woman in Welty. Additionally, my perspective is that body symbolism expresses changing cultural ideas about gender. Judith Butler, building on Simone de Beauvoir's 1949 statement in *The Second Sex* that "one is not born, but rather becomes, a woman" (267), emphasizes the cultural and historical contexts that influence all performances of gender: "'woman,' and by extension any gender, is an historical situation rather than a natural fact" (Butler, "Performative Acts" 403). She mines the point: "Gender is in no way a stable identity or locus of agency from which various acts proceed; rather, it is an identity tenuously constituted in time—an identity instituted through a stylized repetition of acts" (402). Butler reveals the body as constituted through an individual's (or character's) staged performance of a cultural script and constructed "not only through conventions that sanction and proscribe how one acts one's body, the act or performance that one's body is, but also in the tacit conventions that structure the way the body is culturally perceived" (407). This understanding, quite different from Bordo's emphasis on the concrete body disciplined by culture, introduces possibilities for cultural subversion in performance, a point relevant to Welty's comedies, which take pleasure in undercutting culturally prescribed meanings written on the body. Similarly the unregulated and exposed bodies of women of other classes in Welty's stories that focus on young ladies—for whom "too much display is taboo" (Bartky 136)—are also contested sites of meaning.

The Young Lady's Body: Class and Caste

In Welty's girl stories and in the act of creating her early photography, a middle-class daughter, shaped by cultural expectations, observes and reflects

on the body of a woman who by class or caste or behavior suggests a transgression, alternative, or escape. Not so very far behind these daughters historically is the specific prescriptive construction of the lady in nineteenth- and early twentieth-century American culture and in literary history, which sees her body written as slender and frail, submissive and modest. She is the pure and moral "angel in the house," the embodiment of purity at risk, in need of protection and sheltering.[1] These cultural codes conventionally written on the body of the white woman of a certain social class produced a particular historical psychosocial self-regulation of the body: a specific "femininity." Its imagery embodies the gendered dimensions of an economic signifier replete with racial and class components. Much twentieth-century southern literature turned toward problematizing this gender role and performance; the texts of southern modernism are particularly self-conscious about woman's cultural construction *in*, but as importantly, *by* constraining narrative. (Think of Katherine Anne Porter's "Old Mortality," where the young Miranda recognizes that she is being educated and constricted through the family's confusing stories about her Aunt Amy's performance of body.)

Constraint has had an exacting life in southern culture where sheltering the female members of a designated class status expresses the overly determined symbolic protection of a class system and economic hierarchy. In this context, the story of the socially constructed body is significantly about whiteness as well. That is, constraint differs across the color line. The black woman has been historically and culturally exposed to obligatory labor and to manifest sexual incursion. Moreover, black bodies have been constrained by the discipline and ritual terrorism of lynching, which inscribes white power in mutilated and disfigured black flesh. For the white woman, constraint has had a different form and meaning. Bound up with restrictions on her purity, since the concept of whiteness appends notions of sexuality to that of class, her sexuality is a real and symbolic arena where the boundaries of the social structure are governed. It is the protection of the caste system (threatened by the emancipation of the black body from its previous control within the institution of slavery) that is coded in the sheltering of her symbolic purity. In that specific historical locality, the regulation of sexuality through white female sheltering and protection reflects women's potential capacity to challenge the boundaries of the social order by producing mixed-race bodies, a hybridity defying the strict divisions of the apartheid South. The protection and sheltering of white women of the middle or upper classes was quite literally the defense of a southern social organization through the control of reproductive ability. The child of a white man and a black woman might be denied as "fatherless," but the mixed-race child born to a white mother is incontestably family.

This backdrop of race history and social order, which may at first seem entirely unconnected to Welty's girl stories, is relevant to the theme of sheltering

in these stories, which clearly address a coherent world of whiteness. This co-herence needs to be visible to the reader even though there are no black pres-ences to make everyday whiteness obvious, that is, even when the fortification of whiteness is an omitted and obscure backstory. The sheltered daughter of much southern literature lives in this space shaped by the rules of race, caste, and class; the protection of boundaries is felt even when parents seem to be unaware of the cultural caste system's role in standardizing their sheltering behaviors. The shielded daughter's education to constraint needs no contact with the violence of lynching to be about whiteness. Welty, who unlike Rich-ard Wright and William Faulkner does not repeatedly write stories in which a community imagines black men as a threat to white womanhood, instead dramatizes the sheltered daughter in encounters with regulation-breaking other-class women whose whiteness is probationary. These women are so-cially constructed, to use Matthew Frye Jacobson's now well-known phrase, by "whiteness of another color." We will see that these bodies, which are less entitled to and less hemmed in by female sheltering, affect the daughters of Welty's fiction variously.

Welty's Modernism and Her Other Woman: The Sheltered Girl, Female Spectacle, and the Desire for Artistic Self-Exposure

In contrast to the entitled and protected female body made symbol in Welty's girl stories, the body of the other woman is exposed and is often startling and ambiguous in its meanings. Welty, both when she pairs the daughter and her foil and when she focuses on the other woman alone, is arguably not as much interested in the lady's body as in the woman making a spectacle of herself (for better or worse). To help with understanding that pattern, I examine the critical theorist Mary Russo's commentary in "Female Grotesques: Carnival and Theory" in her book *The Female Grotesque: Risk, Excess, and Moder-nity*. Russo's essay captures how "[c]ertain bodies, in certain public framings, in certain public spaces, are always already transgressive—dangerous, and in danger" (60) as she writes about the resonance of a phrase she learned in her childhood, uttered in a "mother's voice":

> Not my own mother's, perhaps, but the voice of an aunt, an older sister, or the mother of a friend. It is a harsh, matronizing phrase, and it is directed toward the behavior of other women:
> "'She' [the other woman] is making a spectacle out of herself."
> Making a spectacle out of oneself seemed a specifically feminine danger. The danger was of an exposure. Men, I learned somewhat later in life, "exposed them-selves," but that operation was quite deliberate and circumscribed. For a woman, making a spectacle out of herself had more to do with a kind of inadvertency and loss of boundaries: the possessors of large, aging, and dimpled thighs displayed at

the public beach, of overly rouged cheeks, of a voice shrill in laughter, or of a sliding bra strap—a loose, dingy bra strap especially—were at once caught out by fate and blameworthy. . . . Any woman could make a spectacle out of herself. (53)

Russo in this passage is identifying the figure of the female transgressor as a public spectacle, a figure that ambiguously has the potential not only to suggest class otherness but to suggest a liberating carnivalesque release from cultural restrictions and discipline, a figure capable of undercutting her own class status or suited to undercut or denigrate class status in general. It is this sort of female self-display that repeatedly gives Welty's demure daughters— from the girl in "A Memory" to Laurel Hand in *The Optimist's Daughter*— something to think about in an exploratory period when thinking is needed.

With this cultural and literary background in mind, in this book I will first consider the group of Welty's most autobiographical fictions, which fascinatingly all radiate from a daughter's position: an early unpublished and untitled story and then "A Memory," "The Winds," "June Recital," and *The Optimist's Daughter*.[2] In these girl stories, daughters repeatedly—though quite differently—escape sheltering, protection, and confinement in order to engage in the imaginative exploration of a provocative other woman from a less sheltered class. These other women, who are not "ladies," are flashers; they expose themselves beyond what a lady should. Welty's other women—from the fleshy bather in "A Memory," to the forbidden Cornella in "The Winds," to the other class Virgie Rainey and Miss Eckhart in "June Recital," to the vulgar, trashy Fay in *The Optimist's Daughter*—model pleasure in female exposure. They are transgressive in the degree to which they make spectacles of themselves. These other women sometimes appall but always attract the reserved middle-class daughters of the fiction who—unsettled—repeatedly mature while thinking about the others.

Welty's stories about young artistic women and the other woman on display—to the extent that they are preoccupied with female self-exposure— seem to address a temporary female anxiety about authorship, described by Gilbert and Gubar as a woman writer's apprehension about taking on a visibility or "authority that seems to the artist by definition inappropriate to her sex" (51). This unease is repeatedly triumphed over in these texts. Meanwhile, the narratives open issues central to Welty's canon: ideas about class, whiteness, probationary whiteness, the female body, social codes, the idea of the lady, female sheltering and protection, exposure, revelation, disclosure, a daughter's escape, and an artist's risk-taking. They sanction, license, and advance Welty's own desire for and acts of artistic self-exposure, even as they express an anxiety about authorship and are the site of her work on that issue.

Gilbert and Gubar present female anxiety of authorship as a hallmark of the tradition of women's literature: there are "feelings of alienation from male

predecessors coupled with . . . culturally conditioned timidity about self-dramatization, . . . and anxiety about the impropriety of female invention" (50), a starting place that Jane Marcus characterizes as part and parcel of a feminist aesthetic of "obstinacy and slyness" (94). Welty—whose fiction loves the pointed risk and sly playfulness of parody, allusions that implicitly amend and revise their antecedents, and inventive amalgamations of genres— characteristically has her bold way with the literary past. Yet, I argue, her recurring stories about reserved young artistic women encountering the other woman on display—circling the topic of female exposure—seem to consistently triumph over issues of reticence, propriety, and baring in fiction and to dare idiosyncrasy, comic satire, startling modernist revision, and modernist literary innovation.

Although I am in this introduction discussing Welty's plot pattern as a response to southern literature's interest in the story of the sheltered female— the lady—which is best understood in its particular cultural context, I need to emphasize that I see Welty as a major modernist rather than as a regional writer, a counterpart to figures such as Eliot, Hemingway, Woolf, Joyce, and Faulkner. I see her as a writer who is at work revising the possibilities of her genre. But unlike some modernists, who both regret and court the "blast" of the modern (here I am thinking of the name of the short-lived but influential journal of modernism, *Blast*), Welty welcomes the shock of the modern in consumer culture and global access and gender change as an opportunity for horizon expansion, and she enjoys "modern" art forms such as jazz, film, pulp fiction, and photography as influences with which to interact productively.

But as much as Welty's stories make use of risks, and enjoy the new, there is also in these autobiographical fictions a sense of needing to overcome the sheltering that is expected to anxiously resist the modern and changeful. Fascinatingly, the pattern of the other woman emerges from the imagination of a writer who repeatedly privileges the word "exposure" in her discussions of her art, referring to what she both seeks and dreads as an artist. It is of course a photographic word, which Welty often uses technically in that arena, but she also adapts it to convey her writer's desire to reach for the gesture and "the moment in which people reveal themselves." Still Welty uses the word ambivalently to confess to "a terrible sense of exposure" (Kuehl 76), which she experiences when giving her words over to "the eyes of the cold public"—her vocabulary recalling what is culturally prohibited for a young white woman of a certain class—as well as to enunciate the most desired goal of her artistic efforts. I emphasize that this is a key word in Welty's personal and artistic vocabulary that bridges her concerns as a woman, as a photographer, and as a fiction writer, a term that she spent time writing about and theorizing with in her essays, even while exposure, I argue, became the central trope in her fiction.

The Other Woman, Exposed, as Literary Double

To further unfold the ambiguities inherent both to the concept of the liberating grotesque and to Welty's dual response to artistic exposure, I consider her plots pairing the sheltered woman and the other woman as literary doubling. Welty's couplings adapt the history of the symbolic body to the history of the literary double, a technique often useful in signifying internal conflict and self-division. As Albert Guerard writes in "Concepts of the Double," a "recurrent preoccupation of double literature is with the need to keep a suppressed self alive, though society may insist on [its] annihilation" (2). Welty's other women all model an ease with and a pleasure in exposure that her thoughtful, quiet young ladies do not share, but the flashers, as I have noted, are sometimes grotesque and highly ambiguous in their significations.

It is arguable that "the power of the double lies in its ambiguity" (Živković 122). The double can be both a model and a grotesque—that doubleness precisely expressing anxiety about choices the central character faces. In the history of doubles, the shadow self may seem a potential menace, "a personality, which for the sake of social acceptance, we would disown" (Guerard 8). The other women, who both appall and attract, embody the central character's internal conflicts. Joanne Blum writes of the double as "a physical acting-out of buried asocial behavior, or simply of feelings, beliefs or actions which the first self cannot express as his/her own" (3). The main character's relationship with the double typically expresses both apprehension about the meaning of the other and a desire for transformation of and difference in the self. The double becomes a lightning rod, drawing flashes of indirect and unforeseen self-revelation.

In Welty's work, the recurrences of the other woman signal various arenas of ambivalence and desire, a fragmentation in narratives that ultimately incline toward integration. Peter Schmidt in *The Heart of the Story* refers to Welty's madwomen and medusas as "ghastly self-images . . . rarely presented in isolation. . . . [They are] paired with images of neat, 'reputable' women, either singly or in groups . . . who represent the proper life a woman ought to lead in society" (4). He quotes Sandra Gilbert and Susan Gubar on the significance of such doubling in women's fiction:

> By projecting [an author's] rebellious impulses not into their heroines but into mad or monstrous women (who are suitably punished in the course of the novel or poem), female authors dramatize their own self-division, their desire both to accept the strictures of patriarchal society and to reject them. What this means, however, is that the madwoman in literature by women is not merely as she might be in male literature an antagonist or foil to the heroine. Rather, she is in some sense the author's double, an image of her own anxiety and rage. (Schmidt 4–5, quoting *Madwoman* 78)

Welty's flashers, however, are not at all presented or coded as predominantly angry but rather as, above all, inappropriately in view, revealing themselves indecorously. These double figures, I argue, signify choices faced in the auto-biographical fictions and by the maturing artist risking and daring. It is in the context of a woman writer's personal conflict that Welty so famously remarks at the close of *One Writer's Beginnings*: "a sheltered life . . . can be a daring life as well" (948).

The portrait of Welty that emerges in her fiction is not of a sheltered woman but of one fascinated by the threat of exposure in her plots and tak-ing artistic risk by moving beyond conventional narration into modernist thematic concern for cultural alienation and into modernist technical exper-imentation. And the complexities of her modernist literary techniques, their obstruction and delayed delivery, seem to perfectly suit Welty's preference for the oblique rather than direct statement, a style reticent about and avoiding directness in ways that bring to mind the lady's averted eye and muted voice but that unexpectedly elevate restraint into a breakout art form, reverberating with subtlety and shattering feminine discipline. Janis P. Stout, discussing Katherine Anne Porter's artistic voice and its connection to her central char-acters' guarded speech, writes of Porter in ways that could equally apply to Welty: "a writer of much in little who speaks by indirection in a style notably concise" (259). Stout describes Porter's handling of her characters Miranda and Laura, her portraits of the artist as a young woman, as speaking little but "in silence . . . ponder[ing] to puzzle out . . . meanings." The restraint, "this silence, this reticence," is not simply a matter of personality but a learned bodily decorum alternately understood as part of the problem and as some-thing being escaped and transformed in the act of authorship, of writing.

The Body of the Other Woman and the Issue of Class

While Welty's fictions are not consistently "historical," they are about a time, place, and cultural history, and it is helpful to historicize the discourse she adapts in her doubling.

Theorizing the double, the philosopher Milica Živković suggests that "the double is never 'free'—it is not 'outside' time but produced within and deter-mined by its social context. . . . it cannot be understood in isolation from it" (121). To take up this point, in this book I seek not only to identify Welty's pattern of writing to transcend her self-division concerning exposure but also to locate the specific cultural ideologies being addressed in her portrayals of the body of the other woman. Her stories fit into, struggle with, and flout the class, race, and gender codes of her time and place, the cultural constructions of the twentieth-century American South. We know order by what we clas-sify as disorder: "The naming of otherness . . . is a telling index of a society's

deepest beliefs" (Živković 124). Welty's other women are almost without fail identified by being what the narrator in "A Memory" says was, in that time period, called "common." Their gestures and behaviors disrupt the structures of the accepted and established social order and classed propriety. An understanding of how Welty uses class and otherness can make coherent what otherwise can be most puzzling in fictions such as "A Memory" and *The Optimist's Daughter*: how to read the other woman. These stories are fascinating in their attention to social hierarchy and the southern caste system's "trash" and "color" lines, a topic that has not yet received the attention it requires in Welty criticism, which overlaps with issues of the classed construction of gendered roles.

Let me clarify and locate the lower-class white woman—on the basis of her unladylike presentation of her body—as dissociated from whiteness. Ashley Craig Lancaster makes the severing explicit in her book *The Angelic Mother and the Predatory Seductress: Poor White Women in Southern Literature of the Great Depression*, and her argument, while not the whole backstory in Welty's case, provides an informing cultural context. Lancaster contends that, beginning in the Depression years when America teetered "on the brink of failure" and "economic changes . . . had annihilated social boundaries that America had created for itself since its inception" (3), feelings of powerlessness fostered a need to assert superiority by othering the poor and blaming the victim. Disparagement frequently works itself into literary representations of underclasses, and one plot type focuses on the poor white woman's self-display.

Discussing that context, Lancaster draws on Toni Morrison's analysis in *Playing in the Dark: Whiteness and the Literary Imagination* of how African Americans were written by white writers—often as animal and sexual—in order to reveal by opposition a privileged concept of American whiteness. Lancaster supports the view that poor whites were denied whiteness; like the African Americans positioned as the threatening racial other and associated with fantastic erotic fears during Reconstruction and Jim Crow, the othered poor elicited scorn and dread, and the underclass woman was assigned a reputation for shameful, overt sexuality. Reflecting a sense that economic depression itself was evidence of a society "diseased" as a consequence of "human 'degeneration,'" the Fitter Family and eugenics movements regarded poverty itself as a starting point for identifying the potential contagion of moral, mental, and physical degeneration (Lancaster 4). This social framework promoted both cultural stereotypes and popular narratives of the poor white woman, who was envisioned as threatening the social fabric through her attractiveness, licentiousness, and reproductive power. Her sexuality was the danger, responsible for the general national "decline and descent" (14) by way of the reproduction of generations of "inferior" people. One feature

of this construction was a close association between the notions of sexual waywardness and feeblemindedness in lower-class, "unfit" women feared to be nonetheless attractive to "'normal' men" (18); they were capable, Nicole Hahn Rafter writes in her introduction to *White Trash*, of "spawning endless generations of paupers, criminals, and imbeciles" (2). Eugenics and Fitter Family movements, while ostensibly aiming to improve the plight of the poor, used supposed scientific reasoning to disenfranchise the needy by marking them as probationarily white at best. These movements envisioned the sexuality of the unladylike underclass woman as threatening the community's social foundation and the national health, not incidentally justifying the medical sterilizations that were an undercover feature of the movements, again pointing toward the threat of her sexuality.

While Lancaster finds that this female characterization recurs endlessly in southern literature, she acknowledges and demonstrates that there are both static and dynamic uses of the literary trope. She does not write about Welty's work, but one need only think of "Lily Daw and the Three Ladies" to see that Welty is perfectly familiar with the eugenics stereotype and that she is using the image dynamically not to mock Lily—who is certainly poor, assumed to be rather feebleminded, and comically considered at perilous risk of being wayward—but instead to lampoon the concerned ladies who have taken her as their ward and social project.[3] Welty satirizes the guardians of reputable ladyhood and respectable whiteness and, in addition, parodies and interrogates the clear but strictly limited choice generally open to women in fiction of either marrying suitably or being revealed as certifiably insane.[4] Lily's protectors' goal is to keep her acting the part of "the perfect lady" (drolly defined by the text itself: "She was a perfect lady—just set in her seat and stared"; *Collected Stories of Eudora Welty* 3)[5] while suppressing what Mrs. Watts delicately refers to as Lily's "maturity." Mrs. Watts observes, "Lily has gotten so she is very mature for her age"—and she does not mean mentally (*CS* 4). The ladies consider the opportunities open to a poor, "mature" girl, and as Peggy Prenshaw wittily comments, they ponder whether her welfare, which is to say theirs, would be "best served by the protections offered by the state in the form of the Ellisville Institute for the Feeble-Minded of Mississippi? Or should she be mainstreamed into marriage with a traveling xylophone player and thus into the society of bourgeois individualism?" ("Welty's Transformations" 24). Like much of the literature of the period, which imagines the ending of a poor woman's story to be either suicide, madness, or matrimony, the ladies see Lily's choice as tottering between confinement at the state institution for the feebleminded and (as should only be expected) concurrently wayward girls, or confinement in a respectable marriage, in this case with a small, deaf, itinerant musician—not "fitter" but just fit enough. The comedy is that the ladies, in ways akin to the familiar literary endings that Welty par-

odies, present these as interchangeable female outcomes: "Some of the people thought Lily was on the train, and some swore she wasn't. Everybody cheered, though, and a straw hat was thrown into the telephone wires" (CS 11).

It would be a misrepresentation of Lancaster's helpful work not to mention that she couples the prevalence of the underclass seductress in southern literature of the period with an equally ubiquitous tale of the poor but angelic mother. But this cliché gets no play or parody in Welty's works, where mothers are never angelic but increasingly complex.[6] While Welty is not uninterested in motherhood (as I show in subsequent chapters), she is more interested in the generation of daughters who—whether as teachers, musicians, beauticians, camp counselors, or architects—are working women, not in line for motherly roles. If complex attention to women's sexuality is one marker of Welty's modernism, so is her attention to women's job choices. And while women's work is at first and for the most part a class marker in her fiction, her interest runs in a countercurrent to the post-Depression Fitter Family culture, which favored a return to more traditional women's roles. Particularly in the Welty fictions with autobiographical inclinations, the issues of both sexuality and career emerge in ways that open chasms between mothers and daughters. Daughters like Josie, Cassie, Miss Eckhart, Virgie, and Laurel are in the process of picturing women beyond the confines of the sort of dualistic cultural stereotypes that Lancaster notes and that confine the mothers and restrict their space for self-definition.

Here we begin to see the radical potential of Welty's imaginative play. The ways in which she develops her own impulse to daring as a female artist inform the ways we can analyze gender, sexuality, race, and class. Welty's creative process developed through her engagement of the self-confident black women in her photographs and the audacious working-class white women in her stories. That a sheltered woman might dare to expose herself on the printed page through a synergetic identification with these othered women takes feminist and gender studies of such muse-like relationships to an unexpected level. The portrait is of a woman artist who creates through her identification with a community of "other women."

Nina Carmichael on the Other: Reading the Issues of Class, Caste, Propriety, and Exposure in "Moon Lake"

To follow up on my suggestion that class issues inform Welty's pairings of the daughter and the other woman, I turn to "Moon Lake." This is a fine text for illustrating the pattern and the pairing that I tie to Welty's impulse to write "other way[s] to live," an exploration that in a sense challenges the insularity of caste, class, and whiteness. Nina Carmichael in "Moon Lake," one of Welty's attentive, middle-class adolescents, ponders her attraction to the or-

phan Easter; her internal monologue is a central coda on imaginatively enter-
ing the other and a strong articulation of Welty's own artistic desire. Nina's
meditation is on the "other way to live," and she thinks, "There were secret
ways. . . . Time's really short, I've been only thinking like the others. It's only
interesting, only worthy, to try for the fiercest secrets. To slip into them all—
to change. To change for a moment into Gertrude, into Mrs. Gruenwald, into
Twosie—into a boy. To *have been* an orphan" (CS 361).

This passage clarifies the attraction of otherness for Welty and points to the
transforming power of imagination and art in her fiction. The other woman
is here a young girl, mused on by a middle-class child largely imprinted with
the notions of the dominant culture but as of yet still capable of imaginatively
escaping into and exploring unauthorized realms. Before the story is over,
Nina will stand and contemplate Easter's exposed body, spread on the camp's
picnic table and surrounded by the gawking and uncomfortable stares of both
Morgana's novitiate and established ladies, and Nina will be unsettled and
in some considerable measure appalled by Easter's exposure. But long before
this scene dominates the story, Nina is fascinated by this surprising girl, the
"county orphan."

Nina is powerfully drawn to Easter even while and very possibly because
the other child is understood in the community at large as one of a group
perceived to be of unknown origin, class, and even racial status, customarily
inhabiting the space of the unwanted child, the social pariah, or the shady
outcast in the care of the state. The Morgana community, in its Christian
"charity," offers the orphan girls a week's probationary whiteness—Matthew
Frye Jacobson's useful term to describe the shifting and fluid boundaries of
white privilege denied or granted to ethnic, immigrant, and underclass groups
socially constructed as both white and other. These orphaned waifs and strays
are brought to share a short season of summer camp with Morgana's entitled
daughters, a gesture "wished on them by Mr. Nesbitt and the Men's Bible
Class after Billy Sunday's visit to town" (CS 342), a negligible act of public
generosity and patronizing self-improvement. Easter is the most charismatic
of the urchins, and her unlikely name, like the name assigned to Faulkner's
abandoned infant Joe Christmas at the door of an orphanage, is a signifying
moniker both uncommon and too "common." It marks the character as an
outsider and yet places her within, or marginal to, the social system.

This name is a difference that Nina addresses when she is startled by Eas-
ter's unexpected spelling of it as "Esther." With the name doubling, Welty
melds two significations. On one hand, Esther is a standard name, but one
that might nonetheless provoke a significant degree of othering by Morgana's
Christian and evangelical residents. Although in this community Esther is
most frequently the name of a black woman (and Welty uses it as such in her
never-published story "The Last of the Figs," which I discuss in chapter 6),

it also calls up the Old Testament woman who, although orphan and out-cast, was favored for her beauty and so was able to represent, intercede, and mediate for her ostracized people: the biblical orphan Esther is honored in the Jewish festival of Purim, celebrated by people giving charity to the poor.[7] Welty doubles that name with Easter, the name of a Christian religious festi-val, which carries associations of resurrection and rebirth appropriate to the plot of the story, since Easter drowns and is resurrected. But for the character, the doubleness is more simply the product of her unopposed liberty to make choices, such as how to spell her own name, a reflection of the orphan's degree of self-parenting and self-invention.

This freedom from socializing parenting is what fascinates the Morgana daughters about the orphan girls and about Easter in particular. Realistically, the foundling's autonomy is the product of her dire and disturbing misfor-tune: she never had a father ("he ran away"), and she remembers that "when [she] could walk," her "mother took [her] by the hand and turned [her] in" at the orphanage (CS 358). Here, Welty makes a subterranean underside of Morgana visible. Yet the Morgana daughters, and Nina in particular, see an asset in this adversity; uncared for, Easter has answered to no one and is "not answerable" (352). To Nina, the orphans suggest an enviably unsheltered life as well as an alien social one: to her, the orphans being "less fortunate," less loved and protected, implies "nobody's watching them" (352), leaving them room to be "dangerous but not, so far, or provenly, bad" (347), gloriously in charge and free of middle-class acculturation. Yet faced with this radical otherness of Easter's identity—the child being able to name herself and her lack of an adult to tell her that her name as she pronounces it and her name as she spells it are different—Nina feels urgently compelled to show Easter how to spell it customarily and conventionally, to spell it "right" as a method of legitimating herself in Morgana proper.

This sudden, alarmed attention to Easter's uncommon and too "common" name exposes the momentary, perhaps short-term, limit of Nina's ambivalent readiness to accept unconventional otherness. Her temporary distress and the ambivalence it reveals moves her nearly upper-class and oh-so-white playmate Jinny Love Stark to launch into a diatribe; in an admonishing harangue Jinny Love tries to set Nina straight by explaining class entitlement, by decoding a hierarchy of names, and by dismissing the draw of the romantic other. She lectures Nina: "I was named for my maternal grandmother, so my name's Jinny Love. It couldn't be anything else. Or anything better. You see? Easter's just not a real name. It doesn't matter how she spells it, Nina, nobody ever had it. Not around here" (CS 357). Jinny Love makes her case for inherited class identity along with white entitlement and belonging—versus the or-phan's social oddity and inevitable exclusion—by explaining what she thinks Nina misses when proposing the correct, but for Jinny Love, inadequately

corrective, spelling: the full legacy of prerogative that is the undisputed privilege of acknowledged whiteness and a certain class and caste position. In a Mississippi cosmos where the differences in property between one family and another are not so dramatic as in, say, Faulkner's Yoknapatawpha, the Starks are only modestly better-off than other families in Morgana, but the distance in the community's scheme of social standing between the status of a Stark and of a county orphan is nonetheless comically and starkly clear.

Nina, attracted to Easter just as Cassie is to both Virgie Rainey and Miss Eckhart—that is, as a proxy and alter ego entered imaginatively to explore behaviors otherwise forbidden or inaccessible—contemplates this other and secret way to live, bridging differences in imaginative acts that also open breathing space and provide escape from her own confined and protected identity. In one episode Nina visualizes "the pondering night" that will kneel to Easter. Nina's extended reverie and imaginative risk reveal a volatile early adolescent ambivalence in and toward sexual fantasy: "The pondering night stood rude at the tent door, the opening fold would let it stoop in—it, him— he had risen up inside. Long-armed, or long-winged, he stood in the center where the pole went up. Nina lay back, drawn quietly from him." Then, while she feels personally constrained and quietly draws back from the creativity and eroticism of this fantasy, Nina imaginatively enters Easter in a surrogacy of doubling; she beckons the envisioned dark night, displacing the encounter onto the orphan: "Come here, night, Easter might say, tender to a giant, to such a dark thing. And the night, obedient and graceful, would kneel to her. Easter's calloused hand hung open there to the night that had got wholly into the tent" (CS 361–362). Once Nina's reverie effectively brings the night to Easter, she yearns to more consciously and intentionally change places with her. "Nina let her own arm stretch forward opposite Easter's. Her hand too opened, of itself. . . . 'Instead . . . me instead . . .' In the cup of her hand, in her filling skin, in the fingers' bursting weight and stillness, Nina felt it: compassion and a kind of competing that were all one, a single ecstasy, a single longing. For the night was not impartial. No, the night loved some more than others, served some more than others" (361–362).

Like Cassie Morrison, Josie of "The Winds," and the child in "A Memory," Nina is experienced in reverie (a practice I have written about in "Photographic Convention and Story Composition" as central to Welty's plots), that is, in imagining her way toward and through another. And like those other protected middle-class daughters, Nina manages an imaginative escape from convention and answerability and restraint that lures her to dream her way across class lines and female proprieties into provocative possibilities. At the same time, Nina's musings about the metaphysical night (her play on the chivalric "knight"?) honors Easter in acknowledgment of all that distinguishes the two of them.

This surrogacy of the other-class double carries the aura of erotic as well as spiritual and creative adventure, which is at odds with the conventional restrictions of a community generally raising daughters to be emblems of sheltered propriety. David McWhirter in "Eudora Welty Goes to the Movies" discusses how this episode of fantasy echoes the romantic gestures and narrative vocabulary of a prominent popular culture event: Rudolph Valentino's *The Sheik* (1921). Pointing to "the controversial and wildly popular 'Dark Lover' of the silent screen . . . [as] an inescapable cultural marker during the period of Welty's youth and adolescence," McWhirter probes Nina's fantasy and its problematic but potentially transformative "cinematic orientalism" (75). He reasons that films in this genre created an "imaginary space where Americans in general, and white southerners in particular, might think beyond the boundaries—legal and symbolic—regulating race relations" (75). McWhirter, drawing on Miriam Hansen's commentary on the reception of *The Sheik*, articulates how the popular film's echoes of the disturbingly familiar racialized rape story—in which the black man threatens the white woman's chastity—are transformatively reinscribed into an ambiguous narrative "linked to the emergence of and anxieties about" female modernity. The film's ending celebrates the New Woman's exercise of sexual choice, an escape of expectation relevant to Welty's stories about young women escaping constraints. At the same time, the close of the motion picture has not unwritten the script's threatening vocabulary, which melds ethnic otherness with rape and mixes freedom and romance with rape, opening issues and opacities also relevant to questions raised by Welty's own rape narratives, addressed later in this book.[8]

In Welty's fictions the fascination of middle-class daughters with their freer counterparts is not simply or primarily about sexual freedom, although cultural and classed social codes written in prohibitions about the body—especially the need for the purity of the white female body—emphasize those terms. Instead, or additionally, the allure of these reveries is more accurately about wide-ranging desire and an aspiration for autonomy developed in coming-of-age stories through the contemplation of otherness. Crucially, the girls' fascination with the body of the other is problematic because, on the one hand it is tied to a recognizable, inherited, racist, class-pedigreed cultural vocabulary, and on the other hand it is remedially and therapeutically working to transform racist and hierarchical discourse through reinscriptions in stories of identification that transgress class lines.

Looking Forward: An Overview of This Book

Exploration of "the other way to live" and a desire for "the fiercest secrets" are topics legible in the messages written on the female body across Welty's career, a topic unfolded variously over the next six chapters.

Chapter 1, "Other Women's Bodies in Welty's 'Girl Stories': Ladies, Flashers, and the Daring Escape of Female Sheltering," looks closely and specifically at the evolution of this pattern in Welty's autobiographical fictions. I read the developing pattern through the genre of the portrait of the artist as a young woman, while staying aware of how southern cultural ideas of class, caste, and racial hierarchy overlap with symbolic concepts of the "lady" and the related practice of sheltering young white women of a certain social status. I map the changing and maturing of the pattern over the course of Welty's career, suggesting fresh readings of the exposed bather in "A Memory," the adolescent Cassie Morrison in "June Recital," the vulgar, tacky Fay in *The Optimist's Daughter*, and the issue of class in Welty's work generally. An early manuscript Welty archived but restricted from public display until after her death, written when she was only sixteen, predicts both the pattern and many of the specific details of the autobiographical fictions she published over the course of her lifetime.

This is the first of three chapters that trace Welty's development as an artist dealing with the tropes of exposure, desire, sexuality, constraint, restraint, displacement, reverie, and fulfillment. These chapters of part 1—"Understanding the Body of the Other Woman"—are each about the tacit "biography" of the implied artist, understood through Welty's handling of the topic of exposure. Her self-education as an artist is evident not only in the pattern of the other woman in her girl stories, which read together compose a sort of novel of education (or *künstlerroman*) written over the course of her career, but is also visible in her early original representations of the black female body in her photographs of other women and is again discernible when she disturbs the silence of her lover manqué John Robinson's closet through her writing of "Music from Spain," creating exposure.

My second chapter, "Welty's Photography and the Other Woman," reveals the pattern of the body of other woman as intriguingly already in place in the 1930s camerawork that preceded her fiction. I suggest that this body of imagery is both a precursor and a key to her fictional corpus; I place my discussion of Welty's photographs after my discussion of her daughter stories so that the connections between the shaping pattern in her fictions and her technological acts of framing other women are clear. In her early photography of black women, one woman is in the frame, and just outside the frame stands the photographer, reaching to an other, imaginatively crossing boundaries in ways that she describes as both eye- and "heart-opening" (Yardley 6). This pattern is the source of her documentary photography's considerable contribution to the representation of the black female body. In this chapter I also place Welty's photos of the other woman into a history of women's bodies in ethnographic images, in early erotic photography, and in images of the Farm Security Administration's American Memory Project in order to distinguish

what is essentially groundbreaking in Welty's camerawork from the more fa-
miliar racial constructions also apparent there. Tracing her photographs in
the context of historical visual representation suggests how Welty's portrayal
of the black body is both of her time and place and yet innovating in some
startling ways that deserve much greater recognition.

Chapter 3, "Silence, Sheltering, and Exposure in 'Music from Spain' and
The Bride of the Innisfallen and Other Stories: Eudora Welty in John Rob-
inson's Closet," transitions from the concern for exposure in Welty's fiction
and photography to her personal escape from sheltering into the risks of a
complex relationship, and then back to its relevance to her fiction and career.
Robinson, who either did not fully recognize or was unwilling to acknowl-
edge and reveal his sexual orientation during the first decades of their rela-
tionship, found the man with whom he would spend the rest of his life only
at the end of what Welty initially understood as their extended courtship.
Robinson's period in the closet and his drawing the curtain of silence on the
topic of homosexuality created a space and an epistemology that Welty also
inhabited, by default. Documenting Robinson's gradual self-exposure in fic-
tions he wrote, I consider Welty, who read, edited, and even typed his work,
and her literary responses to Robinson's limited disclosure. Eve Sedgwick
in *Epistemology of the Closet* describes the closet as containing both igno-
rance and knowledge; recalling Foucault's related observation that "there is
not one but many silences" (*History of Sexuality* 27), I recognize that what
Welty did and did not say in letters to Robinson is not a perfectly legible re-
flection of what she knew and might have desired to say. Keeping in mind her
own sheltered and sheltering silence in (and on?) that shared space, I ask if
the relationship—failed in the sense that it did not produce the partnership
Welty hoped for—was useful to her as a writer with little interest in the con-
ventional heterosexual narrative of female sexuality (where marriage is the
goal and the solution) but rather with a perceptible preference for the plot
of the other woman. Considering the issue of discomfort with exposure as
it relates to this period, I explore whether Welty, electing exposure, covertly
broke closeted silence in her drafts and final texts of "Music from Spain," *The
Golden Apples*, and *The Bride of the Innisfallen*.

The second part of this book—"Controversies in Welty Criticism: Figuring
the Body"—treats three specific topics in Welty studies that can be clarified
by understanding what the pattern of the other woman reveals. These three
debates concern the relationship of the emerging comic woman writer to
feminism; her puzzled-over frequent recurrence to rape plots, including rapes
written as comedies; and her handling of race in fictions written when her
region was first immersed in and then in conflict with the Jim Crow regulation
of the black body. These controversies are both embedded in and answered by
her presentations of the body of the other woman.

In chapter 4, "Was Welty a Feminist? Wild-Haired Maternity, the Freak Body, and Comedy," I address the tension between Welty's coolness toward the term "feminist" and the history of her readers' responses interpreting her as writing with a pronounced female swerve, revising older narrative traditions. Noting Sylvia Plath's admiration for Welty's stories and the unexpected similarity in their satires of the feminine, I read "Petrified Man" using the magazine culture that both Welty and Plath were so aware of. I explore conventional ideas about sexuality as power over the other sex (in beauty and rape both) and about changing medical and popular culture notions about female sexuality, pregnancy, abortion, and contraception from 1930 to 1960. This discussion connects to the subject of the sideshow and "freak" bodies in "Petrified Man," a topic also developed in Welty's many carnival photographs and in southern literature more generally. Like miscegenation and mixed-race identity in Faulkner's fiction, sideshow bodies that transgress boundaries— between human and not, or between savage and civilized, or between male and female—challenge the binary divisions considered absolute in an apartheid culture. The category-breaking sideshow body's recurrence foregrounds a segregated society's fascination with hybridities that dispute and defy both strictly defined cultural classifications and the binary oppositions used to construct an insistently defended but vulnerable, even fragile, cultural order.

The next chapter, "'Before the Indifferent Beak Could Let Her Drop': Interrogating Rape—Comic and Otherwise—in Welty's Fiction," concerns Welty's numerous—and sometimes droll—rape plots, a subject brooded over by Welty critics but not yet adequately addressed. I consider the debate that surrounds these plots and the tendency to read them as evidence that "sexually, something is terribly wrong" in Welty's fiction (Claudia Roth Pierpont's provocative remark in "A Perfect Lady"). By contrast, my analysis revisits Welty's career habit of exploding familiar storylines—in this case, traditional rape plots (think *Clarissa* and *Birth of a Nation*) encoding issues of class, race, and power—in ways that considerably alter the current discussion about Welty's play with rape narrative. And I expand the argument to include Welty's unpublished fiction, now available for study, and consider a late turn in her treatment of rape.

My final chapter considering the controversies in Welty studies, "The Body of the Other Woman and the Performance of Race: What Welty Knew," interrogates the enactment and resistance of the black female body across Welty's fiction. From Phoenix Jackson in her early *A Curtain of Green* and Aunt Studney in *Delta Wedding*, to the marginalized but legible bodies of characters such as Twosie in *The Golden Apples*, to Ruby Gaddy's withholding body in "The Demonstrators," and finally to Esther in the never-published "Nicotiana," a story Welty worked on for over a decade without finishing, I read the body of the black woman as she beckoned Welty across her career.

I am particularly interested in Welty's attention to the performance of race in strategic responses that resist the imposed expectations of white audiences written into the texts. This chapter also allows me to enter the debates opened by my edited volume *Eudora Welty, Whiteness, and Race*, particularly concerning the degree of change and continuity over her career, and whether or not her treatments of marginalized black characters in fictions focusing on white communities successfully point readers toward the complex lives obscured by the color line.

The postscript, "A Last Word on Continuity and Change in Welty's Career," both reflects back on my work in this book and moves forward to propose stylistically distinct periods in Welty's career that nonetheless maintain her attention to the other woman's body. To illustrate the changes in her later phase, I discuss her notes for an unexpected story called "The Alterations" in which a seamstress kills her abusive husband by literally making alterations to him. The notes, which reveal Welty's pre-draft process and are representative of her late career interests, also raise the issue of how a writer stops writing after an epoch of imaginative life.

Understanding the Body of the Other Woman

Other Women's Bodies in Welty's "Girl Stories"

Ladies, Flashers, and the Daring Escape of Female Sheltering

Welty's girl stories, echoing details from her life and generally acknowledged to be her most autobiographical, are a distinct genre in which a middle-class girl (who resembles Welty herself) escapes sheltering while or by imaginatively entering a woman from another class. In all of her coming-of-age narratives, middle-class daughters consider an overexposed "other" woman, and their thoughts take them unexpected places.

The schoolgirl of "A Memory" watches a large, "common" woman alarmingly expose her excessive self at the beach without concern, and then she disturbingly imagines the woman's breasts crumbling and dissolving as if made of the sliding sand that spatters them.[1] Young Josie in "The Winds" is awakened to thoughts about Cornella, a forbidden playmate who lives in the neighborhood's problem house and is often on display, tossing her "vigorously sunned" yellow hair over her face "like a waterfall" and indecorously brushing "it over and over out in public" (*CS* 214). Josie's attractions to the taboo Cornella smoothly double her delight with a cornetist, a confident and self-exposing Chautauqua performer whose beckoning musical exhibition leaves the pubescent and sexually awakening Josie "pierced with pleasure." The adolescent Cassie Morrison in "June Recital" imagines her way into the stories of the vulnerable but risk-taking outsiders Virgie Rainey and Miss Eckhart who, transforming aspects of "The Winds," add to the general pattern of other women. The audacious other-class Virgie, like Cornella, shows her brazen, disheveled self in the street (ultimately with half-dressed Kewpie Moffitt, "naked from the waist" and "carrying his [sailor's] blouse . . . his collar [standing] out behind him like the lowest-hung wings"; *CS* 324), and Miss Eckhart, a "foreign" musician, like the Chautauqua performer, reveals herself in a startling and, for Cassie, disturbing, performance.[2]

In *The Optimist's Daughter*, when Laurel Hand, still a daughter though no

longer young, fixates on the flashy Fay, who teeters brazenly and erratically on green stiletto heels, the pattern of being fascinated by an other woman's overexposure evolves further. As my introduction to this book suggests, these other women—sometimes models and sometimes grotesques—are repeatedly doubles who embody anxieties that the observing character faces. Interactions between the stories' central consciousness characters and the bodies of these other women need to be acknowledged as pertaining to the self and as expressing desire for exposure in addition to anxiety about it.

Welty's various girl stories all feature these "others" who are not ladies, and whom the narrator of "A Memory" reports would have been called "common" (CS 77) when she was a child. Not ladies, the flashers capture the imaginations of the well-behaved, demure narrators, girls who are nevertheless contemplating the possible escape of their sheltering. This pattern invites speculation about Welty as a middle-class girl growing up in a southern culture that was generally clear about sheltering white women of a certain class. Moving into her unconventional writing and risky violations of the culture's traditional story plots, Welty seems both fascinated and beckoned by other women who are not entitled by class to the confining protection that she and her narrating girls contemplate. The stories' female flashers differently embody the risks of exposure in a culture that prescribes female reticence. Meanwhile, the inhibitions fostered by sheltering seem identical with those promoting a female anxiety of authorship and invention, which these stories both address and overcome.

These stories can also be read against the generic conventions of the "portrait of the artist as a young woman," a plot structure that, as Linda Huf notes in her book of that name, routinely concerns tensions between a conventional sexual awakening and an artistic awakening. In Welty's stories, as in the prototype, the terms "love" and "art" are present, but instead of love of a boy being an obstacle to artistic development, that romantic plot expectation is displaced by the image of an other-class woman exposing herself. Simultaneously, the recurring plot displaces the familiar literary endings of female escape into marriage, madness, or death. In all these stories, female exposure repeatedly steals center stage, supplanting both the conventional romantic love plot and the image of the decorous woman, an identity that the modest, more timid central consciousness characters (the teen at the beach, Josie, Cassie, Nina, and, later and differently, Laurel) seem to expect to inhabit. In all these stories, female exposure is modeled for the middle-class girl by her paired double from outside that class. The other woman breaks social codes—especially the code of the lady. These other-class women are excessive and explosive and on display, and they are regularly accused of vulgarity and bad taste. Not ladies, they are flashers, and their self-exposure focuses the middle-class girls' anxieties about the risks of emotional and artistic self-exposure. In each

case the female narrator is considering risk and escape as she simultaneously judges or admires, is repulsed or attracted by the other woman.

These girls press up to the limits of female restriction as they wander toward and wonder about their freer denigrated doubles. Their sheltering seems to be parental, but needs to be recognized as cultural. The discourse of female sheltering historically belongs to a wide range of times and a variety of places, and in each instance it is culturally specific. Anne Goodwyn Jones points out: "[S]outhern womanhood . . . has much in common with the ideas of the British Victorian lady and of American true womanhood. . . . all show women sexually pure, pious, deferent to external authority. Yet southern womanhood differs . . . from . . . other nineteenth-century images of womanhood. Unlike them, the southern lady is at the core of a region's self-definition; the identity of the South is contingent in part upon the persistence of its tradition of the lady" (4). The topic of female sheltering is for that reason particularly and specifically important in the story of southern literature. Porter's many Miranda stories, Faulkner's stories "A Rose for Emily" and "Dry September," and Lewis Nordan's *Wolf Whistle* are only a few examples of fictions in which the southern lady is protected and restricted to the point of disaster. The protected lady receives recurring attention as an element in the complex vocabulary that fixes the southern social order: her body is key in power, race, class, and gender discourses. And because the lady is not only an emblem of a classed body politic but also an actual physical woman whose interests are not necessarily synonymous with the social structure's, the culture's education on ladyhood is also to restrain her from becoming a danger to the caste, class, and gender order should she step over and blur its boundaries. Thus the symbolic lady was safeguarded and disciplined as an emblem of the "purity" of the class structure that defines the southern cultural hierarchy well into the 1960s, and in remnant behaviors and attitudes still.

In *Dirt and Desire*, Patricia Yaeger, with the bather in Welty's "A Memory" and Miss Eckhart in "June Recital" in mind, discusses the southern lady's sanctioned "miniature" body compared to the grotesque and often "gargantuan" bodies of those who break the code:

> [T]he small compass of the ideal white woman's body is oddly at war with its epic stature in [the] minds of white men. This fragile white body, slim as a reed and graceful as a sylph, becomes pivotal in each crucial task of bodily discipline. What is most remarkable about southern women's fiction is the way it refuses such discipline. When the grotesque body marches onto the page, the ideology that controls southern bodies becomes hypervisible in the most unexpected of ways. (120)

Ideally encased in reserved self-control and deference to authority, in self-regulation and discipline, the purity of the lady's body is identical to its min-

iaturism, emphatically protected from pollution, daring, risk, and the enormity of exposure. The protected female body is petite; the exposed female body, huge—in its effects and its glaring association with excesses of all kinds and with the overindulgence of desires. Regulated womanhood is neat, but the break with expectations is colossal.

The background of the southern social order's racial domination, enforced through ritual lynching, and the discourse of white womanhood protected at first seem impossibly far from Welty's girl stories. But in this cultural context, the sheltering that seems in these stories to be parental is consistent with and reflects a widespread cultural prescription. Not surprisingly, then, in Eudora Welty's narratives "A Memory," "The Winds," "The Little Store," and "June Recital," as in "Moon Lake," the issue of the protected female child repeatedly broaches and specifically opens issues of class difference and social hierarchy.

Let me turn for a moment to speculate about Welty's personal point of entry into issues of class. In Jackson, Welty's family was of modest social status. Yet consider the images of the Welty family published by Patti Carr Black in her photo album *Eudora* and in *Early Escapades: Eudora Welty*. Pictures of Welty's parents in her father's office on Capital Street (figs. 1.1 and 1.2; Black, *Eudora* 9), of tables set for Eudora's third birthday party in the Congress Street house (fig. 1.3; Black, *Eudora* 20), of celebrating Christmas, surrounded by her presents (fig. 1.4; Black, *Eudora* 23), of Eudora dressed in white lace and ruffles (made by her mother with the help of a sewing woman), clothes worn in many pictures but especially worn to ride her bicycle, Princess (fig. 1.5; Black, *Eudora* 37), and of Eudora with her brothers playing baseball (fig. 1.6; Black, *Early Escapades* 148)—these images are provocative signifiers revealing class identity.

The middle-class Jackson, Mississippi, pictured there is all but invisible in the photographs Welty herself took and published; those images she made chronicle difference.[3] Welty describes 1930s Jackson as a community "where the richest people are only a little richer than the poor people" (*The Eye of the Story* 340), and Welty's middle-class family was not particularly wealthy. Nonetheless a juxtaposition of the photographs of the Welty family and of Welty's own images of Mississippi's African American children shows class difference in detail.

Those white lace frocks made by Chestina Welty are additionally signifiers in a culture that protects its girls, encasing them in fabrics that suggest both constrained, decorative fragility and something restrictive to keep clean. Suzanne Marrs has written about Chestina Welty as Eudora's model for "the other way to live," that is, for resisting conventional female behaviors. Marrs shows that Welty's mother was not a clubwoman and that she scorned social prescriptions for female proprieties—a disregard perhaps most possible from

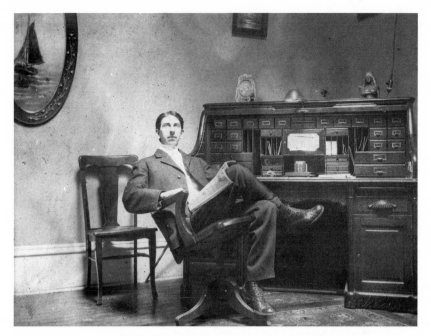

FIGURE 1.1. Christian Webb Welty in his first office on Capital Street (ca. 1906). These family photographs are all reprinted by permission and courtesy of Mary Alice Welty White, the Welty Collection at the Mississippi Department of Archives and History, and Russell and Volkening as agents for the author. Copyright © Eudora Welty LLC.

FIGURE 1.2. Chestina Welty in her husband's office (ca. 1906). Copyright © Eudora Welty LLC.

FIGURE 1.3. The table set for Eudora's third birthday (1912).
Copyright © Eudora Welty LLC.

FIGURE 1.4. Eudora on a Christmas morning with dolls and books (ca. 1912).
Copyright © Eudora Welty LLC.

FIGURE 1.5. Eudora and her bicycle, Princess (ca. 1919).
Copyright. © Eudora Welty LLC.

FIGURE 1.6. Eudora and her brothers playing baseball (ca. 1920).
Copyright © Eudora Welty LLC.

within a secure upper middle-class base. At the same time, Marrs also writes about a mother-daughter tension caused by Chestina's protectiveness and Eudora's guilt about escaping it. In *One Writer's Beginnings*, Welty writes of her mother as "fiercely independent" but in the same passage acknowledges her imposition of her daughter's sheltering. Independence "was my chief inheritance from my mother," Welty writes. "Yet, while she knew that independent spirit so well, it was what she so agonizingly tried to protect me from. . . . It was what we shared. It made the strongest bond between us and the strongest tension" (60). Both Marrs and Welty name some personal rather than cultural reasons for Chris and Chessie Welty's protectiveness of Eudora, chronicling first their loss of a fifteen-month-old child born before Eudora, and then their loss of the unborn child Chessie carried when Eudora was fifteen, a circumstance timed to likely increase her parents' impulse for protectiveness precisely as their adolescent daughter edged toward more mature exploration.

Courtney Bard: Baring and the Portrait of the Artist as a *Very* Young Woman

Whatever the actual Chestina Welty may have said and done, an early unpublished story by Welty (Marrs dates it as 1925) provocatively centers on a mother-daughter relationship full of the regulation, discipline, and restraint of the daughter in ways that foreshadow the stories read closely later in this chapter. This youthful manuscript, sections of a never-finished novella focused on a girl named Courtney Bard, was given to the Mississippi Depart-

ment of Archives and History in 1981 by Welty's friend Ralph Hilton who, cleaning house, found he still had a carbon copy of the manuscript that young Eudora had once sent him to read.

Welty requested that the donated manuscript be "restricted," closed to the public during her lifetime.[4] I speculate that she sealed access for the span of her mother's friends' lifetimes, to avoid the awkwardness of their inevitably associating Chestina with the mother of the story who, like Welty's, is from the mountains of West Virginia and returns there to visit her brothers and mother, who keeps pigeons. Moreover the daughter, Courtney, has a brother named Edward (the name of one of Eudora's brothers). The story in this early manuscript centers on a mother-daughter relationship full of rules and discipline for bodily restraint. It will fascinate a Welty reader who can spot its relevance to her later autobiographical fictions; it shows that in 1925 Welty had already located the seeds of the stories that would grow into "Beautiful Ohio," "The Winds," "June Recital," *The Optimist's Daughter*, and even sections of *One Writer's Beginnings*.

Most clearly the manuscript contains an early draft of "Beautiful Ohio" in its bath scene, and of "The Winds" in its quick treatment of the neighborhood children whom Courtney's mother calls "common" and with whom she would prefer her child not spend time. But it also includes the five-year-old Courtney's listening for the stories overheard in fragments of her mother's conversation. In *One Writer's Beginnings* Welty remembers discovering that there are stories to listen for—"something more acute than listening *to* them"—and realizing that "stories are *there*" (14) in her mother's casual conversations with friends, which prompts her to precociously arrange herself as the audience in the new family car and then command her mother and a friend, "Now talk" (12). Similarly, Courtney responds when she overhears one side of a phone call that intermingles gossip and a recipe, including the mysterious but provoking "Oh, did he live that long? I thought they said he couldn't." Her imagination ignites: "Courtney could see him. He was an old man in a frayed long brown coat and big eyes, and he ran around Them, and They were saying 'You can't live this long, you know.' And he was fooling them."[5] (And beyond *One Writer's Beginnings*, this quick delineation of a man tangled in his community's gossiping voices also calls to mind the plot Welty later elaborates in "The Whole World Knows.") Courtney, whose portentous last name, Bard, alerts readers to the possibility that this is a portrait of a writer's youth, has a sensitive imagination that jumbles her mother's recipe exchange together with gossip about a bicycle accident, but in a way that suggests a child's discovery both of plot and of words. The girl thinks, "Tragic . . . a rich word, too much butter in it. A tragic onion, a tragic bicycle. . . . A swerving bicycle, and a wreck and the onions spilled, and onions are two for a nickel: that must be what 'tragic' means."

Overall the early manuscript's fragments—this is not a rounded, finished story but what looks like drafts of parts of an attempted novella—concern a young girl's discomfort with her mother's overprotection, which is in contrast to her series of encounters with class, family, and racial difference. Courtney's several cross-class meetings include episodes with a family of pinch-fighting, overly numerous Fern children, with her own rural West Virginia mountain relatives, and with the underclass daughters of a laundress—Lucy, Luna, and Loracia[6]—with whom she is taken to play in the absence of other possible West Virginia mates. They also include Courtney's interactions with Uncle Lewis, a bent black man whose arthritic walk and slapping feet the neighborhood children unkindly and extravagantly mock while hobbling behind him: "Uncle Lewis in front . . . the unconscious leader," a mean white mockery that Courtney empathetically recants. Other incidents are with the "common" and therefore forbidden Hockins children—Corine and Joe-boy—who, like Fay Chisom, have come from Texas—and whose family rents an apartment across the street.

Provocatively for a reader who knows what Welty will write ten and twenty years later, Courtney defends her play with these other-class children across the street in details that call up not only "The Winds" but, more astonishingly, "June Recital." The neighbor children want her "to come play their piano." Corine "played one piece 'Firefly' on [it], often, and could run it off in no time." Edward comments on the cooking smells in the house, different from his own, a house that he associates with "old newspapers," details that bring Virgie Rainey, Miss Eckhart, and the MacLain house to mind. Courtney describes how, in that house, "You sit on a chair to play the piano, instead of a bench. . . . And they've got a fringe thing on the top of their piano, and lots of music. Just all over the place." Asked how she knows all that, Courtney admits that, like Loch Morrison in "June Recital," she spies on the house, creeping up on the porch and peering in: "They got an old lady living in the parlor. . . . she isn't any kin to any of 'em. She just lives there and eats with 'em. She's going to teach piano. She pays them ten dollars a month now."

Suzanne Marrs in *Eudora Welty: A Biography* briefly describes Courtney as "a character clearly based upon Eudora, [who] longs to play with the Hockin children. . . . Her mother discourages the friendship: 'I can't understand how those Hockins could have gotten into this neighborhood. They are as common as they can be. Courtney, I would rather you didn't play with them so much, dear'" (5).

To Marrs's quick summary, I would add that throughout the draft's key scenes, there is a repeated tension between the girl's observant explorations of difference and the mother's restrictions and instructions, as well as a parallel arena of struggle over disallowed pleasures. For instance, there is the daughter's pleasure in traipsing barefoot after the water-sprinkler wagon, which had "white horses in front and twin rainbows hanging off the back,

and the shining street behind it," versus the mother's prohibition of running in the public street. The girl is prone to "exuberance" and excitements in conflict with her mother's desire for her to pick up her clothes, to be neat and buttoned, to not run after "dirty" water sprinklers, and to spend time putting things in order. There is the daughter's happiness when running through mountain winds naked before being shamed about her self-exposure. And there is the girl's guarded, secret delight in being bathed by her mother and patted on the belly by her. Under surveillance as a body, expected to please through conformity to gender and class disciplines, the impulse of Courtney to spontaneity and physical bliss becomes the girl's site of resistance.

This mother, created with language and behaviors that bring to mind Patricia Yaeger's title *Dirt and Desire* and Mary Douglas's *Purity and Danger*, is a Victorian lady, represented by "the unknowing look of her back as she turned and left: a tall starched white skirt and the black velvet band above it and the back of the shirtwaist above that, and the tall black hair drawn up with a comb." She repeatedly tells Courtney to be a "good" "nice" girl, a category established in clear opposition to the equally emphasized category of "common" that the child is considering. When, for example, Mrs. Bard tells Courtney she can start to pray for a little sister, the daughter provocatively asks: "[S]he wouldn't be common, would she?" To become a "good, nice girl," as Judith Butler states in her discussion of the performance of gender, is "to compel the body to conform to an historical idea of 'woman.' To induce the body to become a cultural sign, to materialize oneself in obedience to an historically delimited possibility, and to do this as a sustained and repeated corporeal project" ("Performative Acts" 405). Courtney resists this compulsion.

The mother's sheltering regulation, expressed as love, is hard to oppose. Mrs. Bard tells Courtney, "Be careful when you go up the street . . . if anything should happen to you," leaving the child with the apparent discomfort of being so important to her mother that she cannot guiltlessly wander too easily either physically or imaginatively. When the child's mind is preoccupied with stories and songs rather than with her breakfast, the announcement that her mother will have to reheat the meal if Courtney does not soon empty her bowl prompts possible guilt but also a resented sense of fixated redirection: "then '[s]nap!' everything gone except the oatmeal. Persons and animals in songs must hate to vanish that way."

The portrait of relentless parental intrusion on the child's imaginative and bodily pleasures is, it is important to note, mitigated in a few ways. First, the mother is herself the source of her daughter's songs, books, and proper English—that is to say, she is the origin of Courtney's skill with language as well as of gendered discipline. Her touch is also a key and elaborated source of physical pleasure for her daughter. Moreover, she is portrayed as a daughter herself. When in West Virginia, Courtney and her mother bristle and

square off over a wheelbarrow left where the girl "tired of playing with it" (although Courtney fires back that she has *not* tired of playing with it). Hearing this, the grandmother whom they are visiting remarks that her now-adult daughter had "always wanted [her] own way." Later Mrs. Bard shows her own daughterly vulnerability by asking Courtney's grandmother, "Aren't you glad you have your one girl?" The "old lady matter-of-factly, but a little uneasily" responds, "Well—yes to that question," and Mrs. Bard laughs: "You never gave me a compliment in your life, Mama!" While the snip of dialogue confirms Mrs. Bard's lifelong tenacity, it also shows her as a daughter whose own independence has put her in conflict with her mother.

Lastly, the annoyance of the mother's gendered discipline is counterbalanced by a sense of the personal cost of Mrs. Bard's own self-control. In a bath scene that Welty later reworks in "Beautiful Ohio" (1936), Courtney, not for the first time in the manuscript, invites her parent to join her in pleasure rather than choosing to join her mother in gendered discipline. The child, meeting the strangeness of a West Virginia house where having a bath means taking out and filling a tub in a public space, is uneasily undressed. But once naked, "[s]he began running pleasantly around the room, her feet pounding the bare floor happily, her arms waving. The air fanned around her. She went to the door . . . walked gingerly out into the grass. . . . She liked this. Naked on a mountain. The wind. The other mountains. The naked clouds. The naked wind. . . . This was the way to play! The smell of bent grass and the flash of the wind on her moving body." Abruptly, Mrs. Bard responds with a call for self-restraint: "Courtney Allen Bard, what are you doing!" She asks her daughter to think of the consequences of being seen by her Uncle Bob, who "would be so surprised and shamed of his little niece he wouldn't know what to do." She reprimands, "I don't ever want to catch you this way again. The idea! A big girl like you!" But Courtney has replied to her mother, "You ought to just *do* this mother." Then when her mother bathes her in the hot steamy water, "Courtney loved it. Even better than her mother loved it," even though "she struggled a little under the too-gentle hands."

Thinking about this elaborated bath scene in the context of Welty's future plot pattern of the other woman, I see that even this first iteration of her life's work features a middle-class girl caught in an episode of baring that is for her both anathema and pleasure. Other-class girls, who appear throughout the narrative, all fascinate her, emblems of the "common" that the girl is being warned against by her instructing mother in her role as cultural agent, emblems of how not to be. The gesture of baring in this first story is not yet displaced onto the other; here, it is claimed as the girl's own, although uneasily.

Other-class girls, embodiments of difference, although not yet the ambiguous but modeling doubles they will become in the later fictions, are nonetheless ubiquitously and emphatically present throughout the Courtney story.

For example, to provide Courtney with a playmate in a region short on young children, her mother and grandmother take her to the home of her mountain relatives' washwoman, and the scene there resembles those in Walker Evans's Depression era photos of families in poverty. There is a feeling of Mrs. Bard's accepting much lower standards than usual, under the duress of travel, and for Courtney, a sense of otherness. Before the visit Mrs. Bard and her mother discuss the pregnancy of the woman they are dropping in on, who is expecting a fourth child. They implicitly fit her to the emblematic horror tale of the eugenics movement, a poor woman producing too many children, although not yet as many as Courtney's grandmother's own brood of six. As the three approach the house, a child about Courtney's age stands barefoot in the door, "sucking her hand. . . . Her yellow hair . . . long and tangled." As an introduction, Courtney "politely" asks about the other's knotted hair: "[D]oesn't it hurt when they comb your hair?," a remark positioned between empathy and judgment. This yellow-haired girl is Lucy; nearby, "another stringy haired little girl," her sister Luna, holds the baby, Loracia, who is crying because flies "won't let her be." When they hear their mother washing out back, Lucy rather proudly announces that she and Luna deliver it and asks Courtney, "[D]o you carry washing?" Confounded, Courtney strains awkwardly in reply: "There ain't any [laundry] in Jackson. Nobody has any. We don't carry any because nobody has any." Mrs. Bard, clueless about the tensions that have her middle-class daughter on the verge of hot tears, invites the new acquaintances to come play the next day. Stifling her displeasure at her own confusion about how to bridge the class divide, Courtney gets some temporary satisfaction from telling her mother how "other" the girls are: "it don't hurt them to pull their hair clean out. They can't feel a thing."

In this bit of juvenilia, attempted when Eudora was an exceptionally young but ambitious high school senior (she would graduate and be off to college at sixteen), the other women are not yet models of exposure. But the topics of sheltering restriction, of difference, of exposure and its pleasures are already coming together in this "first" story. The connections between this initial autobiographical story and the later ones that I read closely in the rest of this chapter are palpable. In each, the sheltering of the middle-class girl is cultural and guards class proprieties and boundaries, and in each the central girl character uneasily slips out of protection while attending the body of the other woman.

"The Little Store": Listening for the Story Concealed and the Escape of Sheltering

To make my point about the continuity across her canon on these subjects, I want to jump to the other side of her career. Welty's late essay "The Little

Store" (1975) is an informing narrative that recalls her childhood, sheltering, and a possible escape from that overprotection through an encounter with difference. In it Welty recounts a tale that was lived at a corner grocery, a place routinely visited on her mother's errands. She reflects that, as a child, she never wondered about the Sessionses, the other-class family that worked the store; they had then been evident to her only as their function—service and groceries—and were for the most part made invisible by class distinction:

> I didn't know there'd ever been a story . . . going on while I was there. Of course, all the time the Sessions family had been living right overhead there in the upstairs rooms behind the little railed porch and the shaded windows; but I think we children never thought of that. Did I fail to see them as a family because they weren't living in an ordinary house? . . . The possibility that they had any other life at all . . . occurred to me only when tragedy struck their family. There was some act of violence. The shock to the neighborhood traveled to the children, of course; but I couldn't find out from my parents what had happened. They held it back from me, as they'd already held back many things, "until the time comes for you to know." . . . All I ever knew was its aftermath: they were the only people ever known to me who simply vanished. . . . We weren't being sent to the neighborhood grocery for facts of life, or death. But of course those are what we were on the track of, anyway. (*The Eye of the Story* 333–334)

Welty's portrait of her protection from unknown tragedy and her failure to know the Sessions family's story fully is another tale of early sheltering and the aspiration to escape it by entering others' stories.

The portrait of the parent as shelterer and the mother as a representative of classed convention is perhaps not a biographically true reflection of Chestina, but Welty's fictions frequently associate mothers with seemingly comfortable movement around a classed world that daughters disengage from. Marrs writes that while Chestina was not a clubwoman nor circumscribed by conventions defining the lady, "it was Chessie who organized a very conventional bridge party for Eudora the summer before she left for Columbia University. . . . The Jackson *Daily Clarion-Ledger* reported . . . 'eight tables of bridge honoring her attractive daughter.' . . . Like Courtney of her unpublished story, Welty was likely uncomfortable with this sort of event" (Marrs, *Eudora Welty: A Biography* 33–34).[7] Throughout her career, Welty would literally write her way out of the milieu that this classed initiation ritual represents, but both her early familiarity with it and her pleasure in mocking it are perfectly clear in the Jackson "society news" items she wrote for the *Memphis Commercial Appeal* during 1933–1935 (reprinted in Black's *Early Escapades*) as well as in the comic details of her later fictions, which mock all those ladies, their ambitions, and their rituals in which creativity

was channeled only into cream-puff swans articulated with "whipped cream feathers . . . [and] green icing eyes" (CS 328).

Sheltering and Exposure in "A Memory": The Young Lady and the Flasher

"A Memory" (1937) is Welty's first published story to use a middle-class child thinking with an other-class double. It was written before Josie romanticized Cornella, before Cassie Morrison was fascinated by Miss Eckhart and Virgie, and before Nina meditated on the orphan Easter. These later pairings, until Laurel is agitated by Fay, are all less puzzling and less ambiguous than this first one of a fleshy bather and a shy and judgmental girl. But these narrative cross-class encounters all lead a middle-class girl into her imagination and to contemplate sites of resistance to sheltering: art, work, joy, erotic attraction, risk-taking, or the encounter with difference. Repeatedly the daughter escapes protection by encountering the exposure of another woman and wandering into wondering about "the other way to live"—just as Welty wandered as she took her photographs in the 1930s, before settling in earnest into writing.

"Exposure" is a photographic word key to Welty's goals as a visual artist and writer both. It is central in her artistic vocabulary. But its meanings and connotations are complicated. In her preface to One Time, One Place (1971), she speaks of having first recognized her narrative goal of exposure—to disclose the divulging gesture, the inner secret concealed in the concrete and objective by framing it—while working with a camera. She writes of having "learned quickly enough when to click the shutter," but also of recognizing "more slowly . . . a story-writer's truth: the thing to wait on, to reach there in time for, is the moment in which people reveal themselves" (7). So "exposure" is her term for capturing the revealing artistic tell and for conveying in words what a camera arrests with the click of the shutter. It is her goal in the craft of fiction, but Welty understands the complex risk of fiction well enough to simultaneously dread the hazards of exposure. Consequently, she writes of her need for "exposure to the world" (8), but elsewhere she speaks of "the terrible sense of exposure" that she feels "with every book" when she suddenly sees her "words with the cold eyes of the public. It gives me a terrible sense of exposure, as if I'd gotten sunburned" (Kuehl 76). She writes of exposure as a process that "begins in intuition and has its end in showing the heart that expected, while it dreads that exposure" ("How I Write" 249). Exposure is a word she uses to describe dreaded vulnerability as well as a writer's goal. It describes an uneasy female anxiety of authorship, of artistic baring, of being too exposed and inappropriately seen (a feeling related to Courtney's pleasure and shaming at her girlish nakedness) and so, at risk.

The word recalls what is culturally prohibited for a young woman of a certain class. Exposure is what Welty's young women characters both fear and want. These inconsistent connotations caught by the word "exposure" trouble and direct Welty's girl stories as her characters contemplate the expectations that surround them, their desires, and their anxieties. These stories both cling to and rebel against the cloaking and veiling of women.

"A Memory" is an ambiguous but pathbreaking modernist story that can certainly be mystifying. Readers' responses to it repeatedly address four areas of indeterminacy—gaps or openings that one needs to enter in order to interpret what the story will not explicitly say.[8] Interpretative variation itself helps demonstrate the story's indeterminacies. Should the adolescent girl's artistic framing—her habit of composing and containing the world in her squared finger frames—be read positively as youthful artistic prescience, or alternatively, negatively, as a somewhat overly defensive and protective reaction to disorder, to difference, or even to sexual knowledge and the erotic body? Regarding the girl's response to the family of bathers as appallingly "common," is that reaction about her snobbery, their vulgarity, or something else? Is the girl showing her class training by responding to the family with the term "common," or is she using the language of class to express some displaced sexual timidity that the bathers call up? A third ambiguity concerns the ways that readers connect the narrator's memory of first love with the centrality of the overexposed and overfleshed woman she sees at the beach, whose breasts seem to the girl to dissolve at the story's climax. Patricia Yaeger calls this other woman "gargantuan" (*Dirt and Desire* 117), marking her large break with the conventional female miniature and its restrictions. A final recurring issue is about the distance between the girl remembered in the story and the adult narrator telling her story. Has the adult narrator matured, and how? A reading of the story that brings the topics of sheltering and exposure to these questions, and to the body of the other woman, is clarifying.

The story's narrator describes her recollection of the year when she loved a boy to whom she had never spoken, a time when "passion . . . remained . . . hopelessly unexpressed within" her (*CS* 76). This almost adolescent girl performs her preparation to be ladylike in her reticent approaches both to sexuality and to voice. She does not yet know about love, but she has already learned when a young lady is not supposed to speak. Her memory of this "affair" is also a memory of escaping parental oversight. Her parents, who believed their daughter "saw nothing in the world which was not strictly coaxed into place like a vine on [a] . . . trellis," were unaware of the avenues along which their daughter's imagination was straying and "would have been badly concerned if they had guessed how frequently" she glimpsed all from which they had guarded her (75). Escaping from their protection, the girl's first imaginings of

adult love are, not surprisingly, mingled with alarm; no longer feeling childhood attachment, she is startled to feel separate from her family as well as an unknown beloved. There is a relationship in the girl's story between sheltering, silence, and anxiety about exposure.

"A Memory" details the psychology of the child's response to escaping from her parents' sheltering. "Obsessed with notions of concealment," observantly probing her surroundings, she is fragile. To order and to control her experience, she borrows a strategy from her painting class and makes "small frames with [her] fingers to look out at everything" (CS 75). The finger frames, like the frames of reading strategies, angle each scene for interpretation, a selection process that gives emphasis and priority while it also contains and limits. With these frames, the adolescent removes herself from the position of an actor who belongs in the scene. She becomes their seeming composer, like a photographer who in a sense is connected to the scene that she frames principally by her observation and arrangement of it. Primarily, the girl enacts compositional control of the potential exposure she wrests from a scene. The gesture contains the vaguely threatening observations that the girl has begun to make; by transforming random encounters into composed pictures, she disarms and yet approaches the secret life that she feels she is exposing and disclosing.

To enjoy her quickened consciousness, the girl needs to be open, but she is chiefly brittle. She feels a "necessity for absolute conformity to [her] ideas in any happening" (CS 76). One can ask—given her approaching encounter with the bathers—about the sources of her judgments. She seems to be an imaginative girl speculating about others around her and nourishing her narrative intuitions. But many of the specific ideas that she shows us in her recounted memories reflect her cultural socialization; they are normative ideas about romantic love, female silence, proper behaviors, and class.[9]

While the girl's imagination is straying and developing, the unruly and surprising quality of life outside of her mind disconcerts her. Consequently the boy she loves is himself a threat. She confines him to a narrative—another experiment with a controlling artistic strategy. The girl has "never exchanged a word or even a nod of recognition" with the boy. She passes up knowing him. Avoiding what she can only fictionally control, she sidesteps the boy, whose presence suggests potentially dangerous exposures. Unwilling to have him surprise her, she dreads discovering facts about his life at variance with her fantasy. She fears he is of another class. She finds it "unbearable to think that his house might be slovenly and unpainted, hidden by tall trees, that his mother and father might be shabby—dishonest—crippled—dead" (CS 76). When the boy's nose bleeds and he breaks conformity with her vision of him, she faints. When she recovers, the girl obliterates her own sense of

exposure to danger by an imaginative reversal, by picturing the boy as the one endangered. She speculates endlessly on risks he might be exposed to, imagining "that his house might catch on fire in the night and that he might die" (76–77).

Then Welty completely displaces the girl's conventional, if troubled, narrative of romantic love with an image of vast, powerful, and, for the girl, unsettling female exposure. The girl creates this image not from her own social world, where it is repressed, but in a lower-class framing. The girl's memory of the bathers, like that of the boy, is a memory of separateness. It is a more recognizably disturbing separateness, based on class, behavior, physicality, sexuality, but above all, it is based on the remembered bathers' comfort with exposure—exposure that the protected girl both fears and seeks.

The story's older narrator is not identical with the remembered child who was uncomfortable with what she saw as the family's "daring." The narrator comments that when she "was a child, such people were called 'common'" (CS 77), a now-familiar middle-class pejorative. This phrase, it was interesting to see, was handwritten into the final typescript of the story,[10] added as a clarifying revision as Welty polished one of her most obstructed and key early stories. It is this excessive "common" woman, the other woman, who most disturbs and draws the attention of the girl's imagination. She sees her as "white and fatly aware":

> Her breasts hung heavy and widening like pears into her bathing suit. Her legs lay prone one on the other like shadowed bulwarks, uneven and deserted, upon which, from the man's hand, the sand piled higher like the teasing threat of oblivion. (CS 78)

As the adolescent girl stretches out alongside this family with her "eyes pressed shut," she listens "to their moans and their frantic squeals. It seemed to [her] that [she] could hear also the thud and the fat impact of all their ugly bodies upon one another" (79). The exposed body—the corporeality—of this woman, who lies "in leglike confusion" with others on the beach, agitates the young girl, who emerges from her sheltering timidly and with the judgments of an apprentice lady.

Facing this emblem of exposure, the girl self-protectively tries to return to the discipline of her careful, guarded, and controlled narrative of romantic encounter, but it "had vanished." Her dream of a decorous touch of wrists on the school stairs is dissolved by fat flesh and bone thudding on flesh and bone. Suddenly, the girl sees the woman bend over and "in a condescending way," pull "down the front of her bathing suit," "turning it outward, so that the lumps of mashed and folded sand came emptying out. [The girl] felt a peak of horror, as though [the] breasts themselves had turned to sand, as though they were of no importance at all and [the woman] did not care" (CS 79).

Both seeking and unprepared for exposure, the novitiate but escaping young lady watches the other-class woman's quick, baring gesture. In a moment's fantasy, the girl responds by picturing the frightening image of the woman's fleshy breasts cascading down her body. In this involuntary daydream, the girl is imagining what a similar exposure might mean for herself: the possible dissolution of her disciplined, restrained, and confined female self. The girl's dread that the woman will dissolve in her self-exposure is a projection, as is her fantasy of the boy's danger. The image of the dissolving uncovered woman expresses the girl's anxieties about the possible consequences of risky self-baring she both longs for and is alarmed by.

Exposure of the hidden self, desire for and fear of it: unsheltered exposure is the link that creates narrative unity between the story's memories of the unspoken "love" and of the huge, half-undressed woman. The child projects outward her dread of self-display and her fear of boundaries dissolving in consequence. Despite the surfacing of this subliminal image, the girl is as yet unready to understand what disturbs her, and temporarily she retreats again into the short story about a medium-sized boy, who now seems to be a reflection of herself: "speechless and innocent . . . solitary and unprotected," whose eyes she pictures looking "beyond her and out the window" without making contact (CS 80). The young girl has been sheltered into a timidity, a caution, a reserve she will have to escape.

The exposed female body at the memory's center—which Yaeger so efficiently calls "gargantuan"—is a well-packed signifier. The excessive body that fascinates and horrifies the girl is semiotic in a culture that disciplines the female body. Susan Bordo argues in *Unbearable Weight* that society treats "self nurturance and self-feeding as greedy and excessive" and "female hunger—for public power, for independence, for sexual gratification"—as dangerous and indulgent; "the public space that women [are] allowed to take up [is] circumscribed, limited" (171). The bodies of large "broads" are "common"; the slender bodies of ladies are culturally associated with elevated class status. And female miniaturism, Bordo argues, also "functions as 'code' for the suppression of female sexuality . . . exhibited in etiquette and sex manuals of the day [that admonished] . . . the well-bred woman [to] eat little and delicately" (183). Bordo's description of this discipline calls to mind the youthful Scarlett O'Hara when the full-bodied Mammy both scolds the debutante for anticipating pleasure in eating, and checks the young woman's appetite, feeding her in secret before she attends a community barbeque. Like Courtney, who chooses pleasure as her first site of cultural resistance, Scarlett argues that she intends to "have a good time . . . and do my eating at the barbeque." In the film version of *Gone with the Wind* (1939), Mammy, herself excluded from white "femininity" as black and other (McPherson), wheedles and coaxes to protect her vicarious construction of the white girl's surrogate body: "Oh

now, Miss Scarlett, you come on. . . . If you don't care what folks says about dis family I does! I is told ya and told ya that you can always tell a lady by the way she eat in front of folks like a bird." In contrast to the slender body, fat female flesh is an emblem of inappropriate appetites and desires, the undisciplined product of "transgressive" delights (Bordo 110). And to leap from this emblem back to *Discipline and Punish* and Foucault's insight into the bodily discipline culturally institutionalized in the modern army, school, hospital, prison, and factory, which serves as a sort of countermovement to the threats implicit in the new cultural freedoms, we see how the modern woman, increasingly escaping restriction, nonetheless finds more exacting discipline directed to the site of her body (Bartky). Welty's bather is a terrifying symbol of the consequences of escape and yet simultaneously a carnivalesque embodiment of unruly release, a grotesque useful "to destabilize idealizations of female beauty, or to realign the mechanism of desire" (Russo 65). Although part of my argument is that the central characters in Welty's girl stories all wander into wonderings that obliquely focus on escape from sheltering, these young women are all within their texts largely silent, silenced by their thoughts in ways that leave us asking about the extent and form of their escape.

The adolescent girl of "A Memory," who repeatedly expressed her emotions in fantasies she invented about others (the boy, the bather), did not understand the compositions she framed that summer. Nor does the woman who, years later, addresses us with her memories explicitly analyze her young self's daydreams about a timid love and a conspicuous sunbather. But she does invite the reader to interpret the juxtaposed fantasies, pretty well putting herself on display. She does not "say which was more real—the dream [she] could make blossom at will, or the sight of the bathers" (*CS* 77). Instead, she presents "them, you see, only as simultaneous," risking leaving the interpretation to us, risking exposure. This is the change between the child and adult narrator; the adult narrator is no longer the reclusive child who, fearful of boundaries between self and other, spoke stories to none but herself. In addressing us, she obliquely, but willingly, uncovers and expresses her most private self and discloses the story of her escape.

"A Memory" can bewilder because it is often read against predictable conventions that it does not fulfill. A novitiate lady dreams about a first romantic love, but the boy of the story—the representative of the conventional script for the girl's future—appears only briefly. He slips from our attention when female exposure, not conventional romantic love *and* not the lady, takes the stage, clearing the way for narratives more powerful than unsurprising love stories. This earliest tableau of the other woman on display focuses the narrator's youthful conflicted anxieties about self-exposure. It is perhaps a gateway story that permits and sanctions the act of Welty's self-baring in writing, obliquely authorizing the stories, risks, and exposures to come. As such, it is a place to detect the traits of Welty's developing modernism and her risk-

taking relationship to her reader. The tableau painted and left as a puzzle to interpret, should the reader be so inclined, is characteristic of her modernism and of her gamble as an artist who herself flashes and then leaves a reader to discover what she has seen. Welty's plots are not linear; they contain secret rooms and cracked doorways that invite readers to glimpse concealed plotlines. Elsewhere I have written about a characteristic of photographic composition—customarily framing an unexpected and arresting detail that moves a viewer into reverie—as influencing Welty's short story composition, where the plot is located in a reader's response to detail (Pollack, "Photographic Convention and Story Composition"). "A Memory" showcases this formal strategy and so the early development of a matchless stylist.

The spare and complex structure of "A Memory" is especially evident if I compare the story's technique with that of a contemporaneous and unsuccessful manuscript of Welty's titled "The Night of the Little House" (apparently written in 1938, a year after "A Memory," but never published).[11] This curious draft has had too little attention, considering what it makes plain about Welty as a young artist making formal choices in her first productions while coming to recognize and shape her characteristic modernism. Surprisingly, its subplots and characters are familiar from individual stories in *A Curtain of Green* (1941), which are tentatively brought together here.

The 115-page novella is narrated by a young woman from New York, Martha Galen, who has come to Victory, Mississippi, to paint. Welty introduces, as local characters, Clyde and Ruby Fisher (from her recently published "A Piece of News," 1937) and Lily Daw, and at the same time, she drafts the plot of the not-yet-written "The Key," bringing a red-haired stranger together with Ellie and Albert Morgan. Clyde and Ruby have a daughter, Avis; when drawing her likeness, Galen asks Avis to remove her dress only to discover from her exposed body that Clyde beats his daughter, something that the narrator, a rather explicit feminist for a Welty character, wants to stop, eventually with the help of the red-haired stranger whom we recognize from "The Key."[12] The project of Galen's "painting" these local characters in oils and narrative sometimes has the feel of Sarah Orne Jewett's *The Country of the Pointed Firs* or Sherwood Anderson's *Winesburg, Ohio*. The story eventually expands to accommodate both the flirtatious banter and teasing love plots of 1930s cinematic romantic comedy repartee and an outrageous (and spoofing?) violent, apocalyptic Hollywood ending in which guns are fired and lives threatened. The narrator's rented house and paintings burn, leaving Martha Galen to be invited by the comic stranger to his room at the Hotel Constantinople, if only Albert Morgan can be prevailed on to return his key.

The altogether un-Weltyesque jumble of the novella importantly tells us that, contrary to the widespread belief that Welty resisted the novel form even when editors suggested that she needed first to publish a longer work in order to market her short story collections, she actually had attempted the

form, and from her miscarried experiment learned the merit and power of her spare, provocative short story tableaux. When, before long, she excises the nine pages of "The Key" from "The Night of the Little House," she is recognizing and claiming as her own the distinctive methods of her modernism, initiated and achieved in "A Memory." That is, at her best, her stories are whittled puzzles, not centered in conventional linear plots that, even when present, rarely hold a story's heart. Her modernism depends less on linear unfolding than on tessellated architecture, built with interlocking tiles of unexpected shapes that are the intriguing, pointing pieces of her story puzzles. Nevertheless, seeing this experiment, we learn that long before *The Golden Apples*, Welty had imagined bringing the assorted characters of several stories together. When she would try it next, it would be the combining that would create her modernist puzzle.

In 1947 Welty writes to Diarmuid Russell, by then not only her agent but her trusted early reader, to say that several stories she had been writing, she now thinks, are related, in effect announcing her project of *The Golden Apples* to him. He writes back to tease her: "I begin to suspect that what you really are is a dislocated novelist and bit by bit as you go on you'll start reintegrating stories. Are you sure that Ida M'Toy, The Sketching Trip, and A Visit to Charity aren't really pieces of a novel and how about Old Mr. Grenada, The Pageant of Birds and The Wide Net as part of another." These remarks seem to capture what is amusing about the project of "The Night of the Little House." Three weeks later, however, Russell writes again, taking Welty's report more seriously: "I think your sub-conscious must be at work. . . . But I leave this to you and the unseen powers in your head" (September 5, 1947, and September 26, 1947, reprinted in Eichelberger, *Tell About Night Flowers* 203).

"Beautiful Ohio" and "The Winds": Class Boundaries, the Allure of the Other Woman, and the Spectacle of Art

Welty first published "A Memory" in the Autumn 1937 issue of *Southern Review*. In 1942 she would publish "The Winds" in *Harper's Bazaar*. But in 1936, as she was preparing "A Memory" for publication, she was already working on the later story's original version, which she titled "Beautiful Ohio." Its text, like the Courtney story, exists in manuscript only, housed at the Mississippi Department of Archives and History, but it and "The Winds" both develop the sequence and pattern of Welty's girl stories.[13] "Beautiful Ohio" is an astonishingly risk-taking and curiously erotic first rendering that seems to have been judiciously and exquisitely finished and yet also tamed, masked, and expurgated in its published form as "The Winds." Peter Schmidt, emphasizing the risk and lyrical language of "her long prose poem" of a story (144), and Rebecca Mark ("Pierced with Pleasure for the Girls"), reading the stories as about female sexual fulfillment and power embodied in same-sex

muses, have both provided important readings of the relationships between the versions.[14] I add to their discussions to show that the initial story and its published revision disclose a young woman writer's early contemplation of the risk of self-exposure, a pattern in the quilt of Welty's autobiographical fiction. And while certain elements of daring and display are suppressed during the revision of "Beautiful Ohio" into "The Winds," the final version introduces an other-class double who models comfort with self-display.

As in "A Memory," the plot of "Beautiful Ohio" concerns the imaginative escape of a sheltered girl. On the way to a Chautauqua musical evening, Celia thinks how she "had never been taken anywhere at night until now. . . . She walked modestly between her parents."[15] Riding on a streetcar "she flattens her hands on the stiff yellow cane seat so that she will not slide and touch a grown person who sat down beside her. In the seat in front of her, sat her father and mother, their back hair and hats long-faced against the hurly-burly of strangers." She thinks that others on the street "must wonder if [she] will ever come home safely." At the Chautauqua musical evening that is their destination and a central element in both stories, "Celia [is] afraid to clap." The girl has learned the classed codes of female self-containment. But the evening's three musical ladies are emblems of powerful female exposure through art, and they seemingly completely contrast with another female triumvirate that Welty would soon create: Lily Daw's three enforcers of patriarchal proprieties. (The two contrasting triumvirates of mature women perhaps figure and personify the poles of Chestina Welty's contradictory modeling of independence and sheltering.)

Celia's interest in the performing trio focuses on the "tall fair-haired lady in red lace, her white arms holding high, as though she were going to drink from it, a silver trumpet with a gold cup on it."[16] The music from the lady in red catches Celia off-guard:

> But the lady with the trumpet was tall and straight like a hero sending out music straight into the air where it sailed like silver arrows straight over people's heads. Instead of sending out music a little way and calling it back as the others did, she sent it out freely and far and then sent out more. It was also the way the pulse in the rabbit's throat had been but not afraid of hurt and its rising silver penetration shook her soul with a vaunting of the scale and a long calling note.[17]
> The immediate hurrying rhythm of the music pounded the blood in her arms and legs and stomach and she felt as if she were left the responsibility of tossing the tune from one hand to another from beat to beat; it was like a red ball which had been thrown at her . . . which she must juggle and not let fall.

As the song ends, the trumpeter stands with her instrument gleaming against her red dress and smiles—a gesture anticipating Powerhouse's final glimmering smile and satisfaction in performance. Then, with no warning, the trio plays "Beautiful Ohio," bringing to mind Celia's father's birthplace, evoking

"people . . . grown up, but like her father." This vision of the father as the im-age of mature creativity is suddenly displaced, however, by the girl's looking "up the red lace pillar of the lady's dress, . . . past her white raised arms to the golden circle of her trumpet and into its dark gold hole out of which the sweetened challenge came."

This evening of distinctly female performance, emerging as a "sweetened challenge" from the trumpet's "dark gold hole," is followed by what may be the most erotic child's bath—and water heater—in literature: as erotic as Zora Neale Hurston's amazing creaming pear tree. As in the Courtney text, from which the heater and the bath are familiar, and "A Memory," images of the escape of sheltering are at first centered on the body. Now the child pre-paring for her bath focuses on the "often kissed" water heater, which contains a peephole. Through it Celia sees a flame "like a perfect flower shuddering constantly in its protected ecstasy of existence where she could never stick her fingers." Then her mother comes in and pushes "the levers down, fading away the flower . . . , with no expression on her face." Like Courtney's mother, the mother of this story, Mrs. Dalton, is seemingly the harbinger of repression, but she again ambiguously stays and bathes her daughter:

> Celia would do nothing for herself. Her mother soaped her all over and she would not stick out her chest or her stomach or her arms or her legs. She pretended that she was helpless. However her mother turned her she would fall. She made no re-sistance. . . . She pretended that the lady with the trumpet was sitting there in her red gown, bathing her, turning her about, lifting her arm with ascending notes. And she, letting her have all her own way. . . . She felt like telling her mother good-bye.

In this bath scene, a mother is both the agent of suppression and contradic-torily a double for or surrogate of the seducing muse, the trumpet lady, the agent and model in Celia's farewell to childhood.

On the sleeping porch after her bath, Celia enters a fantasy in which she travels through the backyard, a pasture, a field, a street, and a cemetery to a "forbidden creek." In her fantasy she violates her parents' sheltering:

> She walked down the creek bank and touched with her foot the water in the forbidden creek, and waded over the green stones where the snake was, through the cemetery toward the wooden church where the Negro church bell tolled and on and on beyond. She was lost. But she was not afraid, because the lady with the trumpet, coming out of the sky where Venus went in, called to her (almost as if she were young like her) "Come, come. If you come and don't turn back, you will reach the sea and have your heart's desire," and then blew on her trumpet, on and on, her strong lips pushing and throbbing red and smiling at the same time.
> Celia called out and answered her.
> But when her mother came and put her into bed she began to cry.

"Were you lonely here in the dark by yourself?" asked her mother, but the trumpet played on.

"Oh—no—" she said. She turned her face to the wall. It was as though she wanted to be lonely and could not. Something had come to stay.

Escaping sheltering, she follows the call of the lady with the trumpet. Put to bed by her mother, she cries, perhaps to release the intensity of her feeling or perhaps in despair at the gap between who she is becoming and how her mother sees her. But not lonely, she remains connected to the female artist. This coming-of-age story, highlighting mother-daughter tension, a subconscious female eroticism, a girl's escape from her parents, the oneness of sexual and artistic expression, is more provocative than its revision, "The Winds." The reworking, though, will add Welty's distinctive and characteristic turn to the pattern of the other-class double.

"The Winds" opens with Josie awake in the night, thinking about the hayride the big girls and boys are having in the old dark place where young people go—Lovers' Lane on Old Natchez Trace. She imagines "cries of what she did not question to be joy," and an adolescent sexual excitement touches her. But her father's voice shelters her, compelling her to another emotion. "Don't be frightened," he warns as he cuddles her against his thin nightshirt, directing her to a feeling that she had not had. Then, as if the house is possessed by the telekinetic disruptions at times attributed to stormy adolescents, the house shivers. The empty bed in the guest room rolls around, "squeaking on its wheels," and her brother's Tinkertoy tower comes apart, "the wooden spools and rods scattering down" . . . "with a musical tinkle against the floor" (CS 210). "The stairway gave like a chain, the pendulum shivered in the clock," and the sheet music on the piano caves in. Her father explains that it is the equinoctial storm that he is protecting Josie from; he describes it as "a seasonal change" and of course it mirrors Josie's own and is an avatar of the exciting "naked wind" of the Courtney story. Josie upsets her anxious parents by looking outside—in the "strange fluid lightning . . . filling the air, violet and rose"—for the big girl who had moved into the "double-house" across the street. Cornella is the flasher who is not a lady, the other-class woman double of this story. "I see Cornella in the equinox, there in her high-heeled shoes" (211). "Nonsense," her father replies. Mother reiterates, "How many times have I told you that you need not concern yourself with—Cornella!" Father drives home his point: "Josie, don't you understand—I want to keep us close together. . . . Once in an equinoctial storm . . . a man's little girl was blown away from him into a haystack out in a field." The imagery of his threat of vague danger recalls the boy-girl-courtship hayride that Josie had dreamed about as she awoke, and implies its possible consequences for his "little girl." But again conventional romance is displaced by the image of female exposure,

for Josie replies, "The wind will come after Cornella," a statement that is as much celebration as anxiety.

Cornella, a summer inhabitant of the forbidden "double-house" on Josie's block, a rental house where "in the course of the summer [unrelated children] would change to an entirely new set, with the movings in and out" (CS 213), is marked by class otherness and probationary whiteness. The house that, like Courtney's, is bringing a change to the neighborhood, is again a prohibited place for the middle-class daughter, who is being taught class boundaries and being sheltered.

> This worn old house was somehow in disgrace, as if it had been born into it and could not help it. . . . There was always some noise of disappointment to be heard coming from within—a sigh, a thud, something dropped. There were eight children in all that came out of it—all sizes, and all tow-headed, as if they might in some way all be kin under that roof, and they had a habit of arranging themselves in the barren yard . . . like an octave, and staring out across the street at the rest of the neighborhood—as if to state in their rude way, "This is us." (213)

Prefiguring the cornetist's beckoning musical voice, these children arranged "like an octave" suggest a musical phrasing. But these potential companions are specifically banned; "between the double-house and the next house was the strongest fence that could be built, and no ball had ever come back that went over it" (216). "Everyone was cruelly prevented from playing with the children of the double-house" (213).

"Cornella, being nearly grown and being transformed by age, [is] not . . . simply . . . a forbidden playmate" (CS 213), but she also embodies a forbidden female sexuality: trashy, public, and exposed. Her hair is not tangled like Lucy's in the Courtney manuscript, but nevertheless it raises class issues because it is so much on public display: "Big girls are usually idle, but Cornella, as occupied as a child, vigorously sunned . . . [her] bright yellow, wonderfully silky and long" hair:

> She would bend her neck and toss her hair over her head before her face like a waterfall. . . . Josie watched . . . how she shook it, and played with it, and presently began to brush it over and over, out in public. But always through the hiding hair, [Cornella] would [be] looking out, steadily out, over the street. (214)

"She would come out . . . without a hat, without anything" (216). Admiring the show and, even more, the steady gaze of the less-sheltered girl, Josie despairs that her own desire for "daring and risking everything went for nothing." "No matter how old I get, I will never catch up with Cornella" (214).

Rebecca Mark emphasizes that Cornella's name evokes harvest fertility. Welty writes that Josie "had only to face the double-house in her meditations, and then she could invoke Cornella. Thy name is Corn, and thou art like the

ripe corn" (CS 216), an image of the harvest ritual coming and seasonal trans-
formation. Cornella is a ripening and provocative Lolita figure, a muse for
Josie's own impending maturity in a year when Josie rides her bike, Princess,
"with no hands, no feet, touching nowhere but the one place" (212).

Moreover Cornella, like Corine, is also an amateur musician, another sort
of impromptu model. In this revision of the Courtney story and "Beautiful
Ohio" both, Cornella takes over the playing of that song from the lady in red.
"As though the winds were changed back into songs, Josie seemed to hear
'Beautiful Ohio' slowly picked out in the key of C. . . . That was Cornella"
(CS 215). So the marveled-at teen is a student of the type of musical perfor-
mance that is a revelation in the later story's double focus.

As in "A Memory," where two juxtaposed recollections suggest a meaning
rising between them and where a more conventional plot is displaced by a
less conventional and more unexpected one, "The Winds" juxtaposes mem-
ories of insouciant and sensual Cornella with the arousing memory of the
Chautauqua musician—now the cornetist in white, but still a model of self-
exposure through performance and the passion of art. "When Josie's father
kissed her, she remembered the Chautauqua concert earlier that evening. She
had seen The Trio. . . . All were ladies, one in red, one in white, and one in
blue. . . . they began to play a piano, a cornet, and a violin" (CS 219). The
music already had Josie's attention, but when the woman with the cornet
stepped forward, raising her instrument, Josie's response climaxed:

> If morning glories had come out of the horn instead of those sounds, Josie
> would not have felt a more astonished delight. She was pierced with pleasure.
> The sounds that so tremulously came from the striving of the lips were welcome
> and sweet to her. . . . The cornetist was beautiful. . . . like a Queen . . . she
> stood . . . looking upward like the figurehead on a Viking ship. . . . Her closed
> eyelids seemed almost to whir and yet to rest motionless, like the wings of a
> humming-bird, when she reached the high note.
>
> And there not far away with her face all wild, [had been] Cornella listen-
> ing too, and still alone. In some alertness Josie turned and looked back for her
> parents, but they were far back in the crowd; they did not see her, they were not
> listening. She was let free. . . . It seemed to her that a proclamation had been
> made in the last high note of the lady trumpeter when her face had become set in
> its passion and that after that there would be no more waiting and no more time
> left for the one who did not take heed and follow. (220)

Rebecca Mark's title, "Pierced with Pleasure for the Girls," and reading
of this scene unpacks its attention to the corporeal, the creative, and the ho-
moerotic. Gail Mortimer (144) and Peter Schmidt (154) in their discussions
of "The Winds" imagine that Josie faces a choice between being a woman as
defined by Cornella or as by the cornetist. But Cornella and the cornetist are
both women whom Josie wants to be; they are not opposing choices. As Mark

writes, "Welty recognizes the link between the two figures . . . as she changes the woman musician from a trumpet player to a cornet player" ("Pierced with Pleasure for the Girls" 109). The change stresses a connectedness that is underlined by the sound echo, the doubling between "Cornella" and "cornetist." The reiteration between them speaks to my point. Sexual and artistic maturity call for, entail, and grow from comfort with exposure. Cornella and the cornetist share this attribute; they are not opposites but corresponding models. By doubling these figures, the revision she made in the story's final version, Welty is highlighting a parallel, a unity, that culturally is falsely presented as a choice, a duality. Adding Cornella to her original plot, Welty makes visible Josie's bump against the boundaries of female discipline while discovering both her pleasure in her responsive body and her corresponding attraction to exposure in art.

It needs to be said that if sheltering seems to be something to escape in these stories, protection is nonetheless presented as not entirely regrettable. The stories seem to recognize that it may be more fortunate to be Josie than Cornella, that the decorous Josie is more likely to succeed the cornetist as the achieved woman artist, that a certain amount of protection in the long run allows the space to nurture creativity, a space not necessarily available to the relatively at-risk double whose growth will likely be complicated by material obstacles.

In the story's final section, a beckoning tapping at Josie's window foreshadows the appearance of the face of Yeats's "Wandering Aengus" at Cassie Morrison's window in "June Recital":

> A tapping . . . came at her window, like a plea from outside. . . . From whom? She could not know. Cornella, sweet summertime, . . . the lady with the horn whose lips were parted? Had they after all asked something of her? There, outside, was all that was wild and beloved and estranged, and all that would beckon and leave her, and all that was beautiful. She wanted to follow, and by some metamorphosis she would take them in—all—every one. (*CS* 221)

Between the equinox, Cornella, and the cornetist, Josie is awakened to thoughts of a world beyond, the unexpected, the outside, and her future of taking them in and, one might think, of giving them back in art's exposure. In the story's final scene she courts the idea of exposure. Finding a bit of wet paper on the porch, Josie transforms it into a message to, and from, Cornella. "It was a fragment of a letter. . . . The name Cornella was on it and it said, 'O my darling I have waited so long. When are you coming for me? Never a day or a night goes by that I do not ask When? When? When?'" (221).

Mark notes that the conventional romance narrative is in fragments ("Pierced with Pleasure for the Girls" 120). The letter is ambiguously to or from Cornella, but in Josie's hands it is perhaps best read as both to and from

Josie. The message calls her muse and at the same time asks the question of "when" she may find maturity, devotion, exposure, pleasure, consummation, and fulfillment. Josie has been beckoned by Cornella, by the Chautauqua cornetist, and by a season of change to a desire to flaunt herself.

"June Recital": Cassie Morrison's Reverie, Reluctance, and Roaming

"June Recital" is a later story in which a middle-class girl again imagines her way toward other-class women modeling exposure. Again the story counterbalances the alternative of sheltered safety with notions of jeopardy in art, love, and sexuality. Written in 1946, which is to say in Welty's John Robinson period, when she was exploring the love relationship that would eventually end in disappointment if not betrayal, its thematic repetition of a girl considering the risks of exposure plays out quite differently than in "The Winds." Cassie Morrison envies the other-class double, her gifted age-mate Virgie Rainey, whose talent is treasured by Miss Eckhart, their piano teacher, a German immigrant who, with her elderly mother, is among the paying boarders living in the MacLain house, which sits right next door to the more middle-class Morrison house. Cassie's thoughts about Virgie and Miss Eckhart produce a cautionary tale in which self-exposure is attractive but at the same time generates alarming risk, a complex doubleness reminiscent of Welty's construction in her earlier "At the Landing" (published in 1943 though begun in 1934 as "The Children") in which an overly protected girl escapes shelter to enter a flood of experiences, emotions, love, and sexuality, but finds danger and damage as well as exposure.

Cassie's allusive name points and hints. It seems to echo Cassiopeia, referencing both the Greek myth and the celestial constellation, which both glimmer throughout *The Golden Apples*, the myth that sets the Perseus story in motion.[18] But, just as essentially, it summons Cassandra, who found her gift of prescience to be a source of pain. Cassandra stood by a window in the castle of her father, King Priam of Troy, as Cassie stands by hers, and sang her unheeded warning. Cassie's self-description calls Cassandra's story to mind: "She was Cassie in her room, seeing the knowledge and torment beyond her reach, standing at the window singing—in a voice soft, rather full today, and halfway thinking it was pretty" (*CS* 316).

Cassie's "recital," in which a protected young woman's mind goes wandering, reflects its place in her young life. Welty, commenting on her own writerly habits concerning point of view, says, "some of [my] . . . stories might as well be in the first person. . . . when I say 'she' or 'he,' I'm still as much in that character's mind as I would be if she or he were saying it" (Maclay 283). In "June Recital," Welty plunges us into the limited perspectives of her story's two fo-

calizers, Cassie and her brother Loch, and allows the reader to assemble a mosaic from their complementary and contradictory thoughts.[19] While Loch sees what is happening next door from his window and Cassie cannot, she "sees" and composes a story that suggests what Loch misperceives. Meanwhile, the reader, meeting Cassie's section and reformulating Loch's, understands both the events occurring next door and, as crucially, Cassie herself as revealed in her narrative composition. Loch is comfortable climbing out on a limb (literally as well as figuratively) to escape confinement and see what he can, but Cassie thinks of herself as timid, sheltered, and yet suddenly *"un*protected" (*CS* 286, emphasis added) on the threshold of exiting her adolescence. Cassie and her wanderings are at the center of "June Recital," a perspective I hold in opposition to readings that largely ignore her in favor of the story she reveals (see Pollack, "Story-Making in *The Golden Apples*").

Cassie's narrative is the creative composition of a girl who has Yeats in her head, as Miss Eckhart has "the Beethoven" in hers. The tale she composes is nuanced, compelling, and insightful. At the same time, her story-making is the sort that routinely plays a role in an adolescent's production of a gendered self, since it construes and interprets the stories of other women around her. A young teller may define herself, or define "woman," with plots standard for a gendered story and with traditional endings that circumscribe female experience.[20] At the same time, the teller leaves open the possibilities of defining herself against these and of escaping the old story. Cassie's ruminations take the form of an unrequited love story that demonstrates the danger of female emotional risk. Using this familiar plot, Cassie implicitly explores and investigates its assumptions and walks the line between telling the story and being told by it. Cassie's reinscription, however, is not a predictable romantic tale about a man and a woman, but a story of unrequited love between an artist and her disciple, between mentor and student, between an older and a younger woman. Conventional romantic love is once again displaced by a story of female exposure.

The women Cassie "thinks with" are again other-class women. When Loch first spots Miss Eckhart on the walk in front of the MacLain house, he thinks, "Here came an old lady. No, she was an old woman" (*CS* 281). Not a lady to Loch, to Cassie Miss Eckhart is marked by her "Yankeeness" and her German origin. This status as other is intensified by her working for a living. She teaches piano—for the most part to the talentless—out of necessity; dispensing sheet music, she "with a dipped pen add[s] '.25' to the bill on the spot" (289). Similarly, the adolescent Virgie is already a working woman: "Virgie Rainey worked. Not at teaching. She played the piano for the picture show, both shows every night, and got six dollars a week, and was not popular any more" (286). In addition, she is the daughter of "Miss Ice Cream Rainey" (292), a nickname that identifies her mother, Katie, with the selling of cones

at public events. Cassie pictures Katie "scraping up nickels and pennies . . . patting them into shape like her butter, and each time, as [Virgie's] scale went up—just barely getting enough or—as it went down not quite" (292). In comparison to Mrs. Morrison, these working women, one of them a foreigner to boot, all carry the unenviable aura of probationary whiteness in the Morgana community. Cassie exerts herself in her narrative construction to find and keep Miss Eckhart as appropriately other, strange, and unfortunate, but she understands Virgie from the first as *excitingly* other. Cassie thinks of Virgie as enviably, though ambiguously, free from a young lady's confining expectations and so at liberty to have "airs of wildness," dirty hair, "red silk lacers that were actually ladies' shoestrings dipped in pokeberry juice" (291), and a talent for expressing her passion, which she both displays in public performances and takes too much for granted.

Sheltered and middle-class Cassie's meditations are situated in the summer before she will leave home for college when, ready or not, she will go wandering. This summer is a time of preparation. While decorating a scarf to wear on excursions, her musing and memories reveal judgments she is making about how best to meet her future. Her reverie is a speculation on her own capacity for the risks involved in emotional commitment, self-expression, and self-exposure. Her rumination is also punctuated with crucial scenes of overexposure, which are for the most part disturbing to Cassie: Mr. Voight's flashing his nakedness to pupils in Miss Eckhart's studio; Miss Eckhart's emotional baring at Mr. Sissum's graveside, where "if Dr. Loomis had not caught her she would have gone headlong into the red clay hole" (*CS* 299); the teacher's unsettling performance of music "played as if it were Beethoven," which "burst out . . . brilliant . . . like the red blood under the scab of a forgotten fall" (301); the foreign woman's failure to simply "move away" in shame after being raped "as though she considered one thing not so much more terrifying than another. (After all, nobody knew why she came!)" (301); Virgie Rainey's equally astonishing performance at thirteen of Liszt's "Fantasia on Beethoven's Ruins of Athens," which leaves her on display, drenched with and licking sweat as well as showing a symbolic blazon of red staining her white dress, an artist's sweat marking her maturity as clearly as menstrual blood might; and lastly, Virgie emerging disheveled "in utter recklessness" on the public sidewalk with her "naked from the waist up" young sailor and callously clicking by the confused Miss Eckhart, who is being taken way to the poorhouse asylum (325). Cassie's June narrative "recital" then is a variation on a theme she is rehearsing, a composition on a disturbing topic (exposure) that eventually produces an effect. Its impact on her can be measured when, that evening on a hayride, she lets no one "touch even her hand" (329), a hesitancy expressing her feelings about connection, self-disclosure, spectacle, protection, and risk.

Contemplating her possible future adolescent adventures, Cassie is tie-dying the scarf to wear at the night's hayride when she hears the gentle and, for her, portentous opening phrase from "Für Elise" and replies aloud to the music with Miss Eckhart's remembered tribute: "Virgie Rainey, *danke schoen*" (CS 285). She goes to her window to peer out while hiding from what might be Virgie's glance. When the phrase is played for the third time, Cassie is strongly moved, but to an uncomfortable self-perception of her own potential vulnerability:

> Cassie saw herself . . . her small, solemn, unprotected figure was emerging staring-clear inside her mind. There she was now, standing scared at the window again in her petticoat. . . . She had seemed to be favored and happy and she stood there pathetic—homeless-looking—horrible. Like a wave, the gathering past came right up to her. Next time it would be too high. The poetry was all around her, pellucid and lifting from side to side,
>
> > "Though I am old with wandering,
> > Through hollow lands and hilly lands,
> > I will find out where she has gone." (CS 287)

"The poetry" she "hears" are lines from Yeats's "The Song of Wandering Aengus," and this allusion to a quest to fulfill desire is central to *The Golden Apples* as a whole and is also felt in many other Welty fictions.[21] Aengus, one of Yeats's favorite Celtic hero-gods, passionate and restless and associated with poetry, has gone into the starlit night to fish with a pole both natural and magical. A silver trout morphs into a glimmering girl—a visionary invitation and lure. She calls his name and then disappears. He wanders to find her, to pluck the apples of fulfillment, silver apples in the moonlight, golden apples in the sunlight. Growing old with wandering, he persists in his quest and desire.

The poem's recalled lines affect Cassie: "then the wave moved up, towered, and came drowning down over her stuck-up head" (287).[22] Responding, Cassie feels fear, frailty, and homelessness; she feels threatened by emotions that rise up from the "gathering past" and from the poetry, like a drenching wave "too high." Cassie in this passage reveals her capacity for receiving both the music and the poetry. Reacting to them, she feels intuition, vulnerability, and perception flooding over her. What arrives next is the story of the other women. Their tale displaces hers.

Cassie, as she recalls Yeats's poem, is not a practiced wanderer in the world, but a cautious, self-monitored, gender-disciplined young lady who has, with interest, outrage, and envy, watched Virgie Rainey "with . . . customary swiftness and lightness . . . skip an interval, some world-in-between where Cassie and Missie and Parnell were, all dyeing scarves" (CS 302–303). Cassie stands

behind her bedroom curtain, hiding and hesitant. Poised and watchful, she assesses situations while her age-mate Virgie Rainey romps with a sailor next door. Cassie's wandering is less corporeal and more gender-disciplined than Virgie's; Cassie travels mentally, wandering into wondering.

The journey Cassie makes is toward understanding the phrase that "popped to her lips": "Virgie Rainey, *danke schoen.*" Composing the phrase's history for herself, Cassie constructs a tale of unrequited love—Miss Eckhart's for Virgie as a "glimmering girl" (Yeats's words)—both re-creating and altering a standard plot. Cassie composes this story as she stands on the brink of an emotional world that, observing before entering, she wants to assert she is sheltered from. The narrative that passes through Cassie's mind is not a flowing composition, but a series of abrupt scenes and speculations circumscribing her theme of risk and exposure. Cassie's recollection and interpretation constitute a song that she composes and then responds to when, in the fourth and final section of the story, she reenters the life around her in a brief act of heedless self-exposure, rushing out the door in her slip (while her mother reprimands her: "there's no excuse for coming outdoors in your petticoat to cry"; CS 326).

There, Cassie's narrative vision of Virgie Rainey and Miss Eckhart intersects with her direct and actual vision of the two "other women." The disheveled Virgie is seen fleeing the smoky MacLain house with her half-dressed sailor, and she passes Miss Eckhart without offering a word of recognition or aid, ignoring the woman who had once given love to the talented preadolescent "and to no one else," in recognition of her student's potential "to be heard from in the world" (CS 303) by interpreting the music that the teacher loves and offers. As Virgie coldly flees, the now-old woman, with her singed and troubled head in a scorched black cloth ("a fire in her head," literalizing the poem's image), is led away to the Jackson State Mental Hospital. This intruding outside event provides an unplanned finale that concludes and too well confirms Cassie's interpretative reverie on the topic of self-exposure and emotional risk.

We learn later in the interconnected stories of *The Golden Apples*, ending with "The Wanderers," that in spite of Virgie's seeming remoteness here and her ultimate disappointing disregard and forfeiture of her gift, she had indeed accepted when Miss Eckhart offered her Beethoven. But in "June Recital" we are concerned with what Virgie's story means to Cassie. Cassie focuses on Virgie's turning away. Cassie wonders about the music teacher, who "gave all her love to Virgie Rainey and none to anybody else." From her wondering she draws the disturbing conclusion that the old woman's "love never did anybody any good" (CS 307). The redeeming subtleties of Virgie's relationship to her teacher, later essential to the collection as a whole, are not yet visible,

but they will be when "The Wanderers" presents Miss Eckhart and Cassie from Virgie's point of view, as "June Recital" first presents Virgie and Miss Eckhart from Cassie's.

What Cassie stresses is that Miss Eckhart risks exposure and loses the possibility of connection. Cassie sees that Miss Eckhart, not a lady but an unconventional woman, an artist, has given priority to seeking love through art over more conventional relationships and that Virgie belongs to that priority. In Cassie's eyes, the music teacher and her student are as excessive as the magnolia's overlarge bloom; they live with an excess of feeling and a capacity for passionate responsiveness. In their expressive otherness, they resemble Powerhouse, who does not know better than to give "everything" to the point that "people feel ashamed for him" (CS 133). This excess of feeling is what the older woman and her special student have in common, and what they might discipline and express through the form of their music. That Miss Eckhart's music has an unexpected emotional source becomes uncomfortably clear to Cassie on the day when, moved by a summer storm, the teacher exposes herself in a musical utterance. The performance alarms Cassie because it "bursts out, unwanted, exciting, from the wrong person's life" (301). It alters Cassie's perception of her music teacher, a woman she had understood as lonesome and vulnerable, someone compulsively annoyed by flies and ruled by the beat of the metronome. Suddenly Cassie is forced to revise her story of Miss Eckhart to acknowledge, at least temporarily, that the woman has wandered into knowledge somewhere "where Virgie, even, had never been and was not likely to go." "What Miss Eckhart might have told them a long time ago was that there was more than the ear could bear to hear or the eye to see, even in her. The music was too much for Cassie Morrison. . . . She stood . . . with her whole body averted as if to ward off blows from Miss Eckhart's strong left hand" (301). Disturbingly, what is most positive in Miss Eckhart—the self-exposure that surges from her as she performs, "like the red blood under the scab of a forgotten fall"—is received by Cassie as an unexpected assault. Cassie—like Courtney, Celia, and the daughter in "A Memory"—struggles with responses to female exposure, vacillating between desire and anathema.

Somewhere deep in Cassie's vicarious experience of Miss Eckhart's emotions lurks an unpredicted and troubling identification with the woman, one that Cassie attempts to put off but that is very relevant to her as she stands poised on the verge of maturity. It is not lost on her that she, not Virgie, will be Miss Eckhart's heir in the sense that she will study music with the church scholarship spitefully given to her over Virgie in a gesture of middle-class entitlement. She can anticipate what it will mean to become Morgana's next music teacher: "stretching ahead of her, as far as she could see, were those yellow Schirmer books: all the rest of her life" (CS 306). Young Cassie approaches her thoughts about her music teacher as deniable but hair-raising prophecies

about what could be her own future. Cassie's Miss Eckhart is an aspiring but frustrated woman who in her daily life, rather than her music, can rarely find her way to the risks and exposure that might complete her, and when she can and does, her risk-taking unfortunately seems to produce anguish rather than relief. The cautionary tale that Cassie is thinking through has the unsettling potential to validate the code of female social restriction and confinement.

Cassie has repeatedly seen Virgie's knack for exposing Miss Eckhart in ways that make her dread exposure, for example when Virgie taunts the middle-aged woman by binding her with a clover chain at Mr. Sissum's performance in the park. Then "Cassie felt that the teacher was filled with terror, perhaps with pain." These exposures have awakened Cassie's capacity for empathy: "she found it so easy—ever since Virgie showed her—to feel terror and pain in an outsider" (CS 298). Yet Cassie is uneasy with this Cassandra-like gift of prescience and longs to deny it; she wants to distance herself from the afflicted, fearing that her private self secretly is an outsider, capable of hearing the music of those who do not easily win town scholarships. This capacity feeds Cassie's uneasy suspicion of who she privately might be—a possible fluidity of range and identity that she would prefer to conceal even from herself.[23] And this capacity for empathetic identification with the other women disturbs Cassie as much as Miss Eckhart's baring music does. Finding herself so capable of imaginatively entering the outsiders and apprehending Miss Eckhart's anguish, Cassie denies her imaginative identification and potential kinship and assures herself that "on nights like this, pain—even a moment's [personal] pain—seemed inconceivable" (298). Her thought that she is different—not their double—and that, unlike them, she belongs and is by nature safe seems wishful, the product of her desire not to see upsetting realities lurking close.

Cassie's absorbing account of the love between these two women—and their separateness—strikes a chord of mother-daughter connection and struggle. In her tale, Cassie's own mother-daughter story surfaces intermittently to run alongside the other women's complex story. Cassie's relationship to her mother has a bearing on the daughter's point of view. Although she tries to follow Mrs. Morrison's seemingly snobby example of distinguishing herself from these struggling "other women" by dismissing them, or by rudeness, or by expressing class contempt, Cassie and her mother both seem to genuinely fear that they resemble the at-risk women more than they want to know. Cassie can tell their story; she intuits and enters their experiences; she guides the reader into them. Although her account also reveals her mother's modeling a desire to distinguish herself from the troubled women, whose exposure is too apparent (Mrs. Morrison exclaims, "I hate that old MacLain house next door to me. . . . I'm worn out with Miss Snowdie's cross"; CS 295), readers eventually discover that Catherine Morrison is the most troubled of the women, not the most comfortable, when we learn in "The Wanderers" that she has

killed herself. This information is perhaps quietly anticipated by Cassie's apprehending and apprehensive thoughts, that is, her intuitive knowledge of her mother's private self that the daughter is trying not to understand, avoiding this exposure in particular with partially averted eyes.

Cassie's concerns about emotional risk in part seem to come from living with these anxieties about her mother. Mrs. Morrison—who enters her daughter's room to "exclaim and not let herself be touched" (CS 287)—clearly troubles her child. Elizabeth Evans in "Eudora Welty and the Dutiful Daughter" has described Cassie as a submissive daughter who, in the adult life that we glimpse in "The Wanderers," has failed to rebel, to defy, or to wander. This is a position that I resist as failing to fully acknowledge that the later story presents Virgie's view of Cassie (what she sees of Cassie without having access to her thoughts) and as forgetful of the collection's lesson that wandering can be imaginative as well as corporeal. The daughter who decorates her mother's grave with 232 narcissus (CS 456–457) possibly harbors an unforgotten child self who, uncertain of her mother's attention, still desires approval. Their relationship is one source of the girl's fear of emotions: fear of what is risked in them and of what could be exposed through them. Her uneasiness about her mother is expressed repeatedly: Cassie tries "to stay in sight of her mother," because no matter how slightly she strays, "when she got back to their place her mother would be gone" (298). Cassie's dread of what her mother might expose, of a private self expressed in Mrs. Morrison's bouts of self-absorption, is evident in the daughter's discomfort when her mother walks away from her and in her disappointment at not finding herself her mother's priority, anxieties that surface in her memory of a June recital on a night when she feared "her mother might not come at all." Cassie seems simultaneously to suggest and to suppress a shadowy knowledge of her mother, who "was always late" and who "could not walk across the two yards in time to save her life," and who, despite her party facade, has difficulty exposing herself in the public story being composed by such social arbiters as Mrs. Stark, the representative of belonging, who turns "around in her chair down front to spot [and judge] each of the other mothers" (311–312). The suggestion that Cassie's fretfulness implies her discernment of something she would prefer not to acknowledge is finally confirmed by the news of Catherine's suicide.

I have been arguing that there is in Cassie—perhaps for fear of what is to be seen in her mother—a fascinated timidity about exposing private selves, the selves who are always outsiders. Does her anxiety—the possible product of intuitive glimpses into her mother's emotional secrets—help to explain the girl's averting her body from Miss Eckhart's personal, musical, and artistic self-exposure, finding it "more than the ear could bear to hear or the eye to see"? (CS 301). Does it explain her dread of acknowledging that she, like Miss

Eckhart and Virgie, has a private self that is an outsider, an "other" woman, rather than one that comfortably and easily belongs?

Cassie's dread of exposure clarifies the presence of the cryptic boarder Mr. Voight, who flaps the skirts of his robe and flashes in her story. An emblem of disturbing exposure, his gesture worries her, as well it might, and she displaces her anxiety about self-disclosure onto him when he conveniently acts out. Like some dream motif, Mr. Voight's bizarre flapping haunts the girl's imagination. His flashing reveals more than his body to her conjecture; he exposes a frustration and a futility of desire, possibly sexual or simply to quiet the house, but above all he embodies self-exposure as social transgression.

Cassie, I suggest, longs to shun the ominously familiar outsider and potential double in Mr. Voight, in Virgie Rainey, and in Miss Eckhart. Trying out Mr. Voight's "frantic look," she recognizes that she "could not . . . describe Mr. Voight, but . . . without thinking she could *be* Mr. Voight, which was [still] more frightening" than he was (*CS* 296). Her construction of these characters indistinctly suggests and indirectly exposes Cassie's private, feeling self, which both knows and hesitates to know her mother's feeling self. In her strategy of attempting to distance herself, Cassie resembles her mother, who despises the other-class double—Miss Eckhart—for her potential closeness and "just for living so *close* . . . a poor unwanted teacher and unmarried" (*CS* 306, emphasis added). I suggest that Miss Eckhart reminds Catherine Morrison that, in a different way, she too lives alone. Like her mother, Cassie explores her attitudes toward herself as she considers the degree to which she can accept Miss Eckhart.

And, as this young woman reviews Miss Eckhart's history, she is indirectly considering the prudence of risk in commitment, art, and love. As Cassie recalls Virgie's and her own behavior toward the music teacher, she examines her own capacity for tender empathy for the other woman and tries to assert its limitations. Over the years she has performed some chilly emotional experiments aimed at exposing the older woman, for example, by defining pizzicato as "when Mr. Sissum played the cello before he got drowned" (*CS* 300) and by twining arms with Virgie Rainey and flatly refusing to stay for dinner (in support) after Miss Eckhart has slapped her own unpredictable mother for derisively screaming "*Danke schoen, danke schoen, danke schoen*" during Virgie's lesson. Cassie, recalling these little cruelties, asserts the bit of herself that belongs to Morgana and opposes outsiders, and wonders of what she is capable: "There could have been for Miss Eckhart a little opening wedge—a crack in the door. . . . But if I had been the one to see it open, she thought slowly, I might have slammed it tight forever. I might" (308).

Cassie—who here asks how cold, how callous, she might be when compassion is called for—is questioning herself. Cassie's actions eventually are the clearest reply to this earlier self-interrogating reverie: she spontaneously, in-

stinctively rushes in her petticoat to rescue Miss Eckhart, baring her empathy as well as her half-dressed self. Only she stops too soon, in emerging conflict with her instinct. Momentarily rising from her narrative and moving to a front window, Cassie sees law officers carrying off the woman, who is "half sick or dazed" and "about to be touched, prodded, any minute." "To Loch's amazement his sister Cassie came running barefooted down the front walk in her petticoat and in full awareness turned toward town, crying, 'You can't take her!'" (324). Intuiting trouble in a flash and impulsively compassionate, Cassie rushes in her stained undergarment from her bedroom retreat, risking involvement and overexposure. She crosses the doorstep and cries out in a rush of sympathy and outrage, yet she feels empathy too late for anybody to mind her, and she ventures no further. Cassie's impulse is to save Miss Eckhart, but in an act of self-regulation and gendered discipline, she inhibits her desire to blunder further forth. Her stance, poised over a threshold, resembles her hesitation on the metaphoric threshold of her shy late adolescence. She at that moment is unready to risk another step.

Now another moment's fantasy suggests a connection between Cassie's memories and the anxieties that cause her timidity. Cassie comes inside from seeing Virgie walking past Miss Eckhart, her heels clicking, an act that in its way reiterates Cassie's own failure to help the desperate woman. She then has a brief and peculiar daydream about losing the surprisingly desirable scarf she made that afternoon, a tangible emblem of what she lost while telling herself the subtle story of these two women: "She shivered and walked into her room. There was the scarf. It was an old friend, part enemy. . . . She might have lost it, might have run out with it . . . for she had visions of poor Miss Eckhart wearing it away over her head; of Virgie waving it, brazenly, in the air of the street; of too-knowing Jinny Love Stark asking, 'Couldn't you keep it?'" (CS 328). Cassie has made the scarf as an ornament for hayrides and for intervals "out-of-uniform" in college (287). In her fantasy the scarf, an accessory she associates with courtship and the conventional expectation of love, is taken from her by Virgie and Miss Eckhart. In the symbolism of her fantasy, she gives up innocent or naive hopefulness after having seen, in an afternoon's imaginative wanderings, what can happen to love, to giving, to emotional and artistic risk. Her fantasy of loss to the women who fascinate her is the product of her observations.

This day's emotional residue is apparent later that night when, after the hayride and "in her moonlit bed," Cassie rethinks her day's events. "In the distances of her mind the wagon still rocked, rocking its young girls' burden, the teasing anxiety, the singing . . . the smiling drowse of boys, and the way she herself had let nobody touch even her hand" (CS 329). Then as if by way of explanation, she recalls "Miss Eckhart and Virgie coming together on the deadquiet sidewalk. . . . No one could touch them now, either. . . . Both Miss

Eckhart and Virgie Rainey were human beings terribly at large, roaming on the face of the earth" (330).

The tale that Cassie recites has unconsciously reconstructed, with a twist, an old plot that ends by showing the danger of female emotional exposure. This is the story of the dark heroine, the other woman who refuses safety and sheltering. Rachel Blau DuPlessis's book *Writing Beyond the Ending: Narrative Strategies of Twentieth-Century Women Writers* describes the difficulty of escaping traditional plot endings in gendered stories (the good girl married, the risk-taking bad girl punished or dead). But Cassie's and Welty's tales simultaneously explore and destabilize that old story by revealing the near unavoidability of being female and secretly other. Cassie's story shows that she, the conventional, entitled, and protected young lady, only masks and cannot deny her identification with women of dangerous risk, an identification that her insight into the stories of her subject characters demonstrates. Cassie's attraction and empathy are both masked and yet exposed by her speculative contemplation, even as she tries not to find the possibility of the other in her own identity.

"June Recital" is a story in which Welty's treatment of the pattern of the earlier autobiographical stories has further matured, making the earlier stories look simple in contrast. Welty says in *One Writer's Beginnings* that she was neither Virgie Rainey, the adventurer, nor Miss Eckhart, the teacher. But she may be obliquely but recognizably connected to Cassie in these years when, though at the height of her creativity and both attracted to and living artistic and personal risk, she is nevertheless frustrated in her personal life (her relationship with John Robinson) and weighing the need for self-protection against the desire for exposure.

Suzan Harrison in "Playing with Fire: Women's Sexuality and Artistry in Virginia Woolf's *Mrs. Dalloway* and Eudora Welty's *The Golden Apples*" discusses Welty's productive attraction to the fiction of Woolf, a female attraction fostering creativity. She argues, controversially, that "both 'June Recital' and 'Moon Lake' are coming-of-age stories in which homoeroticism opens the imagination and creative possibilities, while heterosexuality closes them" (303). The relationship she is noting is the one between the sheltered daughter and the body of the other woman. That body in Welty's fiction, I would argue, is often an erotic body, opening distinct issues of sexuality, but her attraction is more about making art than making love. Moreover, I hope I have now shown that this story of a woman and an "other woman" is a persistent and recurring pattern in Welty's fiction from its beginning to its end, but that the female pairing is not only about an attraction; it can be seen also as an aversion in which the other is reviled as well as pivotal.

The use of the pattern that "June Recital" reveals as having undergone change continues to morph. Later stories, such as "The Bride of the Innis-

fallen," "Kin," and *The Optimist's Daughter*, show further changes in the fictional structure of the early coming-of-age stories in which one woman advances while contemplating an other woman. In "Kin" and *The Optimist's Daughter*, the pairings are as provocatively ambiguous as in "A Memory," and again foster interpretative debate about how Welty uses class. Interestingly the heterosexual plot is less displaced but rather increasingly present in the later fictions, although rarely central. In "Bride," following Welty's John Robinson period and the disappointment of her initial expectations for their relationship, the heterosexual plot fails while it is the figure of the isolated bride—again, an other woman—that strikes lightning for the escaping American woman and brings the slowly unfolding story suddenly into sharp focus. One could argue that the pattern of "A Memory" is inverted by the plot structure of *The Optimist's Daughter*, where the central repulsion toward another woman seems to stand center stage only to be surprisingly displaced by the unexpected memory of the lost boy, Phil. And yet, as in "A Memory," a grotesque and rather frightening other woman's self-exposure (Fay's, but possibly also Becky's, that is, the mother's) again opens the way for the narrator's progress away from the distortions of her former thinking and for escaping protection, now described as an internalized self-protection.

No Longer the Optimist's Daughter: Exiting the Obligations of a Female Child

The discussion of class issues in Welty's work inevitably leads to the puzzling case of the late novella *The Optimist's Daughter* (1972). Some readers have responded to the pairing of Fay and Laurel by seeing Welty as a class snob. Laurel's attitudes toward Fay can seem to invite a reader, as Julia Eichelberger writes, to choose between accepting the novel as championing the southern caste system of the "genteel Mount Salus" as it defends itself from vulgar white trash behaviors or, on the other hand, as questioning its "upper-middle-class orientation" (*Prophets of Recognition* 127–128). But rather than examining these positions only, it is useful to recognize the novel as a further variation on Welty's habit of pairing a guarded young woman on the verge of an escape with an other-class woman who models impropriety. This novella, as its title suggests, is about being a daughter, and this time the daughter in question is older than in Welty's earlier girl stories. Yet the more mature Laurel is still concerned with issues of a daughter's escape.

The novella is unusually autobiographical and yet a deliberate transformation. In disclaimers that are both obviously true and yet not, Welty has said about it: "I wasn't telling my mother's story. . . . None of the story between Judge McKelva and Becky had anything to with my parents. . . . [They] were not enacted in the story" (Walker 138–139). Coming as it does after the 1966

deaths of her mother and brother, which had been preceded by a long period of Welty caretaking her mother through her extended illness and decline, the novella reopens personal issues, issues again framed in terms of propriety and protection. Dawn Trouard has called it "Welty's personal exorcism . . . , marking the end of her life configured as daughter, cum complicit hostage" ("Burying Below Sea Level" 246). Betina Entzminger argues that Welty grants Laurel "the freedom to do what [Welty] herself was unable to do" (135): to leave behind her parents' house and her obligations to an ailing parent. The novella as a whole addresses what seems to be Welty's never entirely banished, yet triumphed-over anxieties about her choices as a woman writer (134), her guilt over "being [her mother's] loved one gone," and the knowledge that her "joy was connected to writing" (Welty, *One Writer's Beginnings* 103), that is, to her exposure of herself in her work.

In the series of Welty's other women, Fay is of course a—if not *the*—most ambiguous figure. Certainly Fay is a grotesque in the sense of Geoffrey Galt Harpham's definition of a shape-shifting, "disturbing and disrupting power . . . that threatens to collapse . . . dualisms that shape our thinking" (8). She is a rule breaker who is both Laurel's opposite and her double. On the one hand, Fay's selfish, unseemly conduct and her self-centered performances are ardently and harshly judged by Laurel. We seem to be led to assess Fay's shows of thoughtlessness from the viewpoint of Laurel's refinement and quiet tastefulness when Fay decries Clint McKelva's hospitalization ("I don't see why this had to happen to *me!*"; *Optimist's Daughter* 15)[24] or when, although he is required to stay stock still to preserve his sight, she wants him to rise to take her dancing on her birthday and pronounces "Enough is enough," a remark that coincides with his silently passing away.

But Fay is the grotesque double that, as Entzminger points out, "Laurel fears she will become, or fears the community will see her as, if she pursues her goals rather than theirs" (138). Fay is a caricature of the woman impervious to proprieties, concern, coercion, or guilt, who is noncompliant with all the behavioral expectations that others believe should impinge on her. Fay is a daughter who has left her family behind—unlike her sister, who is praised by their mother: she "got married and didn't even try to move away" (*OD* 70). Fay is a daughter who comfortably and outrageously tells the lie that her family members are all dead (at the moment when Welty's relatives, uncomfortably, mournfully *are* dead), a lie corrected when the family turns up for the judge's funeral. And she is a daughter who decides to visit home primarily to head the family off from further entering her life away from them. But Fay is as much a double as a foil for Laurel. Laurel, a woman artist who has left home for a life of work, has also broken her community's expectations for a daughter and is now being asked to accept guilt and to improve her choices, even after her parents have been lost.

Fay is the other woman who lives brazenly outside the heroine's middle-class proprieties. Robert Brinkmeyer recognizes that "Fay and those of her standing are, by Mount Salus' standards, simply poor white *trash*—dirty, defiled, and vulgar" (437). Moreover, she is a parody of trashy femininity, a final example of all there is to cherish in Welty's comedies, capturing and mocking stereotypes of the feminine. Fay is green stiletto heels and peach satin on the bed. She is both comic parody and in-your-face sexuality. She is not a lady; moreover by her class status she is not entitled to be protected as one. Mount Salus is irritated by her having seductively but so easily triggered first the judge and then Major Bullock's impulses for female protection, using her captivating and seemingly vulnerable smallness to usurp a position to which they feel she is not entitled. Major Bullock, without realizing the comedy of his remark, says of Fay, "Poor little woman, she's the helpless kind" (*OD* 5). But Fay is actually female vitality dealing with "[r]esentment *born*" (137).

Laurel resists her father's attraction to Fay's youth and energy, which she judgmentally characterizes as mere vulgarity (Brinkmeyer). Miss Adele, on the other hand, more ambiguously reasons that Fay's selfish sexual self "gave a lonely old man something to live for." Fay has a passionate, selfish vigor about her. As the now-familiar other woman, she is both an example and unsettling. Her shape-shifting doubleness is felt when Fay justifies her reckless and aggressive roughness with her dying spouse: "I was trying to scare him into living! . . . I was going to make him live if I had to drag him." She says, "And I take good credit for what I did! . . . I was being a wife to him" (*OD* 202–203)—and means it. Fay has an ambiguity about her that requires comment.

Part of Welty's attitude toward Fay's hospital assault on the judge is clarified in a letter she wrote to William Maxwell on June 12, 1967, in which she reveals the origin of her plot while uneasily but unwarrantedly expressing concern about liability issues that possibly need review. Suzanne Marrs has made it clear in her analysis of this letter that, however Fay and a host of readers view her behavior, Welty views Fay's rough slap of her critically ill husband with anger and contempt: "As you know, I generally work at more removes or with more disguises from my own life than I did in this story. . . . Before my brother [Edward] died last January, his frantic wife [Elinor] came to the hospital where he was stretched in a harness with a broke neck and hit him, according to the nurse, while she told me if I believed the nurse I was a so-and-so. As you see, I must believe it, deep down. I don't care about her feelings, but you think the story . . . changed is enough removes away to protect the magazine? . . . The idea of such a thing whether she did it or not just burns on" (quoted in Marrs, *What There Is to Say* 224–225).

On one hand Fay clearly is a gargoyle of selfishness. On the other hand, the character Welty creates from the residue of her life is a bit more ambiguous,

and Fay's effect on Laurel is more mixed still. Fay's desire not to be "cheated" and to *want* life is something Laurel, as much as she abhors Fay, is also coming to, something that echoes the roar she attributes to her own dead husband, Phil's, ghost: "I wanted it" (*OD* 181). At the judge's funeral, Fay grotesquely and theatrically strikes "out with her hands, . . . and shows her claws at Laurel . . . [before throwing] herself forward across the coffin onto the pillow, driving her lips without aim against the face under hers" (104). Fay's performance of grief is tasteless and seemingly more self-centered than sincere, but it is also a model of female self-exposure. Miss Tennyson Bullock corrects and chastises her: "now this will be just a little slap," which is meant to put her in her place and bring her to a more decorous propriety. But it is worth recalling that another woman, Miss Eckhart, whom we more generally respect and revere, also threw herself at a man's grave to say "I wanted it." Fay's behavior models the performance of passion perhaps, rather than passion itself, theatrically giving, as Miss Adele understands her, "a sad occasion its due" (130). But it is a rehearsal that aspires to exposing passion, a signifier of something more positive than Fay's dramatic self-display.

Perhaps Laurel judges Fay with such aggravated aggression in order to assert and to show that she knows selfishness when she sees it; voices are, after all, simultaneously judging Laurel's own failures of self-sacrificing womanly comportment. While Laurel judges Fay and wants "acknowledgement out of her—admission that she knew what she had done" (*OD* 156), the community comments aloud and to her face on Laurel's "selfish" choices for her career. Fay taunts Laurel by echoing the accusation of her having chosen a selfish life, and paradoxically charges Laurel with being the insensitive one as she infuriatingly needles Laurel with the insistence: "Oh I wouldn't have just run off and left anybody that needed me. Just to call myself an artist and make a lot of money" (37). Fay's jabs articulate a direct indictment also voiced by others in Laurel's home community. Mrs. Pease flatly pronounces, "Laurel should have stayed home after Becky died. [The judge] needed him somebody in that house, girl," blaming Laurel for the judge's marriage to the other self-seeking daughter (136–137). And Laurel in self-accusation wonders if this were the case.[25] Lucinda MacKethan points out: "Fay . . . can make Laurel feel like a betrayer for [Laurel] has never reconciled her daughter self with her artist self" (92). It is Laurel's uneasiness with the topic of selfishness that circulates in her fascination and fury with Fay. Marrs writes insightfully of the novella's repetition of the phrase "tied down" and focuses on Fay's insensitivity to Laurel's grave concern for her father, who is "not used to being tied down." Marrs shows that the phrase also recalls Becky's final eye operation, when she says, "don't let them tie me down. . . . if they try to hold me, I'll die" (*OD* 142–143), quoting her own father's words on the operating table (Marrs, *One Writer's Imagination* 241–242). And the phrase also speaks to the context of

Laurel's adult life and the novella's implicit concern for her escape from being "tied down" by obligations to gendered self-discipline.

In a book so much about the relationship between mothers' and daughters' behaviors—think of Mrs. Chisom asserting that Wanda Fay's graveside theatricality is "like mother, like daughter . . . tore up the whole house, I did"—Becky, before Laurel, has struggled with conflicted feelings about having left her first family and the family home. Searching through her father's desk, Laurel reads her ill, "widowed . . . and sometimes bed-ridden" West Virginia grandmother's letters to her "venturesome, defiant" daughter in "exile" (OD 180), and Laurel weeps for her mother. During the five-year illness that ends Becky's life, when her daughter is living in Chicago, Becky longs to return home to her West Virginia family and feels regret, crying uncontrollably as she thinks of her own mother having died alone: "I wasn't there! I wasn't *there*!" (168). When her husband, the optimist, tells her "you are not to blame yourself, Becky, do you hear me?," she replies, "you can't make me lie to myself, Clinton" (168). When he assures her, "it's going to be all right. . . . I'll carry you there," Laurel recognizes this "as the first worthless promise between them" (174–176).

The problem with Clinton, which comes between husband and wife in Becky's final illness and simultaneously between daughter and father, is exactly about female sheltering and the sham "protection" of women that is the opposite of exposure. Female protection has been an issue for all of Welty's shy young women. And so it is for Laurel. Consider the passage in which Laurel explains why she had "turned for a while against her father." "He was not passionately enough grieved at the changes in her [mother brought by illness] . . . [accepting] them . . . only of the time being, even to love them, even to laugh sometimes at their absurdity" (OD 171). What Judge McKelva is guilty of in his flawed behaviors with his women is the habit of protection. During Becky's illness, during her regret, he misses the chance to share Becky's rage by instead futilely trying to protect her from it. Soothingly loving even her infirmity, rather than raging against the dying of the light, he misses the chance to partner her refusal to "go gentle into that good night." The judge is the shielding optimist and offending male protector, Becky's "Lucifer . . . Liar." The label of "optimist" decodes as "liar," that is, pretender-protector. Surely the image that Laurel calls up of the "pets" from down home, the pigeons that horrified her while others thought they pleased her, is related to her thoughts about this disturbing aspect of her parents' marriage and at the same time is connected to Laurel's now-conflicted feelings about returns "home." "Laurel had kept the pigeons under eye in their pigeon house and had already seen a pair of them sticking their beaks down each other's throats, gagging each other, eating out of each other's craws." Like an unhappy couple, the pigeons

gag, "swallowing down all over again what had been swallowed before . . . taking turns. . . . They convinced her that they could not escape each other and could not themselves be escaped from. . . . her mother's pigeons were waiting to pluck each other's tongues out" (166).

The novel's bird imagery, which includes the mockingbird's song that undercuts the Mount Salus commentary on Fay and Laurel both, culminates with the chimney sweep (a subspecies often confused with a swallow) that enters the McKelva house. That bird is clearly associated first with Fay (polluting the house, "every room in the house if you let it") and then with Laurel (the bird, caught in the house, will not fly out, though the way is now "perfectly clear," and Laurel asks, "Why won't it just fly free of its own accord?"; OD 192, 194). This doubleness and confluence around the chimney sweep underscores the connectedness of these different women. Fay as the other woman resembles the fleshy bather of "A Memory"—she is a double expressing anxieties about the self, fears of being exposed as grotesque in escape of female proprieties, a figure disrupting the central character's expected story. And disruption opens the possibility of change. Welty's interview comments about Fay make clear her own scathing, derogatory judgment of the character; in conversation with Gayle Graham Yates, she says, "you could scratch the skin and there wouldn't be anything under it" (97). These are comments we can still better understand in connection with the family incident Welty reveals in her letter to Bill Maxwell (Marrs, *What There Is To Say* 224–225).

Welty speaks of Fay's emptiness. It is, however, not a contradiction that readers have repeatedly found Fay to be the one who shows Laurel a path. Robert Brinkmeyer, analyzing the role of the New Orleans carnival in Laurel's story, thinks of Fay as the carnival fool: "[Fay's] comments and her laugh (as derisive as a jay's [5]) mock the hierarchy and its exclusion of her" (436). Suzan Harrison writes that Fay brings both to the novel and to Laurel "the vitality of carnival," finding her "the catalyst that initiated Laurel's movement . . . toward a reawakened life" (*Eudora Welty and Virginia Woolf* 121). Ruth Weston in "The Feminine and Feminist Texts of Eudora Welty's *The Optimist's Daughter*" asks, "Is [Welty] not, then finally sympathetic to Fay, who may have failed with Judge McKelva but finally scared Laurel into living?" (88). Betina Entzminger—who sees that "the threat [in the novel] is not . . . that [Laurel] will become Fay but that she will . . . see herself in the negative stereotype Fay embodies and guiltily relinquish her creativity"— reasons that in coming to terms with Fay, Laurel gains strength and learns that "a life of self-denial rewards no one in the end" (138). All of these readings see Fay as a disruption that clears the way for Laurel's opening to a less gender-restricted life.

The pattern of a daughter who has issues with protection—as in "A Mem-

ory" and "The Winds" and in the by-product of the development of an internalized protectiveness in "June Recital"—recurs in *The Optimist's Daughter*. While the optimist is a protector, his daughter, who has been uncomfortable with her father's behavior, has internalized his habit. Now she faces that proclivity. Rethinking her father's protection of her, she comes to acknowledge the extent to which she has trapped herself in protection, even in her own protection of him. Her thoughts travel fitfully to her protection of the memory of her marriage, prematurely lost to death and safeguarded both from and in her memory since Phil's early passing cheated the two of them of a more complex relationship. She thinks that there was not "a single blunder in their short life together" (*OD* 161). Since Phil's death, "love was sealed away into its perfection and had remained there. . . . She'd gone on living with the old perfection, undisturbed and undisturbing" (154). She has committed herself to the protected memory of "old perfection," which could not have been lived if Phil had survived and the relationship had endured, matured, and progressed. Visited by Phil's ghost, she pictures Phil's "eyes wild with the craving for his unlived life, with mouth open like a funnel's" (181), roaring desire in a cry that is as demanding as Fay's or Becky's. He "wanted it" in spite of the certainty that his missed life would not have been flawless and perhaps would have been as imperfect as her father's. Importantly she remembers that Phil's attraction had been precisely that he had shown her that love was more than protection:

> She grew up in the kind of shyness that takes refuge in giving refuge. Until she knew Phil she thought of love as shelter. . . . He had showed her that this need not be so. Protection, like self-protection, fell away from her like all one garment, some anachronism foolishly saved from childhood. (187)

Recognizing this gift now prepares Laurel to live beyond Phil. Like Zora Neale Hurston's Janie, who outlives Tea Cake, the adored lover who showed her what she needed, Laurel survives Phil, outliving the necessity of his lesson. Her reflection leads her to relinquish the role of protector. She leaves Phil's breadboard behind with Fay, heading back to Chicago and to her work with design, enabled when Phil "taught her to work toward and into her pattern, [and] not to sketch the peripheries" (188). Waving to Laurel as she leaves for the train, her friend Tish calls, "You'll make it by the skin of your teeth" (208). Laurel has, late but in time, accepted that—as Welty writes in one of the story's preliminary versions—"protecting was the feeblest act of love."

Sally Wolff's and Suzanne Marrs's readings of early versions and drafts of *The Optimist's Daughter* have helped readers to understand that Phil's presence in the text was a late addition, one Welty struggled with for more than a year. She initially drafted the story without him (before 1967), felt something was missing, and eventually wrote him extensively. But she put his narrative

into a folder marked "omit this part for now" when she first published the long, changing story in the *New Yorker* (1969), before finding her way to adding him to the story of Laurel's escape (in 1971 and published the following year). A reader familiar with Welty's biography must wonder if Laurel's missed, mourned, and held-onto past relationship with Phil has its source in Welty's own vanished romantic relationship with John Robinson (although when Sally Wolff in 1992 asked Welty if Phil was based on John Robinson, Welty demurred, saying that the character had resemblances to her brother Walter, who "made a breadboard, . . . had double jointed thumbs, . . . went through battle in Okinawa"; Royals and Little 266).

Is it a coincidence that Welty's relationship with Ken Millar (pen name Ross Macdonald) is beginning as Laurel is letting go of her protection of Phil's memory? Marrs's biography discusses the importance of the early Millar-Welty letters to *The Optimist's Daughter*, shaping the novel's discussion of "convergence." And as Welty is writing Fay, she is herself unexpectedly becoming Margaret Millar's other woman, allowing herself a treasured attachment to a married man, and putting herself in a position to feel accused of being the overexposed spectacle, the woman who is not a lady, a label that Millar's wife may or may not have leveled, but Welty clearly considered in her unfinished, unpublished manuscripts drafted in 1981–1984. The story approached differently in the fragments of three variously titled iterations—"Henry," "Affinities," and "The City of Light"[26]—concerns a triangle between Henry, a man afflicted with Alzheimer's (as Millar was in those years), his desperate and accusing wife, and a former student (variously named), who was intellectually intimate with Henry before he became ill. Accused by the wife of having had an offending and vulgar sexual relationship, the narrating character, as Marrs puts it, "wonders if she and Henry should have become lovers" (*EWAB* 492). As in Laurel's denouement, this character considers protection, self-protection, and risk, thinking, "What you could call my bringing-up can't be blamed for what I did. . . . I think that I was simply afraid of great joy." One moving handwritten fragment changes from third to first person in order to describe the lost feeling of returning from a visit to see the ailing Millar in Santa Barbara. The character is so distressed (or is Welty in this fragment writing in her own voice?) that she becomes literally lost in her hometown, confused and turning hopelessly in the streets, unable to find her way in what should be familiar and feeling that this "aimless and timeless" experience is a "nearness to him," to his Alzheimer's experience, which is treasured, since "anything, anything can affirm love." Marrs and Nolan's volume *Meanwhile There Are Letters* affectingly reveals this period of the Welty biography through reproduction of both the Millar-Welty letters and excerpts from "Henry."[27]

There is then a pattern in Welty's most self-referential fictions, central to

her work from its beginning, that matures and changes over the course of her career. In it, exposed women's bodies reveal cultural and artistic issues both. Tracing the shifting pattern across those autobiographical fictions, I have read them collectively as a kind of *künstlerroman*, revealing the evolving concerns of a complex woman writer as she lives the role throughout a daring, productive, and satisfying career that altered the form of the short story. In the next chapter I find this pattern of the other woman intriguingly evident in Welty's 1930s photography as well, and I see it as the source of an innovative contribution to the representation of the black female body. The body of Welty's photography was, I suggest, a precursor to her fictional corpus. Now that I have outlined the pattern in the fiction, I hope to convey and appreciate its presence in her camerawork.

Welty's Photography and the Other Woman

Having briefly lived in New York City at the age of twenty-one, after she had gone wandering and then "ready or not" enrolled at Columbia University (1930–1931), Welty returned to Mississippi, took pictures, and openly considered photography as an art form and as a possible career path.[1] She had enjoyed New York City and returned home with an altered eye: her photographs focus on Mississippi scenes that, before New York, might have been either too removed from her sphere or too routine in it to have been seen in detail.

In the next few years, she would travel her home territory with camera in hand, and her discussion of that endeavor, as well as the consequent body of work she produced, like her girl stories, expresses both the shy daughter and the venturesome artist. Her camera, like her writing, became a tool she would use to explore, to dare, to encounter. Many of the photos she shot feature African American women, and this group of images, like her girl stories, frames the body of the other woman to reveal cultural patterns. Again, that body leads her to artistic experimentation, in this case producing images that are notable for their innovations in the pictorial representation of the black female body. These creations are one more site revealing Welty as an artist producing change, an emerging modernist experimenting with ways to see and signify.

The Camera as a Shy Person's Protection Throughout Heart- and Eye-Opening Early Exposure

Explaining how she first came to her interest in photography, Welty describes in interviews with Gayle Graham Yates and others her delight in finding her father's negatives and learning of his several cameras, as well as her childhood memories of her parents printing in the kitchen once the children had

gone to sleep (Yates 87). Using what she had learned at home, Welty, the daughter of this inveterate amateur photographer, would make photographs for twenty years, most intensely in the 1930s, exposing prints in the kitchen of her parents' home on Pinehurst Street in Jackson, as her father had before her. Throughout 1933–1936 she, a once-sheltered young woman, now in her twenties, roamed around rural Mississippi, at first in a Works Progress Administration job, doing the fieldwork she needed to write publicity for "every sort of project" (Ferris 155)—farm-to-market roads, juvenile courts, airfields being made out of old pastures, county fairs, libraries—often traveling by bus and train. She describes this exploration as a "heart- [and] eye-opener" for a young woman who had been sheltered:

> It was a matter of getting to see something of the state. I'd never seen any of it before, except on family car trips. I hadn't realized anything about the life here. It was . . . wonderful. . . . I was independent and on my own, traveling. I went to every county seat in the state. It was a—I almost said "heart-opener"—a real eye-opener. . . . I'd always been sheltered, traveling with my father. (Yardley 6)

Welty's self-revision in this comment reveals that she was moved by what she framed, and as much emotionally altered by it as drawn to the liberation and aesthetics of seeing and framing photographically.

Roving for her work and her personal education, in her free time she also carried a camera—her "shy person's protection" (*One Time, One Place* 7)—as an aid in her escape from sheltering and as a means of exposure. Her story "A Memory" suggests how the camera could be a technology acting to both protect and reveal. When the young narrator escapes her parents' protection, feeling as if a secret of life is nearly revealed to her at every glance, she borrows a strategy from her painting class of "making small frames with [her] fingers to look out at everything" (*CS* 75) to temper her feelings of unsafe exposure. The gesture distances the exposure she seeks and at the same time focuses and promotes her vision. The gesture is both protective and an incipient artist's. It is of course an easy step to think that Welty's camera did similar work when she framed what she felt she had been sheltered from, and her photography gave her a reason to look at and feel connected to scenes from which she otherwise might feel unconnected and into which she was not entitled to enter.[2] The photographs are a record of her traversing boundaries of class and race and the borders of Mississippi and Great Depression poverty—to *see*.

Welty soon begins to think about the photos she is taking as connected to "Black Saturday," a now-lost manuscript of stories and photos that in 1935 was submitted to and rejected by Harrison Smith of Smith and Hass with the response that it would be impossible to publish another book so like Julia Peterkin's *Roll, Jordan, Roll* (1933). *Roll, Jordan, Roll* was not at all like Welty's stories and images, however; that nostalgic plantation novel was accompanied

by images of Gullah people photographed by Doris Ulmann on Peterkin's Lang Syne plantation. Its "noble agrarian" images of wise, worn black "folk" working close to the land and representing a passing culture is summed up by the text: "undisturbed by the machine age, they live close to the earth that feeds them" (Peterkin 18). That Smith and Hass found a resemblance between Welty's work and Ulmann's and Peterkin's—work that Welty said she disliked[3]—seems to be a justification for the company's rejection of a second book featuring fiction about and photos of African Americans, a rationalization conveying both their concern for niche marketability and their choice to avoid issues of race. On the other hand, in her 1989 interview with Hunter Cole and Seetha Srinivasan, Welty judges that the project "was an amateurish idea," commenting that "there were obvious [objections] to what [she] was proposing" and that her prospective editors "weren't much interested in the photographs—they were not that kind of editors, that was not their department" (195–196). There is no known record of which stories and photos were in the manuscript she submitted, which she said she eventually threw away:

> I got a composition ring book and pasted little contact prints in what I fitted
> up as a sequence to make a kind of story in itself. I tried the subject of Saturday
> because it allowed the most variety possible to show a day among black and white
> people, what they would be doing, the work and the visit to town and the home
> and so on. I submitted along with the pictures a set of stories I had written, unre-
> lated specifically to the photos except that all were [placed in] the South. (195)

Current holdings at the Mississippi Department of Archives and History include twenty-nine of the original forty-five mounted photos that Welty selected for a two-week one-woman show displayed March 31–April 15, 1936. These holdings give us some idea of which prints, in that time period, she was most carefully attending. Her 1971 selections for the portion of *One Time, One Place* subtitled "Saturday" is another likely indicator of the images she once thought of as "Black Saturday." Somewhat confusingly, Welty says that the earlier project was "essentially the same as" the later one, though *One Time, One Place* is clearly more expansive and redefined and contains some later photos. She also describes eventually publishing all of the proposed collection's stories—"first in magazines, then in *A Curtain of Green*, then in 'The Wide Net'" (196), although we do not yet know exactly which stories these are.

Showing the Photographs

In her biography, Suzanne Marrs tells the story of Welty's two New York City shows in 1936 and 1937. Welty, in "a spontaneous . . . stop by the galleries of Lugene Opticians, Inc." (*EWAB* 50), impressed Samuel Robbins, who offered

her, beyond his helpful technical advice,[4] the 1936 showing at the Lugene Gallery and then a second show at the Camera House in 1937, both of them gallery spaces attached to his camera shops. But it was not until 1971 that Welty's photographs were published in book form, first in *One Time, One Place*. Since then additional books of Welty photographs have been issued: *Twenty Photographs* (1980), *In Black and White* (1985), the inclusive volume *Photographs* (1989), the focused collection *Country Churchyards* (2000), and, posthumously, Pearl McHaney's *Eudora Welty as Photographer* (2009), a selection of previously unpublished images. This published body of work represents the more than a thousand negatives archived at the Mississippi Department of Archives and History. Marrs's essay cataloging and introducing the department's photography holdings in her book *The Welty Collection* is the foremost early discussion of the themes and range of the entire body of Welty's archived work—moving from images of people encountered in travel around Mississippi, to cemeteries and churchyards, to scenes on the Natchez Trace and at Rodney's Landing, to carnivals and sideshows, to street scenes in New York and New Orleans.

The most significant attention to her photography has come from Welty studies rather than art history, although the work certainly is a match for discussions devoted to the general topics of women's camerawork or 1930s documentary photography. Increasingly though, Welty's photographs are receiving broader and interdisciplinary attention. My 1997 essay, "Photographic Convention and Story Composition," considers the interconnectedness of Welty's compositional technique in her different mediums. Tim Adams Dow in *Light Writing and Life Writing* treats Welty's photography as autobiography, alongside her memoir *One Writer's Beginnings*. Katherine Henninger's monograph *Ordering the Facade: Photography and Contemporary Southern Women's Writing* places it in a sweeping discussion of "fictional photographs"—those that writers invent in their fictions—as well as actual ones. Three essays from my edited volume *Eudora Welty, Whiteness, and Race* consider the social issues raised by the photographs: Susan Donaldson's "Parting the Veil: Eudora Welty, Richard Wright, and the Crying Wounds of Jim Crow"; Keri Watson's "Eudora Welty's Making a Date, Grenada, Mississippi: One Photograph, Five Performances"; and Mae Miller Claxton 's "'The Little Store' in the Segregated South: Race and Consumer Culture in Eudora Welty's Writing and Photography." Pearl McHaney significantly adds to the discussion in *A Tyrannous Eye: Eudora Welty's Nonfiction and Photographs*.

Meanwhile, museums are showing Welty's work. Images she shot were installed in the permanent collection of the Ogden Museum in New Orleans in 2002. Her photography had its first European show in France in 2004. And *Passionate Observer: Eudora Welty Among the Artists of the 1930s* was exhibited at the Mississippi Museum of Art in 2002, then at the National Museum of Women in the Arts in D.C. in 2003–2004, and has since been on national

tour. The exhibition's companion volume, edited by René Paul Barilleaux, places her in artistic contexts, and its essays, including Patti Carr Black's, are another major contribution to enlarging the discussion of her photography across disciplines. During the Welty centennial celebration in 2009, the Museum of the City of New York mounted an exhibition entitled *Welty in New York*, which then toured the country. Deborah Willis's essay, "Eudora Welty: The Intrepid Observer," in McHaney's *Eudora Welty as Photographer* brought an art historian's eye to the photographs. In 2013 the Ogden Museum featured a showing of "vintage prints" in *Eudora Welty: Photographs of the 1930s and 40s*. These were eighty-four of her snapshot-sized contact prints, from which a viewer familiar with her published images could discern the choices she had made in the compositional croppings she later applied and could also recognize the companion photos shot in series. These exhibitions and publications, especially Willis's commentary, are all markers that Welty's audience is becoming increasingly interdisciplinary, as it should.

Representing the Body of the Other Woman in Photographic History

Photography is a medium always concerned with representation through image and often through the image of the body. Welty, who had as a young woman briefly begun to study for a career in advertising, was certainly fully aware of the power of representation. She experienced early and sustained delight in composing visual and verbal parodies, which contain hints of amused critiques of commercial representations—critiques more commonplace in the 1970s than the 1930s. The comedy in both her fiction and her photographs conveys a woman's amusement in revoicing, exposing, and mocking the usual portrayals of women.[5] Ann Waldron's 1998 biography presents Welty as herself living in the shadow of representations of the female body when she suggests that Welty's passion for writing was a consequence of her not being conventionally beautiful. The implication is that Welty, caught in society's prescriptive and dictatorial gaze, was uncomfortable with her body. Waldron's assertion seems to be that, unable to construct the mass-marketed exterior mask of beauty, Welty forfeited conventional definitions of female identity and therefore she instead wrote, evidently by default. That argument is naive in its approach to Welty as a writer and a woman. My own perhaps unexpected response to it has been to look for and consider the gaze that Welty turned onto female bodies—to ask about what she chose to bring to exposure and to interpret the glance that made those choices. In the 1980s Laura Mulvey in *Visual and Other Pleasures* and Teresa de Lauretis in *Technologies of Gender* considered women artists and filmmakers whose work redirected the conventional gaze that constructs woman as a predictable beauty spec-

tacle by refocusing on images that suggest other ways to see. Welty's 1930s photography, as I hope to detail, likewise shows us other ways to see.

Considering this topic has brought me to think about Welty's photographic representations of the African American woman's body, comparing them to what I call the "grammar" of racial images established by the history of that body in photography generally. The comparison has helped me to see how Welty's images are of her time and yet also how they are innovative, presenting us with alternative visionings. And it has brought me to more fully appreciate the connections between these photographs and Welty's fiction. Like the girl stories that followed them, these photographs frame the body of the other woman. Welty calls her *One Time, One Place* a "family album" (9), and it is interesting to see how Welty constructs her chosen "family," with ties across class and across race. A familiarity with historical patterns in photographic representation allows us to see how Welty is using and then creating imagery in these prints. To identify some legible patterns in the representation of the black female body, I examine two early image types that emerged in the nineteenth century after Louis Daguerre's 1839 patent on his process in France, before sampling the work of American photographers leading to and including depictions in 1930s documentary photography. My intention is to frame Welty's contribution with that history of representation in order to consider her place in women's camerawork and as an idiosyncratic documentarian.

In *The Black Female Body: A Photographic History*, Deborah Willis and Carla Williams, contemporary photographers who have also become principal curators of African American photographic imagery, document and analyze early portrayals of black women. One sort of typical representation was made in ethnographic nudes, images encouraged by the World's Fair in Paris in 1867, where alongside exhibits of technological and industrial advances, displays of African bodies conveyed the work of colonial appropriation. Willis and Williams describe the emergence of an "ethnographic aesthetic" rendered in pseudoscientific presentations of "frontal, rear, and side views" that classified so-called racial types (31). Not surprisingly, given the sexual history of colonialism, these studies of the female body pictured, as Judith Williamson writes in another context, the "woman of color constructed as 'nature waiting to be colonized,'" linked with verdant lands possessed (106).

This sort of "scientific" presentation (fig. 2.1), which involves excessive exposure and, at the same time, a fundamental erasure from the normative category of woman, culminated in the phenomenon of Saartjie/Sara Baartman, a South African Khoikhoi woman who was displayed naked throughout Europe, for an admission fee, to demonstrate an asserted sexual difference in the shape of her buttocks and to illustrate the related sexual theory associated with her as the "Hottentot Venus." Following this ill treatment, other African women were subsequently photographed to demonstrate an implied physical

deviance from some abstract notion of the Western body and beauty; their concretely sexual images are simultaneously about body, desire, and racialized fascination. This is the sort of historical representation that causes bell hooks, in an essay that begins with the memory of entering a candy store with white women friends, to write about finding herself having a confrontation with a pair of chocolate breasts; she sees the confection as presenting black women as a commodity "available to anyone white who could pay the price." She writes in "Selling Hot Pussy": "I look at these dark breasts, and think about the representation of Black female bodies in popular culture . . . and the types of images popularized from slavery on" (62).

The other prevalent black female image of this period of early (which is to say, French) photography was the black female nude appearing as the companion to a sexually suggestive white female nude. Whiteness here is defined both in opposition to and by association with the black body. Willis and Williams choose Félix-Jacques-Antoine Moulin's boudoir scene (fig. 2.2) to illustrate this icon; in this recurring picture type, the black body—although often less sexualized than the white body—serves as an associative marker of the white woman's sexual availability. The artist and writer Carla Williams, commenting on the pattern in photographic history, calls these black figures "the slaves of the slaves of lust" (Willis and Williams 36). These erotic photographs pre-date Édouard Manet's painting *Olympia* (1862–1863, exhibited in the Salon of 1865), which shows a shockingly "naked," rather than classically "nude," figure of a white courtesan accessorized by her signifying black servant (fig. 2.3).

George Needham's essay "Manet, *Olympia*, and Pornographic Photography" makes obvious that the painter adapted the other-woman pairings of early erotic photographs and the visual convention they had established. Likewise Sander Gilman's study "Black Bodies, White Bodies: Toward an Iconography of Female Sexuality in Late Nineteenth-Century Art, Medicine, and Literature" analyzes nineteenth-century "medical" and "scientific" treatments of both Saartjie/Sara Baartman and prostitutes to discuss their correlations and explore the conceptual association and "linkage of two seemingly unrelated female images" (206) in the story of sexuality. Paired in photographic history, the exposed body of the black woman is frequently presented as a marker of a white woman's revealed sexuality, even while the image communicates an erasure of black female sexuality. The artist Lorraine O'Grady in "Olympia's Maid: Reclaiming Black Feminist Subjectivity" reflects on the legion of attendants to the myriad white Olympias figured and refigured in the history of representation, using the name of Manet's black model, Laura, to establish the attendant's identity: "Laura's place is outside what can be conceived as woman. She is the chaos that must be excised. . . . The not-white body has been made opaque by a blank stare" (14).

In this tradition of erotic photography black and white women are both separate and connected, coupled and discrete. Black and white female photographic pairings, as in Moulin's boudoir scene or in *Untitled (Woman with Attendant)* (fig. 2.4), frame Western culture's division of women into racial and class identities and at the same time reveal an overall notion of women. O'Grady writes:

> The female body in the West is not a unitary sign. Rather, like a coin, it has an obverse and a reverse; on the one side, it is white; on the other, not-white or, prototypically, black. The two bodies cannot be separated, nor can one body be understood in isolation from the other in the West's metaphoric construction of "woman." White is what woman is; not-white is what . . . she had better not be. (14)

Readers of southern literature generally have seen this Janus-faced woman in the conventional pairing of a sheltered white woman, reserved, aloof, and guarded as chaste, with a black woman who is afflicted by another set of expectations—to be always available both as warm caretaker and as sexual object. Together, the contrasting ideas of woman express southern culture's gender role division and stereotyping tied to class and racial divisions.

The idea of inextricably coupled black and white figures is of course part of the technology of photography. Willis and Williams report that Sir John Herschel, who was one of the first to use the term "photography" in 1839, was fascinated with figures in negative: "fair women transformed into negresses," he called it, an operational description that provocatively also conveys the significations of the Olympia-Laura pairings. Willis and Williams write that in these early photographic images of black and white female bodies, "[i]t is upon the sexuality presented by the black woman that the sexual white woman constructs *her* desires" (42). Thinking both of and beyond Moulin's imagery, the black woman is expected to be exposed, and then the white woman, acting to free herself from convention, chooses to expose herself. This formulation is important to the concept of the body of the other woman that I am exploring here: in the cultural predicament of Welty's girlhood, clearly felt in her girl stories, exposure is something white daughters are disciplined to avoid but that the self might desire. In the early photographic pairings of white and black women's bodies, as in Welty's coming-of-age stories that join the sheltered girl and the other-class woman, white female desire is expressed in code through the exposure of the other woman's body. In this context, the pairing is perhaps in some ways a colonizing of the other's body; the other woman's body becomes the double expressing the self. If Welty's girl stories displace onto the body of the other woman both desires for and reluctances related to exposure in authorship, perhaps her photographs of African American women suggest a dynamic that works somewhat differently.

In the stories, by contrast to the photographs, the other remains distinct from the central consciousness character, and anxiety about exposure may be freely heaped onto the other-class double. But in the photography, the body of the other woman is the material from which the artist makes her product and expresses herself. In a sense these bodies—taken in photographic exposure— are directly colonized to reveal their image's composer.

In Welty's photos, the African American woman subject is in the frame and, just outside it, stands the white woman photographer and her reaching gaze—reaching to the other identity, not her own, in which exposure is not only culturally prescribed but required. Is this one reason that the paired other women of Welty's story plots are not black women? That is, are Welty's other women white because in her time and place, black women's exposure is not yet a choice? For the black woman (and character) in Welty's era, exposure is a compulsory, obligatory behavior, and to that extent, her exposure is incomparable and not narratively analogous to the white daughter's. But for the probationarily white girls and women of her stories, visibility and overexposure are regarded as a predilection and not an inevitability, and therefore they better model the choices faced by the sheltered but escaping daughter. Relative to this point, it is a truth that the cultural assumption of a black woman's expected comfort with exposure was dramatically enacted each time Welty asked if she might take a picture of an African American woman whom she did not know but wanted to see, creatively. Her request likely could not have been easily refused as the advantaged young white woman crossed the 1930s Mississippi color line with her camera.

These early photos repeatedly inform and confirm my reading of Welty's later plot couplings in which one woman's desire for artistic exposure is expressed by her framing the body of the other woman. Like her stories these photos model various forms of exposure: in them the spectacle of a body conveys the imaginative, the sensual, the enduring, the feminist, the mysterious, the traumatic, the political, the individual, the social. Moreover, in the photography as in the stories, these bodies catalyze Welty's modernism: their exposures promote alternative visionings.

Representation of the Black Female Body in the United States: Enter Eudora Welty

As photography moved from France to the United States, a different grammar of images of the black woman developed. In America, images of black women at work, often in the fields or the laundry room, were recurrent. In these images, the now well-documented exploited sexuality of African American women was cautiously obscured. One might expect the frequency of the depiction of the laboring black body to have dispelled the invisibility of Af-

rican American labor—these images compulsively document the black body working—but paradoxically these American work images accompanied the persistent phenomenon of worker invisibility and even the contradictory racial stereotype of the shiftless black worker. The African American photographer Prentice Polk's "The Boss" (1932) is a slightly comic meta-framing that both reflects and reflects on a more usual American depiction (fig. 2.5). A woman's solid body—clad in a hole-riddled sweater and work apron—and her assessing eye convey strength, labor, and confidence. As the woman stands with her hands anchored at her waist, she looks at us with a knowing, judging expression: her gaze assesses the photographer—and us, her viewers—rather badly. A possible comic or challenging tone emerges as the stereotyped mammy-at-work image seems both to be seen and transcended by the woman, who looks from beneath her headcloth with disdain at the camera that frames her that way.

The American photographic tradition of the black body was further developed in the 1930s in the New Deal's Farm Security Administration image-making. This highly influential photography program portrayed the challenges of rural poverty and was an immediate context and backdrop for Welty's own production. Between 1935 and 1942 government photographers for the Resettlement Administration (renamed the Farm Security Administration in 1937) captured more than 220,000 powerfully moving images of the Depression. The photographers' assignment was to illustrate FSA projects and the social problems that the projects were to address. The group worked under the direction of Roy Stryker, the head of the historical section of the FSA. Interestingly Welty was at Columbia University's School of Business when Stryker was teaching introductory economics in 1931. His economics course was popular because he taught it with images: "He'd bring pictures to class . . . and would tack them to the walls and point. 'You want to know about economics? Economics is not *money*. Economics is *people*. This is economics,' he'd say about his pictures" (Anderson 4).

Christian Welty, concerned for his daughter's ability to make a living, had sent Eudora to Columbia hoping to prepare her to enter the field of advertising; undoubtedly he recognized a potential commercial market for her special skill with words and images. Eudora withdrew from the program the following September when her father, who had been unexpectedly diagnosed with leukemia in the spring of 1931, died. Welty discusses this period in an interview conducted by her friend Jane Reid Petty:

> I kept thinking in secret about doing some things. I wanted to write when I went to Columbia. I went there to graduate school with the idea of learning a job to support myself while I tried to be a writer. . . . My father was exactly right. He said that you can never earn a living by writing stories.

Of course *he* wished I could write everything for the *Saturday Evening Post*, but he gave up on me for that. I was writing all this time but I never showed anything to anyone. (208)

I wonder not only about what would have happened to young Eudora's program of study had her father lived, but also about the extent of the formal education in images and representations she received in her short-lived program. When I wrote to Columbia University to discover if she might have known Stryker as a teacher when she was a student in the business school, I learned from John Carter in the registrar's office that Welty had taken a mix of "secretarial" courses along with comparative literature and an English class. When I replied that we in Welty studies thought she had studied advertising, he wrote, "yes, she did study advertising, [on the] track which required steno[graphy as well as] . . . advertising and marketing." That is, on the woman's track. Welty apparently quietly added literature courses while also doing her duty to her father. Marrs reports that she "made A's in advertising, a C in marketing, B's in typing and stenography" (*EWAB* 26), a performance that conceivably corroborated her father's identification of a viable market application for her talent.

Welty may not have known Stryker at Columbia, but in the FSA textual records a surprising letter reveals that she definitely did apply to him for a job in 1936 (see Kidd). Stryker had no opening, having recently filled one with Jack Delano. It is disconcerting to think that if he had had an opening that year and hired her, Eudora Welty might have turned out to be an FSA photographer and a documentary writer, or possibly never a writer at all.

Documenting Social Trauma and Alternative Documentaries

Documentary was Stryker's strategy, objective, and defined genre. He believed in his photographers' power to *document*, which for him meant to tell the story of the Great Depression, to generate knowledge of social ills and solutions, and to communicate those images not dispassionately but with affecting sentiment that could fuel political progress. Anthony Lee considers the view that trauma was the ostensible proper subject of Stryker's envisioned "archive of social concern . . . [:] physical or psychological wounding . . . the wounding in ordinary people caused by unprecedented deprivation and despair" (3–4). But as Lee acknowledges, Stryker's photographers "could never quite agree on what documentary amounted to or how their pictures of the Depression fit snugly, if at all, with the New Deal's programs they were purportedly championing" (3). From the start members of the FSA team followed their own visions, recording what each saw as subjects to be documented, often arguing with Stryker's directive shooting scripts, revealing personal

concerns in the habits of their framings. In "Against Trauma" Sara Blair has written about their "alternative and competing ideas for documentary work" in her discussion of the particular narrative logic of Ben Shahn's documentary engagements, all overriding what she understands as Stryker's more formulaic documentary (summarized with his calculating, barefaced, but perhaps not cynical recommendation that the team members "Be on the lookout for a rag doll"). Thinking along Blair's lines, I will have more to say about alternative documentary in Welty's photos. But first it is informing to note that within the FSA cadre, a general area of disagreement was precisely about photographs of black bodies. Because Stryker did not want his photographers to dwell on images that would seldom be picked up by the media, he urged them to de-emphasize the documentation of black lives. Nonetheless, the photographers did shoot many such images.

Nicholas Natanson in *The Black Image in the New Deal* considers the prevailing race images among the FSA photos as well as the issue of representa-tion, and like Willis and Williams in their work, Natanson is powerful on the subject. In response, I highlight a series of well-known FSA images to illustrate some categories, my own brief list of familiar types, influenced by Natanson, to better define the imagery emerging as current in Welty's historical moment.

Above all, there are diligent laborers anonymously working, as in Ben Shahn's "Cotton Pickers" (fig. 2.6), in which the produced cotton seems an extension of the laboring black bodies, their bags like cocoons emerging from their toiling backs. The individuality of bodies of different ages and genders are subordinated to and largely erased by the dominant task at hand: bend-ing, picking, hauling, turning nature into commodity. The figures seem to crawl the furrowed field, caterpillar-like, their sacks ingesting and expanding. Another remarkable work image is Gordon Parks's "Washington, D.C. Gov-ernment Charwoman" (fig. 2.7). Parks, the only African American photogra-pher hired by the FSA, spent nearly a month photographing and interviewing Ella Watson, a government cleaning woman in an FSA building. His image of Watson at work freezes her gender-neutralizing role as the sole family provider and merges it with a story implied by her ill-fitting, pinned-closed dress, apparently made for and perhaps originally purchased to clothe a flesh-ier body. The U.S. flag behind her dwarfs Watson and frames the utensils of her employment and labor, the mop and broom, suggesting the strained, uncomfortable relationship between African American toil and that symbol of American freedom and identity. The title of the photo, "Washington D.C. Government Charwoman," reiterates that ideological tension.

Another familiar type found in the FSA photography is the image of the poverty of the wounded proletarian. In Ben Shahn's "Sharecropper's Family" (fig. 2.8), for example, the broken-out windowpane in its weathered casing frames the suspicious anxiety of a destitute parent and the sad, watching

hopefulness of a child. The four-paned window is seemingly intact above, shattered and repaired, but inadequately so, on the left, and completely missing in the segment that frames the family's faces. Beneath them a rag is used to seal the splintered wood frame, while the rough grain of the wood shows a house that has never known the protection of paint.

A third familiar image type is the poor but statuesque noble agrarian figure, sometimes resembling African sculpture, as in Dorothea Lange's "Ex-Slave with Long Memory" (fig. 2.9)—who resembles Welty's character Phoenix Jackson from "A Worn Path"—in a soiled apron, a tattered sweater, and a startlingly white, attention-drawing headcloth that suggests the wrapping of a mind full of recollection. This woman stands with a stick held like a scepter and with a command of space that suggests endurance, perseverance, and memory. In another version of this image type, Jack Delano's Georgia woman ("Negro Tenant Farmer, Greene County, Georgia"; fig. 2.10), shot from below, towers in stature. Colossal, she rises and rises before us. She is another woman dressed in what does not fit her, but she wears it as if it does. She is veined with work. Her face reflects the sun's harsh illumination; her downward-looking eyes seem to see past the present. Her glance brings our eyes to hers and to a mouth that holds a slant, perhaps questioning a response.

The last of my image types reports the signs of a segregated society. Dorothea Lange's "Plantation Owner and Field Hands" (fig. 2.11) is a statement of power hierarchy in the Mississippi Delta. The white plantation owner with shaded eyes dominates the frame. A Mississippi '36 license emerges from between his legs. He is both attached to and supported by his shiny power car. He is not, however, quite at the center of the frame and in back of him, almost pushing him out of its center, are the figures of four black men, his field hands. They are, it would seem, behind him. Two of these men are sitting in postures that are self-contained. But the front figure is tensely cocky, and his angled foot is just in front of, ahead of, the white boss.

Another of these apartheid images is Russell Lee's "Colored Water Cooler in Street Car Terminal" (fig. 2.12). Here, a streetcar terminal in Oklahoma City in 1939 shows the signs of the time. The shiny clean, neatly dressed, and hatted young black man carefully and politely drinks from a paper cup filled with "colored" water. Natanson writes that each FSA photographer contributed a few images of this sort to the file although the administration's official policy was not to challenge segregation directly. Stryker's advice to the photographers who were shooting images of the African American body in the South, clearly articulated to Dorothea Lange, was to instead "put emphasis on the white tenants, since we know that those images will receive much wider use" (Natanson 4). That official position did not change until 1941, when Richard Wright and Edwin Rosskam published *12 Million Black Voices* using FSA photographs, which caused Stryker to say, "We have always

been interested in the Negro problems . . . and have taken pictures of these problems since we have been in existence" (Natanson 4), a statement about the documentary mission that was both true and not.

While these examples illustrate scripted race images, the FSA photographers' consequential work typically transcended reductive types. Their compositions were powerfully seen and framed complex messages, even while their images precisely fit these familiar categories of representation of the black body. The FSA did indeed produce revealing photographs that influentially addressed social issues and needs; they stood in opposition to what Stryker referred to as "the goddam newspaper pictures," which emphasized condescension, criminality, and the primitive (Natanson 58).

Welty and the Grammar of Racial Representation

The 1930s assortment of familiar depictions is evident in Welty's photographs. I show that she employs these same four image types before making the additional point that Welty's images reflect her own sense of alternative documentary: she repeatedly frames her vision in distinct and personal ways. Ultimately I argue that although Welty was an "amateur" because she was not commissioned, many of her photographs of black women were fully engaged in creating a few provocative types of representation that transcend the familiar types and freshly reveal other ways to see, ways that attach to Welty's issues as a young woman and an emerging artist.

It is not always clear to viewers aware of Welty's early work history that she was never either an FSA nor a WPA photographer. She worked in 1936 at the Works Progress Administration as a "junior publicity agent" (a title that Welty says signified that she was "a girl" while her boss was not).[6] Her photos, while on occasion published by the WPA, were not taken for the WPA or the FSA. Her work assignment was to provide publicity for projects, to write their descriptions, and to talk to people at project booths at fairs, but she took photos when traveling on the job, and a few of her images were put to work. For example, *Mississippi: A Guide to the Magnolia State*, compiled and written by the Federal Writers' Project of the Works Progress Administration, contains three unattributed black and white photographs by Eudora Welty: "Gathering for a Political Rally" (9), "Shantyboat Life" (16), and "A One-Mule-Power Cane Press" (45). These were valorized as speaking in a recognizable vocabulary by their placement in a government publication.

Although Welty never shot images for the FSA, not surprisingly a number of Welty's African American photographs are work pictures that in the context of the Farm Security Administration moment have a clear and familiar political grammar. For example, "Chopping Cotton in the Field" (fig. 2.13) frames a familiar workday subject matter and implicitly the trauma of agricultural

labor in the context of dire poverty. In it, the thin, spare but grounded figure of a woman harvests, but her reaping tool seems to disappear in the air, leaving the woman's effort more visible than the instrument of production. Welty's poignant "Washwoman" (fig. 2.14) is another photo about toil; the figure of the laundress is a portrait of work paused briefly. Her tired body is at rest; her facial expression is poised midway between depression and relaxation. Her downward gaze seems focused inward, and she has the look of someone slipping into fantasy. Empty washtubs suggest both a job done and one that will again have to be done. A cat near her is washing itself. Freshly washed shirts absorb the sun's heat, while the laundress—more comfortable than when laboring in that heat—curves into stillness in partial shade.

Of Welty's work photos, "The Mattress Factory" (fig. 2.15) is an especially beautiful photograph, filled with repeating shapes and textures. Three figures escape the workspace in rest. The photo's drama is in the faces of the two women, who look away from their work and the dark space of the workroom, through a door that is open to the bright outdoors. The figures of the women are not at the photo's center—a mattress and space dominate. Instead of being central, the figures of the women are cornered by their workspace, and they are drawn to its liminal aperture: the door to a bright place—one they do not enter. The camera documents the lived history of these individuals, but their labor and longing leave no personalizing marks on the space they inhabit.

In these last two work images Welty shows more than the laborer; she shows subjects escaping labor in reverie, slipping into imagination, a characteristic theme of hers in both photography and fiction. I have written about this elsewhere (Pollack, "Photographic Convention and Story Composition") as a kind of plot in Welty's work associated with the "plot" of her photographic composition, which invites a viewer to muse on a detail and to slip from the material into imagination. Considered as an influence in her short story compositions that also explore escape into and through reverie, as when Ruby slips into fantasy in "A Piece of News" or Powerhouse escapes his gawking white audience by slipping into the lyrics he improvises for his blues song, these work portraits convey the inner life available in the midst of daily routines. It is apparent then that even these work photos, which use the familiar photographic grammar of the era, begin to show her alternative vision and focus.

Nevertheless, many of Welty's photos do follow the FSA script to document the body in traumatic poverty. "A Woman of the Thirties" (fig. 2.16) and "Making a Date" (fig. 2.17) are in this sense both examples of Stryker's sort of documentary narrative. In these images, in which humanity prevails despite economic trauma, we might see what Stryker celebrated as "the camera's power . . . to document" in representation "plain, honest, simple, naked,

sincere" (Lee, "Introduction" 3). But even here, Welty's commentary suggests her distinct view of her documentary subject. Asked by Hunter Cole and Seetha Srinivasan if her Depression photographs make an editorial comment, Welty answers that "poverty in Mississippi, white and black, really didn't have too much to do with the Depression"; rather, "it was ongoing," which suggests that Welty is not so much interested in an economic crisis with distinct boundaries as in a cultural dilemma with a distinct racial history—not directly addressed by the New Deal problem solvers (Cole and Srinivasan 195). Moreover, in another discussion of "A Woman of the Thirties," Welty suggests that the documentary narrative she frames is about another woman's personal story, and perhaps about the political in it: "When a heroic face like that of the woman in the buttoned sweater . . . looks back at me from her picture . . . what I respond to now, just as I did the first time, is not the Depression, not the Black, not the South, not even the perennially sorry state of the whole world, but the story of her life in her face" (*One Time, One Place* 11).

Similarly and differently, the title of the photo "Making a Date" and the man's earnest, cap-in-pocket approach to the woman he is courting emphatically reveal humanity prevailing in extreme, almost obscene, poverty. These figures in their worn clothes are framed and hemmed in by merchandise-filled store windows and high-priced cars. The challenging glance of the woman, meeting the eye of the camera and now our observing eye, is full of provocation and a considering judgment that assesses how she is being seen, by whom, and why. The drama of "Making a Date" is and yet is not about trauma; it is what Sara Blair calls "against trauma" in her discussion of Ben Shahn's images of Lower Eastside Jewish men and women. Blair writes of Shahn's "resisting the categorical assignment of trauma as fate" ("Against Trauma" 41). In this sense of "against trauma," Welty's image delicately balances a portrait of civilizing courtship against the brutality of poverty; nevertheless, the lines of "Making a Date" bring our eyes down to two pairs of shoes that are emblems of working poverty in the African American community of Grenada, Mississippi. Dorothea Lange, part of Stryker's FSA group, also photographed feet as this sort of emblem of traumatic poverty in "Feet of a Negro Cotton Hoer" (fig. 2.18) and "A Sign of the Times—Depression—Mended Stockings" (fig. 2.19). Lange's "Mended Stockings" is an image that shares Welty's frequent habit of photographic irony since its mutilated stockings—beyond all further mending—suggest a woman whose desire for grace is perfectly intact, and the image, like Welty's, veers off into a gendered narrative about a woman in addition to the one about economic trauma.[7]

Like the archived FSA photos, a few of Welty's pictures frame the story of apartheid Mississippi, directly reporting a segregated society. For example, in "Dolls" (fig. 2.20) the faces of the children are not as clearly visible as the faces of the white dolls that the girls have been given to love. This photo

frames the racial predicament of two black daughters in a culture that links womanhood normatively to whiteness, a dilemma that Toni Morrison helps us to see in her novel *The Bluest Eye* (1970): "All the world had agreed that a blue-eyed, yellow-haired, pink-skinned doll was what every girl treasured. 'Here,' they said, 'this is beautiful, and if you are on this day "worthy" you may have it'" (20).

Unexpectedly and provocatively, Toni Morrison was the rare early reader to speak of Welty's work as political. Morrison in 1977 called Welty "fearless" on the topic of apartheid culture ("Interview with Mel Watkins"). Welty's perspective appears to be implied in her framing of "Colored Entrance" (fig. 2.21). In this photo, a young African American man is required to use the "colored" doorway to a movie theater while two white women, a blurred image (barely discernible as two figures until we notice the number of legs moving quickly) at one edge of the photograph, swiftly pass the accustomed sight. Caught at the center of the image, the young black man, in clothes that have the residue of a productive workday about them, attempts to enter the imaginative world of the cinema. His figure is conspicuously restricted in the tight modern landscape, which is conveyed by the sharp angles of cold, clean cement. The constraining infrastructure of cultural apartheid—the literal sign of the times—hangs over him, announcing COLORED ENTRANCE. An emergency exit is visible but inaccessible. White figures move freely on either side of the constricted space that confines him; they appear on the one hand as a menacing shadow and on the other as a retreating blur. The black man's figure bleeds into a shadow that unsettlingly does not entirely take shape as a person's. Like other documentary photography of the period, Welty's composition is clearly communicating social commentary.

Welty and Other Ways to See

Having made the point that Welty was in some ways working quite close to the documentary context that was on the up in 1935–1942, I now demonstrate that she was at times working considerably beyond its types and tradition. In the photos that most interest me, Welty is probing a historical experience but documenting something that is not the Depression, not trauma, but rather a narrative that speaks to her. This historicity has economic and racial aspects, but it is also a story of the body of the other woman, a story of the women she repeatedly pictures as enjoying a certain freedom to create themselves, finding release from the discipline of the work week as they enjoy their "Saturday off." Like Courtney in Welty's early story, their pleasure is a site of resistance, an escape from discipline, now a racial as much as a gendered restraint. Deborah Willis comments on the Welty photographs' treatment of race: "she captured women spending time with their girlfriends at church socials, going to

the fair, and doing hair on their front and side porches. . . . her photographs of women laughing and window shopping depict the freedom these [black] women found after a day's work. . . . These women she photographed were not bound to traditional roles found in the American imaginary" ("Eudora Welty: The Intrepid Observer" 82–83). More like the Photo League (whose meeting space was provocatively close to the locations where Welty had her New York shows), whose projects Sara Blair in "Against Trauma" describes as "far less predictably activist" than the FSA group, Welty develops an alternative documentary practice. In her record of these other women's escape from self-restraint (seen in "Washwoman" and "Mattress Factory"), she seems alert to links between herself and her black female subjects yet mindful of the structural differences between their struggles in the southern caste system. As when she explores the "artist travelling in the alien world," that is, a description of herself, by writing about her black jazz musician Powerhouse (notably in the same time frame during which she was taking these photos), Welty seems to clearly identify across the color line: she experiences not belonging to the conventional world of whiteness. And yet in her relationship to these black female subjects she also stands apart and does not belong in their frame either. As I have described, she is outside of the frame, reaching in some kinship toward the black woman exposed in the frame. The images record what Welty—a young middle-class woman in her twenties—somehow knows to see and to appreciate as affirming narratives. The photos also have about them a "lenticular" quality, a term that Tara McPherson has used to portray the representation of race in America (17); "lenticular" describes the technology of some novelty postcards that, depending on the angle one holds them, show a black woman or a white woman, alternately, while the two are never simultaneously present in the same frame.

Welty's images of black women's beauty, personal choices, and self-creation, which I next discuss in some detail, are not romantic portraits of the other. They are not like Faulkner's portraits, say, of Molly and Lucas in *Go Down, Moses*, who in keeping the "Fire and the Hearth" warm in their family succeed in love in a way impossible in the big house world of the white McCaslins. There, Faulkner's romantic other stands in clear contrast to Richard Wright's portrait of a "black boy" living the "bleakness of blackness" in Mississippi, where the emotional tone is not love but fear and the "absence of tenderness" (*Black Boy* 37). In contrast to Faulkner's essentializing portraits of romantic others, Welty's photos are material portraits; these are the bodies of actual women, and their images are filled with their agency. Paradoxical as it seems to show the "freedom" of black women in the midst of Jim Crow, the Depression, dire poverty, and lives overly full of labor, the images show all that Welty is sensitized to know, to see, to appreciate, and to document in these other women's lives. The resulting images challenge the period's usual rep-

resentations of black women. I consequently mean to show that, in addition to those grammatically familiar FSA representations of the black body, Welty shot some surprising and innovative photos that are characteristic of her work and important in her representation of race, body, and the other woman. I identify three particular sorts of revisioning depictions by Welty: the images that unconventionally frame black female beauty; the portraits that suggest self-creation and self-determination; and the pictures that unexpectedly frame the black body in ways that convey the subject's imaginative play. These original depictions further counter the reductive but commonplace and traditional visual imagery of black bodies, which was a sort of erasure.

To understand Welty's context in portraying black women's beauty, I now turn to the general topic of her relationship to notions of female beauty, its regulation, and its reproduction.

Critiquing Mainstream Notions of Beauty: Advertising and the Promise of Female Possibilities

I have noted that Welty came to photography after spending time at Columbia thinking about advertising as a possible profession. Katie Conboy, Nadia Medina, and Sarah Stanbury point out in *Writing on the Body* that advertising locates women's beautifully regulated bodies (and in the 1930s, that would be white women's bodies) as "[s]o material" to the institutions of culture and class and "to the reproduction of capitalism, that they can be sold or used to sell other commodities or products" (8). Moreover, the advertising industry is itself one key venue for establishing and disseminating the cultural requirements for female self-regulatory practice—for example, the notion that a girl becomes a woman through such gendered disciplinary practices as weight control, skin and hair care, and attention to fashion—since it broadcasts to its targeted markets in magazine culture. In advertisements, women's bodies are routinely read as "a form of nature to apprehend, dominate, and defeat"—and a woman's "natural" female body of small waist, dainty body parts, and silky hair is presented as "requiring . . . unnatural maintenance" (2). The upkeep of this woman's body is frequently presented in advertising as requiring a thorough bodily discipline that from a certain detached angle is potentially comic; consider the climbing rhythm and exasperated humor of Sandra Lee Bartky's description in "Foucault, Femininity, and the Modernization of Patriarchal Power" of the required self-regulation:

[Female maintenance] requires not only attention to health, the avoidance of strong facial expressions, and the performance of facial exercise, but the regular use of skin-care preparations, many to be applied oftener than once a day: cleansing lotions (ordinary soap and water "upsets the skin's acid and alkaline

balance"), wash-off cleansers (milder than cleansing lotions), astringents, toner, make-up removers, night creams, nourishing creams, eye creams, moisturizers, skin balancers, body lotions, hand creams, lip pomades, suntan lotions, sun screens, facial masks. Provision of the proper facial mask is complex: there are sulfur masks for pimples, hot or oil masks for dry areas, also cold masks for dry areas, tightening masks, conditioning masks, peeling masks, cleansing masks made of herbs, cornmeal, or almonds, mud packs. (137)

A result of the work of advertising is that a Foucauldian "panoptical . . . connoisseur resides within the consciousness of most women. They stand perpetually before his gaze, and under his judgment . . . [and a] woman may live much of her life with a pervasive feeling of bodily deficiency" (140, 149).

To catch Welty's attitude toward commercial images institutionalizing ideas of beauty in order to sell products, you only have to know the spoofing photo "Helena Arden" (fig. 2.22), a title combining two well-known cosmetic brand names: Helena Rubinstein and Elizabeth Arden. Welty did not take this photo but posed for it, head wrapped in a sheet, readied for a Voguish beauty preparation. But in her comic parody the product she seems about to apply to her eyelashes with a toothbrush is shoe polish, and the other unexpected Helena Arden preparations that await her are familiar as well—pea soup and Sunbrite cleanser, products used daily in women's housekeeping. The black British photographer Joy Gregory, who like Welty had an early background with advertising images, identifies a certain call for freedom and female possibility in fashion photography but recognizes it is "a contradiction" since it persuades women to read their "bodies as photographic images . . . unpublishable . . . until retouched" (cited by Willis and Williams, 180, as from Gregory's statement, quoted in Graham-Brown, "Images of Women"). Welty's "Helena Arden" lampoons the contradiction and mocks the promise; the lotions and potions summoned to produce female possibility are clearly identified as products routinely used in daily female regimens of domestic maintenance and drudgery, at odds with fashion iconography's glamour. At the same time, Welty's comments about her send-up express precisely the sort of ambiguity that Joy Gregory clarifies: Welty says that her burlesque "satirizing the advertising game" also expresses "admiration of" and "longing for" the "smart world" of places like New York's artistic scene (Cole and Srinivasan 201). This sort of longing for self-invention and freedom, problematically jumbled into an encounter with the panoptical connoisseur, becomes her topic when Welty writes "Hello and Goodbye."

"Hello and Goodbye" shares its title with one of her photos (fig. 2.23), made when Welty worked for the Mississippi Advertising Commission, and it is another measure of Welty's view on conventional notions of beauty. She seemingly glossed the shot with the sketch, a story concerned with both pho-

tography and beauty pageantry. Published in the *Atlantic* in 1947, never collected by Welty, and reprinted in Pearl McHaney's *Eudora Welty: Occasions: Selected Writings*, it is only one example of Welty's lifelong use of her early photos in the details of her fiction. "Hello and Goodbye" is a story narrated by a woman photographer on assignment to shoot a beauty queen and the queen's "Hostess," a former "Miss-Know-Your-State-Better." The more experienced beauty has acquired some professional skill at posing but also some emerging clarity concerning her own ambitions and the industry's attention to formulaic good looks. Again like the fashion photography that Gregory critiques, the story divulges an aspiration to freedom both expressed by the beauty queens and contradicted by the routines assigned to them. The story satirizes their conventionally constructed poses and yet sympathizes with their desire to see the world. Posturing for the project of their red-faced sponsor, Mr. Murray, tired and hot in their silk "traveling" clothes, "they were posing with hats, purses, suitcases . . . saying 'Good-bye, Jackson! Hello, New York!'" (McHaney, *Eudora Welty: Occasions* 288). The photographer thinks that the "Queen had so patently won . . . for this . . . and had stepped incredulous out of New Hebron or Monticello or Carthage or somewhere with the cheers of some consolidated school house behind her, . . . she hadn't known she was this pretty, that it would cause so much to happen" (290). Evidently not really on the cusp of anticipated independence, the young queen accepts instructions from her slightly more experienced companion, another woman who has won contests but who has not yet been satisfied by the promised reward. Like the more graceful of the two waving women in Welty's photo, the hostess can advise how to "give" and throw weight for a camera. Her exact posing advice to the inexperienced queen is "Wake up. Now. Let's *look just beyond* Mr. Murray" (294). She instructs the queen and possibly herself as well: "You're through waving. This is just a quiet good bye with Mr. Murray and the suitcases and you're looking a little past him now." Her voice becomes hard as she continues: "We're going to have us a good time before we get old and die" (295). In Welty's 1939 photo, the figures of two young women are overmatched by Mississippi's new capitol building although they, as if at the story's droll fashion model directive to "give," reproduce familiar, identical poses. Welty remembers a scene that seems to be this one when she describes her occasional work as a fashion photographer for shops in Jackson, arranging models "in different places the way they did in *Vanity Fair*—in front of the New Capitol, around town like that" (Cole and Srinivasan 201).

Female Escape Producing Welty's Photographic Innovation

This amused and bemused attitude toward the photographic gaze on women and the conventional white idea of the beautiful, I suggest, also produces

Welty's series of alternative framings of African American female beauty, which go far in countering the long-established erasure of black women's magnificence. Made in a time when such images were rarely fashioned by white photographers, these are products of Welty's personal wandering of a landscape she had been sheltered from, while they simultaneously document a period in her own journey of female escape.

I compare Welty's images with the work of Consuelo Kanaga who in the 1930s and '40s created a distinctive group of "Negro studies" in order to show "what appreciation I have for these beautiful people" (quoted in Millstein and Lowe 39). Kanaga's "Frances with a Flower" (fig. 2.24) captures the subject's softness and silent pleasure—what Kanaga calls "the spirit." Sharply contrasting Frances's dark skin, moist in sunlight, her arched eyebrows and glistening hair, with a white flower, this is a now-celebrated portrayal of female beauty. Barbara Head Millstein speaks of Kanaga's African American images as "unique in their portrayal of blacks as individuals rather than stereotypes" (Millstein and Lowe 35). Judith Fryer Davidov in *Women's Camera Work* suggests that Kanaga's portraits of black women are affirming in a way not apparent in other portraits by white photographers of the period. And yet, I argue, there is Eudora Welty's work: a number of her images, like "Frances with a Flower," celebrate African American female beauty.

Welty's "Saturday Off" (fig. 2.25), for example, is the portrait of a graceful woman full of easy, comfortable, nearly erotic self-confidence. The sensual rounding lines of the figure draw us from face to rump down to entwining bare feet that angle and point us up again, past the bent elbow and wrist to the face, and to the direct eyes, which smoothly and contentedly see and measure—with just a hint of tickled amusement—the woman behind the camera and now us too, making us glad to be taken into this reciprocal gaze. In the history of the photographing of the black subject—which is largely based on what I call "forced photographic submission" (as in the early images I have discussed)—the photographer's assertion of power over the person is clear, and the subject's participation in the image-making could not be escaped. But this exceptional photograph by Welty is filled with the subject's agency and unexpected collaboration. There is perhaps a fleeting, but felt, intimacy here between subject and photographer that we enter and are included in as the woman in the image collaborates with Welty the photographer. Welty recalls her negotiations with potential subjects in an interview with Hermione Lee:

> I would go to the poorest part of the state, in the depths of the Depression, and
> I would say to people, a lot of them black, "Do you mind if I take a picture?"
> and some of them would say, "Never had a picture taken in my life." And I'd say,
> "Just stay the way you are." They'd be in some wonderful pose, a woman on a

porch, leaning forward from the hips, like this, her elbows on here and her hands crossed, with this wonderful curve of buttocks and legs, bare-foot on the porch. Beautiful woman. I would say, "Do you mind if I take your picture like that?" "No," she'd say, "if that's want you want to do. I don't care!" (151)

"Saturday Off" is a portrait of comfort with exposure, taken in the time period when Welty is writing her early girl stories. It suggests the photographer's fulfillment through displacement, affinity, and collaboration.

There is some connection here to and transformation of what troubles bell hooks about the white eroticization of the black body: hooks thinks about Josephine Baker's rise to fame in the 1920s and '30s, performing that black mask of the erotic as she sashayed to celebrity, fortune, and self-creation on the Parisian Folies Bergère stage, reveling in routines that stunningly announced that "the rear end exists." She quotes Baker's biographer Phyllis Rose: "With Baker's triumph, the erotic gaze of a nation moved downward. She had uncovered a new region for desire" (hooks 63). Welty's sensual image, which spirals the eye toward and beyond "this wonderful curve of buttocks and legs, barefoot on the porch," transformatively acknowledges the erotic as an element of grace rather than demeaning animalism. The portrait is a tribute rather than indecorous, approving a woman's sensual spectacle.

Other framings of African American female beauty include "The Saturday Strollers" and "Preacher and Leaders of Holiness Church." "The Saturday Strollers" (fig. 2.26) captures the camaraderie of girlfriends. Three jaunty women move together, and their skirts shift in curves that echo the swerves in the two hats. The ring of those lines joins the three figures together to underscore their connection as women full of pleasure and their inclination to be pleasure for one another. "Preacher and Leaders of Holiness Church" (fig. 2.27) is nearly a Madonna portrait, illuminating an individual woman's features. The image circles from the pastor's hand, holding the word, to his obscured face, around a group of increasingly visible faces, until coming to rest on—or almost seeming to develop into—the sweetly revealed unconventional beauty of the centered woman, who is surrounded by an ethereal light communicating spiritual radiance.

In another sort of image, Welty shows her subjects' self-invention. For example, "Nurse at Home" (fig. 2.28) shows a woman in her uniform, having chosen her career and posted the sign that announces her professionally. "School Teacher on Friday Afternoon" (fig. 2.29) shows a woman who is in the stage of transformation that fashion can bring, presenting herself as ready to amble and strut, to be respected and admired, while also giving us a sense of the presence she likely commands in her classroom. Even "Window Shopping" (fig. 2.30), which Mae Miller Claxton has written about so compellingly as an image suggesting the shopper's economic separation from

the goods she contemplates in a segregated Jim Crow society, seems to fit my category of portraits about self-creation. In it, a well-assembled woman may be looking at merchandise, but she also seems to be contemplating some future possible self in reverie. Interestingly, this image, mounted for one of Welty's New York shows, then carried a title likely assigned by someone else: "Lingerie," a caption closer to the stereotypical narrative for a representation of the sexual black woman. The alternative title, written in Welty's own hand on the back of the mounted photo is, fascinatingly, "Teachers Don't Get Paid," which connects the image to women's work and professionalism as well as to Stryker's script of hard times and financial trauma. Moreover, Welty labeled the obviously earlier contact print, on display in 2013 as part of the Ogden Museum's vintage prints exhibit, "Payday." It is equally interesting that Welty eventually revised the caption to "Window Shopping," a naming that emphasizes the woman's reverie and the idea of her personal choice, as well as a mind, desire, and imagination set off by a display in a shop window.

Above all in this category of depictions of self-invention and determination, I think of "Born in This Hand" (fig. 2.31), one photo in a series portraying Ida M'Toy. Midwife for black and white, at the name of any well-known citizen Ida M'Toy would make the recorded gesture, expressing both her pride in her accomplished achievement and its playful presentation (making this image also a candidate for my next group, in which imagination and imaginative play are depicted). Welty unfolds the photographic portrait at length in her narrative sketch detailing a remarkable, idiosyncratic woman:

> [I]f there had never been any midwives in the world Ida would have invented mid-wifery, so ingenious and delicate-handed and wise she is, and sure of her natural right to take charge. She loves transformation and bringing things about; she simply cannot resist it. . . . Ida's constant gestures today still involve a dramatic outthrust of the . . . hand, and let any prominent names be mentioned (and she mentions them), and she will fling out her palm and cry into the conversation, "Born in this hand." (*The Eye of the Story* 343)

M'Toy, who called herself "the first practical nurse in Jackson," had for thirty-five years been catching babies; Welty describes midwifery as having given "her a hand in the mysteries" (*The Eye of the Story* 338). On finding her physical nimbleness ebbing, Ida's narrative of self-invention recommenced; she followed the thread "between delivering the child and clothing the man" (337) right into a prosperous business in used clothing. Welty portrays this venture as being as creative as midwifery: "It could be a grubby enough little business in actual fact, but Ida is not a grubby person, and in her handling it has become an affair of imagination, . . . an expression of a whole attitude of life as integrated as an art or a philosophy" (340). Her portrait is of a working woman, making a living in the hard times of the Great Depression,

engaged in promoting life and making beauty: M'Toy "finds all ornament a wonderful and appropriate thing, the proper materializing of the rejoicing or sorrowing soul" (344). Preferring "symbolic and celebrating" apparel, she adorns clients so that they depart "dressed like some visions in [her] speculation on the world." Welty's tone of gently comic irony risks condescendingly aggrandizing the nobility of a black "rich old woman" (336) who has been gloriously eccentric while recognizing the "demands upon her greatness" (347). But Welty's irony ends up conveying immense respect across the color line, and she created a persuasive homage when she snapped the shutter on a gesture containing a narrative—as she explains in her preface to *One Time, One Place*, "I learned quickly enough when to click the shutter, but what I was becoming aware of more slowly was a storyteller's truth: the thing to wait on, to reach there in time for, is the moment when people reveal themselves" (7).

Another aspect of this image of M'Toy as well as of "Window Shopping" and "School Teacher on Friday Afternoon" is that Welty has framed these individuals at various stages of social mobility, even during the Depression, bringing attention to what I might call racial and social change, unlike images that convey the more standard grammar of racial representation. A number of Welty's portraits of black women show African American mobility in contrast, say, to photographs that associate the poor with rough shacks and dire poverty—images more easily co-opted by viewpoints that accepted eugenic attitudes, understanding the poor as a population unfit for modernity and tacitly blamed for their poverty. Welty's documentary camera becomes a means of exploring what Sara Blair, writing about photographs of Jewish immigrants, describes as a variable, rather than arrested, advancement in images showing phases of assimilation to American modernism ("Against Trauma").

This group of unexpected images, which emphasize women's professional identities, is a segue to another notable group: Welty's innovative images that frame the African American body in ways that emphasize imaginative play. These photos are entirely different from familiar racial representations that condescend or are impersonal. In "Bird Pageant," "Woman with Ice Pick," and "Tall Story," figures disclose their imaginations in attitudes that might recall Powerhouse's inspired inventive riffing on Gypsy, the cloned double of Welty's own creative play.

"Bird Pageant" (fig. 2.32) is one of several photos with which Welty documented a pageant written and staged at Farish Street Baptist Church. The production was also the subject of her essay "The Pageant of Birds," first published in the *New Republic* (October 25, 1943) and then thirty-five years later in an altered version in *The Eye of the Story*. This performance, in the African American tradition of satiric and subversive signifying, features a national symbol associated with U.S. power and authority, the American eagle, with a blackbird by its side. Welty wryly describes the procession of the eagle:

Her wings and tail were of gold and silver tin-foil, and her dress was a purple kimono. She began a slow pace down the aisle with that truly majestic dignity which only a vast, firmly matured physique, wholly unselfconscious, can achieve. She had obviously got to be the Eagle because she was the most important. Her hypnotic majesty was almost prostrating to the audience, as she moved, as slowly as possible, down the aisle and finally turned and stood beneath the eagle's picture on the wall, in the exact center of the platform. (*The Eye of the Story* 317)

Barbara Ladd analyzes the pageant's imaginative play with national symbols: "The seating of the eagle is accompanied by flag-waving and the singing of 'The Star-Spangled Banner' by this audience 'almost prostrat[ed]' . . . and is followed by the 'procession of the lesser birds' who would bow to the Eagle Bird and to the audience before 'taking their positions.' Among the birds [is] . . . 'one beautiful blackbird, alone but not lonesome'" (Ladd, "Writing against Death" 169). This playful performance in the midst of the Great Depression has political significations: the relationship between the eagle and the blackbird might mischievously code hierarchy in the American and Mississippi economic narratives. Welty characterizes this quirky pageant as a demonstration of magic-making, of our tendency to "bedazzle ourselves out of what is at hand." In this case, she says, "folks had got hold of some bright tissue paper."[8] She describes her encounter with the spectacle as growing from a chance walk on Farish Street, where she sees a community of inspired and inventive black women, whom she catches in the act of taking joy in being pleasure for one another:

I saw these girls with big paper wings, carrying them over their arms along the street. I asked about them and they said they were going to have a bird pageant at their church, Farish Street Baptist, and would be glad for me to attend. And when I did, of course I wouldn't have taken a camera into the place. I wouldn't have misused my invitation by disrupting the program by taking a picture. Even so, they made us sit on the front row, which already called attention to us. It was a marvelous pageant, original and dramatic. (Cole and Srinivasan 209–210)

Welty makes the point that she received the invitation respectfully, taking photos only when the players arranged themselves after the performance. As Patti Carr Black has made clear, unlike the FSA documentary photographers, who traveled with extensive camera equipment and lighting and who instructed their subjects on their poses, Welty was less intrusive ("Back Home in Jackson" 36). Also unlike the touring FSA photographers, Eudora Welty belonged in the landscape she shot, if not in the frames themselves. But I would add that Welty crossed the color line to take these pictures and that, shooting at Farish Street Baptist Church, she is a Jackson, Mississippi, insider who is simultaneously a delighted outsider appreciatively negotiating her welcome.

"Woman with Ice Pick" (fig. 2.33) is another photo of imaginative play, cap-

turing a moment of wacky, roguish melodrama shared between black subject and white photographer. Asked "if there were ever any angry reactions to her taking photos," Welty replies, "No, I don't remember any. I don't know why there would have been. I remember in Utica photographing the black bootlegger who said 'I'm gonna kill you.' . . . She had an ice pick. . . . She was teasing" (Cole and Srinivasan 208). This photo is an abruptly improvised free play on the decipherable theme of black subject–white photographer. It makes a comedy of, while acknowledging, the tensions understood in the relationship, and it lets us know too that Welty had discovered these tensions and was not without self-awareness in these framing acts, even while in her 1989 interview she makes clear that she feels she had been, to a great extent, without self-consciousness in the 1930s. Welty's relative ingenuousness as she crossed the color line with her camera can cause us to return to her photos to look for evidence of uncomfortable interactions. Surprisingly few become obvious. In "Making a Date," for instance, the woman's eyes seem to be clearly asking who is framing her and why. In "Home by Dark," the backward glance of the woman in the wagon suggests distance, but she might be uneasily surveying the photographer rather than the road traveled. "School Children Meeting a Visitor" (fig. 2.34) frames a variety of reactions to the white photographer; it is a portrait not merely of children but of differences in response to her.

In her interview with Hunter Cole and Seetha Srinivasan, Welty broaches aspects of the photographic interaction she had not consciously imagined in the 1930s. Her retrospective comments defend her early experience even after the world changed its perspective in and after the 1960s:

> I think my particular time and place contributed to the frankness, the openness of the way the pictures came about. This refers to both the photographer and the subject. . . . I was never questioned, or avoided. There was no self-consciousness on either side. . . . There was no sense of violation on either side. I don't think it existed; I know it didn't in my attitude, or in theirs. All of that unself-consciousness is gone now. There is no such relationship between a photographer and a subject possible any longer. . . . Everybody is just so media-conscious. . . . Everybody thinks of pictures as publicity or—I don't know. I wouldn't be interested in doing such a book today, even if it were possible, because it would assume a very different motive and produce a different effect. (Cole and Srinivasan 191)

Pointedly asked how she, a young white southern woman, was received in black districts, she replies, "Politely. And I was polite. It was before self-consciousness had come into the relationship or suspicion. That's why it couldn't be repeated today, anywhere" (209). It seems likely that Welty approached the subjects she did both because she was drawn to them in her own self-education and desire for exposure, but also because in the 1930s these

were subjects she could approach in a mixture of shyness and risk-taking, entitlement and sympathy. Nonetheless Welty's assertion that she was not taking photographs "to exploit" but rather "to reveal" her individual subjects and "the situation in which I found them" (207) is borne out by the images themselves.

A final photograph among those illustrating imaginative play is too notable not to mention, even though it pictures two men rather than the "other woman." "Tall Story" (fig. 2.35) catches the tale of narrative connection in a frame. The viewer enters between two hatted men who are confronting one another and then circles between the imaginations of the story-maker and his responsive audience. This extraordinary picture makes stunning use of its visual medium to convey the subjects' voices, the intimacy of imagination shared between friends, the amusement of anecdote, and the equal joys of storytelling and critical reception.

I want to stress how rare I think this framing of African American play is during Welty's moment in the history of photography. The one photographer who stands out for me as capturing something like it is Marion Post Wolcott, a camerawoman working just a few years behind Welty and for the Farm Security Administration. Wolcott's series "Jitterbugging in a Negro Juke Joint Saturday Evening" (fig. 2.36), like Welty's images, has wandered off the Stryker reservation and strayed into an alternative act of documentary. But Wolcott's "Juke Joint" photos are images of physical play and joy rather than the really rare thing I find in Welty's work—a framing of the African American body in a way that captures imaginative play.

I consider these three innovative sets of affirming images—which bring African American beauty, portraits of self-invention, and imaginative play and pleasure into focus—to be varieties of subtle resistance to racial degradation. They contain a clear political power in their time and place, different from the official script of trauma that Stryker intended for the FSA documentarians. Welty's photos of black women may not have had a planned racial or political agenda, but they clearly enter, interact with, and in ways correct a set of clichéd racial images that were culturally familiar and prejudicial. They also demonstrate her characteristic attention to the other woman while addressing issues of personal exposure and political agency attached to her story as an emerging artist.

Silence, Sheltering, and Exposure in "Music from Spain" and *The Bride of the Innisfallen and Other Stories*

Eudora Welty in John Robinson's Closet

In this chapter I move from my interest in the pattern of the other woman and issues of exposure in Welty's girl stories and photography to consider Welty's personal escape from sheltering into the risks and exposures of a complex relationship. I consider the biographical story of her romantic connection with John Robinson in connection to a thread evident throughout this book: Welty's nearly lifelong disinterest in writing the conventional heterosexual narrative of female sexuality (in which marriage is the goal and the solution) and her perceptible preference for the plot of the other woman. I interrogate her longed-for relationship with Robinson, who either did not fully recognize or was unwilling to acknowledge and reveal his sexual orientation during the first decades of their relationship and who, at the end of what Welty seemingly understood as their intimacy, presented the man with whom he would spend the rest of his life.[1] I ask: if their attachment did not lead to the partnership Welty seems to have hoped for, was it in another sense nourishing to her particular development as a writer? For Welty, whose plots frequently explore departures from both literary convention and social conventionality and whose storylines contain scenes, emblems, and acts of exposure, what effect did her sharing the concealment, sheltering, and silence of John's closet have on her fiction? Was she, in those years, like May Bartram in Eve Sedgwick's groundbreaking reading of Henry James's *The Beast in the Jungle*, a woman abiding in a man's closet, a place of unspoken and "unmentionable" erotic "warfare" within a man? (*Epistomology of the Closet* 203, 182). And what is the effect of that "masculine civil war" on the woman sharing his "fate"? What was Welty in particular—a woman who had repeatedly chosen exposure, although that choice was not an inevitably easy path for her—doing

in John's closet? Is their relationship misunderstood in readings that tend to apply the plot of compulsory heterosexuality? Sedgwick says of readings of *The Beast in the Jungle* that it is too easily assumed that John Marcher *should have* desired May Bartram and that Bartram's emotional determinants and erotic structures were conventional rather than complex. Sedgwick distinctly censures the sort of heteronormative reading that assumes knowledge of what May "Really Wanted and Really Needed . . . [which] shows of course, an uncanny closeness to what Marcher Really (should have) Wanted and Needed, himself" (*Epistemology of the Closet* 200).

While wondering about the curtain of silence around the topics of desire, passing, sexual panic, and homoerotic possibility that seemingly marked their period in Robinson's closet, I discuss the little-known fictions he wrote that in retrospect are the site of his gradual self-exposure, although the disclosure was not effortlessly deciphered by his first and now most important reader, Eudora Welty.[2] Although mentoring, nurturing, reading, in some cases typing and contributing to his drafts, and promoting them for publication, did Welty overlook, ignore, or slowly and gradually and then perhaps precipitously grasp what seems to be Robinson's increasingly in-your-face voicing of discomfort with heterosexuality? His fictional material might in the 1940s for a time have seemed to belong to the gender-questioning habits of modernism, but it was more. Welty was sharing with Robinson a psychic place that Sedgwick refers to as "the epistemology of the closet," a space that contains both ignorance and knowledge. Sedgwick suggests that ignorance might be as "potent and as multiple a thing there as is knowledge" (3), and Foucault suggests, on a similar note, "there is not one but many silences" and no simple transparent opposition "between what one says and what one does not say" (*History of Sexuality* 27). In other words, is what Welty said and did not say while writing letters to John Robinson from this place of hush and avoidance perhaps not a perfectly legible reflection of her ignorance and knowledge?

And the questions continue. Was John Robinson's silence on homosexuality matched by Eudora Welty's silence on the topic of sexual desire, if that is what this was? Then there is the riddle of what sexual desire is—and what it was for her, a woman seemingly so much choosing a partnership between writers that she did her best to shape John thus, regardless of his lack of real promise, attending that potential in a way that displaced other budding issues of concern. In the culminating years of their relationship, her letters unceasingly beg John to write and to publish, but she never explicitly proposes or advocates marriage, a quiet that might be a woman's prescribed timidity or might perhaps be something else—an indicator of erotic pathways tying excitement to production of the word more than to any conventional longing for marriage. Welty's swelling silence about her precise desire in and for the relationship possibly exceeded Robinson's, at least as far as we can tell from

her abundant and otherwise revealing surviving correspondence; it might have lasted a lifetime. But I argue that her silence was broken in fictions that responded at first to her perhaps unconscious awareness of her circumstances with Robinson, a response arguably visible in the drafts and the text of "Music from Spain" and later discernible in *The Bride of the Innisfallen and Other Stories*. Several stories in this collection reacted to her now-conscious awareness, particularly "No Place for You, My Love," "Circe," "The Bride of the Innisfallen," "Ladies in Spring," "Kin," and "Going to Naples," to take them in the order written rather than collected.

"Music from Spain," one of a very few stories Welty wrote from a male point of view, is in this context particularly fascinating when considered as a response interacting with and revising one of Robinson's self-outing manuscripts, one that I will show Welty fully and sharply critiqued in a startling letter of artistic mentoring that now seems to be an effort at personal counsel as well. In particular Welty's story reworks an image she comments on in her instructing critique: the funhouse figure of a rowdily laughing mechanical woman. That comic spectacle is a point of connection with the flasher bodies of the other women from Welty's autobiographical girl stories, displayed in exhibitions that capture the transgressive, dangerous, or endangered. In Robinson's "House of Mirth," the female figure laughing raucously from the closet of the funhouse is alternately pictured as stoned, broken, and silenced, but in Welty's critique she is counterproposed as the promise of female "life, sex, and laughter." Then in "Music from Spain," Welty seems to follow the corrective advice that she offers to Robinson regarding his misconstruction of a character who feels victimized in his marriage, while she performs a gender change on her body-of-the-other-woman plot with multipled doublings. That is, although the text concerns a failed marriage and contains other women's bodies on display, her story's central encounter is between her character Eugene MacLain and the demonstrative body of an emblematic *other man* with an easy way of making a spectacle of himself. Eugene shares no language with the story's musician from Spain, but he nonetheless is informed by the other man's self-exposure—through his immense body, his expressive art, and the "terrible recital" of his uninhibited roar—a pattern suggesting Eugene's anxieties about the unspeakable through a doubling (or, in this case, "twinning") familiar from chapter 1 of this book. And of course, the plot's concerns with communication and exposure are in retrospect relevant both to Robinson's gradual revelation of his closeted sexuality and to Welty's accruing personal and artistic risk. In this case perhaps she is speaking, in fiction, of a desire for disclosure that she could not otherwise articulate from the confines of John's closet.

The closet silences and shelters. But these fictions of Robinson and Welty speak, creating a space where questions are asked and comments made. Fascinatingly, while their silence was in 1948 obliquely broken by fictional state-

ments, the pair's close and less closeted friend Hubert Creekmore published a novel, *The Welcome*, which I also discuss in this chapter. It provocatively and explicitly concerns a young man who returns to his Mississippi hometown and to its intense social pressure to marry. There he explores and confronts both his sense of himself as a homosexual man and his bearding attraction to a striking, intellectual, and socially anomalous woman artist. *The Welcome* should be added to the list of fictions that seemed to break the silence of the Welty-Robinson closet in the years 1947–1948, before it would be broken by John's act of partnership with Enzo Rocchigiani in 1951, that is by his exiting the closet.[3]

The Welty-Robinson Letters: Her Hope for John Robinson's Writing and Her Proposal of a Literary Intimacy

John Robinson wrote a number of stories and sketches; he published a small percentage of his work. In the 1940s Welty encouraged him and continuously promoted him to her own publishers (routinely contacting Pascal Covici of Viking Press, William Maxwell of the *New Yorker*, Frederick Morgan of *Hudson Review*, and John Palmer of *Sewanee Review*).[4] Eventually she arranged for Diarmuid Russell, her own agent, to represent him.

During the 1940s Welty and Robinson wrote to one another regularly; their archived letters—for the most part hers, since she destroyed the bulk of his[5]—chart much of what we know of the relationship, particularly its shape as a literary intimacy. As early as March 1941, Welty dedicated "The Wide Net" to John, who had told her about a young Delta woman's husband dragging the river for her body with his neighbors and their enjoying the pleasure of the day. Welty also used John's great-grandmother Nancy McDougall's diaries (1832–1870) as a source while she was working on "Delta Cousins" (1943) and *Delta Wedding* (1946), and then sent him the chapters as she wrote them. In letters throughout the 1940s, Eudora and John wrote about their drafts in progress, about their reading Faulkner and Joyce, about reactions to the other's manuscripts, about films seen and assessed, about Robinson's life as a student working with Marc Schorer, and eventually about brainstormed plans to collaborate on various literary and film projects, including work on a script version of *The Robber Bridegroom* (1949). Welty's letters to Robinson regarding her *Golden Apples* draft (the stories were located in "Battle Hill" before the name "Morgana" was chosen) show her talking to him as a fellow writer and potential advisor.

Throughout her letters to him in the late '40s, once he has come home from the war, Welty seems intensely, ardently attracted to the idea of a companionship and collaboration between authors sharing creativity and passion for the written word, and she imagines Robinson as that sort of counterpart, treats

him as her colleague, and does her best to shape him into one, regardless of his ultimate lack of substantial success. Her ceaseless encouragements to him contain invaluable reflections on her own process. Although we of course know in hindsight that Welty was the master writer and John was not much of a writer, she asks for his opinions, sounding him out, for example, as she plans what would become *The Golden Apples*—the stunning composition in which she was coming to full artistic maturity—and wanting to hear his judgments. She describes her revision of the stories she initially wrote as independent of one another, after she discovers they are connected: "There are eight Battle Hill stories, ranging in time from 1907 on up. . . . Diarmuid thinks people will expect stronger connections and explanations, maybe, but I have said (still without the reading over) they won't get them. So unimportant, to me. I wouldn't ask you to read all over, but just as you might recall some of the stories."[6] Welty repeatedly invites Robinson to enter the work, and she thanks him for typing her manuscript and for "keeping me from putting my hands on it any further—I'm not sure on changes to it at present . . . unless, if you think of something crying out for changing." She begs for his opinion: "What title shall the new book have? . . . Wish I knew which you liked, for a book title."

Equally, Welty longs to enter Robinson's work, writing that another thing on her mind is the impulse to edit his story ("The Back Is Open") by half. "I keep reading it with a pencil hovering in my hand, longing to try it—it's one of my habits with my own stuff, trying to see how far things will go alone, on their own. (Then my worse habit, of amplifying the finished story, shortening 40 pages to 60)."[7] She relentlessly brainstorms possible collaborative projects: a literary magazine, film treatments of early American folklore (particularly Paul Bunyan and Johnny Appleseed), a Guggenheim fellowship to carry on with the film projects (Welty writes on January 29, 1949, "several were given for creative work in film this year, looked it up"), a film version of Faulkner's *Sanctuary*, and a documentary jokingly referred to as "Mankind So Far." Gradually they settle on working together on a film script, and then on *The Robber Bridegroom* in particular. Eudora writes to John, sounding hesitant about reopening a work she has finished, but ready to be persuaded by him: "Maybe if you like the project and we talk about it a little I will feel OK about it. I would like to do a play—the best in the world. That is, with you, I wouldn't with anyone else that I think of."[8] And then, exuberant and passionate and giving: "Dear John: So pleased to get your letter. What are those notes you're making on Robber? Could we? I do think so too. In the first place, we could rush in, not fearing to tread. Sure it's free, it belongs to me, which is to say to us, to do anything we like."[9] And in another letter, she writes: "Robber never so much pleasure as now it's ours" (January 25, 1949).[10] Arguably she is, by this time, promoting a project in order to help John out of what seems to her to be depression, erratic behavior, undercom-

mitment, and unmooring, which she does not understand but which may be an indication of his living through a period of adjustment and anxiety concerning his homosexuality. Her refrain in letters to Diarmuid Russell is "John is not in the best of health or spirits. I get worried at times. . . . My hope is a story will sell and he will throw himself into his writing" (February 9, 1947, reprinted in Eichelberger, *Tell About Night Flowers* 196). In all these letters throughout the 1940s, there is an artistic relationship being negotiated as much or more than a romantic relationship, and there is an overlap in her vocabulary for the two, which again suggests pleasure tied as much to the production of work as to any conventional longing for marriage.

The letters just mentioned were written *after* Welty returned from her second trip to San Francisco, when John had not responded to her coming as she had hoped, but rather fled the scene. Marrs writes that Eudora departed Seattle "on August 12 [1947] for a [second] stay in San Francisco, near Robinson. Her ten weeks or so in San Francisco, however, were not all spent in close proximity to him. By mid-September, having sublet an apartment in the city, Eudora found herself responding to letters from John. From Laytonville, California, on his way to a vacation at Lake Louise" (*EWAB* 157). Judging from Eudora's letter to him on September 12, he seems to have cast his presumably unexpected trip as based in a need for space and solitude to write. She writes to him in Laytonville from San Francisco:

> I hope the work as it gets done is a kind of transparent thing. . . . I think some writing can when it's good *of its own* reach a kind of finality, and this is it, and what I hope for yours. Sure it will be labor—and you couldn't ever do it in a rooming house—privacy will mean everything. Do I conflict with it, or could I help you keep it,—can you tell? . . . Will you be coming home one day soon? . . . Have a good trip—it is so fine to see the places. . . . the best of luck to the trip and the shape of the work—bring the news. Love, E. (September 12, 1947; reprinted in Eichelberger, *Tell About Night Flowers* 202–203)

In November, when he has moved on to Los Angeles, she writes, concerned because he has apparently reported being ill: "Write and say how you feel." She is, however, asking about more than his physical health when she continues, "Things aren't right. Do you think they are?" (November 17, 1947, reprinted in Eichelberger, *Tell About Night Flowers* 207).

Behaving erratically, but not speaking plainly, John's actions seemingly left Eudora unsure of herself but still attached to the anticipation expressed in her letters about collaboration. Throughout their letters during the '40s, common interests and pleasure in one another are clear enough.[11] Welty, missing John, writes: "why is it always like this, without you?" John writes to a friend: "Eudora makes me yearn for that part of the country."[12] Overall, a significant element in Welty's attraction seems to be the erotic appeal of

a collaborating union between two working writers. For a long time, this attraction withstands both the difference in their dedication to the project and his vacillating, uncertain commitment to her: Eudora pushing on with a delighted determination while John is infinitely more easygoing in ambition, a temperament caught by Marc Schorer in a letter to the Fulbright committee on Robinson's behalf:

> His only flaw (and it is rather part of his attractiveness than a real flaw) is an inclination toward indolence, by which I mean to say that nothing seems to strike him as quite worth a lot of high pressure in the achievement of it. There is a good deal to be said for this attitude, especially in a writer who has no intention of compromising his literary ideals; and I hope that by mentioning it I have not lessened his chances for a grant. He is an admirable and gifted person who knows what he wants and how much he is prepared to pay. (quoted in Waldron 190).[13]

This is of course not a description of Welty's attitude toward her own work or toward John's for that matter. Her letters express concern for Robinson's focus and perhaps a sense of confusion about what distracts him from a clearer commitment: to her, to writing, to collaboration, to ambition. Before she succeeds in connecting John to her agent, Russell, *she* acts as his agent, sending out his drafts before he thinks of it and often without his permission, on impulse but also doggedly, copying them over as necessary, seemingly giving more of her energy to his unlikely career than a feminist reader might wish— before ultimately realizing that, as I argue, the relationship was in due course productive for Welty as a woman writer.

There are also archived letters that Eudora and John each wrote to friends, such as Nancy Farley and William Jay Smith,[14] about the other's writing, visits, and activities and, in the 1950s and beyond, simply about their more coolly keeping in touch with one another. The letters and stories with which I am most concerned, however, frame Welty's two trips to San Francisco to be with Robinson after his discharge from the army (the promising first trip in November 1946–March 1947 and the second, disappointing one in August– October 1947). They give some insight into the period when Welty was sorting out her concern for John and figuring out what was and was not happening between them. A number of these letters mention the story "All This Juice and All This Joy," which Welty places for Robinson in Cyril Connolly's *Horizon*, issued in England. On its acceptance, she writes, "not surprised one bit about Horizon but just feel like preening or dancing." And when the story arrives in proof, she writes:

> Dear John,
> The proofs are at you so maybe soon over the Horizon. . . . How does it look printed up? Can't wait to see. A beautiful, good story—watch for any errors due to me—I remember when typing coming upon some alternate words and though

I think they were your suggestions one might have been mine.— Let me know if he says what month. We can order lots of copies! . . . I feel gay about whatever we will do—and feel it will be good—we can find exactly what—have you had new thoughts? I'm so open to it that everything I read seems quite possible of dramatization by Robinson and Welty or always our pure original which I always trust. Must get this off in the mail. Much love—hope everything is going well and wish I could enclose all the Mississippi and the Pearl River, in case you would like today.[15]

I wonder if—to the extent that Eudora Welty nudged and prodded Robinson to write the stories in which he seems gradually to reveal and accept his sexual identity—she might have been a catalyst for Robinson's finding in his closet not merely an absence of desire (or panic in the face either of compulsory heterosexuality or of unhappy homosexuality) but rather an assent to queer identity and desire. If his takeaway from writing all along had more to do with self-discovery than with publication, was she herself, in her urging John to write, a crucial facilitator and pivotal engineer of his eventual clarity and exit from the closet? This role might echo Sedgwick's comments about May Bartram's part not being to "fortify" John Marcher's closet but "to dissolve it," by paradoxically advocating for "progress . . . to a self-knowledge . . . that would [free] him to find and enjoy a sexuality of whatever sort emerged" (*Epistemology of the Closet* 207).

Reading John Robinson

The story "All This Juice and All This Joy," the best of Robinson's scanty published pieces, is revelatory in hindsight.[16] It is set in and structured on a layered landscape, a California oceanside that combines beach, cliff, thicket of pine, jutting promontories, caves. This is Lands End in San Francisco, the site of Playland, a beach amusement park that Eudora and John visited together and that featured a renowned funhouse mechanical woman emitting a raucous recorded cackle, Laughing Sal, on display now in San Francisco's Musée Mécanique near Fisherman's Wharf.[17] This landscape provides separate stages for several sets of characters to act on, and yet allows some intersection of their plots. The action occurs at Easter, and the original title of this work used in correspondence with potential publishers, "Rite of Spring," seems to refer to the characters being variously, seasonally awakened to sexual transitions, as characters are in Welty's own later and very different "Ladies in Spring" and in her earlier "The Winds."

Robinson's revised title, "All This Juice and All This Joy," seems ironic; these characters have more juice than joy, and it would be accurate to call the fiction's topic "sexual awakenings and arrests." The story twines a number of plot strands. A heterosexual couple's experiment with intimacy frames

the story; it begins and ends with what initially seems to be a sexually eager, recently discharged young soldier and a more hesitant young woman, who are heading toward their first carnal encounter. On a promontory below them are two young men who, late in the story, are suggested to be homosexual. One lies naked, sunbathing; the other is sighting and shooting the seagulls that alight on a sunken ship's mast while new gulls continually and heedlessly replace each sacrificed bird. On a path above, adolescents engage in flirtatious shenanigans. Two adolescent girls, who initially walk arm in arm, are separated by boys who, after threatening to throw the young women over the precipice, provoke one girl clad in dungarees and a tight sweater to chase them, leaving the other "fragile-looking girl" behind. The chase takes them to a cave covered with "primitive, obscene drawings . . . with initials, dates, messages." There the pursued and breathless girl studies the wall pictures before the boys lift her over their heads, and then one of the boys sits "astride her stomach" while "red-faced and panting . . . [they] stare at each other" ("All This Juice and All This Joy" 344).[18] Below, on the beach, a middle-aged beachcomber works to keep up a fire. Seeing wounded birds falling into the ocean, but unable to see the shooter from his vantage point, he imagines the birds involved in some unending and unexamined ritual self-sacrifice, "made for the sake of their kind," like the characters drawn heedlessly to the sexual rites of spring. The middle-aged man feels pity for both birds and men, and eats a sky-blue Easter egg, a traditional marker of spring fertility, smashing "the shell to bits in his hand" (JJ 345).

Two other strands of the story briefly intersect and are more developed than the others: the plot of the two young men is more full of action, mounting to violence, but it is not the climax of the story. The other is the more briefly unfolded plot of the soldier and the young woman.

In the story of the young men, the naked sunbathing boy who reclines on his trousers, self-conscious about his broken-out back and his calf size, has often gone to the beach with the friend who is shooting birds with a rifle. "They lay on a blanket, self-conscious, displaying their muscular, brown bodies. They did handstands and other stunts which they had perfected, aloof from the crowd but aware of the gaze of spectators who passed their way. Girls sometime[s] came and talked to them, but not receiving their accustomed adulation, soon went away" (JJ 345). These are boys who experiment with physical display but, aloof, refuse girls' attention and do not provide the "accustomed adulation." A stocky, hatless man in a turtleneck sweater, whose "skin had a luminous, hairless look," unexpectedly approaches them. The stare of this phallic-looking man makes the sunbathing boy uncomfortable. When the man asks, "Want to see some pictures," his right hand fidgets "in his pants pocket." He speaks of "something good a little while ago . . . couple back there," apparently having spied on the soldier and his girl (JJ 346). "The

boy who had lain on the ground blushed. He turned and walked away . . . pretending that he hadn't heard, or only half heard, everything being experimental today, touching him lightly. He climbed around the side of a rock and sat on a high shelf above the ocean. There in the shadow he squatted like one of Audubon's drab females of the species—listless, while the male preens himself in brave colours and defies the world" (346). His companion, the preening boy with the gun, better resembles Audubon's showy male specimens. Aggressive, he sputters, "you dirty ——!" Abruptly and unexpectedly this boy hits the vulgar offender with a rock, again and again. When the assaulted man's "face seemed painted with blood," he mumbles something almost unintelligible, and the boys hear only fragments: "wanted to be like you . . . the road I came . . ." The outraged boy now strikes the offender's hands and head with the butt of the rifle. "The man's body fell backward to the earth, his hands jerking compulsively at his sides." He remains still, with his pictures "scattered all about him" (347).

What are the provocations to violence here? Are the boys offended by the vulgarity of the older man, or by his assumption of their shared vulgarity? Is the pornography vendor referring to the boys' innocence or to male pairing when he says, "wanted to be like you"? Is the boy with the gun a Percy Grimm figure whose brutality is self-protective, perhaps masking a fear of being outed by an identifying association—in this case a closeted fear of being on display as "deviant"? Does the assault displace and disguise anxiety about the reception of homosexuality behind a hypermasculine belligerence and compensatory cruelty?

This violence could have been the central action. But it and the story as a whole are framed by the sexuality of the soldier and the young woman, and the violence in some ways seems to be a contrived diversion to distract from the other unsatisfying development of the story: the unexpected end to the couple's sexual experiment. The story opens with the soldier's response to the girl's judgment that they had better go back. He presses his case: "Let's see what it's like" (JJ 342). The couple finds part of a torn postcard that literally shreds the conventional narration of wartime romance. They decipher, between gaps: "When the war is . . . and you'd be . . . I'll be . . . waiting if you want me to. 'Like us,' said Tom." Tom leads his girl to a spot under the trees, "beneath the branches . . . black upright stems closed in on all sides. [The girl] felt like a swimmer with her head above water. . . . Suddenly she felt that all this was *under* water" (343). As Tom holds her, she becomes too talkative—about her nephew's Easter egg hunt that morning—and her hair snags in their embrace. "Tom was pulling her down beside him. She untangled her hair slowly, carefully, then lay back stiffly on the pine straw." Fearful that she hears somebody (seemingly the man who saw "something good"), she urges

departure, but her partner ignores the sounds, reassures her, and kisses her "as she trembled as though she were cold" (343).

At the story's end, following the episode of violence toward the voyeur, the narrative returns to the couple after their intimacy. Their situation now confirms the foreshadowing expressed in the landscape of trees grown into the "tortured shape" of turned avoidance, of "flight." Although there is no wind this day, the trees have grown "windblown, one-sided, straining from the ocean in every branch" (JJ 342).[19] The couple is again beneath these trees: "The girl lay on her back. . . . 'So that's that,' he thought. It seemed to be the end of a long journey and why he had set out on it was not so clear to him. Nearby he saw crushed newspapers, brown from weather, empty match folders, rags. It was an untidy place pervaded by an odour of decaying feces" (347). If not sexual "panic," this is at least distaste, the absence of heterosexual desire. Yet as they leave, an old man "beam[s] on them and bow[s] approval."

> The boy and girl smiled back. The girl rested heavily on Tom. But he did not mind. He walked erect and set his feet firmly on the road. He took a deep breath and was conscious of the naked movement of his body beneath his clothes. Suddenly he felt disengaged from the scene, almost as though he were a spectator and a not unfamiliar couple were passing before him. It was as though he only imagined this happening to him—in actuality it happened to somebody else. The sensation passed. The sun was still warm. The blue ocean stretched endless in the lazy distance. He breathed in the pine-laden air and with almost no effort gave himself up to the day. (347)

The story, stylistically so different from Welty's work, ends with Tom's movement away from heedless rites of spring, away from his (hetero)sexual experiment and desire, with an elaborated, but not specifically named, self-recognition that changes him.

What invites exploration here is that Welty had seen this story in draft in 1947–1948, had submitted it for John, and had typed its final draft for him. From her spot inside John's closet, she read how uneasily Robinson the writer portrayed the heterosexual and the homosexual, whether she was ready to consciously wonder about the portraits or not. Considering that in 1951, Welty would be undeniably surprised when John exited the closet by bringing Enzo Rocchigiani to the States before returning with him to live in Italy, it is clear that Welty hoped for and perhaps to a degree continued to expect another outcome between them. Regardless of what she knew about John's male characters' lack of desire in this story and others I am about to discuss, it seems that she believed she and John had an intimacy. Perhaps she thought it was as important as sexual intimacy because it was so important to her—a

potential literary intimacy fulfilling other pathways of desire. Was she perhaps not as much betrayed by John's embrace of his homosexuality as she was by his failure to grow as a writer? And what was John's desire for their relationship? Did he intermittently convince himself that he wanted intimacy with Eudora? Did he possibly sometimes pretend to because, as John Marcher says to May Bartram, the relationship helped him "to pass for a man like any other," rather than being one with what he thought was a "special" fate? Or was John seduced by being seen as a potential writer by a woman whom he could see *was* one? Given that she destroyed his letters from this period,[20] the answers are obscured by Welty's apparent silence on these topics.

Among the archived drafts of other Robinson stories, which were never published, there are three titled drafts that seem to be naming and exploring what John had otherwise closeted: "Pickups," "House of Mirth," and "The Black Cat," as well as a set of notes related to the latter story. Welty may well have read the drafts of "Pickups"; although there is no date on the manuscript, it seems to be an early one, and Welty and Robinson had the habit of reading each other's drafts in 1946–1952.[21] By contrast, one can assume that Welty did not see the notes Robinson repeatedly made for the story referred to as "The Black Cat." The draft of Robinson's "House of Mirth," however, is unambiguously attached to a responding letter that Welty wrote after reading the story at his request, seemingly in 1947, between her two trips to San Francisco.

"Pickups" concerns a relationship between two single men who talk together about women while responding differently to sexual and social pressures.[22] Cavalier Ed enjoys women whom he can take when ready. Joe feels uncomfortable having to perform with these women. On a walk in the countryside the two consider their different ideal girls: for Ed, an actual woman he once picked up; for Joe, the idea of woman expressed in a poem. The young men pick up two young women. Ed takes one; Joe, left with the other, sees disappointment in her eyes. Nothing happens between them, but Joe prepares for Ed the story of how he "did." Ed offers:

> "Pretty good pickups, eh."
> "Pretty keen," Joe replied eagerly.
> They walked on in silence. Joe noticed for the first time that the sun had already gone down and it was fast becoming dark.

In an another draft of the story, where the characters are Joe and Elliot, Joe overtly wonders, "Should he tell Elliot that he had been repulsed by Luella?" making the issue more plainly one of emerging sexual orientation than of a preference for literary romance.

"House of Mirth" is a thirteen-page, more complex draft filed in the Mississippi Department of Archives and History, as mentioned, with a letter of

response from Welty. Robinson's story is about a man who has felt pressured to marry but has closeted his panic and his wish to speak in objection; Eudora's letter responds to her sense of the character's self-deception. Internal evidence suggests her response was written in the summer of 1947. She mentions work on "the speech," which presumably was her lecture for the Northwest Writers' Conference in August 1947 at the University of Washington, "Some Views on the Reading and Writing of Short Stories," the first "speech" she ever made. Welty would publish shortened versions of this lecture in the *Atlantic* in February 1949 and then in a 1950 limited edition, but she at first wanted to save it for use as an introduction to a story anthology that she hoped to work on with John. Her Sunday letter ends by saying that she will see John soon, around August 10. Her lecture fee of $800 covered the costs of her second visit to see him, but it was during that stay that Robinson inexplicably absented himself, traveling to Laytonville, California, in a silence and evasion prepared for perhaps only by the content of his story.

In Robinson's draft of "House of Mirth," his central character, Mack, has felt pressured to have an affair with and *marry* Susie. Single, he feels "a target . . . an object of interest and derision" in his boardinghouse.

> He felt that he was being pushed and the propulsion came from outside, from the other boarders. It moved in sly remarks from the landlady prodding. . . . It progressed in crude remarks. . . . One morning when both Mack and Susie were late coming down to breakfast one of the male boarders remarked: "Well, guess it won't be long before you two lovebirds won't care whether you get up for breakfast or not." So it went from boardinghouse chaff, picture show dates—even from ennui—to marriage. Mack felt frightened at first. There seemed to be a conspiracy against him. . . . Susie herself seemed at times to be taking sides against him, the side of the boarders. . . . Once stirred up her female-will became a towering force, something quite apart from her shy character. Marriage, marriage, marriage. It became an obsession with her. It was she who talked of it first. . . . Friends of hers turned up on all sides, married couples she took Mack to visit. . . . Their houses, even their lives, were on exhibit, like the model house in a new subdivision thrown open to attract buyers. It . . . terrified Mack . . . the drive of it, the power operating in it, pushing him out of the safe bounds. . . .

> The marriage date was announced. It was worried out of them by the landlady who had to know, on account of renting the rooms. The taunting laughter from the boarders stopped. A new warmth exuded in its place, directed towards the engaged pair. They were the center of a rosy-ring, protected and sustained by the others in a circle of approval.

The reluctant marriage ends when Susie dies delivering a stillborn child. This strand of the story—about Mack pushed and propelled toward an approved marriage—merges with another line of plot in which he sees a funhouse (a "house of mirth") advertised by a fat, cackling Molly, a transfor-

mation of Playland's Laughing Sal. This figure reminds him of a Molly from his childhood—a waitress with an easy sexual habit, who became the town scandal when Mack was a boy of sixteen. Molly had routinely mocked the attention of the boys emboldened by town gossip: "why you little shrimp . . . and then her high ringing laugh." Soon she "was ridden out of town . . . [and] he too went away after that."

Mack considers an obscure meaning of Molly's laugh: "She always made Mack feel better. For him, her laughter was a kind of revenge. He never felt that she was laughing at him. On the contrary he felt that she had taken his side, that she was laughing at the people who laughed at him." Mack seems to identify with Molly, having felt both different and laughed at. One wonders if Molly's laugh seems to him to side against the other boys' conventional sexual narrative. In the story's denouement, a brick hits the funhouse Molly; she is only a machine and comes apart grotesquely. But "[t]he mechanical laughter went on."

Robinson's draft reveals the social pressure that Mack feels to marry, and Welty's first response is provocative and informing. I quote three sections of her letter to convey her view that John has mishandled the portrait of Mack and his marriage and her sense of what is inauthentic in the portrayal:

> Dear John,
> I think your fire was turned a little low in this one—fine as much of it is. I don't think you've realized it in all of its possibilities. . . . The trap is Mack's whole life, and the way you did this in mute and noisy background ways is just lovely I think . . . moving. But then you . . . don't let it come through. . . . The real scape-goat is the wife of course, whom Mack married not to love but to find the object of his blame—he searched for this . . . she is sacrificed . . . ruthlessly. . . . Seen one way, the laughter that seemed so free and wild in the woman then is put down . . . (this is what I think you don't make come out enough) his self-deception is never clear to him. . . . It is he who really throws the stone, stoning even the image of life and sex and laughter and so on—but in the story the action of the stone throwing . . . is left anonymous . . . we never see it thrown and perhaps Mack did not throw it, we are unprepared for it . . . but he should have.[23]

Seeing the wife as Mack's scapegoat and victim rather than his victimizer, Eudora questions John's understanding of Mack: "The wedding, respectability, conformity are really just the things a character like Mack would seek—why in the world would he be bitter except that he . . . knows . . . his real reasons. Does he? He sees it closing down like a trap—his beloved trap—he does not bother even to think of alternatives—ain't no love or courage—would be the same thing—in this story."

Welty elaborates on Mack's abusive choice of marriage as also out of character, defending Mack's potential as she defends John's:

> his marriage is a form of blind cruelty, fixing blame—he *wants* his trap—just so there is a scapegoat and he finds the perfect one in that poor creature as blind as

he is. . . . Mack is sensitive . . . yet his acts are wholly insensitive—never would such a sensitive man go through his life lacking in feeling and lacking in action, I believe, as Mack does here. You have made him aware, yet inert—aware but completely self-justifying, I would say—I'm exaggerating a little to make the point for the edges are not so sharp as this. . . . It is beautiful in many places, you can't help writing with sensitivity and beauty (in my considered if excited estimation, which is not lack of being "hard" on you).

These excerpts are from a five-page letter that, by discussing characters, discusses marriage and what can be wrong in it. This is one of Eudora's few references to marriage in her letters to John. In her revisioning of his story, Welty sees Mack not as Susie's prey but as her assailant. She sees the stoning of Molly as Mack's assault on the female "image of life, sex, and laughter," reflecting his decision to marry in order to belong. And Welty's tender critique ("it is wonderful. . . . Maybe this is really a novel. . . . The brilliance is all in flashes, intuitions, but not sustained—could you be lazy at moments?") is also annoyed—for the woman married primarily so that a man can better belong. Perhaps Eudora is half-consciously or unconsciously giving John the man, as well as Robinson the writer, direction here about life choices not to make.

The image with which Welty thinks Robinson should do more—the figure of the laughing funhouse woman—interestingly also appears in Welty's 1947 manuscript "The Flower and the Rock."[24] This draft version of "Music from Spain" is also the story of a husband (named Dowdie before he became Eugene) who assigns blame in a marriage that has become a trap, and he too comes to contemplate "a mechanical dummy of a woman":

> Larger than life, dressed and with a feather in her hat, [she] stood beckoning on the gallery of the fun house and producing wound up laughter. The motions of her head with its feather in her hat, and of her arms and hips, were raucous and hilarious as the sound that was transmitted out of her insides. So even on deserted nights the laughter was never turned off—like a helpless thing.
> The helpless thing, that sounded like crying with a good start, followed Dowdie down to the sands, where the waves came in.

Welty's wound-up woman's laughter is not joyous, but a "helpless thing"— "that sounded like crying"—a sad symptom of being without relief. Dowdie does not stone the laughing woman, but he has hit his wife. Unlike Mack, he is fairly aware of a self-deception he cannot communicate or express.

Eudora's Response: Breaking the Silence

Welty's "Music from Spain," the San Francisco story that grew from "The Flower and the Rock," seems on second glance to be another site of exposure related to the closet. In what appears to be a further transformation of and an

interactive allusion to Robinson's "House of Mirth," Welty writes of a man—Eugene MacLain—who will not speak and problematically chooses to shelter his feelings, avoiding exposure. The story is allusive, as all the stories of *The Golden Apples* are, invoking the genre of modern quest narratives peopled by half-directed wanderers but particularly evoking—as Rebecca Mark has recognized—both James Joyce's *Ulysses*, in which another Molly is featured, and T. S. Eliot's "Love Song of J. Alfred Prufrock," in which a love song is stillborn and silenced. Like the girl in "A Memory," Eugene has a keen sense of what, by social prescription, cannot be spoken.

At the end of Joyce's *Ulysses*, it is again a Molly, another woman writ large, who cries out "yes, yes" and suggests the possibility of "life, sex, and laughter." But the outcome of Welty's story is debatably much closer to Eliot's "Prufrock." Like Prufrock, Eugene stands on the verge of an assertion of will. Like Prufrock, he imagines the act, the risk that might transform his current sexual paralysis—in Eugene's case a possible by-product of a privately felt, closeted emotion that has put walls between him and his wife, Emma. Eugene can visualize transforming his crippled relationship to his wife, can imagine seeing her not as the "fat thing" he has recently made her out to be. "*She could still bite his finger, couldn't she?*," he thinks (CS 396). The other women whom he, in the course of his day, weaves into imaginative wanderings toward and away from Emma are her doubles, and there are "twins on twins" for both Emma and Eugene in this story. In the pattern I have already delineated, these women are all emblems of exposure, bodies in various states of display. There is the "strange beauty"—a butterfly woman birthmarked in a way that "would be considered disfigured by most people—by himself, ordinarily" (CS 404), whom he nevertheless finds attractive. There is the fat lady of the freak show, also named Emma, whose underpants have been hung out in advertisement and whose glance expresses an accusation: "they done me wrong" (405)—her exposure is outrageous humiliation. Next is the dead woman—hit by a streetcar—who causes Eugene to confront death as he and his wife have, or arguably have not, remaining silent on the subject of their daughter Fan's death, and sheltering themselves from what is going unsaid (410). And there is the waitress whose painted eyelids "looked like flopping black butterflies," recalling the butterfly beauty, but on whose "body the illusion of gold, of silver, and of diamonds were all gone" (424). This waitress attends the Spaniard with favor: "It was *sugar* you wanted," she says. But when she turns to Eugene, she unexpectedly tells him, in words that echo Robinson's Molly's "little shrimp" remarks: "In my country I have a husband. He too is a little man, and sits up as small as you. When he is bad, I peek him up, I stand him on the mantelpiece" (425). This disdainful female dominance breaks gender roles by miniaturizing male rather than female (like the small men in sideshow posters whom I discuss in chapter 4, stared-at figures who challenge strict gen-

FIGURE 2.1. Saartjie/Sara Baartman displayed as the "Hottentot Venus," with white audience members' responses imagined and captioned. Louis F. Charon, *Les Curieux en Extase; ou, Les Cordons de Souliers* (1815), British Museum. © Trustees of the British Museum.

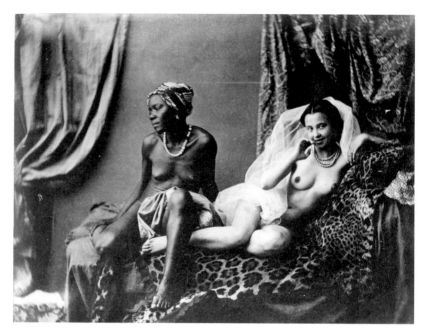

FIGURE 2.2. Félix-Jacques-Antoine Moulin, *L'Odalisque et son esclave* (ca. 1853). Courtesy of Bibliothèque Nationale de France.

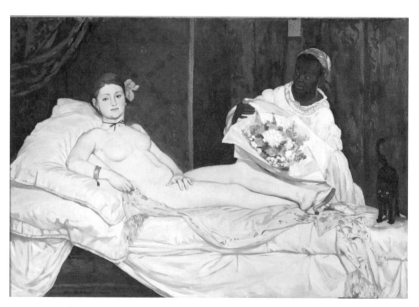

FIGURE 2.3. Édouard Manet, *Olympia* (1862–1863). Photograph by Erich Lessing, Art Resource, New York.

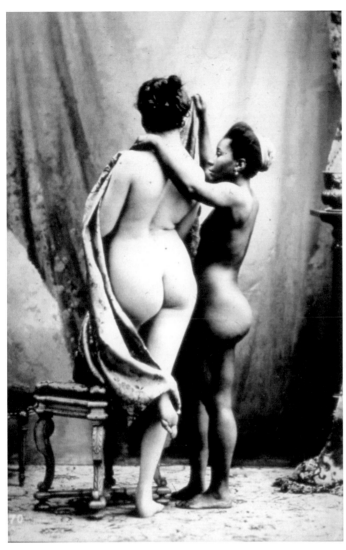

FIGURE 2.4. Unknown artist, *Untitled (Woman with Attendant)* (1890s).

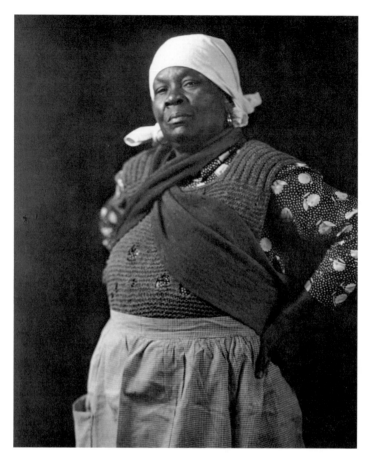

FIGURE 2.5. Prentice Hall Polk, "The Boss" (1932).

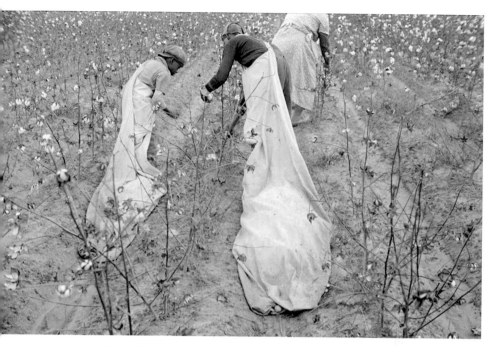

FIGURE 2.6. Ben Shahn, "Cotton Pickers" (1935).
Library of Congress, Prints and Photographs Division,
FSA/OWI Collection LC-DIG-fsa-8a17074.

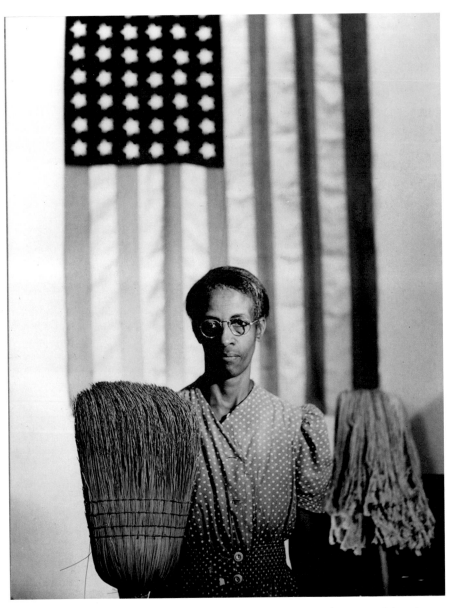

FIGURE 2.7. Gordon Parks, "Washington D.C. Government Charwoman" (1942).
Library of Congress, Prints and Photographs Division, FSA/OWI Collection,
LC-DIG-fsa-8b14845.

FIGURE 2.8. Ben Shahn, "Sharecropper's Family" (1935). Library of Congress, Prints and Photographs Division, FSA/OWI Collection, LC-DIG-fsa-8a16183.

FIGURE 2.9. Dorothea Lange, "Ex-Slave with Long Memory" (1938). Copyright © Dorothea Lange Collection, Oakland Museum of California, City of Oakland. Gift of Paul S. Taylor.

FIGURE 2.10. Jack Delano, "Negro Tenant Farmer, Greene County, Georgia" (also known as "Georgia Woman"; 1941). Library of Congress, Prints and Photographs Division, FSA/OWI Collection, LC-USF34-044697-D.

FIGURE 2.11. Dorothea Lange, "Plantation Owner and Field Hands" (1936). Library of Congress, Prints and Photographs Division, FSA/OWI Collection, LC-USZ62-131226.

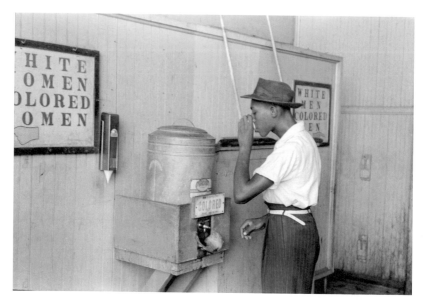

FIGURE 2.12. Russell Lee, "Colored Water Cooler in Street Car Terminal" (1939). Library of Congress, Prints and Photographs Division, FSA/OWI Collection, LC-DIG-fsa-8a26761.

FIGURE 2.13. Eudora Welty, "Chopping Cotton in the Field"
(Warren County, 1935). Copyright © Eudora Welty, LLC.

FIGURE 2.14. Eudora Welty, "Washwoman" (Jackson, 1930s).
Copyright © Eudora Welty, LLC.

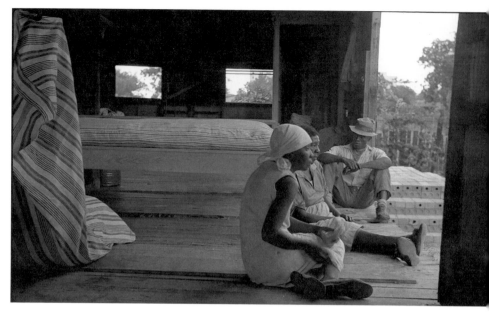

FIGURE 2.15. Eudora Welty, "The Mattress Factory"
(Jackson, 1930s). Copyright © Eudora Welty, LLC.

FIGURE 2.16. Eudora Welty, "A Woman of the 'thirties"
(Hinds County, 1935). Copyright © Eudora Welty, LLC.

FIGURE 2.17. Eudora Welty, "Making a Date" (Grenada, 1935).
Copyright © Eudora Welty, LLC.

FIGURE 2.18. Dorothea Lange, "Feet of a Negro Cotton Hoer"
(near Clarksdale, 1937). Library of Congress,
Prints and Photographs Division,
FSA/OWI Collection, LC-DIG-fsa-8b32076.

FIGURE 2.19. Dorothea Lange, "A Sign of the Times—
Depression—Mended Stockings" (1934).
Copyright © Dorothea Lange Collection,
Oakland Museum of California, City of Oakland.
Gift of Paul S. Taylor.

FIGURE 2.20. Eudora Welty, "Dolls" (Jackson, 1930s).
Copyright © Eudora Welty, LLC.

FIGURE 2.21. Eudora Welty, "Colored Entrance" (Jackson, 1930s).
Copyright © Eudora Welty, LLC.

FIGURE 2.22. Unknown photographer,
"Helena Arden,"
featuring Eudora Welty (1933).
Copyright © Eudora Welty, LLC.

FIGURE 2.23. Eudora Welty, "Hello and Goodbye"
(Jackson, 1930s). Copyright © Eudora Welty, LLC.

FIGURE 2.24. Consuelo Kanaga,
"Frances with a Flower"
(early 1930s). Courtesy of the
Brooklyn Museum.

FIGURE 2.25. Eudora Welty, "Saturday Off"
(Jackson, 1930s). Copyright © Eudora Welty, LLC.

FIGURE 2.26. Eudora Welty, "The Saturday Strollers" (Grenada, 1935).
Copyright © Eudora Welty, LLC.

FIGURE 2.27. Eudora Welty, "Preacher and Leaders of Holiness Church" (Jackson, 1939). Copyright © Eudora Welty, LLC.

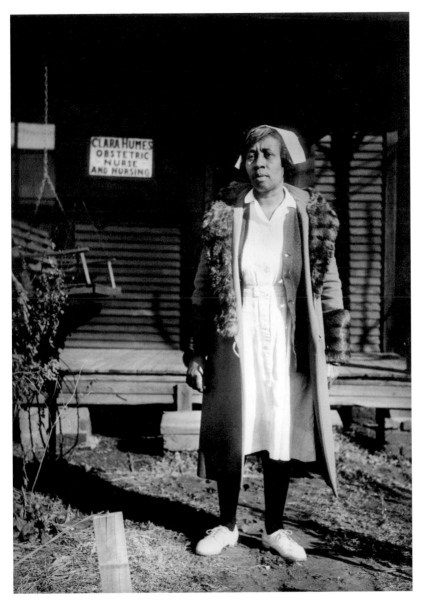

FIGURE 2.28. Eudora Welty, "Nurse at Home" (Jackson, 1930s).
Copyright © Eudora Welty, LLC.

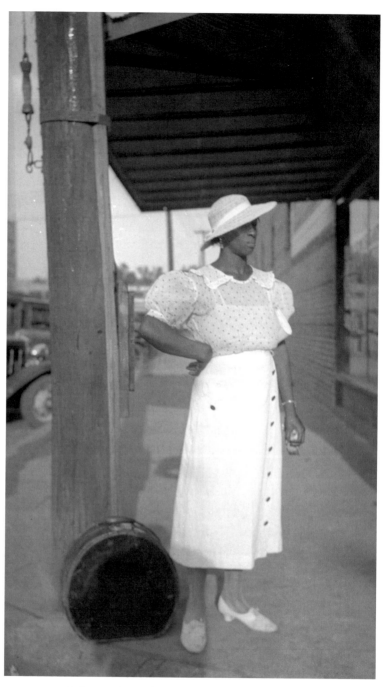

FIGURE 2.29. Eudora Welty, "Schoolteacher on Friday Afternoon" (Jackson, 1930s). Copyright © Eudora Welty, LLC.

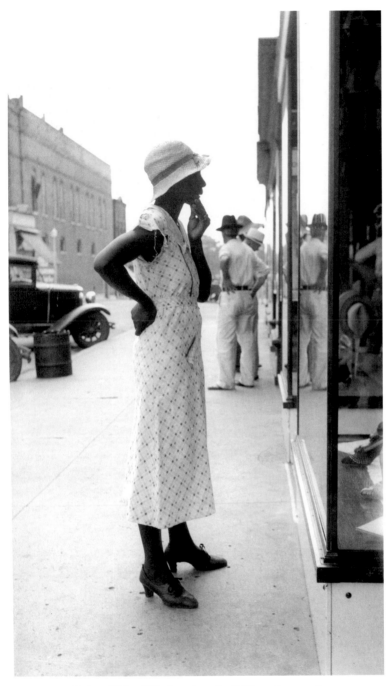

FIGURE 2.30. Eudora Welty, "Window shopping" (Grenada, 1930s).
Copyright © Eudora Welty, LLC.

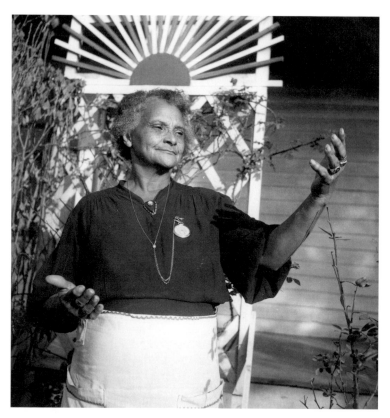

FIGURE 2.31. Eudora Welty, "Born in This Hand" (Jackson, 1940). Copyright © Eudora Welty, LLC.

FIGURE 2.32. Eudora Welty, "Bird Pageant"
(Jackson, 1930s). Copyright © Eudora Welty, LLC.

FIGURE 2.33. Eudora Welty, "Woman with Ice Pick"
(Hinds County, 1930s). Copyright © Eudora Welty, LLC.

FIGURE 2.34. Eudora Welty, "School Children Meeting a Visitor"
(Jackson, 1935). Copyright © Eudora Welty, LLC.

FIGURE 2.35. Eudora Welty, "Tall story" (Utica, 1930s).
Copyright © Eudora Welty, LLC.

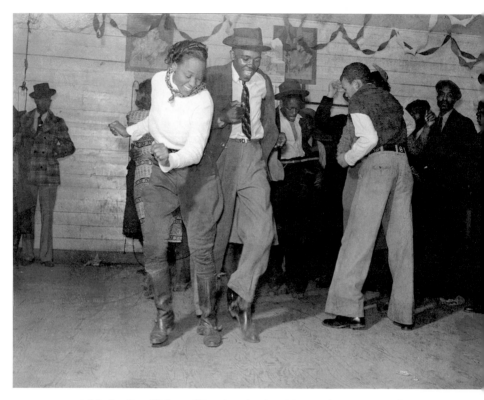

FIGURE 2.36. Marion Post Wolcott, "Jitterbugging in a Negro Juke Joint, Saturday Evening" (Outside Clarksdale, Mississippi, 1935–1945). Library of Congress, Prints and Photographs Divi FSA/OWI Collection LC-DIG-fsa-8c36090.

der categories). All of these other women are avatars of Emma in her complex relationship with Eugene. Even the Spaniard—who picks Eugene up in the air and holds him over the rocks below and who, like the Sibyl on the wall in Miss Eckhart's studio, is both muscular and womanly—is at times himself another of Emma's doubles, on display.

Emma's other woman avatars are feisty, erotic, fascinating, freakish, strange, accusing, dominant, expressive, and exposed. In spite of Emma's complex appeal, Eugene—resembling Prufrock—is finally unable to enact his fantasy of self-exposure to her, to part the curtain between them. (Recall Welty's discussion of her artistic impulse "to part a curtain . . . that falls between people"—the exposure she is trying for in fiction and photography; *One Time, One Place* 12.) Unable to part the curtain or speak his feelings, like Prufrock, Eugene walks fogged streets and senses his own social and sexual failure, composing a love song that never escapes his mind. Throughout the day he hears two hit songs of the 1940s. One suggests Eugene's problem: the unquoted refrain of "Rocks in My Bed" performed by Blind Boy Fuller is "Baby I'm getting awful tired / Of sleeping by myself." And the other suggests the source of his problem: the lyrics are "Open the door, Richard / Open the door and let me in / Open the door, Richard / Richard, why don't you open that door?"[25]

Here is desire sung explicitly and emphatically before a (closet?) door. Eugene's response to the plea embedded in these musical allusions is a disturbing fantasy about walls in his and Emma's room going "soft as curtains and [beginning] to tremble," walls that "threaten to go up" (CS 408). And like some cousin of Melville's Bartleby, who prefers dead-wall reverie to bringing walls down or curtains up (as for a musician on stage?), Eugene is made nervous by this image. Later when he imagines opening the door to his home and climbing the stairs to Emma, he pictures her waiting "like a bride, with the white curtains of the bay window hanging heavy all around her." Eugene imagines Emma expectant but veiled, closeted by drapery. But Eugene does not part that curtain even in fantasy, although he imagines Emma in some future time, "sinking upon him . . . returning him awesome favors in full vigor, with not the ghost of the salt of tears" (423), a moment in which Welty imagines sexual connection.

In and beyond fantasy, Eugene emphatically does not make this love scene happen. Like Eliot's Prufrock, he wanders "streets that follow like a tedious argument / Of insidious intent / To . . . an overwhelming question," but does not speak to break his silence. Aroused but restrained, "as if he listened to sirens" (this includes those anguish-provoking beckonings Odysseus heard while bound to his ship's mast rather than everyday sirens only), Eugene discovers a feeling he has had before—of something round in his mouth. This image is provocative and recurs in Welty's work. In *One Writer's Beginnings,*

she notably writes of her first physical awareness of words: "The word moon came into my mouth as though fed to me out of a silver spoon. Held in my mouth the moon became a word. It had the roundness of a Concord grape" (10). In "At the Landing," in another quotable instance among many, Jenny and Floyd each pick "some berry or leaf to hold in the mouth" (CS 244), which displaces words. I therefore suggest by association that the "something" in Eugene's mouth is an unspoken word, now highly eroticized:

> But its size was the thing that was strange.
> It was as if he were trying to swallow a cherry but found he was only the size of the stem of the cherry. His mouth received and was explored by some immensity. It became more and more immense while he waited. All knowledge of the rest of his body and the feeling in it would leave him. . . . his mouth alone felt and it felt enormity. (422)

Eugene has desire on his tongue but cannot utter it. Passive, he is probed by enormity. He cannot speak because of the immense expanding silence that has "no taste—only size." This representation of arrested speech merging into the imagery of homoerotic fellatio is a segue from the body of the woman to the other man, here the artist.

Eugene has pursued not Emma but rather the Spanish guitarist—who by contrast to Eugene, but like Welty's other women, is a large and living emblem of dramatic self-expression and easy self-exposure. Eugene's relationship to him is partly based in what anthropology calls "contagious magic"—a hope to magically acquire another's traits through contact. Like the reserved daughters of Welty's girl stories, who are fascinated by women drawing attention to themselves, Eugene tries to catch the artist's ease of self-expression. The Spaniard loses his hat to the wind on a cliff by the sea, and Eugene, catching it, loses his own. "Inspiration with him now," he puts on the Spaniard's hat and spirit: "The band inside was warm and fragrant still. Elation ran all through his body" (CS 421–422). But despite this attempt at magical contagion, Eugene is Eugene, and the Spaniard is the expressive artist, huge, foreign, and androgynous, a walking secret, not entirely decipherable, speaking a language not understood, although seen and heard.

In writing about Eugene, Welty is writing about a man who is fascinated by the artist but does not play that role himself. This plot perhaps reflects the emerging truth about John Robinson, who is, in more than one arena, not speaking. Eugene studied music with Miss Eckhart, but his advancement seemingly stopped with "The Stubborn Rocking Horse," a piece he liked and could play well, but its title now suggests a lack of clear movement forward. Unable to articulate his thoughts about Emma even for the Spaniard, who cannot translate and receive his speech, Eugene is powerless to swap identities with the artist. He tries to tell him: "You assaulted your wife. . . . But in

your heart . . ."—and then he stops to think, "it was a lifelong trouble, he had never been able to express himself at all when it came to the moment" (CS 421). By contrast, quite unlike the inarticulate Eugene, whose mouth is swollen with unspoken words, the Spaniard suddenly opens his to loose "a bullish roar." Eugene silently seems to desire to appropriate the roar as a grotesque expression of what is pent up in him. Before the Spaniard bellows, Eugene embraces the other man, "clung to [him] now almost as if he had waited for him a long time with longing, almost as if he loved him, and had found a lasting refuge" (421). Then the Spaniard howls: "What seemed to be utterances of the wildest order came from the wide mouth." The artist stands physically exposed, like the other woman, eyes "open to the widest, and his nostrils had the hairs raised erect in them. . . . What was he digging up to confess to, making such a spectacle?" (421). Yet for all Eugene's attraction, for all his suggestive encounters, MacLain, inarticulate, remains distanced from the artist and risk-taker. His desire remains unspoken.

At the end of the day, Eugene MacLain returns home to Emma. He races up to their flat, opens the door, and finds, "come for supper," her great friend Mrs. Herring, whose punning name (erring) suggests the error of negligence of which Eugene has silently accused Emma: she was visiting with Mrs. Herring while their daughter Fan fell ill. Eugene's own erring in this culminating moment of his strange day is his failure to speak. "Right away he [thinks] he might as well not tell [the women] anything" (CS 426). Hours before he had thought, "if only he could have spoken" (423). Now he is mute. Instead it is Emma who, in the last lines, opens her mouth to pop grapes (an avatar of the collection's elusive golden apples) "onto her extended tongue" (426), grapes that recall Welty's description of the satisfying word that, when she was a child, "came into her mouth . . . [and] had the roundness of a Concord grape" (One Writer's Beginnings 10).

True to his childhood nickname of Scooter MacLain, Eugene runs from what he needs to say to Emma. "Fleet of foot at the very heels of a secret in the day," he has met the Spaniard and wondered at "the way things are flung out at us, like the apples of Atalanta perhaps, once we have begun a certain onrush" (CS 403). His day with the musician from Spain has proved to be a distraction—like the golden apples that distracted Atalanta during her race and became an emblem of conflicted desire (Eugene's, but perhaps John's and possibly Eudora's). Rather than discovering and acting on his longing, Eugene has withdrawn into a passive daydream—a fantasy that, unlike Powerhouse's imaginative invention of Gypsy's death, does not transform his everyday life because Eugene is unable to sustain the transforming potential of his desire. To do so, he would have to bring his private daydream—about walls transforming into curtains that can be parted—to a public stage and risk finding an audience for it, as an artist does. He would have to speak directly to Emma.

This is a fascinating stream of transformations between Robinson's stories of the period and Welty's: from the cliffs, thicket of pine, beach, and jutting promontories of the California oceanside in "All This Juice and All This Joy" to the remarkably similar Lands End beach with cliffs, caves, steep paths, pine, and birds above in "Music from Spain." Similarly, the image of the laughing and stoned mechanical "House of Mirth" Molly of Robinson's story morphs into the image of the beckoning, raucously laughing, and crying mechanical woman in "The Flower and the Rock." Robinson's characters Joe and Mack, who are hesitant to speak, change into Welty's characters Dowdie and Eugene, who are full of closeted emotions but unable to say. These transformations reflect shared lives and, above all, shared manuscripts. I wonder if in these transformations Eudora might be discovering herself as the artist who speaks a foreign language while discerning John as more personally and professionally hesitant to commit to a passion of revelation through words. Is she realizing that her love of the word will not develop with John, whose sexuality is going elsewhere and who has not turned out to be a writer? And is she then herself hesitating to part the curtain?

"Open the Door, Richard": Imagining Exposure in Robinson's "The Black Cat" and Creekmore's *The Welcome*

Eudora in the late 1940s writes of a man who will not speak what needs to be said. Unlike Eugene, however, John Robinson seems to have already begun to express himself and his sexual point of view, perhaps as he is discerning it or confirming it or accepting it in himself. He took notes for a story called "The Black Cat," a narrative sprouting from an excursion on which he took Eudora and their new friends Arthur and Antoinette Foff to visit a 1940s San Francisco Barbary Coast bar that his jottings seem to imply was a gay scene. John introduced Eudora to the Foffs in December 1946, and it seems likely that these notes were a response to bar visits made in 1947 while Eudora was visiting, written after she left John in March.

> "Let's go to one of those places you've been telling us about," they said, as we got up from the table.
> "About time," I said. They had lived in S.F. all of their lives, had written a novel about it, a good novel, this young couple, yet had never seen what was once known from one end of the world to another as the Barbary Coast.
> "Let me get my glasses too" said Jane, the wife. "I don't want to miss anything."
> It was too early when we arrived there and I thought we would be let in for one of those depressing nights when nothing happened, when all the aspiring artists who lived about these only looked in, saw that the place was dead, passed on sadly; when the waterfront characters, seamen off ships, young men with mar-

celled hair, the girls in pants with the careless hair of young boys, looked in one by one, sometime[s] stopping with a distracted look, drinking a beer, staring a moment at the pictures on the walls, barely speaking to the Bartender (who knew them all), leaving suddenly.

In a letter drafted to a friend and saved seemingly as further "notes" with the others for the story, Robinson again recounts the tale of the bar visit:

California is still an oddy place at that. . . . Reminds me of a time I took Art Foff and wife (writers we met when Eudora was here), a young couple, to a bar called the Black Cat. They are so pure and fresh-looking and have never been anywhere. Every sort of thing in San Francisco came to our table that night, which was just right. Two particularly articulate ones were a . . . girl in a wheelchair, bangs, tortoise shell glasses and a man. Their fight was the man was too attentive to her husband, a well-known architect. They used all the four-letter words and then invented some more, left in [an] amiable mood. That was the place where I saw one night a priceless fight. A ripe, plump thing of about 40 came in and sat at the bar, with the strangest hat. It had two long loops of white material, one on each side, bridal-looking, coming way down below her shoulders and going back under her hat.[26] She sat down, took out a long cigarette holder and bought a drink with a $50 bill. Immediately two dikes (where did these females get *that* name) watchful at one end of the bar broke up and moved in on each side of her. Then a tall supercilious young man with a flowing whitish mustache forced one of the dikes out by just elbowing between. They argued and drank (the bride buying all) and then the contestants started calling each other names across her (such names) until the bartender interfered saying no name-calling allowed in here. "But she's proud of it," the man protested. Finally such a drunken state developed that the poor woman's hat came all undone and white streamers were down to her knees on both sides and the other two were tugging over her pocketbook and the bartender jumped across the counter and threw all three out into the street. There the bride was weaving while the man and woman had a fistfight over her, two taxis waiting, finally the man won out. The other woman, clipped hair, blue jeans, returned to the bar and drank mournfully. A . . . woman next to me said, "watch me needle this poor dike," and went over and said "well, you're slipping, five years ago you'd never have let him get away with that, taking that strawberry blonde away from you." She gave a sort of sickly smile, paid for her drink, went out and started up her motorcycle and made an angry takeoff.

The San Francisco scene has clearly caught John Robinson's imagination in these sketches, and throughout he clearly relishes knowing more than his "pure and fresh-looking" friends, elaborating a tension between knowledge and ignorance that belongs to the epistemology of the closet. The openness of this bar culture of "the Cat" (a place Welty mentions too when in "Music from Spain" a large black woman, a trolleycar conductor, calls out, "See you at the Cat") seems entirely different from anything available in Mississippi.

The Mississippi scene to which San Francisco was the contrast was well documented when Hubert Creekmore, John and Eudora's close friend and Walter Welty's brother-in-law, in 1948 publishes *The Welcome*.[27] Suzanne Marrs has pointed to this novel as possibly having as its indirect source the Robinson-Welty relationship, a possibility that implies that Creekmore perhaps knew or guessed at John's secret before Welty did (*One Writer's Imagination* 104). Whatever the case, the novel, a good one that is now on lists of early gay fiction,[28] is a fascinating chronicle of the sexual codes and classed gender prescriptions of a Mississippi town in the 1930s and '40s, where homosexual love is both present and unacknowledged, where single men and women of any type are stigmatized, and where marriage is a prerequisite to "qualifying" as an adult member of the community. Coincidentally or not, the novel opens in "Mr. Herring's" drugstore in the wasteland of "Ashton," Mississippi. It is the story of a love triangle between Don Mason, James (Jim) Furlow, and Isabel Lang. In the early 1930s, as college students, Jim had dated Isabel, but at the end of their customary double dates, Isabel had felt unexpected jealousy at being "the one who was put aside, while you two were the ones who really—said good night to each other" (Creekmore 124). Indeed the important relationship had been between the two young men. Don once portentously acknowledged this, causing Jim to react either with heterosexual choice or with some combination of cowardice and homophobia, and Jim on a rebound subsequently put both Isabel and Don aside by finding and marrying Doris. This sudden marriage has, over the years, proven to be a painful mistake. For his part, Don escaped to New York and remained there for years. Now, however, he has returned in response to the pull of an invalid mother, and he develops an enlarging friendship with the town's other non-conforming and still eccentrically unmarried member of his age group, the mature Isabel Lang.

Isabel Lang is considered "certainly the catch of the town," and yet she is talked about as hopelessly unmarriageable because of "those peculiar habits she's got . . . reading deep books, painting naked figures, wearing pants" (Creekmore 9). It is eye-opening to realize that this description perhaps reflects Creekmore's view of Eudora Welty's situation in Mississippi. Having outlived her parents, Isabel lives alone. Dulcy, the Langs' long-retained servant, warns Isabel that "some of the ladies in town are . . . just plain scared for their boys to go out with you." Don's mother is more forthright still: "If she didn't come of a good family, she simply wouldn't be tolerated for all those outrageous things she does . . . the way she dresses, the things she talks about, those pictures she paints" (173). Isabel is an intellectual woman in a community where women drink tomato juice before dinner while men drink bourbon. As much as by her bourbon drinking and wearing pants "in town," Isabel is put outside by her artistic choices. Doris Furlow catches Isabel look-

ing closely at the life around her, mentally framing it: "the mud-tan wagons, the brown teams, the variegated quilts on the spring seat, the vegetables, the man in his fading blue jeans, the woman in her dark gingham dress, shapeless sweater and sunbonnet" (179). Asking Isabel "What's so fascinating?," Mrs. Furlow's impatience with Isabel's close attention to the scenes around them might suggest the initial local reaction to Welty's photographs of dusty wagons and porches, of men in blue jeans, women in gingham dresses, and children in poverty's tatters: "Really Isabel, I know you're talented—but why can't you paint beautiful things? . . . I don't know how anyone could make those ugly, dirty things beautiful. . . . I see enough things like that around me every day. I certainly wouldn't want a picture of it on my dining-room walls" (179).

Like Isabel's, Don's tastes are also judged odd: "He always talked about things you never heard of" (Creekmore 4).

> Don was always reading magazines and books that would have shocked the citizens of Ashton. There was one called *The New Republic*, and a literary one, *The Dial*, and *Poetry* and other strange and wild publications. Their minds were stimulated by what they read, sometimes angered, but they had an illusion of movement, or purpose, it might have been, and progress away from their cramped surroundings. (26)

There is a rightness to the pairing of Don and Isabel in spite of theirs not being a heterosexual story. Even Jim mocks his two friends' arty tastes and interests, while acknowledging their shared discernments. Teasing them, he asks: "is proletarian better than Gertrude Stein?" (177).

Ashton, by contrast, is comfortable with a routine of "movies twice a week," wives making "formal calls on each other twice a month," and children growing up "to live exactly the same way their parents had lived [and to] gossip about each other . . . on the summer porches" (Creekmore 25). Creekmore's portrait of "the desert of Ashton" (181), a valley of ashes, is most hilariously captured in his satire of the women's Seven Arts Club, which the gifted and successful Isabel cannot attend "because you have to be married to belong" (98). At this women's club, members answer the role call with "beautiful words" rather than names, words such as "Moonlight, Sunset . . . [and] Mother Love," and their group project is to each write a poem on "the same subject, something like 'Desire' or 'Passion' or 'Nature,' so that no one will lack inspiration" (205). Creekmore's view of these women's creativity makes Isabel an exception indeed, and yet she is unappreciated because she has not met Ashton's basic criterion of adult life: marriage.

The character Doris embodies a caricature of the town culture that, to varying degrees, stifles Don as well as Isabel and, most of all, Jim, who does the least to resist it. Doris prizes a grotesque and satiric purity and cherishes

a companion sense of the danger of both the cultural other and sexuality. She cannot imagine why her husband would imagine leaving Ashton for "some strange city, swarming with all kinds of—dirty people, foreigners." When Jim complains that they never sleep together, she righteously proclaims: "But we're above things like that. We're not common trash" (Creekmore 134). And when she discovers that Jim wants a child, she—resembling Welty's Mrs. Fletcher in "Petrified Man"—fears the bodily changes of female sexuality: "Women get fat afterward. They look awful while they're pregnant. I couldn't stand it" (135). Doris does have one erotic scene in the book—with a new car for which she has traded Jim one sexual act and the promise of a child. The car is for her an emblem of her elevated class status and, comically, the stimulant of her pleasure: "She got out and walked around the car, opening the doors, stretching on the back cushions, stroking the radiator cap, the fenders, the upholstery, and then peaceful and spent, she drove back to town" (154).

While the novel mocks the married woman as a gargoyle, it also captures the plight of the unmarried in this community—and this dilemma is not exclusively a female one. Don feels that, "as a young unmarried man, he had no place [in Ashton and] was in fact looked upon as shirking his duties to society. Vague allusions, direct questions, and occasional innuendo from his family and friends made him forcefully aware of the isolation, the social quarantine, which was slowly closing around him" (Creekmore 30). On one occasion Don explains to Jim why he left Ashton and the difficulty of being single there: "unmarried people in small towns are left out of whatever society there is for adults. The single ones are supposed to bother about finding someone to marry so they can qualify for the group. Most of them marry just so that they can qualify" (33).

Then, Jim develops a plan to escape Doris by belatedly choosing Don. Don rejects Jim's too-late interest, and Jim accuses Don: "So you want to 'belong' too," he sneers. Afterward Don tells Isabel: "I'd like to mean something here, but I'm afraid I don't. I never will. The town wouldn't let me. . . . That's why I ought to sink away in a big city. . . . I don't think I fit. I'm sure I don't. . . . It's not what you have to give. . . . it's what people are willing to take. I don't belong here" (Creekmore 215). Don declares his dissimilarity, but asked by Isabel if he would like to belong, he thinks he would.

Don, then, is caught between his closeted knowledge and his desire to belong ("if I stay, I'd have to marry," he tells his mentor and employer, the churlish news editor, Saxon, who has himself remained single at a social cost). Don's genuine relationship with Isabel, in whom he finds a counterpart, further complicates his situation and decision:

> About his whole life with Isabel—the picnics, the long evening conversations, the
> suppers, the movies, the lazy rides in her car—there was a calm but buoyant air

of pleasure and inevitability. He was conscious of no straining away, no boredom and no desire beyond the present. Sometimes when they sat alone in the night or walked across the field and woods, now turning brilliant with ruddy autumn colors, and talked about new poetry and new novels and new ideas, with jokes suddenly materializing to shatter their seriousness or one of them gently spoofing the other, he felt a strange sense of identification that his earlier days with Jim were a mirror of these—a reflection, long past, of the actuality of a future which was now. (Creekmore 172)

Isabel's dilemma is slightly different from Don's. She has, on her own, found a way to be alone in Ashton. Now though, enjoying her relationship with Don, whom the town expects her to marry, she finds she "does not want to be left again with her solitary interests, lonely in her house, alone in her body and spirit" (Creekmore 223). She has imagined suffering the fate of two of the town's young "old maids," Anita Leffingwell and Alice Barnette, both of whom have been told by Doris in admonition that unmarried women "turn into something called career girls" (8), like Isabel Lang, "who doesn't bother with what people say about her" (9). These two lonely young women invite Isabel to join them for three-handed bridge or rummy, and Isabel quickly rebuffs their invitation with the assertion that "Don comes up to the house a lot" before she regrets her obviously self-congratulatory insensitivity (183). When even Don asks her why she is unmarried, she assures him: "I did all the proper things. . . . I made the most of my looks, I was never serious with a man" (124). "Friends think I'm . . . eccentric because I haven't conformed to their standards" (125). But Don wonders, with appreciation for fortuitous happenstance, "how many of her present qualities might never have developed if [she] had married" young, given the routines, codes, and social prescriptions of Ashton (128).

So the center of the novel is Don's conflict between his unrevealed secret and his desire for contentment in the community of Ashton. He harbors a sense of himself as a gay man, which he is loath to share—although when Isabel asks him: "Why didn't you bring a wife back from the East?," he replies, "Do you think I could make a woman happy?" (Creekmore 124). Don's moment of personal acknowledgment comes spontaneously, perhaps accidentally, in a conversation with his friend Tray. Tray is an old schoolmate who has moved into a close relationship with the principal characters, although he is outside their society, having grown up on the North End, where people "worked in the railroad shop." By class Tray comes from that probationarily white world that "never quite got in with the merchant and professional families who made up what was considered society. [His group] felt little love for the ladies with their formal calls and clubs and seated teas. The children mixed in school and church. But [usually] that was the end of it" (54). Now he finds something approaching social inclusion, perhaps by virtue of his own disregard of class

and his emotional loyalty to those he admired in school. Thinking only of enlisting a supporter to see Jim through the deadlock of his stifling marriage, Tray innocently asks Don, "You still like Jim, don't you?" Don's unexpectedly exasperated remark—"do you want me to tell you everything?"—abruptly outs him to Tray:

> Through the dark, Tray could watch the frightened surprise wavering over his face until it settled into a mask of guilt. There was a long silence. . . . So that was the story. . . . In the first surprise of realization, Tray was a little dumbfounded, a little inclined to assume such things didn't happen here in Ashton, to friends. Don had been going around with Isabel; people expected them to marry soon. Did Isabel understand what she was involved in? Then, after a moment's reflection, he saw that his only surprise was one of acknowledgment. He had really known all the time, but didn't want to admit it. . . . People were too silly about their feelings. After all, they'd glorify their affection for dogs and the dog's devotion to them, but any such emotion between two men they would degrade in every way. (199)

It is Tray who tells Isabel. She has despaired over Don's failure to move any closer to her, his disinterest in her sexual overtures, and her increasing sense that he is not considering marriage. She goes to Tray for help in buying a car, thinking that she will leave Ashton herself. Tray tells her obliquely, but directly enough. She replies with confusion and judgment: "'That's—dreadful' she said in bewilderment." And Tray advises her acceptance:

> "No, Isabel don't look at it that way. . . . There's ways of loving—degrees—but I guess at bottom it's all the same thing. . . . Help Don," said Tray. "He may never marry unless—unless you—" (Creekmore 223)

What is the relationship between this novel and the Welty-Robinson relationship? The novel explores a cultural situation that parallels theirs in time and place. The portrait of the couple's relationship when they "talked about new poetry and new novels and new ideas, with jokes suddenly materializing to shatter their seriousness or one of them gently spoofing the other" seems to capture the lighthearted qualities of the Robinson-Welty relationship, which was full of art, parody, and play.[29] Do I mean to say the novel is biographically accurate? No. But it is suggestive in the context and informing about the culture that surrounded Eudora and John as they worked out their futures.[30]

Interestingly, Creekmore's novel ends not with Isabel's acceptance of Don's sexual difference but with her decision to win him over. Not without trepidation and imagining "that an inextinguishable dislike of her was welling up in him," while "wanting him to be her lover" and growing "more depressed" (283), Isabel tells Don she knows "about you and Jim." Breaking the silence within the closet, though not exiting it, Don asks:

"Did you ever think we—might marry each other. . . . We could be happy together. . . .

"We have been. It could go on. . . . I love you Don; and my love hasn't been hurt by knowing you loved Jim."

"But, maybe, someday. . . . You couldn't ever be sure. I couldn't promise anything. . . ."

"I won't be jealous of what I don't know. . . . I think, now, I should be your wife. I know this is terrible, saying such things. I shouldn't try to convince you. . . . I can't be surprised; and that can't ever come between us. I was questioning me—my own honesty, I suppose. It will be very difficult for us both. But I want to try. I want you to marry me." (287–288)

But the novel does not end with Don and Isabel's unorthodox imagined compromise, but with Jim, who becomes increasingly agitated at their wedding until, hitting bottom, he calls Don "the damned little fairy." When Jim cries over his sense of loss, Tray comforts him, articulating the novel's longed-for desire: "If only people could forgive each other for loving" (307). Tray's wistful remark, and perhaps even Don and Isabel's compromise, seems to be Creekmore dramatically presenting a version of Michel Foucault's argument in "Friendship as a Way of Life," an interview follow-up to his *History of Sexuality*. Foucault counsels that homosexuality (and sexuality) might not be about secrets but about relationships. Thinking about sexuality in the closet, he finds preoccupation with the secret of desire to be a regrettable misstep: "Perhaps it would be better to ask oneself, 'What relations, through homosexuality, can be established, invented, multiplied, and modulated?' The problem is not to discover in oneself the truth of one's sex, but, rather, to use one's sexuality henceforth to arrive at a multiplicity of relationships. . . . The development toward which the problem of homosexuality tends is the one of friendship" ("Friendship" 135–136).

What happens in the lived relationship, for Welty at least, is without the sense of resolution Creekmore offers Don and Isabel. It may be, when in early 1948 she writes to Katherine Anne Porter of feeling "troubled a little in my life,"[31] that she is still hoping for a life partnership—until John's choice of another becomes visible. Marrs writes of what happened in 1951, "when . . . at age forty-one, John had left Italy for Mexico, a twenty-year-old man named Enzo Rocchigiani was with him. Eudora seems to have assumed that John was merely trying in his good-natured way to be of assistance to a young friend. . . . Then in New York, after John had settled into a clerical job for the New York Times, Eudora saw the two men together. In late July, when she entertained Dolly [Wells], John and Enzo with a cold supper, Eudora sensed that the two men were a couple" (*EWAB* 202).

Her letters to the poet William Jay Smith and his wife, beginning after she

and John meet Bill and Barbara Smith in Florence in 1950 and continuing for decades, sound notes of Eudora's thoughts of John (William Jay Smith Papers). These letters, held at Washington University, are mostly dated by day and time but not year; however internal evidence suggests that the following three letters were all written by Eudora in 1950–1951. She writes to her new friends the Smiths after her departure from John and from Florence, "It was sweet of you to think of having John up—I feel myself that nice as it would be, going anywhere would only postpone the day when John must decide something—Don't you? I wish things would work out for him—that he would work them out—for they aren't good now." In another she writes: "John is still at the villa, has probably written you. I don't know what he'll do next. He sometimes says he'd like all of us to meet somewhere. He's written two stories lately and one I liked very much, the other not sure about—but it is gay."[32] And last: "John looks well—He still has Enzo, & is so far working two days a week at the N.Y. Times in a clerical job of some kind. I wish he could get in to some more congenial and more lucrative place in New York if he wants it."[33]

The period 1950–1951 was clearly a time of Eudora's wondering over John, seemingly as much wondering over his movement away from writing as wondering over his sexual orientation.[34] In this period, John dedicates his sketch "The Inspector," published in *Harper's* in June 1950, to Eudora. And in 1951 Eudora makes a trip from New Orleans to Venice, Louisiana, with a young professor, the soon-to-be Faulkner scholar and editor Carvel Collins, the sojourn from which grew "No Place for You, My Love" (Marrs, *EWAB* 204–206)—in which a woman's recent troubled history is unspoken but present and felt as she has a close encounter with someone new. Later letters to Smith and to others track Eudora's and John's visits together over the years as well as their continuing willingness and sometimes eagerness to see one another.

Exiting the Closet: *The Bride of the Innisfallen*

This brings me back to the impact of sharing John's closet both on Welty's fiction and on the pattern of the other woman. It is difficult now to read *The Bride of the Innisfallen and Other Stories* without a strong sense of its autobiographical roots. Welty is clearly working through a certain level of trauma in these seven stories, which repeatedly concern a woman changed by and surviving a relationship. The central women in "No Place for You, My Love," "The Burning," "The Bride of the Innisfallen," "Ladies in Spring," "Circe," "Kin," and "Going to Naples" all experience various degrees of hopefulness, pleasure, disappointment, betrayal, abuse, and the need for recovery as a result of a relationship. Dawn Trouard has observed that the collection's "female characters . . . who are entering pubs and rivers alone, who turn men

into swine and return to Toledo without regret" show Welty "out to discover the vitality of women who are unsponsored and free," creating "liberatory alternatives" rather than tragic endings to traditional heterosexual plots ("Welty's Anti-Ode to Nightingales" 669).

I note that the pattern of Welty's girl stories, which I have discussed as emphasizing a tension between conventional expectations and the risk of self-exposure, shift in these women's stories toward issues of privacy and guardedness, toward uncovering something hidden and toward the adventure of exposure. Most to the point, the idea of an unrevealed secret exposed recurs in all but the last of the stories. In "No Place for You, My Love" a secret is divulged by the bruise on the woman's temple; in "The Burning" it is disclosed in Jonah's bellow; in "The Bride of the Innisfallen," it is released by a wife protecting the possibility of "pure joy" against "love with the joy being drawn out of it" (CS 517). In "Ladies in Spring," a man's surreptitious affair with an unexpected younger lover, one seemingly suspected by his wife, is unveiled. In "Circe," a woman's astonishing power is made known along with its limits and disappointments. In "Kin," the riddle revealed is the lost meaning of Felix's remembered longing, expressed in his scribble "River—Daisy—Midnight—Please" (561).

Of them all, the story that most clearly conforms to the pattern of the body of the other woman is "The Bride of the Innisfallen" in which an American girl observes the bride on display. Just as in other Welty stories, the bride is a double and a foil, and voices call for the American girl to "[l]ook at her, look." Then "a girl who had not yet showed herself in public . . . appeared by the rail in a white spring hat and over her hands, a little old fashioned white bunny muff. . . . Delight gathered all around, singing began on board, bells could by now be heard ringing urgently in the town. . . . The bride smiled but did not look up; she was looking down at her dazzling little fur muff" (CS 516). The bride is caught between the "delight" of others, whose romantic expectations are fulfilled by her appearance, and an inwardness. Her gaze focuses on a fur muff—hers and dazzling. Emerging from the now-familiar scene of a central female character contemplating another woman out in the open and on display, the American girl moves through customs feeling "exposed—as if, in spite of herself, when she didn't know it, something had been told on her. 'A rabbit ran over my grave,' she thought"—an image that recalls not only the muff but Katherine Anne Porter's story "The Grave" and its focus on the discovery of secrets of the female body and womanhood, which are exposed by the skinning of a rabbit pregnant with young (CS 516). Feeling a secret released, the central character in "The Bride of the Innisfallen" moves into a landscape of discovery and sees with joy that "in all Cork today every willow stood with gold red hair springing and falling about it, like Venus alive. Rhododendrons swam in light, leaves and flowers alike: only

a shadow could separate them into colors. She had felt no lonelier than that little bride herself, who had come off the boat. Yes, somewhere in the crowd at the dock there must have been a young man holding flowers; he had been taken for granted" (517).

This moment might seem to evoke the standard heterosexual plot that I claim Welty does not write. But the sublime reverie sparked by the bride's display calls up something else. In response, the American girl exposes her secret of what she is recovering from: "Love with the joy being drawn out . . . *I* was nearly destroyed, she thought. . . . You must never betray pure joy—the kind you were born and began with—either by hiding it or by parading it in front of people's eyes; they didn't want to be shown it. And still you must tell it" (CS 517). This memory of a damaging love and the desire to tell of the joy of recovery is the story's revealed secret, and a personal one.

The final story of the collection, "Going to Naples," does not unravel a relationship secret as the volume's other stories do. Instead, and so movingly in the context of the author's lived experience, it discloses the pleasure of a woman dancing alone. Traveling to meet a grandmother who still resides in Naples, Italy, Gabriella is another daughter in another girl story, attended now by an Italian American variation on the instructing mother, who this time is more eager to place her daughter in marriage than to shelter her. Mama farcically chides Gabriella, "If you don't pay attention, you'll be like Zingara some day—old maid! You see her neck?" (CS 590). And although Mrs. Serto takes clear comfort in her daughter's ability to attract the pursuit of one of the few available young men on board, Aldo Scampo, she nevertheless feels it necessary to reiterate that her other five daughters, "like me, married by eighteen." Gabriella, too fat to conform to the female miniature, too large to be completely comfortable with her body, with a propensity to express her pleasures, protests, and ready responsiveness to life all with the same indiscriminate scream, is both a daughter following the conventional expectations for young womanhood and a droll variation on Welty's familiar overexposed culturally other woman (recall the lump of flesh that pops like a pear through a hole in her stocking). Yet in the fiction's startling moment, the one without which there would be no story, Gabriella escapes expectation, restraint, inhibition, and the need for permission to take pleasure in her own exposed and astonishing grace and joy. On gala night, when her comic suitor, Scampo, is too seasick to attend at all,

[t]hat great, unrewarding, indestructible daughter of Mrs. Serto, round as an onion, and tonight deserted, unadvised, unprompted, and unrestrained in her blue, went dancing around this unlikely floor as lightly as an angel.

Whenever she turned, she whirled, and her ruffles followed—and the music too had to catch up. It began to seem to the general eye that she might be turning

around faster inside than out. For an unmarried girl, it was danger. Some radiant pin through the body had set her spinning like that tonight, and given her the power—not the same thing as permission, but what was like a memory of how to do it—to be happy all by herself. (CS 586–587)

The spectacle of an "ungrasped, spinning girl" displaying joy, grace, and happiness (587) is then, in a different sense than applies to the other stories, the collection's final revealed secret.

In 1936 John Rood, the editor of *Manuscript*, wrote to Eudora Welty to tell her he would publish "Death of a Traveling Salesman," and he asked the young writer for information about herself. In his next letter, in response to what Welty has told him, he writes: "Your letter was very interesting—what do you mean that you never did anything like being put in jail! After all, everybody doesn't have a one man show of Negro photographs."[35] Eudora has written to Rood with a wry expression of regret for not being more unconventional, and Rood replies that he finds her interesting and quite uncommon enough. In her lost letter of response to Rood, as elsewhere, Welty played at and sometimes even passed for being conventional, even a "southern lady," maybe as Hubert Creekmore's Don passed in Ashton for the sake of the privacy that passing afforded. In Welty's case, there may be in her performance the pleasure of impersonating and satirizing the part she plays: a tongue-in-cheek game. Rood reacts to Welty's self-mocking self-presentation with the fact of her "one man show of Negro photographs," proof of her unconventional identity.

The connection between Rood's reply and the history I have wondered about in these pages strikes me as this. Did Eudora's attraction to John possibly unconsciously center in his difference, in his "queer" aesthetic? Did she feel, around him, like someone who did things as surprising as being "put in jail"? Was he a collaborator in her liberation from being a proper lady? Did she love him not entirely despite the fact that he was gay, but perhaps unconsciously and unknowingly because they shared a sense of difference even more than a devotion to the aesthetic word? Eudora's relationship with John—even as she was seemingly disappointed by it—was not at all the customary desire for a "wartime man," whom every unmarried girl had to have, as Ann Waldron suggests in her biography (172). Perhaps she had a complicated and erotic desire for a life of shared writing—or a life of partnered difference—a desire for an intimacy that had its basis in unconventional ideas and arrangements between a man and woman in her time and place: 1940s Mississippi.

Controversies in Welty Criticism: Figuring the Body

Was Welty a Feminist?

Wild-Haired Maternity, the Freak Body, and Comedy

I have shown that Welty's most autobiographical stories pair a central character with an other-class woman—attractive or grotesque—a double who embodies and exposes a conflict in the central character. But another group of Welty stories focuses directly on the bodies of other women in ways that introduce controversial subjects that have kindled disagreements in critical response—animated arguments about her handling of the satire of women, her treatments of the topic of rape, and her portrayal of race.[1] In this chapter, the first of three concerning these three polemics in Welty studies, I read one signature story in order to address a few contentious questions not settled by critical debate concerning Welty's comedies about women—that is, do her comic stories unsympathetically satirize women, or are they "feminist"? What does it mean that a woman writer who spoke of the "hilarious" and "lunatic feminist fringe" is so often interpreted through feminist critical approaches? (Walker 136). Can Welty's work be put into conversation with later women writers more easily acknowledged as "radical," such as Sylvia Plath? Are the issues raised by her comic portrayals of women ones that a next generation of women writers would also interrogate?

"Petrified Man" as a Case Study

"Petrified Man" (first written 1937; rewritten and published 1939) approaches the subject of the feminine with comedy and satire. Not long ago in a course on American women writers, my students' comparison of "Petrified Man" and Sylvia Plath's *The Bell Jar* clarified for me three similarities in their satire of the feminine. First, the fictions similarly attend to deluded ideas—sold through cultural venues such as the salon, magazine culture, and advertising—about the body as the source of female power. Next, the characters in both

works see pregnancy as a kind of disempowerment (think of Leota inadequately consoling Mrs. Fletcher in the midst of her "fallin' hair": "You just get you one of those Stork-a-Lure dresses and stop worryin'"; CS 19), a reflection of changing notions about pregnancy and abortion in twentieth-century modernity. Lastly, and above all, both critique a culture that problematically conceives of sexuality as dominance over the other gender, a misimpression visible in their storylines' attention to the aspiration to female power through beauty, and the practice of rape.

With these observations in mind, I discuss Welty's feminism generally and the story "Petrified Man" in particular in four sections, each an alternative approach to the topic. I first contemplate and unfold the story's themes in the context of body studies. Then I assemble an illustrated cultural studies companion to the text's issues, reading pertinent advertisements taken from the magazine culture that both "Petrified Man" and *The Bell Jar* satirize. Next, keeping in mind the story's juxtaposition of the monstrous feminine with the fascinating freak body and thinking across the recurrence of sideshow curiosities in literature of the period generally, in southern literature in particular, and in Carson McCullers's work most specifically, I consider the hybridity of sideshow bodies, which challenge southern apartheid culture's strict gender divisions, in order to explicate both the fiction and Welty's photograph series "State Fair, 1939." Lastly, I follow the thread of comic gender antagonism from Leota's salon to several other Welty stories ("The Wide Net," "A Piece of News," and "Circe") in order to trace her treatment of vulnerable female power in preparation for chapter 5 on her controversial uses of the rape plot.

Pickled Fetuses and Petrified Men: Power, Sexuality, and the Female Body

While reading Sylvia Plath's unabridged journals as a brushup for teaching my American women writers course one year, Plath's plan to "[r]ead Eudora Welty aloud" caught my attention: "That is a way to feel on my tongue what I admire." Plath describes reading "A Worn Path," "Livvie," and "The Whistle" in her September 25 and 26, 1959 entries (507, 508). Mulling over her attraction to and admiration of Welty's fiction and considering Welty's place in Plath's self-education, I found myself suddenly startled to think back from the dead babies of *The Bell Jar* ("big glass bottles full of babies" with their large white heads curled over bodies the size of frogs) and Esther Greenwood's struggle with the notion of the mother-woman, to Eudora Welty's pickled fetuses—the twins in a bottle—and Mrs. Fletcher's revealed discomfort with her pregnancy in "Petrified Man," a story that Plath would have

encountered in her apparent scrutiny of *Selected Stories by Eudora Welty*, a 1954 Modern Library publication. In a passage that provocatively prefigures Plath's "glass bottles full of babies," Leota describes the dead babies she saw at a freak show:

> "Aw. Well, honey, talkin' about bein' pregnant an' all, you ought to see those twins in a bottle, you really owe it to yourself."
> "What twins?" asked Mrs. Fletcher out of the side of her mouth.
> "Well, honey, they got these two twins in a bottle, see? Born joined plumb to-gether. . . . They was about this long—pardon—must of been full time, all right, wouldn't you say?—an' they had these two heads an' two faces an' four arms an' four legs, all kind of joined here. See, this face looked this-a-way, and the other face looked that-a-way, over their shoulder, see."
> "Glah!" said Mrs. Fletcher disapprovingly. (CS 20–21)

Teaching Welty just before Plath in my course that semester, I was struck, as I usually am when I reread "Petrified Man," with my admiration for the story, for how good Welty is in her comic, and not-so-comic, uproariously revealing portrait of women's issues—long before Betty Friedan's 1963 *Feminine Mystique*. More than three decades after drafting the story, Welty in her 1973 interview with Alice Walker is less than perfectly sympathetic in her discussion of the "hilarious" "lunatic fringe" of the feminist movement (136). But in 1937 Welty had herself been hilarious and lunatic about a culture problematically defining sexual power as power over the other sex.[2]

Leota's salon—a perfumed, lavender, powder-coated "den of curling fluid and henna packs," where cigarette ashes are "flicked into the basket of dirty towels" (CS 17)—is a place where she and her client Mrs. Fletcher discuss sexuality (without admitting any felt vulnerability) while constructing beauty to help petrify and control their men. The women talk—all in the same breath—about their husbands, pygmies, and a petrified man whom Leota has seen at "the travelin' freakshow."

> They've got these pygmies down there, too, an' Mrs. Pike was just wild about 'em. You know, the teeniniest men in the universe? Well, honey, they can just rest back on their little bohunkus an' roll around an' you can't hardly tell if they're sitting or standin'. That'll give you some idea. They're about forty-two years old. Just suppose it was your husband!
> [And] they got this man, this petrified man. . . . [H]is food . . . goes out to his joints and before you can say "Jack Robinson," it's stone—pure stone. How'd you like to be married to a guy like that? All he can do, he can move his head just a quarter of an inch. (CS 21–22)

In these lines, Welty has the woman repeat the question of having a husband "like that"—small and paralyzed—while readers realize that Leota and

Mrs. Fletcher indeed say they are married to little men ("I tell Fred he's still a shrimp, account of I'm so tall"), whose movements they—when optimistic about their own asserted control over their men—seem to believe they can petrify and dominate: "Mr. Fletcher can't do a thing with me. . . . If he so much as raises his voice against me, he knows good and well I'll have one of my sick headaches, and then I'm just not fit to live with" (CS 19). The sideshow label of the "Petrified Man" shows off one of Welty's favorite comic techniques, in which she literalizes metaphoric language. Here the sideshow attraction is just one more petrified man.

At the same time, and without quite realizing it, the women implicitly acknowledge their awareness that they are overstating their power advantage. Their Medusa charms are the promised product of female bodies that, in spite of their striving, are out of their control, and so women come to Leota's shop to discipline their forms as best they can.[3] These women would nod in agreement with Sandra Bartky's discussion of the discipline made obvious in women's magazines and beauty salons (although Welty's women might resist the Foucauldian critique implicit in Bartky's droll chronicle of the effort and expertise required to manage "natural" female bodies). Describing the expertise that discipline calls for, she writes:

> Skin care discipline requires special knowledge: a woman must know what to do if she has been skiing, taking medication, doing vigorous exercise, boating, or swimming in chlorinated pools; if she has been exposed to pollution, heated rooms, cold, sun, harsh weather, the pressurized cabins on airplanes, saunas or steam rooms, fatigue or stress. . . . [Moreover, a] woman must learn the proper manipulation of a large number of devices—the blow dryer, styling brush, curling iron. Hot curlers, wire curlers, eye-liner, lipliner, lipstick brush, eyelash curler, mascara brush—and the correct manner of application of a wide variety of products. (Bartky 138)

But all this wryly comic female effort is to limited effect. In spite of Welty's women's versions of their relationships with the husbands they call shrimp, compare to pygmies, and claim to dominate, direct, and rule, their charms might stiffen but certainly do not ossify their men, who are not at all petrified. This fact is underlined when the sideshow's so-called Petrified Man is recognized in his shadow identity as a repeat rapist. The disturbingly limber Mr. Petrie apparently thoroughly agrees with the general cultural assumption that sexual power is power over the other sex. That perverse notion of sexuality pervades not only the women's ranging topics of conversation, their beauty shop behaviors, and their problematic conventional wisdom, but also the uncovered fact of rape—and therefore is a key to the cohesion of the story's disparate parts.

Unpacking Feminist Satire of the Feminine

Several of my students during that semester when I was reading Plath's journals came to class puzzled by "Petrified Man" and uneasy about a woman writer's (possibly unsympathetic) satire of women. They described finding the women characters discomfortingly hard: too vain to be pregnant and seemingly indifferent to the idea of rape as they quickly shifted concern from the unrecognized rapist in their lives to the matter of the $500 reward advertised in *Startling G-Man Tales*. As Lauren Berlant has pointed out, it is the culture determining the women that is hard (the article-less title, "Petrified Man," seemingly describes, more than the eponymous sideshow attraction, the general state of mankind). The women reflect the disturbing sexual culture that shapes them. Some of my class's readers felt that Welty's satire undercut the women, revealing them as working to produce a persona and body meant to be a strategic advantage in an erotic contest, but gaining—as Bartky describes women's predicament—only "some admiration, but little real respect and barely any social power." Welty's story illustrates Bartky's case: following the guidelines offered by mainstream culture leaves women in a position to be "[i]n spite of unrelenting pressure to 'make the most of what they have,' . . . ridiculed and dismissed for the triviality of their interest in such 'trivial' things as clothes and make-up." Paradoxically, success in using the body as the means to social power "does little to raise [a woman's] status" (Bartky 73).

My students' growing concern for Welty's characters gradually led to seeing the story's women as not frostily indifferent so much as uncomfortably nonplussed when they discover that Mr. Petrie has raped four women at least. The characters' banter about female power is suddenly brought up short to face female vulnerability, and Mrs. Fletcher attempts to reassure herself in an act of denial. She huffily hopes that certainly she would "a' felt something" (*CS* 28). She would have known the rapist as one if, like Mrs. Pike, she had taken breakfast to the man staying next door; she reassuringly asserts that she positively could spot a rapist in an ostensibly petrified man. The women's confidence in their power and control is, of course, deeply and dangerously illusory. Throughout the story, Welty uses laughter to expose the contest in sexual relationships encoded and articulated in the beauty shop behaviors, in the magazines the women read there, on the street where Mr. Petrie dominates, and above all in the spousal relationships that the women speak overconfidently of directing: "Women have to stand up for themselves, or there's just no telling. But now you take me—I ask Mr. Fletcher's advice now and then, and he appreciates it, especially on something important, like is it time for a permanent—not that I've told him about the baby. He says, 'Why, dear,

go ahead!' Just ask their *advice*" (25). Interestingly the tender topic she avoids opening with her husband but risks with Leota is how she feels about pregnancy and the threat it poses to her sense of control.

In all these repeated manifestations, Welty exposes sexuality culturally defined as a contest for command over the other sex. This is the same culture that bell hooks analyzes in the chapter "Selling Hot Pussy" in her *Black Looks: Race and Representation*. In this culture the female body is cast as "a potential weapon" in "an erotic war," and eroticism is perceived "solely as a way to assert power" and ruthless, rather than pleasure-based (unless the pleasure involved is pleasure in power). She is concerned for the turnabout implied as women respond to their experience of powerlessness in a patriarchy by "using sexual power to do violence to the male Other," which she reveals as a position from which women deludedly assert agency despite evidence to the contrary (hooks 68–69).

The Monstrous Feminine: Pregnancy in Twentieth-Century Modernity

It is this definition of sexual influence that causes Welty's women to be particularly anxious about their actual sexual bodies, which change in shape from the fixed form of power in "beauty," the asset upon which the women seemingly base their hopes for a game advantage. Leota's salon is dedicated, on the path to "beauty," to what Jane Ussher points out in her title: *Managing the Monstrous Feminine: Regulating the Reproductive Body*. Ussher writes about the cultural tensions between the divine feminine and the monstrous feminine. She comments on the airbrushed female body of art and religion—and, I add, of advertising, magazines, and salon beauty—which represents the powerful "divine feminine": "all abhorrent reminders of her fecund corporeality removed—secretions, pubic hair, genitals, and disfiguring veins or blemishes all left out of the frame." She notes that the airbrushed image "requires frequent revisiting . . . to keep anxiety about the unruly fecund body at bay" (3). Ussher describes the resulting female self-discipline of the body by quoting Foucault in *Power/Knowledge*: "There is no need for arms, physical violence, material constraints. Just a gaze. An inspecting gaze, a gaze which each individual under its weight will end by interiorising to the point that [she] is [her] own overseer, each individual thus exercising this surveillance over, and against [herself]" (4). This is, after all, the serious mission that the comic salon is dedicated to: controlling the female body to create chastened female power. But as Bartky states, "the disciplinary project of femininity is a 'set up': it requires such radical and extensive measure[s] of bodily transformation that virtually every woman who gives herself to it is destined in some degree to fail. Thus, a measure of shame is added to a woman's sense that

the body she inhabits is deficient: she ought to take better care of herself; she might after all have jogged that last mile" (139). And even if she succeeds in producing the right kind of "practiced" body, it is the production of "a subjected body . . . on which inferior status has been inscribed" (139).

By the paradoxical logic of this culture, the pregnant body—the actual and definitive sexual body—promises to undo, rather than fulfill, female sexuality. Mrs. Fletcher humorously equates maternity with dandruff, a blemishing illness she comically suspects can be caught from one's husband, along with that other deforming condition. And she worries about losing all hope of preserving the miniature female body as she contemplates expanding into fertile female excess:

> "You can tell it when I'm sitting down, all right," [Mrs. Fletcher] said.
> Leota seemed preoccupied and stood shaking out a lavender cloth.
> She began to pin it around Mrs. Fletcher's neck in silence. (CS 23–24)

Together the women seem to contemplate her coming change.

Ussher elucidates this subject of a woman's discomfort with her pregnant body: "The pregnant body takes up space, literally and metaphorically. More space than a woman is expected to occupy." No longer miniature, "[t]he tightly drawn boundaries of femininity are violated . . . as the growing fetus pushes out of the fecund flesh. Simultaneously signifying reverence and revulsion—the beatific Madonna, asexual and to be worshipped, and her antithesis, grotesquely distended fecund sexuality, epitomised by pornographic representations of pregnant and lactating women—it is not surprising to find that pregnancy is experienced by many women as a time of ambivalence" (90). Mrs. Fletcher, newly pregnant, assesses the alterations coming with distress. Moreover, her discomforted concern for "showing" has another source: public recognition of her pregnancy cuts off access to an option she has considered: the further bodily discipline of abortion. "'If a certain party hadn't found it out and spread it around, it wouldn't be too late even now,' said Mrs. Fletcher frostily, but Leota was almost choking her with the cloth, pinning it so tight, and she couldn't speak clearly. She paddled her hands in the air until Leota wearily loosened her" (CS 24).

Plath and Welty are not usually mentioned in the same breath nor as in a line of influence. But in a way that Esther from *The Bell Jar* would certainly understand, the women in Welty's salon define pregnancy as "hair fallin'"— the loss of the beautiful Medusa (or Samson) locks that might keep the women's dominion safe—and a relinquishing of public power. Here is Welty's text on the felt concession of moving from "cute" to "pregnant":

> "Honey, 'cute' ain't the word for what [Mrs. Pike] is. I'm tellin' you, Mrs. Pike is attractive. She has her a good time. . . .

"Hair fallin'. . . ."

"Aw, Leota."

"Uh-huh, commencin' to fall out," said Leota, combing again, and letting fall
another cloud. . . .

"Thelma's lady just happ'ned to throw out—I forgotten what she was talkin'
about at the time—that you was p-r-e-g., and lots of times that'll make your hair
do awful funny, fall out and God knows what all. It just ain't our fault, is the way
I look at it."

There was a pause. The women stared at each other in the mirror. (CS 17–18)

Their silence together is another moment of shared understanding.

An Illustrated Cultural Studies Companion to Welty's "Petrified Man"

Sylvia Plath worked at *Mademoiselle* magazine in 1953 and discovered there a
relevant, evident cultural lunacy on the topic of female dominion that would
ten years later produce *The Bell Jar*. Given that history, I indulged a quick
look at the contents of the magazines that Leota would have kept in her shop
for signs of the culture that she and Mrs. Fletcher reflect in "Petrified Man."
The results were informing.

Welty of course had her own connections to the venue of glossy publica-
tions. She would be published by *Harper's Bazaar* and would develop a most
important lifetime friendship with its editor, Mary Louise Aswell, who early
in Welty's career published nine of Welty's stories and showed her perspicac-
ity in quickly accepting "The Winds," understanding (as Kreyling, *Author
and Agent* 66–72, shows she did) its strength ahead of male editors and even
Welty's respected and beloved agent, Diarmuid Russell. Aswell would also in-
clude "The Winds" in her anthology *It's a Woman's World* (1944) in a section
called "Women in Love," placing Welty among other *Harper's Bazaar* story
writers, such as Virginia Woolf, Anita Loos, Dorothy Parker, Colette, and Kay
Boyle. But magazines such as *Harper's* showed a considerable and fascinating
divide between the support they gave to avant-garde women's writing and the
cultural messages in their product advertising. Magazine culture in both its
articles and its advertising routinely addressed topics of female authority and
vulnerability, and current notions of the natural female body were routinely
sold there but from schizophrenically different points of view.

My exploration of the ideas being sold in magazine advertising repeatedly
though not surprisingly uncovered the signs of a legible cultural message that
developed between 1920 and 1950, which cast the natural body as the cause
of power lost. Modernism recognizes gender as a construction and in this
period frankly preferred the artfully constructed identity to the natural one.
Researching "modern" changes in approaches to women and advertising, in

the medicalization of pregnancy, in the history of maternity clothing, and in the practice of abortion, I assembled an improvised illustrated cultural studies companion to "Petrified Man." Decoding the stories told by these images potentially shrinks the distance between contemporary readers, such as my students, self-conscious and aware; Mrs. Fletcher, a woman seemingly reluctant to be defined by pregnancy; and Eudora Welty, a woman seeking power (and perhaps even sexuality) through writing rather than more culturally conventional behaviors, especially in this early moment of her life. I share here a few of the found images in the context of remembering once again Welty's near-miss of a career in advertising, and recalling her photographic parody "Helena Arden" (fig. 2.22), which gently mocks the routines undergone in Leota's shop and the idea of woman as a canvas needing cosmetic completion, or a body needing discipline. In reading these advertising images, selected from a vast cache of possible supporting images, I treat them as reporting their time and encoding twentieth-century social values. They are symbols addressing "socially desired . . . traits, [attempting] to persuade the consumer that [a] product" will foster some "highly coveted lifestyle" (Cortese 11). These images demonstrate how advertising packages our cultural assumptions to sell them back to us.

Daniel Delis Hill's very useful *Advertising to the American Woman, 1900–1999* reveals a transition that occurred during the 1920s in the marketed notion of female beauty. The movement is from selling female virtue to selling a more sexually charged notion of the feminine. A 1923 Pompeian Bloom powder advertisement (fig. 4.1) is typical in its promise that "the reward of beauty" is a bridal veil. A demure woman with "sweet frank eyes" polishes her bloom and beauty on her wedding day by dulling "shine" with a selected shade of foundation.

That modest, decorous image stands in contrast to the depiction of the beautiful in Vivaudou's Mavis ads (figs. 4.2 and 4.3) of roughly the same time (1924). Those ads not only announce the idea of woman as cosmetically constructed but show the idea gaining social acceptance and emerging marketability. The demure women of earlier advertising copy are increasingly replaced by "sexually charged" female images, reflecting Hollywood's screen star glamour (Hill 95).

Even as the woman of glamour is constructed, modern advertising begins to address women's fears that their bodies are naturally out of control, nature not art. A 1939 ad selling Listerine mouthwash mimics the melodramatic plots of *True Romance* magazine stories (fig. 4.4). The line "I had only myself to blame" scripts the natural body as undermining female appeal, power, and control. The poor heroine thinks, "At thirty I had lost the only man for whom I cared." The personal flaw responsible for her guilty regret is love lost to halitosis. Subliminal and explicit messages are reinforced in indented

FIGURE 4.1. Pompeian Bloom cosmetics: "The Reward of Beauty" (1923).

FIGURE 4.2. Henry Clive,
Vivaudou's Mavis advertisement
(1924).

FIGURE 4.3. Henry Clive,
Vivaudou's Mavis advertisement
(1924).

"*I had only myself to blame*"

"THERE, making love to another woman, was the man I had been seeing steadily for two years . . . the man I had hoped to marry. It was the heart-breaking climax to weeks of growing indifference, which I could not understand and which put us further apart each day. This was the end. At thirty, I had lost the one man for whom I cared. Looking back now, I know that I had only myself to blame. I attributed his indifference to every cause but the right one* . . . a condition that every woman should ever be on guard against."

Suspect Yourself

There is nothing that kills a romance or nips a friendship so quickly as a case of *halitosis (unpleasant breath).

The insidious thing about this offensive condition is that you yourself seldom suspect its presence. Others do, however, but never mention it. The subject is too delicate.

So Easy—So Pleasant

Why risk offending, when there is such an effective, pleasant, and easy precaution against halitosis?

Listerine Antiseptic halts fermentation of food particles, a major cause of breath odors and then overcomes the odors themselves. Immediately after its use as a mouth rinse or gargle, the breath, indeed the entire mouth, becomes fresher, sweeter.

Be Agreeable to Others

Get in the habit of using Listerine Antiseptic every morning and every night, and between times before social engagements. It is your best safeguard against offending others needlessly. Keep a bottle handy at home and office; tuck one in your handbag when you travel. It's the one thing you can't afford to be without.

LAMBERT PHARMACAL COMPANY
St. Louis, Mo.

P. S. Do you know that the Listerine Antiseptic treatment for dandruff has produced amazing results for thousands?

FIGURE 4.4. Listerine mouthwash: "I Had Only Myself to Blame . . ." (1939).

headlines: "Suspect yourself"; "Be agreeable to others." Control the natural body to control the man in your story. Moreover, the advertisement's visual representation shows one woman surprised by the shrinking space around her and framed by shadow, and another woman willingly contracting the space she occupies in male arms.

Similarly on this theme of the danger of the natural body, a Chlorodent ad announces, "There's another woman waiting for every man" (fig. 4.5). Spiderlike, a woman is juxtaposed with a web to entrap male prey. The prominent image seems ambiguously to confuse the spider identity with one for which the female client is trying. (Is the product's customer the woman or the other woman, or both?) In 1949 Simone de Beauvoir would observe: "It is required of woman that in order to realize her femininity, she must make herself both object and prey, which is to say she must renounce her claims as sovereign subject" (642). Here, however, the image associates woman with predator as much as prey. The idea being sold is control of men through control of the female body.

Most startling is the narrative line of the 1933 advertising copy used by Lysol disinfectant: "Number Eleven in a Series of Frank Tales by Eminent Women Physicians / Romance Is Born Anew / When Marriage Is Freed of Fear" (fig. 4.6). Scientific and professional in its approach, this ad copy advises on the intimate uses of disinfectant. Dr. Helga Bast of Copenhagen, having saved the marriage of a couple imperiled by a failure of "proper feminine hygiene," offers assurance that this disinfectant, as the agent restoring marital and sexual balance, is safe for delicate female membranes, even during childbirth. Welty's Mrs. Montjoy, Leota's close-call, delivering-any-minute client, endures a last-minute salon permanent for its promise of "exquisite control" to take into the delivery room. Dr. Helga Bast scientifically recommends more—the power of an antiseptic, disinfecting control of the female body. The closeted message here is transparent in the history of contraception and abortifacients. "Disinfecting" douches were certainly used as contraception before and after the American Medical Association in 1937 first accepted birth control as integral to medical practice; only then and only gradually did the diaphragm become generally available from doctors, and only in those states that did not prohibit their sale (McBride 116).

In his book *Abortion Rites: A Social History of Abortion in America*, Marvin Olasky describes the tradition of euphemistic advertising copy for other such female washes. The Victorian abortionist Madame Restell in the 1800s ran ads for her herbal "uterine tonic" and "female rinses" recommended for "all ladies wanting instant relief for monthly irregularities, from whatever cause." The ads asked, "Are you worried and nervous? Are you troubled because your periods are irregular? If you have not neglected attending to them over three months, you can speedily be relieved without the least danger or

No wife wants her husband to carry the memory of her morning breath to work with him.
The attractive woman he meets during the day won't have it.

There's another woman waiting
for every man —— AND SHE'S TOO SMART TO
HAVE "MORNING MOUTH"

We're not saying that if wives simply use Chlorodent their husbands will never look at a pretty girl.

But we do know if you use Chlorodent, your good-bye kiss works for, not against you. For Chlorodent really gets rid of that stale, fuzzy "morning mouth." Your own clean, fresh taste tells you your breath is sweet—even hours later.

The secret is chlorophyll-plus. You see, Chlorodent has a big, generous helping of chlorophyll, plus a patented cleaning agent. Chlorodent is so effective it brightens teeth measurably, better than any

other toothpaste formula, bar none. Brighter teeth. A cleaner mouth. An exciting breath. All this we guarantee—at Lower Brothers Company will return your money. Isn't that reason enough for buying Chlorodent—today?

P.S. Smear chlorophyll also benefits Chlorodent Tooth Powder.

"Anti-enzyme," too, for continuing decay protection

Stop 'morning mouth'—
enjoy that wonderful, clean,
fresh Chlorodent feeling!

Chlorodent

FIGURE 4.5. Chlorodent toothpaste: "There's Another Woman Waiting for Every Man" (1953).

"ROMANCE IS BORN ANEW"

When Marriage is Freed of Fear

"My files are filled with cases of marriages remade . . . by advice on proper marriage hygiene.

"The other day a ship sailed out of Copenhagen with two of the happiest people in Denmark on board . . . bound for a 'second honeymoon' cruise.

"Yet one month ago, they were the most bitterly unhappy man and wife I have ever seen.

"Case 312-A in my file. The old story. An ideal marriage . . . until fear crept in.

"The fear that begins in a woman's mind . . . inspired perhaps by some slight feminine irregularity. A woman's system is a sensitive instrument. Its working parts, its organs, are timed to clock-like precision. Fear of a profound physical crisis is more than enough to completely delay this delicate timing. A minor irregularity causes the fear. The fear causes further irregularity. And before long a frightened wife and a puzzled husband find their beautiful marriage an emotional chaos.

"Case 312-A was helped just like all the others. Advice on the subject of marriage hygiene. Explanation of antiseptics. Many women often rely on antiseptics which fail to destroy germ-life in the presence of organic matter—where an antiseptic for feminine hygiene must always prove effectual.

"I always recommend 'Lysol' because it is certain. It always destroys germs in the presence of organic matter. Yet it is safe . . . soothing to the most delicate feminine membranes. It can never sear or harden tissue as other antiseptics may. For years 'Lysol' has been the choice of hospitals and clinics, for every surgical purpose, even in the delicate operations attending childbirth. And since 'Lysol' is prescribed for use at a time when feminine membranes are most sensitive, it must be the safest for regular home use.

"Antiseptics of some other types quickly

Photograph by Miss Bee in Copenhagen
Dr. Helga Bast, of Copenhagen, one of the most distinguished gynecologists of Denmark. Corresponding Secretary of the International Association of Medical Women

break down, cannot be depended upon. But 'Lysol' is a stable mixture always uniform and active in strength.

"I prescribe its regular use in marriage hygiene for the health and peace of mind of every wife."

(Signed) DR. HELGA BAST

Let "Lysol" Guard the Family's Health

Use it in your home as protection against colds, tonsilitis, sore throat, grippe, and to disinfect after these ailments. Use it for prevention and disinfection in case of children's diseases—mumps, measles, etc. Excellent for soldiers' feet. Helps to heal cuts, burns, etc. Protects mother and child in operations attending childbirth. Directions for every use on every bottle.

Send for the "Lysol" Health Library

Send for a copy of our interesting booklet, "Marriage Hygiene—the Important Part it Plays in the Ideal Marriage," written by three distinguished women physicians. For protection against spread of germs, infections and disease, send for "Keeping a Healthy Home." If a baby is on the way you will want the authoritative booklet, "Preparation for Motherhood." Please use the coupon.

Lysol
Disinfectant

LEHN & FINK, Inc., Bloomfield, N. J., Dept. LF-11
Sole Distributors of "Lysol" disinfectant

Please send me, free, postpaid, the booklet "Marriage Hygiene." (Check other booklets if desired.)
☐ Keeping a Healthy Home
☐ Preparation for Motherhood

Name_____
Street_____
City_____State_____

FIGURE 4.6. Lysol: "Romance Is Born Anew" (1933).

inconvenience" (Olasky 193). Home-remedy contraceptives and homemade abortifacients addressed women's needs while euphemistic advertising gave women the opportunity to pretend that their efforts at contraception and abortion were actually something else. Here, the specific fear from which marriage should be freed is certainly unwanted pregnancy.

Recall the story of Mrs. Fletcher and her indignation at being outed as pregnant by rumor. In the 1930s abortion skyrocketed: 800,000 abortions were performed in each year during that decade (Garrow 272). Other fictions of the time also address the topic of abortion—Hemingway's "Hills like White Elephants" (1927), Langston Hughes's "Cora Unashamed" (1933), Faulkner's *As I Lay Dying* (1930) and *The Wild Palms* (1937)—but none of these stories hit on Welty's Mrs. Fletcher's situation of a conventionally married woman making this choice for reasons of controlling the body that has been culturally constructed as a woman's instrument for controlling men.

The connection between pregnancy and a woman's loss of power is the script of a 1940s Johnson and Johnson ad that seems to report and recommend the loss of a woman in motherhood (fig. 4.7). This image astonishingly packages cultural assumptions that are hard to imagine women wanting to buy back. In "Whoa, Mom! Can't You Take It?," a tiny mother in harness and traces is held by a giant baby. The illustration clearly, but weirdly, conveys all too well the idea of a woman harnessed by her role as mother. The giant baby, fantastically responding to the mother's wish that she had her baby's easy life, warns that having not been a considerate-enough mother, she will now know firsthand the chafing of his skin. She guiltily admits, "I haven't been a careful mother, have I?," and she dutifully promises improvement. "Watch me reform, Baby," the tiny chafing mama says, promising to give fuller attention to baby powder.

This image, though peculiar, nevertheless accurately reflects changing "modern" ideas about pregnancy, maternity, and restriction. The increased restriction of pregnant women developed with male physicians replacing midwives (1870–1930) as the medical profession took over a realm from which men previously were completely excluded. Rebecca Bailey, describing the twentieth-century invention of medical gynecology, writes: "what the doctor actually knew [about pregnancy and delivery] and what he said he knew, and even what he believed he knew, were radically different matters" (249). The situation of the "modern" doctor making a mess as he claims authority in a female realm is visible in Welty's *Delta Wedding*: Dr. Murdoch, adjusting his "gas" machine, causes Ellen's mother and then himself to pass out, leaving Ellen to deliver Shelley with Partheny's competent help.

As male physicians newly approached maternity as an illness to be controlled, "medical advice . . . was given for every aspect of women's life, including what to eat, [and above all] what to not do, and even how to dress"

"Whoa, Mom! Can't you take it?"

BABY: Shame, mom! You said you'd like to have a baby's easy life — but now that we've changed places, you *fuss!*

MOM: D'you blame me, lamb? These straps! This wriggling around! If *I'm* uncomfortable, how does *your* tender skin stand it?

BABY: Stand it? Mommy, I'm miserable! And now *you* know, too, why babies need Johnson's Baby Oil and Johnson's Baby Powder!

MOM: Honey, I'll *get* 'em — quick! Then what do I do?

BABY: Just this, Mom. After my bath,

protect my skin all over with pure, gentle Johnson's Baby Oil. And don't forget to use it at diaper changes, to help prevent what my doctor calls "urine irritation!"

Other times, I'll thank you for soft, soothing sprinkles of Johnson's Baby Powder, to help keep chafes and prickles away!

MOM: I haven't been a careful mother, have I? Watch me *reform!*

BABY: Watch *me* reform too! With Johnson's to take care of my skin, I won't have half as many howls coming!

Johnson's Baby Oil
Johnson's Baby Powder

Johnson & Johnson

FIGURE 4.7. Johnson's baby oil and Johnson's baby powder: "Whoa, Mom! Can't You Take It?" (1947).

(Bailey 250). Pregnancy became a "normal illness" (Ussher 17). "What had been such a short time before a sphere of total ignorance for men, abruptly became one in which they had preeminence, and total authority" (Bailey 250). Men's power and persuasion were based on how much women had invested—wanting to survive childbirth in a time when survival was not assured. Medical science promised to protect the pregnant woman with a restricted lifestyle. Doctors, unsure on issues of safety, found it easiest to say no and to forbid everyday activities (for example, singing and bathing as well as tennis). The history of restrictions during pregnancy seems to have followed a pattern: the new activities young women wanted to take up, pregnant women were asked to give up. In "Clothes Encounters of the Gynecological Kind," Bailey discusses how dress now also became a mark of pregnant women's separation in society. Victorian medical doctors forbade the tight-fitting socially correct garments of the day, leaving women to wear "the cover of darkness." There was no public sanction of improvised maternity dresses worn outside the home and no commercially available maternity clothing. Women simply were expected to be in "confinement" and therefore had no need to dress. But in 1911 Lane Bryant ran a most liberating ad in the *New York Herald*: "It is no longer the fashion nor the practice for expectant women to stay in seclusion. . . . To . . . go about among other people, she must look like other people. Lane Bryant has ORIGINATED MATERNITY APPAREL in which the expectant mother may feel as other women feel because she looks as other women look." After the ad ran, the Lane Bryant shop was overrun. "By the close of the day, the entire inventory had been sold." Lane Bryant's tea gown was the garment sold as maternity clothing (Bailey 255, 258).

Certainly Mrs. Fletcher, twenty-five years later, would be able to buy maternity clothing; she would likely follow Leota's advice and buy one of those "Stork-a-Lure dresses." Yet these advertising images help to clarify what Welty has Mrs. Fletcher and Leota discussing in their seemingly idle salon chats. Perhaps these ads allow a better appreciation of what is petrifying the women: they fear that if they are not in control, they will be controlled in a culture that defines sexuality as power over the other.

Is Welty's treatment of the pregnant body here aberrant or part of a consistent pattern in her fiction? It is fair to say that in different stages of her life as a woman, Welty's treatment of pregnancy varied. In early stories like "Death of a Traveling Salesman" (1936), "Flowers for Marjorie" (1937), "The Wide Net" (1942), *Delta Wedding* (1946), "Shower of Gold" (1948), and even "Circe" (1949), pregnancy creates a difference that can be joy but is also separateness.[4] I do notice though that beginning with *The Bride of the Innisfallen and Other Stories*, a time when Welty likely felt her biological clock ticking, children are more present and more endearing than in her earlier work.

As a final comment on the topic of Welty, advertising, and women's mag-

azines, there is one more unexpected story to tell. In March 1998, *Jane*—a woman's magazine that operated from 1997 to 2007 and that was designed to appeal to an irreverent, female, young adult target audience (aged eighteen to thirty-four)—selected lines from Welty's missed-love story "No Place for You, My Love" to serve as the basis for a ten-page fashion spread, subtitled in the issue's index with the lines "Leave me alone. I'm having a non-fashion fashion moment." The quoted passage "It was the wrong hat for her, thought the Eastern businessman who had no interest whatever in women's clothes" accompanies the longing sultry looks of a fashion model in a bent straw hat, rowing a boat (*CS* 78–79). Another page quotes: "'I have a car, just down the street,' he said to her. . . . 'Have you ever driven south of here?'" (82–83). This question is associated with an image of a model in an open field, dressed in a lacy lingerie-like top, but she is bent over, back bare, with her head between separated legs. Subsequent pages complete the passage: "I didn't even know there was any south to here. Does it just go on and on?" That line announces an image in which a model contemplates her personal southern regions, and then, cheekily and suggestively, one more Welty line is added, "That's what I'm going to show you" (84–87). The choice of Welty, impertinent to be sure on the topic of women and fashion, is possibly apt for the tone of the magazine, and it is an unexpected and certainly droll co-optation. Welty might have with astonishment and amusement appreciated the irony of her lines finding a new audience among young women in hair salons, patiently awaiting their beauticians.

The Freak and the Fair: "Petrified Man," Sideshows, Sexuality, and Welty's Carnival Photos

The visual frames of advertising history create a context that can inform a reading of "Petrified Man," focused as it is on women and their bodies. But it is not necessary to go outside Welty's own oeuvre to discover a helpful set of illustrative frames: Welty's photos of sideshow gatherings and banners—particularly the series "State Fair, 1939"—provide another informing visual context for "Petrified Man." Like Carson McCullers, a writer with whom Welty felt no affinity at all but with whom she is more frequently linked than with Plath,[5] Welty contemplated notions of the freak body in a culture fascinated by its display. In "Petrified Man," as in McCullers's stories, there is a calculated elision of the distance between the monstrous feminine body and the freak bodies of the sideshow. Moreover, the two young southern women writers' treatments of the fair and the freak seem to display their own freak banner in fiction that shows the rituals and assumptions of conventional heterosexuality as more than a bit freaky.

In McCullers's *The Member of the Wedding*, twelve-year-old androgynous

Frankie is coming of age during her "summer of fear," a transition attended by her identification with and fear of sideshow freaks.

> In the past year [Frankie] had grown four inches. . . . Therefore, according to mathematics and unless she could somehow stop herself, she would grow to be over nine feet tall [before her eighteenth birthday]. And what would be a lady who is over nine feet HIGH? She would be a Freak. . . . Frankie had seen all the members of the Freak House last October:
> The Giant
> The Fat Lady
> The Midget
> The Wild Nigger
> The Pin Head
> The Alligator Boy
> The Half-Man Half-Woman (19)

McCullers's list of "Freak House" residents unquestionably echoes the historical record: these *were* the acts on display ubiquitously. And America's fascination with these bodies was itself gargantuan.

Southern literature is frequently drawn to the landscape of the sideshow body (as Rachel Adams has so ably shown), and it is useful to understand the fascination of hybrid bodies in the particular context of narratives interpreting and challenging the South's apartheid culture, devoted to the maintenance of strict category divisions—categories based on binaries that inform systems of gender and class as well as race. Sideshow bodies mesmerized because they occupied what Elizabeth Grosz has called "the impossible middle ground" (57) between the poles of cultural categories that seemingly brooked no such middle ground or ambiguity. The sideshow body bridged conceptual oppositions—"oppositions dividing the human from the animal" (as in "Mule Face Woman"), oppositions between "one being [and] another" (as in the case of conjoined twins in a bottle), and between "nature and culture" (as in "Keela, the Outcast Indian Maiden," whose eponymous character eats live chickens) (Grosz 57). Sideshow bodies also bridged the oppositions between one sex and another (the half-man half-woman, the bearded lady, but also small men—Leota's "pygmies"—and large women), between "adults and children" (little people), between humans and superhumans (giants), and between "the living and dead" (petrified men) (Grosz 57). These provocative bodies all appeared to transgress rigid social categories, violating seemingly unconditional boundaries that were thought to order civilization. They embodied challenges to cultural categories (Thomson 6).

Sideshow audiences made this sort of carnival venture commercially successful because their members were typically happy to pay to look on the extraordinary and feel "normal," purchasing what Leslie Fiedler refers to as "the

tyranny of the normal," expressed in condescending if fascinated stares. With the price of admission, viewers acquired the comfort of being conventional. Leota takes that sort of pleasure, as tiny and petrified men fit her world view in its utopian mode. But McCullers's Frankie's fear is about her total inability to find that variety of smug comfort. She experiences what Fiedler in his early seminal book *Freaks* traces as the recurring literary plot of the "secret self" recognizing its double; in this case Frankie is almost certainly recognizing the hybridity of her androgyny, of being a boy-girl.[6] She fears being known by her sideshow doubles for "[i]t seemed to [Frankie] that the [performers] had looked at her in a secret way and tried to connect their eyes with hers, as though to say: we know you" (McCullers 18). Frankie dreads the "freak" recognition of her potential to become an androgynous giant rather than a lady, unable to fit into the constricted space allotted to the feminine miniature, and fears anomalous desires breaking out of an insufficiently bound body. As Rachel Adams and Sarah Gleeson-White have in different ways shown before me, McCullers is sympathetically and metaphorically interested in the nine-foot-tall woman Frankie projects as her future, a body that towers in and over a culture in which prescriptive femininity is diminutive.

Let me turn from discussing the fascination and fear of Carson McCullers's Frankie to the tradition of the sideshow banner, then to Welty's record of these banners in her photographs, and finally to their connections to her story "Petrified Man." The book *Freaks, Geeks, and Strange Girls* by Randy Johnson, Johnny Meah, Jim Secreto, and Teddy Varndell, displays sideshow banners of the great American midway. There are many "strange girl" representations, among them the wonderful work of the artist Snap Wyatt, perhaps the best of the banner painters of his generation. In his "Oh My! But *She* Is Fat" (fig. 4.8), a female giant, immense but feminine, is presented as an oceanic body, partly immersed in the surf, a body announcing large appetites and gratifications that cannot be hidden. She holds hands with a man who is, in comparison, tiny, though he is distinctly interested in and fully engaged by his companion, who is pronounced "Positively Alive"; he is happily in her hand. This caption has multiple meanings. It reads both as a commercial promise of what will be seen inside the sideshow tent and as a comment on an outsized desire that this beckoning body seems to represent: the miniature body of the decorous lady has been swapped for, supplanted, and decentered by the body of the "gargantuan" woman (Yaeger's useful term in *Dirt and Desire*). Like the oversized bather in Welty's "A Memory," the woman on this banner is at the beach and exposing her provocative femaleness, which is large and "Positively Alive." A related type of sideshow banner is of the tiniest man, represented in Johnson, Meah, Secreto, and Varndell's collection by "Major Debert" (artist unknown). This is the "teeniniest man" whom Welty's ladies verbally circle in "Petrified Man." The tiny Major Debert, along with Leota's

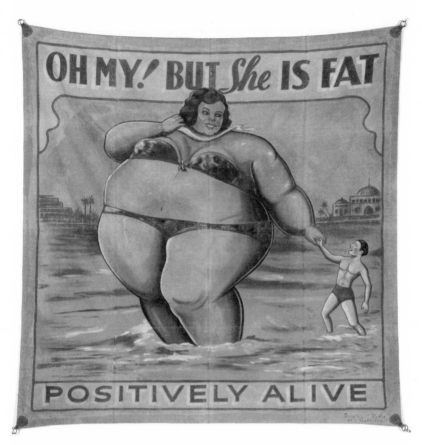

FIGURE 4.8. Snap Wyatt, "Oh My! But *She* Is Fat." Photograph by Jim Secreto.

pygmy, is a minimal performance of masculinity and quirky in a manner that corresponds to the large lady's nonstandard femininity.

In this context of category hybridities and notions of gender benders, I turn to Welty's 1939 carnival photos. At state and county fairs she repeatedly photographed sideshow banners, which, unlike posters printed on paper, are extremely large paintings executed on canvas, difficult to photograph because of their size. Welty seems to have been drawn to their whimsical images, out of this world in the sense of being storybook imaginative, and to the comic playfulness suggested by their fusions. Her prevailing sense of humor is visible in reframed images such as Rubber Man (fig. 4.9), Junie Alive (fig. 4.12), and Headless Girl (fig. 4.13), all of which Welty titled "Sideshow, State Fair." But these photographed banner images are at the same time a bit disturbing and worthy of close reading.

Consider Welty's mule-faced woman (fig. 4.10), a hybrid image that merges human and animal. The photo with its comic appeal belies the history of pho-

tos of mule-faced performers—who were women afflicted with a dreaded deforming disease that gave their faces a hardly human quality. (Grace McDaniels was the most notoriously photographed of these women.) But the comic strength of the banners Welty photographed may be that their humor, like Welty's verbal comedy, literalizes the word-play of familiar colloquialisms, in this case absurdly confusing the beautiful woman with a face "as stubborn as a mule's."[7] The image perhaps also touches on the comedy of finding a beast in a lady. And just as the lady is satirized here, so is female fashion, while the photo summons and literalizes adages like "you can't make a silk purse out of a sow's ear"—or a "mule's patootie."

Sideshow banners traditionally flirt with sexuality in ways that are sometimes taunting, sometimes lurid, sometimes just odd. For example in the poster "Wonderful Amazing Siamese Calves Two Bodies Eight Legs" (fig. 4.11), two calf bodies are not only joined but perhaps arranged to resemble a gravity-defying, lifelong copulation in the missionary position.

Most of the banners also connect to issues of gender. Junie—the cow with the human face—has a dark-skinned female face on a bovine body, literalizing the insult that "a woman is a cow" in a way that invites laughter (fig. 4.12). Similarly, in the sideshow banner "Headless Girl" (fig. 4.13), a curvaceous body on display is pictured greeting two apparently appreciative men. Her male companions, who seem to be struck by her torso, never notice that her identifying face is missing.

The sideshow spectacle was produced not only by the visual performances of category-breaking bodies; it was also constructed narratively by the oral spiel—often called the "lecture"—that was delivered by the showman "professor" who introduced the exhibit. The sideshows were augmented by pamphlets or broadside "histories" (for example, was Alligator Boy's mother scared in a dank and dismal swamp by a slithering scaly critter?).

Another of Welty's carnival photos, "Hypnotized" (fig. 4.14), is thick with activity. In it the gaze of the professor (on the right), whose role would have been narrator, directs the viewer's eye toward the cluster of a hypnotist and three showgirls in various degrees of exposure. A rigid man is, perhaps, hypnotized, but as Matthew R. Martin has written, this figure "suggests the immobility of the Petrified Man." The banners behind this scene announce assorted strange girls: the dancing girls of nations, the burning of "she," the female life cycle change presented as the turning of life, and Odar—a full-figured, floating female apparition that seems to emerge from a turbaned male head. All of this commotion is taken in by seven sets of excited and appreciative boy eyes.

Another of Welty's sideshow images (fig. 4.15) leads the viewer not to the freak bodies of other women displayed in the posters but rather to the gaze that comes to the fair. Together three faces convey young males' reactions to the idea of freak desire, which is linked to the women advertised as on display.

Individually the white boys' faces model a variety of representative responses: excited, leering, judging, amazed, fascinated—hypnotized! Matthew Martin suggests that Welty's focus on these mesmerized audience faces "undermines the boundaries between spectator and spectacle," destabilizing "categories like observer and observed or freak and normal" (4).

I now return to the similarities and differences between what McCullers and Welty are up to in *The Member of the Wedding* and "Petrified Man." Rachel Adams in "'A Mixture of Delicious and Freak': The Queer Fiction of Carson McCullers" points out that McCullers's text, sympathetic to the unconventional, works to unsettle the normative and to "queer" notions of gender normalcy: "For Frankie, the queer is often associated with unpleasant, tentative forays into the world of heterosexual romance, such as the 'queer sin' she commits with Barney MacKean, a neighborhood boy, and the attentions she receives from a sailor [sic] in a smelly hotel make her 'feel a little queer.' Such uses of the term work to queer heterosexuality, revealing it as not universally pleasurable" (562).

Frankie's boarder Mr. Marlowe seems to be having a disturbing but "common fit" when she sees him with his wife through the bedroom door that they neglected to close (McCullers 137). And Frankie wants to kill nasty Barney after he lures her to commit that unspoken but articulated queer sin in the MacKeans' garage: "the sin made a shriveling sickness in her stomach, and she dreaded the eyes of everyone" (26). In a crazy minute that was "like one in the fair Crazyhouse, or real Milledgeville," Frankie brings a glass pitcher down on the head of the soldier who "was not rough, it was crazier than if he had been rough," when he pulls her down on the bed upstairs at the Blue Moon (136). These encounters all lead the reader to perceive conventional heterosexuality as a freakily bad fit for Frankie, as bad as the fit of her drag-queen orange "wedding" gown, which heteronormative Berenice acknowledges "don't do" (89).

Welty too shows heterosexuality as freaky, not as a matter of personal fit, but more pervasively in the confused overlap between ideas of sexual attraction and sexual domination. By contrast to McCullers's story, in which Frankie's identification with category-breaking bodies is explicit, Welty's stance is distanced in both "Petrified Man" and the sideshow photos. The technique in the photos is to reframe the banner images in a kind of visual reutterance that embraces Bakhtin's heteroglossia, restating "another's speech in another's language, serving to express authorial intentions but in a refracted way" (40). This reframing adds an extra layer of looking onto the viewing of the sideshow images, adding distance and inviting commentary and reflection. The freak banner is revoiced with an ironic, wry, or analytic difference.

In Welty's sideshow fictions ("Petrified Man" and "Keela, the Outcast Indian Maiden"), juxtapositions show the conventional as freaky and the "nor-

mal" as strange, challenging categories of gender and race that might otherwise seem ordinary to her readers.

The Comedy of Sexual Antagonism: Female Spice, Pleasure, and Power in Welty's Fictions

In this chapter I have mined one story and attempted to create a cultural studies framing of it. But it is also important to connect the story to other Welty fictions. "Petrified Man" is an early story that treats both comic sexual antagonism and unsettling rape. Contention across sexual relationships is a topic comically revisited in other Welty stories such as "The Wide Net," "A Piece of News," and "Circe"—which, like "Petrified Man," shape upbeat comedy from gender antagonisms and treat women's strategies for pleasure and power in that context. These sex comedies refract gender antagonism as Hollywood's 1930s comic films did. Forwarding women as sexy because they are sassy, irreverent, and independent, these films provided an advancement for women in popular culture (see Maria DiBattista's *Fast-Talking Dames*). Understanding this pattern of willful women may ultimately be useful in understanding Welty's treatment of rape, a frequent plot element that is displayed in an almost alarming variety of tones in her fiction, including the comic, and that is the topic of chapter 5. But I first consider in more detail her treatment of the comedy of heterosexuality.

"The Wide Net," provocatively dedicated "for John Fraiser Robinson," begins: "William Wallace Jamieson's wife Hazel was going to have a baby." William Wallace feels separate from his pregnant wife, resenting her acting as though she were delivering "tomorrow," as well as her looking "straight at nothing . . . with her eyes glowing" (*CS* 169), "like a piece of pure gold, too precious to touch" (176). Hazel is "a golden-haired girl" (175), one of those glimmering girls like the changeling in Yeats's "The Song of Wandering Aengus," who call, beckon, and dart through "the *hazel* wood" (line 1, emphasis added). "A pretty girl," Virgil says to William Wallace, "[i]t's a pity for the ones like her to grow old, and get like their mothers" (*CS* 171). Hazel is pretty, as Virgil says, and smart too, as Doc and William Wallace attest. Her retort to her husband's distant response to her pregnancy is to teach him a lesson—one that is powerful, not petty. Seemingly in a tit-for-tat for his having spent "the night sitting in a ditch . . . singing in the moonlight" (171) with his buddy Virgil on an unannounced night out, she leaves him a suicide note, sending him to drag the river for her drowned body. This is, however, not a jealous woman's punishing trick. If pregnancy undermines female power in "Petrified Man," here asserting female power throughout pregnancy requires some strategic game playing. Hazel positions William Wallace to meet the

natural world in its "changing-time" and by analogy come to appreciate, and to develop some empathy for, her own change of season.

Diving "down and down into the dark water," the narrator asks, in free indirect speech that blurs with the thoughts of the character in a way that makes clear what William Wallace *might* have learned without making it absolutely plain that he *did*: "had he suspected down there, like some secret, the real true trouble that Hazel had fallen into, about which words in a letter could not speak . . . the elation that comes of great hopes and changes, sometimes simply of the harvest time, that comes like a tune with a little course of its own to run in the head . . . ?" (CS 180). While Hazel succeeds in creating for William Wallace this deep lesson about pregnancy, elation, the female body, seasonal change, and the natural world, the story ends by acknowledging her separate female experience.

When her husband finds her safe at home, to reassert his power over her, he "turned her up and spanked her," but without diminishing her pleasure in their relationship, her own cleverness, or her sense of control. Smiling (perhaps with a Lauren Bacall or Katharine Hepburn look), she gives him notice, "'I will do it again if I get ready,' she said. 'Next time will be different, too.' . . . Then she was ready to go in, and rose up and looked out from the top step, out across their yard where the China tree was and beyond, into the dark fields where the lightning-bugs flickered away. He climbed to his feet too and stood beside her, with the frown on his face, trying to look where she looked. And after a few minutes she took him by the hand and led him into the house, smiling as if she were smiling down on him" (CS 188). It seems that the story's comedy is in their banter, in Hazel's spiciness, and in her woman's knowledge.

Like Hazel, Ruby Fisher in "A Piece of News" is pictured responding to her relationship with her husband, although this one is more troubled. Clyde is a depressing partner who "pokes Ruby with the butt of his gun" when he finds her daydreaming.[8] The habits and limitations of their relationship are revealed as he enters and grumbles, "what's keeping supper. . . . Don't you talk back to me. You been hitchhikin' again, ain't you? Someday I'm goin' to smack the livin' devil outa you" (CS 15–16). For her part, "[w]hen Clyde would make her blue, [Ruby] would go out onto the road, some car would slow down, and if it had a Tennessee license, the lucky kind, chances were that she would spend the afternoon in the shed of the empty gin" (14). Although Clyde growls about his dinner not being ready, he unexpectedly "almost chuckle[s]" when correctly guessing that Ruby's "been hitchhikin' again" (15). His fullest response to her sexual independence is the threat of smacks that he can apparently defer because he is not that bothered by the thought of Ruby finding her pleasure elsewhere. Interestingly, the story, as Louise Westling and

Dawn Trouard have pointed out before me, is not about Ruby's sorrow; it is about her sensual and imaginative delight. Westling writes, "[T]he story defines an autonomous female sexuality that has only an oblique relation to patriarchal institutions defining traditional bonds between women and men" (*Eudora Welty* 67), and Trouard sees Ruby as one of those Welty characters inhabiting a "world where men's proper place is ancillary" along with "the ideological lie of dominance" ("Diverting Swine" 338). Trouard evokes Luce Irigaray's concept of extraterritoriality—a zone where women's experience of their own pleasure remains outside the accepted discourse on women's desire as attached to men. Westling writes, "Ruby Fisher simply enjoys her body and stretches dreamily . . . unapologetic for her sexual adventures " (*Eudora Welty* 67).

"A Piece of News" develops in an intersection between imagination and sexuality when Ruby responds to reading an article—in an out-of-state newspaper used by her partner in an afternoon gambol to wrap a gift of coffee—about a Ruby Fisher shot in the leg by her husband. Her first response is surprise, consternation, and anger at being named in a script not hers. The story is "mistaken": "Clyde had never shot her, even once" (*CS* 14). But "her anger passe[s] like a remote flare of elation" (13) as she awakens to the narrative's potential. For Ruby is a woman who understands narrative: "When she was still, there was a passivity about her, or a deception of passivity, that was not really passive at all. There was something in her that never stopped" (13). The something is imagination. And Ruby discovers the autoerotic potential of reading as she drifts into narrative invention.

Undead, Ruby playfully pictures herself dying. "She would have a night-gown to lie in, and a bullet in her heart. . . . She would lay silently for a moment, composing her face into a look which would be beautiful, desirable, and dead" (*CS* 14). Edgar Allan Poe once wrote, "the death, then, of a beautiful woman is, unquestionably, the most poetical topic in the world" (679). And "beautiful, desirable, and dead" has repeatedly been the predictable, conventional literary ending for the too-independent woman. But Ruby, one of that kind, is in charge of this melodrama, and under her direction the expected performance of "beautiful . . . and dead" is a delighted, mocking parody (which can remind the reader of Welty's own delight, from her juvenilia onward, in parody and its power to revoice with a difference). Ruby fantasizes her desirability and death at the hand of a passionate and jealous husband. She amusedly imagines Clyde's tears of repentance as he admits, "Ruby I done this to you" (*CS* 14). Her envisioned script spurred Dawn Trouard to write: "Are we willing to imagine a woman not somewhat happy, even in death, if the men she knows would finally say they were wrong, *and* responsible?" ("Diverting Swine" 342). Ruby's play rewrites her actual relationship with Clyde; the parts they perform in her fabrication are close enough to life to be

well cast, but the fantasy is enacted with a dissimilarity that thrills her. It is not the titillation of violence that awakens Ruby, but imagining the covetous desire implied by violence.

Ruby tentatively shares what she has found when she risks showing Clyde the newspaper. The article changes their lives for a fleeting moment. It acts as a corrective on Clyde's usual behavior toward her—he meets the account with a denial that he did that—but the piece also carries news of some restored possibility between them. "Rare and wavering, some possibility stood timidly like a stranger between them and made them hang their heads" (CS 16). Ruby first and then Clyde (slowly and densely, with resistance stemming from his preference for the literal) meet the story that did not happen, approaching it in a way that ignites an embodied response. At the story's end the newspaper burns, creating a moment's warmth between them. And Ruby—who seeing her name had said softly, "that's me" (13)—revels in this interval of self-possession.

"Circe" (first published in *Accent* in the autumn of 1949 under the title "Put Me in the Sky!"; reworked and published in *The Bride of the Innisfallen and Other Stories* in 1955) is another story about gender antagonism and female power. In Welty's handling of Odysseus's encounter with Circe, the enchantress evaluates and comments on her domination and vulnerability both. She greets the "beautiful strangers" who land on her island with the word "welcome" but calls it "the most dangerous word in the world," an assessment of her own authority, dominion, and intent. Her broth turns the men into swine, and she smiles at having literalized her appraisal of male housekeeping skills. When she reduces or reveals the men as snuffling pigs, she is startled to feel an unexpected presence behind her:

> I spun round . . . thinking, O gods, it has failed me, it's drying up. Before everything, I think of my power. One man was left.
> Before I'd believe it, I ran back to my broth. I had thought it perfect—I'd allowed no other woman to come near it. I tasted, and it was perfect—swimming with oysters from my reef and flecks of golden pork, redolent with leaves of bay and basil and rosemary, with the glass of island wine tossed in at the last: it has been my infallible recipe. Circe's broth: all the gods have heard of it and envied it. No, the fault had to be in the drinker. If a man remained, unable to leave that magnificent body of his, then enchantment had met with a hero. (CS 532)

Odysseus, however, is protected by an herb rather than by qualities of male heroism (although arguably he has the herb because he is a hero). With that advantage, he finds himself seduced by Circe rather than trounced by her. Invisible, she bathes him, speaks to him in the voice of a woman, and wins him. "I took the chain from my waist, it slipped shining to the floor between us, where it lay as if it slept, as I came forth. Under my palms he stood warm and

dense as a myrtle grove at noon" (532). She complains, though, of his male response: he talks, literally not figuratively, about old conquests, and too much. Again like Yeats's glimmering girl of "The Song of Wandering Aengus," she beckons to him ("I called him by name"), but self-absorbed and preoccupied, "[h]e cared nothing for beauty that was not of the world, he did not want the first taste of anything new" (533).

Welty drafted "Circe" in the period when she was sorting out her disappointing but perhaps clarifying relationship with John Robinson, and she created an enchantress with creative power (Welty frequently referred to writing as "magic"),[9] who might or might not feel regret for her lack of ordinary, mortal happiness. Trouard argues that unlike "the cultural scripts [that] have told us [that Circe feels] great grief [at Odysseus's departure] . . . she doesn't" ("Diverting Swine" 351).

> Most critics . . . argue her despair over the departure of Odysseus. But she has already declared that his presence is "displeasing"; his welcome worn out. Her knowledge of his inevitable death in the "menacing world" by the very son she is now carrying, makes her a highly suspect portrait of a woman in love. Her biological misery, hostess now for the half-mortal child, is more likely the source of her entire complaint. In this dark night of the soul, she must evaluate the trade she has in fact made—goddess pregnant, she must at least feel some compromise in her magic, in the new version of "making" that is underway. (350)

Is Circe pregnant, Circe compromised? "I was sickened, with child. . . . The little son, I knew, was to follow—follow and slay him. That was the story. For whom is a story enough? For the wanderers who will tell it—it's where they must find their strange felicity" (CS 537). This passage I think leaves Circe both enriched by her story and tied to its consequences. In spite of her prophetic, predictive knowledge of her son and her lover, she has to admit, "foreknowledge is not the same as the last word." Welty's reinscription of the lore of Circe reveals female power tied to working "magic," with consequences producing autonomy and independence, and if, on the one hand, some ambiguity, on the other, a "strange felicity." To return then to the question of whether Welty is a writer who fits in conversation with later women writers more easily acknowledged as "radical" and who, in her comic portrayals of women, raises issues that a next generation of feminist women writers would also interrogate, the answer must be yes.

"Before the Indifferent Beak Could Let Her Drop"

Interrogating Rape—Comic and Otherwise—in Welty's Fiction

"Petrified Man" is Welty's first opening of the topic of rape, and she is comically brusque about it. Treated with humorous reduction, rape in "Petrified Man" appears as a disturbingly predictable extension of the sexuality being defined in the beauty salon and the culture at large as domination. Throughout her career, Welty frequently returned to the topic or plot of rape, handling it variously in "Petrified Man" (1937), *The Robber Bridegroom* (1942), "At the Landing" (1943), *Delta Wedding* (1946), three stories in *The Golden Apples*—"The Whole World Knows" (1947), "June Recital" (1947), and "Sir Rabbit" (1949)[1]—as well as "The Burning" (1951) and "The Shadow Club," an unfinished 1970s manuscript that she worked on periodically without completing. As in her handling of other plots or topics that she returns to, Welty treats this one in a variety of tones and genres. Welty's comic rapes, including *The Robber Bridegroom* and "Sir Rabbit," a subset of her rape narratives, emphasize female desires, fantasies, and daydreams. Public discussions of Welty and rape at academic conferences have tended to end in protests that what happens in a given story is not rape but something else—perhaps seduction, consensual sex, consensual sexual violence, or fantasy. My intention here is to reopen the topic to explore what Welty is writing about when she writes about rape.

Welty critics, particularly Rebecca Mark, Suzanne Marrs, Sarah Peters, Peter Schmidt, and Patricia Yaeger, have written important analyses about rape in their discussions of various works by Welty. These readings consider the rape plot of individual Welty texts, but Louise Westling has twice risked interpreting the rape plot as a pattern in Welty's fiction. In 1986 in *Sacred Groves and Ravaged Gardens: The Fiction of Eudora Welty, Carson McCullers, and Flannery O'Connor*, she emphasizes the seeming inviolability of Welty's women:

[T]hroughout her fiction she champions women's free choice of lovers and their essential sexual wholeness. This inviolability is . . . clearly seen in her presentation of rape. Ellen Fairchild accepts her brother-in-law's dalliance with the bayou girl, and we have seen that the encounter seems to work ultimately as a charm against danger. In "At the Landing" Jenny Lockhart is raped first by Billy Floyd and later repeatedly by the fisherman at the landing when she goes out in search of the elusive Floyd. The story implies that she is finding the fulfillment she lacked while living with her genteel grandfather. Virgie Rainey's piano teacher, Miss Eckhart, in *The Golden Apples* refuses to be humiliated by a black man's attack on her at night when she was walking alone. The townspeople would have liked her to move away in shame rather than simply go on with her life as if nothing has happened, but she seems to see her problem as nothing more than a temporary indisposition. King MacLain's predatory habits are known all over Morgana, but Welty presents them comically, as in the case of Mattie Will Sojourner, whose husband is outwitted and left behind while King prances off through the woods with his wife. Most critics excuse these antics as analogous to Zeus's seduction of mortal maidens, and one of Welty's chapter titles, "Shower of Gold," makes this association clear. Nevertheless, on a realistic level King is an incorrigible philanderer who deserts his gentle wife, Snowdie. In most of these instances, rape appears to be a natural, if sometimes inconvenient sexual encounter from which women, like slightly annoyed hens, pick themselves up, shake their feathers, and go on about their business. The roosters strut away to further conquests. (99)

Then in 1998 in *The Green Breast of the New World: Landscape, Gender and American Fiction*, Westling addresses the topic again, emphasizing the extent to which rape is both frequent and unremarked in the plots, writing that Welty's "treatment of sexual assault darkened as her career progressed . . . but she never seems fully able to confront it from within the consciousness of a female character who is its victim. She never directly condemns it, but instead always seems to sympathize with the need of the man who 'takes' a woman" (131).

In some contrast to Westling's early discussion of Welty's portraits of female inviolability, Claudia Roth Pierpont has contributed to making the topic of rape in Welty's fiction still more provocative. Building on a presumptuous suggestion in Ann Waldron's 1998 biography of Welty, she goes even further than Waldron and writes in her now-infamous review essay, "A Perfect Lady":

> Although Waldron concludes that the available facts do not establish "whether [Welty and Robinson] were friends or lovers," she notes that Welty's fiction is fraught with signs that, sexually, something was horribly wrong.
>
> The books and stories would be quite sexless, in fact, were it not for the rapes—which are among the strangest such scenes in modern fiction. Without violence, without emotion, even without flesh, these peculiar events are all abstraction and tortured syntax. He "robbed her of that which he had left her the day before," Welty writes in *The Robber Bridegroom*. . . . "He violated her and still he was without care," according to a 1942 [sic] story called "At the Landing,"

in which the heroine eats an enormous meal immediately afterward, gratefully demonstrating her "now lost starvation." Waldron convincingly suggests a source for this dire but bodiless sex in Welty's deep entanglement with a man who would not touch her. (Pierpont 161–162)

Pierpont's psychoanalysis of Welty's rape plots is, as Michael Kreyling writes, clearly "intent on making the Welty pot boil" ("Welty and the Biographer" 131).

What has not yet been said and needs saying is that Welty's fictions rework familiar literary narratives of sexuality and rape in surprising ways, and her unexpected performances specifically interrogate a number of older versions of the rape plot. But before following this line further and arguing that artistically (and, so, personally) Welty's work is charged with something emphatically right rather than "horribly wrong," I want more broadly to answer Pierpont's implication that Welty's female rape fantasies are troubled signs of her own repression: tortured, possibly masochistic or adolescent at best, and in a post-Freudian view rather shamefully neurotic.

In a 1985 essay called "The 2,000-Year-Old Misunderstanding: Rape Fantasy," the film and literary critic Molly Haskell discusses her own evolving view of women's relationship to rape narratives. She tells of being interviewed by David Frost about her abhorrence of the rape plots in popular films and her insistence that these reflect strictly male fantasies. Frost challenged her assumption, wryly asking, "But what about women's rape fantasies? . . . Surely they have them. Where are the movies that portray them?" Haskell, caught off-guard in Frost's interview, insisted that women never, ever fantasize about rape. She reports having made the assertion because "rape is an act of battery carried out with sexual equipment . . . and no sane women—and very few insane ones—express such a desire, even unconsciously" (128). But, giving the topic more thought and discussion, she found herself corrected by numerous feminist friends who disagreed, explaining that women's rape fantasies have "nothing to do with the physical pain of ripping your vagina open . . . nothing to do with having a couple of teeth knocked out." Rather, the narrative is about "a partner chosen by a woman" who acts "not out of hostility but out of desire," and the plot is about pleasure, while of course actual rape is "a woman . . . violated against her will" (128). Haskell goes on to assert that fantasy is no "reflection of a woman's actual sexual behavior," and psychological study has found that "the most assertive, creative, independent wives were the most likely to fantasize [rape]. . . . Precisely those women . . . not confined to subordinate or masochistic roles . . . enjoy fantasizing the opposite (being dominated)—the 'road not taken'" (136). So in Haskell's view, female rape fantasy and narrative is as or more likely to be the exploration and indulgence of female pleasure than an example of repression.

Whatever we think of Pierpont's offhand psychoanalytic assertions and Haskell's anecdotal comments, Pierpont falls short of considering either the art or the variety in Welty's puzzling evocations of rape. Rather than read Welty's rape stories as all of a piece, a more useful analysis will see them as varied but related performances and, more critically, ask what we are talking about when we talk about rape in fictions. This is the question Sabine Sielke asks in her literary history *Reading Rape: The Rhetoric of Sexual Violence in American Literature and Culture, 1790–1990*. Sielke's analysis suggests that what is being discussed via the rape narrative is usually something else entirely: power, social change, class, race, difference, identity. Like Haskell, Sielke makes the point that rape narratives relate to real rape incidents and even to real rape fantasies "in highly mediated ways":

> [J]ust as men's castration anxieties do not . . . express . . . a desire to be castrated, women's rape fantasies do not prove that women crave sexual violation. . . . Instead such fantasies are a means women (writers) employ to renegotiate the fictions of—a supposedly masochistic—female sexuality deemed to complement an aggressive male sexuality. As such, they are imaginary interrogations of gender identities, sexualities, and power relations. . . . Just as we need to distinguish real rape from representations of rape, we . . . need to separate real rape fantasies from rape-fantasy fictions that reflect a double awareness of their own fictionality. What then, is the function of rape fantasies in women's texts? (160)

Or to make the question specific, what issues do Welty's representations of rape—comic and otherwise—interrogate?

My most general answer is that they are plots that consider female pleasure and independence, that they do tend to essentialize the positions of men and women, and that they play with and revise the vocabularies established by more canonical literary narratives of rape and also the gender identities embedded in these old plots. Like most American literature that includes rape, Welty's narratives are to varying degrees about class and race and social change. They are distinctly not revenge narratives in which a woman is punished for her independence ("At the Landing," even as it comes close, is different still, as I hope to show). As a pattern and as Westling notes, even in the dark tales, these rapes are survived and often—though not always—thoroughly so. To best understand the issues raised by Welty's representations of rape, a closer and specific textual analysis is called for.

Welty's Comic Rapes: Rape Fantasy in *The Robber Bridegroom* and "Sir Rabbit"

As a modernist and a woman writer, Welty characteristically revised old stories. She had a distinct taste and talent for the intricate and subtle parody of

familiar narratives. More than that, unconsciously doing the revisionist work of a woman writer, she often strategically revised whole generic patterns, playing with the old both to undercut—often with laughter—and to make the new. Sielke tells us that this is something rape narratives also do—revise older rape stories. In Welty's odd comic rape stories, she revises classic rape plots that she specifically and explicitly embeds into her playful and challenging texts through allusions. In the case of *The Robber Bridegroom*, the specific old story being revised is the ballad "Younge Andrew" and in the case of "Sir Rabbit," it is Yeats's "Leda and the Swan." In these two texts her heroines revise the old stories in ways that transform plots and bring forward issues of female voice, female imagination, female point of view, female pleasure, and female autonomy. By attending to these revisions, I will be revising Pierpont's remark that the oddness of Welty's comic rapes is a sign that "sexually, something was horribly wrong." Welty's sexuality might perhaps have been more textual than actual, but her stories are about revision, not repression.

In American literature the roots of the rape plot are in Susanna Rowson's *Charlotte Temple* (1791) and Hannah Foster's *The Coquette* (1797). Would Welty have known these late eighteenth-century fictions? It would be wrong to put familiarity past a writer who so routinely remembered and reworked old stories, but the point is, she did not need to know the specific texts; she certainly knew the genre. In these and other narratives of the type, the female mind is penetrated by male words and, as in Samuel Richardson's *Clarissa* (1748), maleficent seductions end in rape. The meaning of this traditional rape plot is as much about class, power, and social change as sexuality (think of Richardson's Clarissa, who is vulnerable not only because Robert Lovelace is a lying and malicious man intending rape but because she is attempting to stand alone against his aristocracy, against her patriarchal family, and, behind those, against the period's entire economic system). Another signification is about gender and power for, in these tales, women are rapeable, and men are not. The classic plots construct polarized gender differences that cast female sexuality as open to victimization and violation. Welty's comic rapes, however, do not. There, women successfully manipulate the situations that might threaten them, to move toward female pleasure.

A key to the rape narrative in *The Robber Bridegroom*, not often noted although I have written about it before, is that Rosamond sings and others sing to her, throughout the text, snippets of "Younge Andrew" (Child, no. 48), an old ballad about lying seduction, theft, sexual violence, fathers, lovers, and betrayal. In the full ballad, called up by its refrain, which recurs in the text, Andrew persuades the girl who loves him to rob her father so they may marry. But later he unpredictably steals all her clothing and the money that she has taken for his sake; abandoning her, he gives her the choice of going home naked and shamed, or dying on the spot. When the betrayed and jilted

girl, who chooses to go home naked, is sent off by the robber bridegroom, who preferred to steal all she would have freely given, she returns home to her father. Her father then leaves her to die naked on his doorstep, and she thus is maimed by two loveless men. "Younge Andrew" is a story of rape defined as one man's theft of another man's property, in which female value is synonymous with male control of female sexuality (i.e., her purity). Its poor heroine is hopelessly caught between lover and father in ways that call up Catharine MacKinnon's analysis of rape, which was treated by the law not as "a violation of woman's personhood . . . but [as] damage to male property, a kind of robbery," of interest only as an event between men and primarily a threat to the established socioeconomic order and so a class issue (Sielke 19). At one level *The Robber Bridegroom* parodies this established plot. Rosamond's father, Clement, comically negotiates for his daughter's protection with her potential rapist, Jamie Lockhart, in a barter that proposes her as precious goods, passed between men in recognition of their alliance.

The traditional seduction and rape narrative also scripts a woman's loss of social viability (her figurative death) to be a result of her failure to cooperate with class-based female protection. If seduced and/or raped, she forfeits her capital for maintaining or improving her class status, and, as Sharon Stockton argues in *The Economics of Fantasy: Rape in Twentieth-Century Literature*, the narrative of rape reflects vulnerabilities within capitalism. *The Robber Bridegroom* is a text that parallels the doubleness and duplicity of an economic thoroughfare (the Natchez Trace) and an economic capital (New Orleans), and in the narrative, capitalism itself is paralleled with the doubleness and duplicity of masculinity. Rosamond's difficulty is how to have her way while handling those varieties of doubleness, and most specifically the duplicity embodied when the tedious suitor brought by her father is the robber bridegroom that she secretly prefers.

When transgressive Rosamond sings the old ballad's refrain about a dangerous lover, she seems actively to conjure Jamie—a glimmering and shape-shifting boy who is the counterpart to the glimmering girl in Yeats's "The Song of Wandering Aengus"—just as the original ballad's heroine dreamed up her lover: "As I was cast in my ffirst slepe, / A dreadful draught in my mind I drew, / Ffor I was dreamed of a yong man, / Some men called him yonge Andrew" (Child 48.1). So an issue in the ballad's dual seduction/violation plot is a young woman's "unruly" sexual fantasy and vulnerable, dreaming imagination. In *The Robber Bridegroom*, Welty's heroine is penetrated by more than one seductive but problematic old story ("Younge Andrew," the Grimms' tales, Apuleius's story of Psyche and Cupid)—but Welty recalls and at the same time transformatively revises their plots. Unlike the classic Philomela, whose rape is synonymous with silencing (her tongue is cut out so that she cannot name her rapist), Rosamond is known as the girl from whose

lips mutable "lies would simply fall out like diamonds and pearls" (*Robber Bridegroom* 39): that is, her treasured gift is for making stories suit her. Her preoccupation with the "Younge Andrew" ballad allows a reader to glimpse her strategy for self-creation (she fictionalizes her way into her future) while both explaining the reasons for her suspicion of romantic love and yearning for it. Jamie finds "Rosamond singing so sweetly, as if she had been practicing just for this" (45–46). But she rewrites the ballad even as they borrow their interchanges from its storyline: Jamie's interest in each successive layer of clothing as he steals them; Rosamond's supplication: "were you born of a woman?" (48); Jamie's reply that he will have all; Rosamond's story of the father and seven brothers who will want revenge; and her decision to go home naked rather than die on the point of a sword—all come from the original ballad. In effect, when these two meet, they invent their sexualities along the ballad's lines while Rosamond is simultaneuosly revising them. Singing lines from the ballad, telling its story (17), Rosamond is educating herself about a potentially victimized definition of woman, which she expects to disarm. Part of what she will disarm is this:

Red as blood the horse rode the ridge, his mane and tail straight out in the wind, and it was the fastest kidnapping that had ever been in that part of the country. . . . [Jamie Lockhart] laid her on the ground, where, straight below, the river flowed as slow as sand, and robbed her of that which he had left her the day before. (64)

Is what happens to her here in this fairy-tale rape? Djuna Barnes writes in her wild, poignantly aware, genre-breaking comic parody of classical rape narratives, *Ryder* (1928), "at least . . . it never hurts in the reading" (193), a comment on how *literary* rape, even brutal literary rape, has the potential to be titillating. Welty's light movement from rape to love—oddly as it must strike Welty readers whenever they venture certain kinds of feminist framings—itself has troubling antecedents in history. Frances Ferguson in her essay "Rape and the Rise of the Novel" explains how rape could unhappily be made "right" in accordance with Saxon law:

The raped virgin could retroactively consent to her rape. . . . Only with such an assumption could the legal recompense for rape turn out to be marriage, which formally (in this case legally) implies the consent to intercourse that was previously lacking. Marriage recasts rape [in this history], so that marriage is a misunderstanding corrected, or rape rightly understood. (92)

But Rosamond happily rather than tragically marries her "rapist." She, not her father, is the revising agent. The plot is about her opposition to her father's design until she discovers in the comedy of mistaken identities what or who she wants and has her way.

Yet in this fairy tale, Welty is not content to give Rosamond the power to transform rape into love without making Rosamond acknowledge the alternative, disparate reality of rape. The heroine is fantasy raped, but her counterpoint double, the Indian maiden, the other woman, is spread on a table, mounted, and then killed. This doubling reworks the Grimm brothers' "Robber Bridegroom." In their dark fairy tale, a father arranges for his daughter's marriage to a man who fills "her heart with a sense of horror."[2] When she visits his house in the woods unannounced, a bird sings to warn her: "Turn back, turn back. . . . You are in a murderer's house." Hiding, the daughter witnesses the robber bridegroom and his men drag in another girl. "Then they ripped off her fine clothes, laid her on a table, chopped her beautiful body in pieces and sprinkled salt on it. . . . One of them noticed a gold ring on the murdered girl's little finger. Because it did not come off easily, he . . . chopped the finger off, but it flew into the air and over the barrel, falling right into the bride's lap." The bride, later telling the story of her awful "dream" in the presence of the bridegroom's guests, ends her narrative by flourishing the evidence of the finger, bringing the wedding plans to a halt.

Welty's *Robber Bridegroom* clearly references this prototype while fitting it to her pattern of the other woman; she investigates the brutality of rape through the exposed body of the Indian maiden. Interestingly when John Robinson suggested that Welty consider cutting this violent scene for their never-to-be completed collaboration on a scripted version, she wrote to refuse: "I feel in one way the murder or rape should stand . . . all that bandit scene with a girl who might have been Rosamond if she weren't herself pertains to [Jamie Lockhart] and is the black half of his deeds . . . and I feel that the actual horror should be given—simply and quickly, but no mistake—I feel this element should be in it" (December 1948).[3] Welty's choice is to balance her comic rape with "actual horror."

It is particularly interesting, given Welty's unfolding history with John Robinson's closeted identity, to think of them collaborating in 1949 on the further revision of a tale about secret identities and the unknown beloved. Peter Brooks in *Body Work: Objects of Desire in Modern Narrative* asserts an explanatory parallel between the emergence of the concept of privacy as a mark of personhood and the rise of the novel with its attention to sexuality and the individual body. As if in confirmation, *The Robber Bridegroom*'s allusive play with stories of seduction and rape highlights notions of separateness, individual identity, and love as an invasion of privacy, discussed through discourse figuring exposure of the body. Welty's plot turns in a way that creates a role reversal between Jamie's comic invasion of Rosamond's body of privacy (her private body) and her eventual violation of Jamie's privacy, when she removes his mask and discovers the secret personal identity that he has guarded.

This plotline also rewrites the old story of Psyche's seduction by Eros. In the tale told in Apuleius's *The Golden Ass*, the god of love comes in disguise to Psyche, who welcomes him. But then she is counterseduced by her jealous sisters to discontent and a need to expose his secret identity. Her special lover, Eros himself, warns her that he will leave her if she ever looks too closely at him. But Psyche, with her name that suggests the mind and its need to know, turns a light on Eros while he sleeps. Welty's reworking is close to this plot: when Rosamond is investigating Jamie a drop of hot oil from her lamp burns his shoulder, and the slumbering beloved awakens and departs. Only after arduous pursuit does Psyche regain Eros; in Welty's revision, Rosamond regains Jamie only through gradual acceptance of her lover's separateness, the secrets of his identity that have nothing to do with berry stains.

In the archetypal seduction narrative of American literature, the loss of virtue and honor, whether forced or not, "leads only one way, downhill" (Sielke 19). However Welty and her heroine together revise those old stories so that Rosamond strides uphill—to love, wealth, social standing, and a daughter's freedom. If this tale evokes older, more sinister tales only to transform them joyously, it also upsets the optimistic expectations freshly built. Rosamond's success in handling her father and her lover and confidently having her way both occur in a tale so evidently built on stories that it explicitly reminds us that robbery and rape lead to love in fiction only. Welty's allusions, having intensified the reader's awareness of being immersed in fiction, undercut the text's transformations with the aura of make-believe and modernist fairy tale, and emphasize doubleness, more than optimism, explicitly as the narrative closes in New Orleans, a city where "beauty and vice and every delight possible to the soul and body stood hospitably, and usually together, in every doorway" (*Robber Bridegroom* 182). There, Rosamond gives birth to twins fathered by Jamie.

While *The Robber Bridegroom* reworks the rape plot of "Younge Andrew" and issues of female self-determination in the midst of narratives of property and duplicity, "Sir Rabbit" challenges the embedded rape plot of Yeats's "Leda and the Swan," a traditional story full of female passivity and vulnerability as well as masculine divinity, power, knowledge, and control. Mattie Will's sexual fantasy—her fictionalizing—is one component of Welty's larger story cycle about mythmaking in a small town. That is, *The Golden Apples* concerns a number of characters who wander imaginatively, but privately, in reverie. Daydreaming, story-making, fantasy, gossip—these are impermanent but readily accessible creative forms available to the cerebral rather than actual wanderers of *The Golden Apples*, many of them women who wander into wondering and who inhabit private inner lives that are more exploratory than their conventional public lives suggest.

Commonly, criticism associates Welty's evocation of Yeats's "The Song of

Wandering Aengus" with King MacLain and Virgie Rainey, but the title of the cycle's final story, "The Wanderers," is equally relevant to the narrators who amble into others' lives and "compose" reveries on the meaning of wandering. Wanderers, then, come in two guises: those who seek imaginatively and those who seek adventurously. Through Welty's control of point of view, the reader enters stories being composed by Katie Rainey, Mattie Will Sojourner, Cassie Morrison, and Nina Carmichael—who all share the centers of their stories with the characters they create while mythologizing. Their subject characters—King, Virgie, Easter—are interesting not only in their own right, but for their mythic stature in their neighbors' imaginations. Through a community's shared mythmaking, they are made emblematic of the individuals' longings for freedom; of boundary breaking; of creative, erotic, probing roaming. These wanderers become characters in their neighbors' thinking. The short story cycle—which puts the focus dually on imaginative and actual wanderers, who together comprise the story of Morgana, rather than on either the housebound or the adventurers alone—partly concerns the tension between fantasy as it is used to satisfy the needs of the story-makers and fantasy as it surrounds the subject characters (such as Ran and Virgie), who resent their neighbors' reveries that, entering the public sphere, define the community but also intrude on the individuals' unfolding lives.

This strained (and constraining) relationship between teller and subject is an issue from the collection's outset. Snowdie MacLain's resentment of Katie Rainey's engagement with the MacLains' story in "Shower of Gold" is obvious when Snowdie will not let Katie deliver her butter any longer, but instead comes to get it, effectively keeping Katie from taking away any additional narrative about her house (CS 274). Katie's telling of Snowdie's story is drizzled with sexual fantasies that set up "Sir Rabbit"; she wonders about King MacLain's "outrageous" nighttime appointment to meet his wife in the woods. She provocatively suggests that, on his most recent visit to his wife, King may have tarried long enough to father another child somewhere, obliquely suggesting that her surrogate fantasy may have been personally fulfilled and that she may be a more complex woman than her daughter—in the collection's final tale—seems to think she is. Katie's follow-up remark, "What makes me say a thing like that? I wouldn't say it to my husband, you mind you forget it," flirts at naming her involvement with King, imaginative or actual (CS 274). But as particular as Katie's involvement may be, she is also reflective of an entire community that engages in fantasies that make use of King MacLain.

In Katie's and the community's imaginations, King is the emblem of unconventional freedoms, especially sexual ones. Mattie Will in "Sir Rabbit" thinks that "he never did feel constrained to live in Morgana like other people and just visited Mrs. MacLain a little now and then. He roamed the county end on end, living up north and where-all, on funds; and might at any time

appear and then, over night, disappear" (CS 331). Snowdie, in her unconventional marriage to King, seems not only to accept but to allow her husband's wandering and to be relatively content with the independence he leaves her. "Her version is that in the woods they met and both decided on what would be best" (264). Snowdie's permissive or independent responses to the transgressive "scoundrel" King irritate but fascinate her neighbors, Katie among them, because Snowdie fails to play the expected role of betrayed wife; she allows King to go and come, seemingly without bitterness but with continued eagerness for and pleasure in his sporadic visits. "Why didn't she rage and storm a little?," Katie asks (266). What particularly catches Katie's imagination is Snowdie's response to King's long-distance invitation: "suppose you meet me in the woods" (264). Katie's meditative monologue, addressed both to a passing traveler who stops at her roadside stand and to her readers, considers familiar plots about husbands and wives, but tells an unconventional story. (Recall that Welty is writing *The Golden Apples* as she is sorting out her coming and going relationship with Robinson and undoubtedly feeling the pressure of their community's conventional narratives about men and women, plots that the two of them will not deliver.) With Plez's help, Katie "fabricate[s]" the MacLains in what Patricia Meyer Spacks calls "serious gossip"—an art form that greatly resembles the study of literature and satisfies the same needs: to wonder and speculate on other lives; to sort out complicated predicaments, dilemmas, conceptions, and moralities; and to discover and create a point of view and a voice in the process of that reverie. As Katie observes, "With men like King, your thoughts are bottomless" (274).

Mattie Will's fantasizing about King, like Katie's storymaking and even more like Cassie's reverie on Virgie and Miss Eckhart in "June Recital," plays a role in the young woman's production of a gendered self. In constructing her fantasy she defines herself and a gendered story with and against standard plots and old tales. That "Sir Rabbit" is a sexual fantasy is not clear to everyone; some have read it as a descriptive report. But the significant controversy should not ultimately be whether Mattie Will implausibly succumbs to King's seduction with a shout for Blackstone to "turn . . . around and start picking plums" while her stunned husband lies a few feet away (CS 338). Rather, the more complex and fruitful debate, as Patricia Yaeger's early work on the story first recognized, is about how in this text Welty has her way with Yeats's "Leda and the Swan." I explore this by examining the transformation of the poem's established rape plot, which is called up by Welty's allusions.[4] Yeats's sexual plot is remade in a story of female sexuality different from passivity and violation, one instead acknowledging that Mattie *Will* pursue her pleasure, aggressively and imaginatively.

Welty's story, constructed in two demarcated sections, begins in a forest romp with the MacLain twins. The first question for a reader is whether this

opening escapade is a memory or a fantasy, an uncertainty that need not and cannot be settled as if in a court but that guides a reader into the center of the tale. Mattie Will is first touched by a thought of the fabulous philanderer King MacLain, and she calls out, "Oh-oh, I know you, Mr. King MacLain" (CS 331), even while recognizing her own impudence at dreaming an encounter with the mythical man on whom she has never laid eyes up close. In a direct inversion of Yeats's "Wandering Aengus," Mattie Will Sojourner (her maiden name is a counterpart to Yeats's "wanderer") glimpses an arousing glimmer in the woods. Ready to fantasize King MacLain's reaching for her, she finds herself surrounded by his twin sons—with "two eyes here and two eyes there . . . and all those little brown hands" (331). With pleasure as much as surprise, as in a fantasy that displaces and improves, Mattie Will substitutes the "town boys" for the erotic legend of King: "two little meanies coming now that she'd never dreamed of, instead of the one that would have terrified her for the rest of her days" (331). She pictures the boys, out in her country, undone knee buckles jingling, fair bangs in the soft downy light, "a pony pair."

> They made a tinkling circle around her. They didn't give her a chance to begin her own commotion. . . . One of the twins took hold of her by the apron sash and the other one ran under and she was down. One of them pinned her arms and the other one jumped her bare, naked, feet. Biting their lips, they sat on her. One small hand, smelling of a recent lightning bug, blindfolded her eyes. The strong fresh smell of the place . . . came up and they rolled over on the turned-up mold, where the old foolish worms were coming out in their blindness. (332)

Mattie Will, "too old—fifteen—to call out now that something was happening" (331), reciprocally engages the frisky brothers: "She had set her teeth in a small pointed ear that had the fuzz of a peach, and did not bite, since they were all in this together, all in here equally now" (332).

This opening frolic jumbles sexual capering as much with the exposure of female desire as with concern for female vulnerability. At first the story seems to situate the romp as memory: "She would think afterwards, married, when she had the time to sit down—churning for instance—'Who had the least sense and least care for fifteen. They did, I did. But it wasn't fair to tease me. To try to make me dizzy, and run a ring around me, or make me think that first minute I was going to be carried off by their pa. Teasing because I had to open my mouth about Mr. King MacLain before I knew what was coming" (CS 333). But what sounds like wistful memory regains the feeling of an embellished one as Mattie Will imagines what her young husband, Junior Holifield, would think: "Tumbling on the wet spring ground with the goody-goody MacLain twins was something Junior Holifield would have given her a licking for, just for making such a story up, supposing, after she

married Junior, she had put anything into words. Or he would have said he'd lick her for it if she told it *again*. Poor Junior!" (333).

With story-making and its suppression—a husband's patriarchal control and his attempt to repress her female desire—overtly evoked, Welty's story abruptly shifts into a second section. This division suggests not only a change in time and place (from kitchen churning to another afternoon in Morgana's woods), but also a move deeper into Mattie Will's ribald fantasy life.

Reinforcing the impression of a slip into sexual fantasy, the text's presentation of King is full of language that carefully suggests evanescence and evaporation. King is both substantial and not. He is "sometimes as completely hidden by even a skinny little wild cherry as if he'd melted into it" (*CS* 335). He is one apparition speaking to another: "'Bless God. Come out in the open, young lady. I can hear you but not see you,' Mr. MacLain called, appearing immediately from the waist up" (335). His configuration as a white "glimmer" (334), Welty's explicit appropriation of Yeats's "Aengus" poem, reverses the poem's gendering and positions Mattie Will as beckoned sojourner and erotic wanderer. In her fantasy, however, she becomes the prize in an afternoon's competition between her husband, Junior, and King MacLain. What is unexpected is that the fantasy lingers so much on the presence of Junior and Blackstone in the woods with King and Mattie. She frames her fantasy with a discussion between her husband and her rapist concerning the issue of "trespassing," again suggesting the treatment of rape as a kind of robbery, of interest only as an event between men. While King suggests they are "two hunting men letting each other by and about their own business" (335), Junior sees King as the agent of class entitlement, as "the one gits ever'thing he wants shootin' from around trees, like the MacLains been doing since Time. Killed folks trespassin' when he was growin' up, or his pa did, if it so pleased him. MacLains begun killin' when they begun settlin', and don't nobody know how many chirren he has" (336).

Unlike in *The Robber Bridegroom*, this male interaction is not a trade of female property that allied men propose; it is more a class competition, a theft signifying a *droit du seigneur* for the king of the woods. Why does Mattie's fantasy go there? Is King's status exciting? Or is her pleasure tied to the danger and voyeurism implied in having Blackstone and Junior so close to her and King in the woods? Another pleasure enjoyed is certainly Mattie Will's escape of Junior's possession. She triumphs over his expectation that he will control his wife's desire, volition, and voice. He warns her, "Show yourself and I'll brain you directly" (*CS* 336), but Mattie will. Invited by King in the flirtatious language of mannered chivalry, "Won't you come out and explain something mysterious to me, young lady?," he sounds to her as "if he just thought of it [her pleasure?] and called it mysterious" (335). Mattie scripts Junior into a desire

to fight for her and has Junior offer to "shoot [King] right now if he catches a holt of Mattie Will, don't care what happens to us or who we hit, whether we both go to the 'lectric chair or not" (337). But "Mattie Will looked up at Mr. MacLain and he beamed at her." Then the trespassing King, given her "go ahead" glance, fires his buckshot, sends a "load out . . . down over her where she held to some roots on the bank, and right over Junior's head. . . . Baby holes shamed [Junior's hat] all over, blush-like" (337). King's weapon explodes, and Mattie Will's husband is symbolically cuckolded, marked, and mortified.

What happens next is Mattie Will's comic, undercutting, satirical triumph over Junior's notions of masculinity: "Big red hand spread out on his shirt (he would always think he was shot through the heart if anybody's gun but his went off). Junior rose in the air and got a holler out. . . . There was a fallen tree, a big fresh-cut magnolia some good for nothing had amused himself chopping down. Across that Junior decided to light . . . head and body on one side of the tree, feet and legs on the other. Then he went limp from the middle out, before their eyes" (CS 337). With one embodiment of controlling masculinity disposed of, Mattie Will welcomes King MacLain's stirring and swelling "like the preternatural month of June." King thumps Junior, "like a melon he tested and let him lie—too green" (338), and Mattie Will calls to Blackstone, "Turn *your* self around and start picking plums!"

The rape fantasy that Mattie Will proceeds to unfold repeatedly calls up "Leda and the Swan." But Mattie will revise this major modernist text's vision of masculinity as godly swan, that is, divine, elegant, poised, perhaps preening, the physical embodiment of breathtaking grace and strange, imposing power. "Shower of Gold" has already played with the image of the swan in Katie Rainey's remarks on the community's reaction to King's marriage to the pink-eyed Snowdie: "'I swan!' we all say. Just like he wants us to, scoundrel" (CS 263–264). There, Katie's colloquial exclamation allows Welty to layer an allusion to Yeats onto the community construction of King as a glamorously divine transgressor. The allusion conflates two Zeus myths (Danäe's shower of gold and Leda's swan) in ways that present King's sexual transgressions as, essentially, a rogue's gift. But Mattie Will's comic variation on Yeats's swan recasts King as the less divine goose: "MacLain's linen shoulders, white as a goose's back in the sun, shrugged and twinkled in the glade" (338), and before the story is over, she recasts him as a sexually frenetic comic rabbit, undercutting King just as thoroughly as she has taken Junior down.

Leda and the swan is a bit of mythology that has a long history of artistic interpretation. See, for example, the Antonio da Correggio (1532, fig. 5.1) and François Boucher (1741 and ca. 1740, figs. 5.2 and 5.3) interpretations in which the swan is a phallic invader connected to female pleasure. See also Théodore Géricault's painting (1880, fig. 5.4) in which the muscular Leda is the equal of the divine bird she is about to grapple with, and Salvador Dali's

Leda's Swan (1961, fig. 5.5), which makes the two wild, equal, and joyful partners. In comparison to these renderings, Yeats's 1924 poem's rape plot emphasizes an astounding and unforeseen violence and attack:

> A sudden blow: the great wings beating still
> Above the staggering girl, her thighs caressed
> By the dark webs, her nape caught in his bill.

Moreover, the poem specifically eroticizes female submission and vulnerability:

> He holds her helpless breast upon his breast.
> How can those terrified vague fingers push
> The feathered glory from her loosening thighs?

The eroticism of Yeats's female vulnerability is in direct contrast to Géricault's presentation of his muscular Leda. Yeats's presentation contrasts too, as Sharon Stockton notes, with T. S. Eliot's in "The Waste Land," where rape is a regretted marker of debased sexuality evoking neither wonder nor excitement. But different as they are, Yeats's and Eliot's modernist texts similarly yearn to assert and restore male power in the context of its diminishment by the historical circumstances of their period. By contrast, Welty's rape plot presents both the glory and the ironies of a mythological masculinity, while moving to mock it, introducing a female viewpoint more interested in female pleasure and autonomy than in the twentieth-century modernist tribulations of patriarchy, which it nevertheless recognizes.

Yeats's poem also asserts masculinity, not at the mercy of history, but as history's father, designer, and source: with this rape Zeus will spawn Helen and, in turn, the Trojan war:

> A shudder in the loins engenders there
> The broken wall, the burning roof and tower
> And Agamemnon dead.

And the question that Yeats poses for Leda is about both the precise nature of the intimacy that has fallen upon her unasked and, importantly, its informing and elevating impact on her. Yeats asks: if penetrated by the divine source of history, is Leda improved and educated to share Zeus's shocking awareness?

> Being so caught up
> So mastered by the brute blood of the air,
> Did she put on his knowledge with his power
> Before the indifferent beak could let her drop?

It is exactly this inquiry about female insight into the mythic masculine that Welty chooses to parody and transform in her comic retelling. Her rape

fantasy brings Mattie close enough to the mask of masculinity to study it. The climax of Welty's story is a minute beyond erotic pleasure. It has to do, at last, with studying the masculine and in a flash understanding its limitations. The knowledge of King that Mattie takes from her close encounter with the thought of him reveals him not only *as* the legend but as pressed by it:

> When she laid eyes on Mr. MacLain close, she staggered, he had such grandeur, and then she was caught by the hair and brought down as suddenly to earth as if whacked by an unseen shillelagh. Presently she lifted her eyes in a lazy dread and saw those eyes above her, as keenly bright and unwavering and apart from her life as the flowers on a tree.
>
> But he put on her, with the affront of his body, the affront of his sense too. No pleasure in that! She had put on what he knew with what he did—maybe because he was so grand it was a thorn to him. Like submitting to another way to talk, she could answer to his burden now, his whole blithe, smiling, superior, frantic existence. (CS 338)

As Leda in Yeats's poem perhaps puts on the swan's "knowledge with his power / Before the indifferent beak could let her drop," Mattie Will daydreams her way into an intuition of King's secret burden—knowledge of his unappeased (frenetically insatiable?) longing, which is at odds with his grand public masculine mythology. King may be majestic in his appetite, but penetrating King with fantasy, Mattie Will recognizes that his wandering suggests a quest and pursuit that is "blithe, smiling, superior, [and] *frantic*."

The effect here is of mock-heroic parody. King is not Zeus, and in a moment Mattie will recognize him as a rather frenzied Sir Rabbit who dances in the wood. Just as she left the all-too-male Junior undercut—unconscious and limp across a tree—she pictures walking "right up on Mr. MacLain" in a similar posture and studying him closely: "asleep—snoring . . . his back against a tree, his head pillowed in the luminous Panama, his snorting mouth drawn round in a perfect heart open to the green turning world around him. . . . now she had time to look at anything she pleased and study it" (CS 340). And what she pleases to study is his private part, figuratively and literally: his masculine "parts looking no more driven than her man's now, or of any more use than a heap of cane thrown up by the mill, and left in the pit to dry. But they were, and would be" (340).

As Mattie Will investigates King's masculinity, he awakens suddenly, apparently terrified for what such close scrutiny "could or would take away from him—Mr. King MacLain." He "leaped to his feet, bolt awake, with a flourish of legs. He looked horrified—that he had been seen asleep? and by Mattie Will?" Mattie, enjoying the arousing myth of King MacLain, would *not* take anything away from him or it, but she sees King differently than Katie does.

Despite his legendary manners and gallantry, she pictures him not as a regal, transgressive swan, but as a rutting rabbit:

> In the night time
> At the right time
> So I've understood,
> 'Tis the habit of Sir Rabbit
> To dance in the wood—
> That was all that went through Mattie Will's head. (340)

Mattie is remembering a ditty that reached a wide audience through American school primers. But in this context, the poem is not sexless childhood doggerel. Unlike the elegant swan who mates in elaborate ritual and display, the rabbit is a creature whose courtship and mating is legendarily brief (less than a minute), a renowned breeder whose sexuality, however, is emblematically frenetic. Like Br'er Rabbit, Sir Rabbit is a trickster figure and as such is associated with the unpredictable and outrageous, with the violation of taboos, with sexual prowess, but also with both the preposterous and comic deflation. Mattie Will's visioning celebrates King as an insatiable lover of women—and just as completely sees through him. Not a dangerous, divine lover, he is a hyperactive one. Having understood King as both myth and something less—a man aware of the discrepancy between his public and private selves—Mattie imagines the defensiveness that this self-knowledge might produce. She fantasizes him discovering himself studied; the agitated Sir Rabbit, sensing that Mattie Will has surely "put on his knowledge with his power," protectively chases Mattie off: "Mr. MacLain beat his snowy arms up and down. 'Go on! Go on off! Go to Guinea!'" (CS 340).

Like Katie Rainey, Mattie Will "figures" King. When his idealized sexuality and legendary quest appeal to her imagination, she conceives him as an attractive delinquent whose glory is his desire. But when she studies this delinquent masculinity, she wanders into the idea of his unappeased longing. Like Katie's, Mattie's conception of King—established by allusions scattered throughout the text—is at first fabled and thrilling, but then undercut. The effect is that while Katie and Morgana have built one myth of King, Mattie Will and Welty emphasize another. And in this one he plays not the miraculous Zeus, nor the renowned lover, but the wandering Aengus, the never-to-be-satisfied sojourner whose desire is both commonplace and heroically gargantuan, both comic and poignantly representative. He is a man who, when old and on the verge of death in "The Wanderers," is still voraciously hungry and plagued by a feeling that, despite all his comings and goings, he has "ended up at the wrong end" of desire (CS 443). Then Virgie treats him with respect, while Snowdie shakes her head over him in a gesture expressing a mix of exasperation, comprehen-

sion, and forbearance. Ultimately Mattie Will's image of King as a comic folktale rabbit mingles and merges into the more somber memory of those "lost beasts" that roam the conclusion of "June Recital," seeking fulfillment.

On the one hand, then, Welty's comic rape plots are "imaginary interrogations of gender identities, sexualities, and power relations" that revise the conventional story of a "supposedly masochistic female sexuality deemed to complement an aggressive male sexuality" (Sielke 160). On the other hand, Welty's presentations of Rosamond's and Mattie Will's empowering constructions of Jamie and King have as a context her series of stories that repeatedly focus on the way central characters (and communities) invest certain men with glamour and the status of hero, a series that includes *Delta Wedding* (George), "First Love" (Aaron Burr), and "At the Landing" (Billy Floyd). All these men, like Jamie and King, are associated not only with glamour, but also with disappearance. (Although this is less obvious in George's case, disappearance is precisely what Robbie fears is threatened in her husband's too-cavalier risk-taking on the trestle, what Ellen regrets about George's move to Memphis, and what Laura perhaps expresses by giving him the "gift" of stealing his pipe so that she can return it.) And disappearance is also presented as a masculine freedom. Additionally these beloved men all exhibit a doubleness that to varying degrees disturbs the idealized construction of their glamorous masculinity. Jamie, King, Billy Floyd, and Aaron Burr are all more complex than ideal, despite how they are at times seen. George is a family paragon who, while desiring to reconcile with his angered wife, oddly announces to his sister-in-law that he has slept with a glimmering girl found in the woods—a random and unexplained sex act in a cotton gin shed between a plantation scion and a runaway, at-risk young girl. Although the novel again sidesteps the makings of a conventional rape plot, this incident certainly smacks of something other than a girl's fulfilled sexual fantasy, especially when she ends up abruptly killed by the train that misses George.

Is the riddle of this pattern explained by the psychological makeup and imagination of a writer who as a young woman lost her father to a sudden lethal illness? Daughters who lose fathers in critical periods of psychological development often respond to men with a mix of idealization and anxiety. Some even arrange relationships that replicate the experience of loss (which could seem to apply to Welty's relationship with John Robinson and to her later relationship with Ken Millar, the safely married man doubly lost to Alzheimer's). Welty's central consciousness characters, however, use the stories of their fantasy men in ways that empower the women, as Welty, writing, perhaps makes assets of her adversities.

It seems too that after "Sir Rabbit" and after her experiences with Robinson (which resemble a woman studying a man's presumed performance of glamorous masculinity and recognizing the gap between the performance and

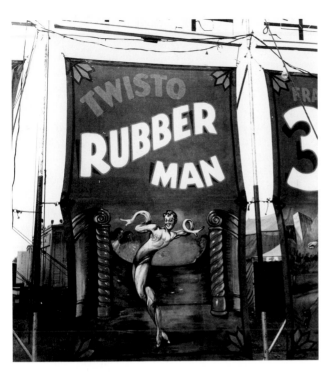

FIGURE 4.9. Eudora Welty, "Sideshow, State Fair" (Rubber Man, Jackson, 1939). Copyright © Eudora Welty, LLC.

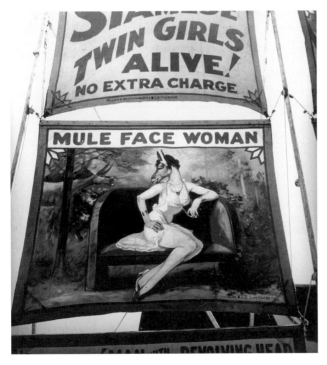

FIGURE 4.10. Eudora Welty, "Sideshow, State Fair" (Mule Face Woman, Jackson, 1939). Copyright © Eudora Welty, LLC.

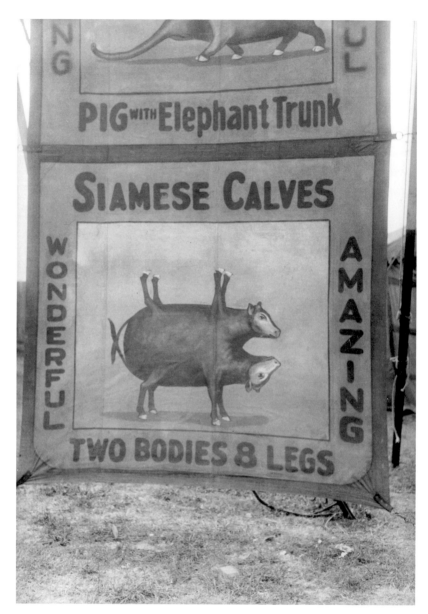

FIGURE 4.11. Eudora Welty, "Sideshow, State Fair"
(Wonderful Amazing Siamese Calves Two Bodies
Eight Legs, Jackson, 1939). Copyright ©
Eudora Welty, LLC.

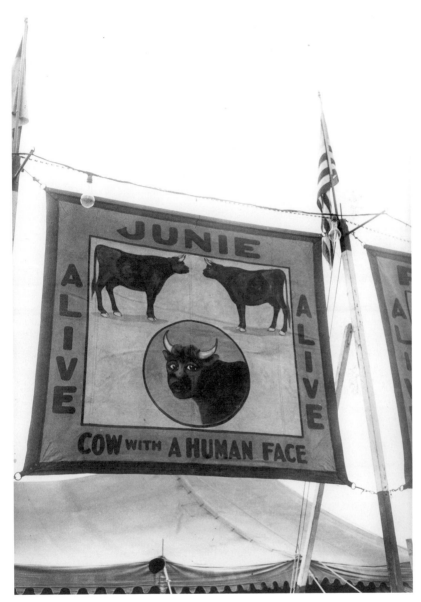

FIGURE 4.12. Eudora Welty, "Sideshow, State Fair"
(Junie Alive, Jackson, 1939).
Copyright © Eudora Welty, LLC.

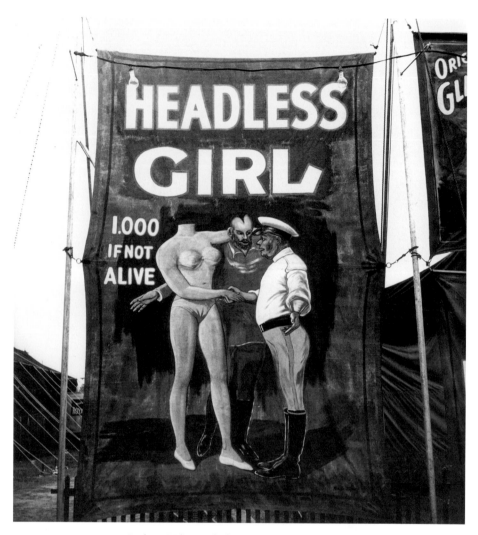

FIGURE 4.13. Eudora Welty, "Sideshow, State Fair"
(Headless Girl, Jackson, 1939).
Copyright © Eudora Welty, LLC.

FIGURE 4.14. Eudora Welty, "Hypnotized" (Jackson, 1939).
Copyright © Eudora Welty, LLC.

FIGURE 4.15. Eudora Welty, "Sideshow, State Fair" (Jackson, 1939).
Copyright © Eudora Welty, LLC.

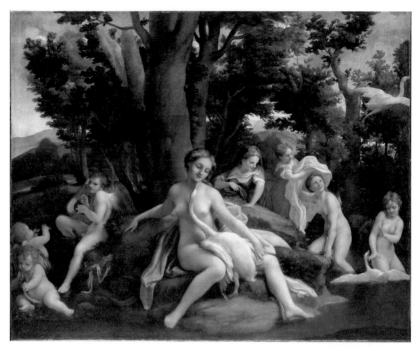

FIGURE 5.1. Antonio da Correggio, *Leda* (1532).
Courtesy of Staatliche Museen zu Berlin.

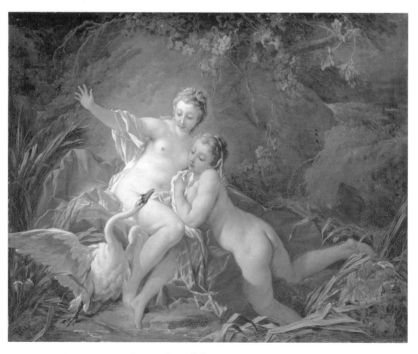

FIGURE 5.2. François Boucher, *Leda and the Swan* (1741),
Courtesy of Nationalmuseum, Sweden.

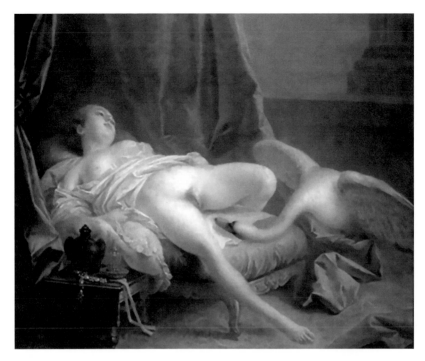

FIGURE 5.3. Attributed to François Boucher, *Leda and the Swan* (ca. 1740).

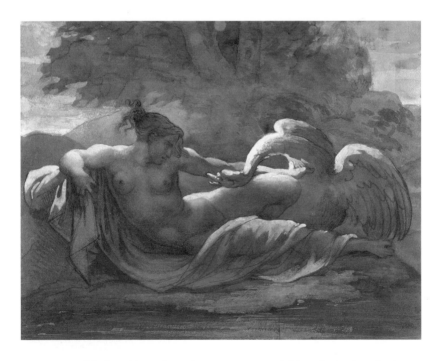

FIGURE 5.4. Théodore Géricault, *Leda* (1880). Louvre (Cabinet de Dessins), Paris. Photograph by Peter Willi, Bridgeman Images.

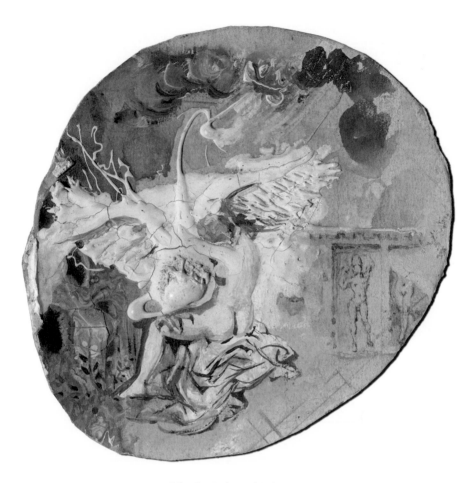

FIGURE 5.5. Salvador Dali, *Leda's Swan* (1961).
Image courtesy of Fundació Gala-Salvador Dalí
© Salvador Dalí, Fundació Gala-Salvador Dalí, Artists Rights
Society (ARS), New York 2015.

his own vexed, uneasy self-ignorance), Welty's initial pattern—in which ideal-
ized men retain their glamour even after they should have lost it, in which men
with thrilling freedom wander, all while their doubleness becomes visible—
shifts. After *The Golden Apples*, and even in that volume's final story, "The
Wanderers," it is women who risk finding freedom (Virgie; the various women
in "The Bride of the Innisfallen," including the American woman; and, later,
Julia Mortimer and Gloria Renfro in *Losing Battles*, and Laurel Hand in
The Optimist's Daughter). Meanwhile the men, like Jack and Judge McKelva,
come to represent home.

The Rape Plot Chiasmus: *The Robber Bridegroom* and "At the Landing" as a Reversed Pair

That *The Robber Bridegroom* and "At the Landing" are related as a chi-
astic reversed pair—a treatment of the same plot in contrasting literary
genres, variations written in the same time period—is an idea I have writ-
ten briefly about elsewhere (see "On Welty's Use of Allusion"), discussing
not only the classical allusions embedded in *The Robber Bridegroom* but
also those allusions in "At the Landing" that inconspicuously but noticeably
hark back to Welty's *Robber Bridegroom*. The stories, published in 1942
and 1943 and seemingly written at more or less the same time,[5] are linked
by the repetition in the names Jamie Lockhart and Jenny Lockhart and by
the parallels and inversions in the light and dark treatments of a daughter's
escape—into exposure, into fantasies of love, and into sexual fantasy, sexual
danger, risk, and experience. As in a creative writing class challenge, Welty
has replayed one plot in two disparate genres: fairy-tale parody and natural-
ism (although her use of the genre in each case is complex and amalgamated).
She explores two related tales of rape and love, following them to their very
different outcomes. I here trace in detail the parallels and inversions in the
two fictions' treatment and use of the rape narrative. In "At the Landing,"
one previous and familiar story of rape is summoned, reconsidered, and re-
vised: Welty's in *The Robber Bridegroom*—the fantasy in which rape can be
"made right" by retroactive consent and where there is a too-comfortable
(or uncomfortable) elision of revered and mythic masculinity and the male
rapist.

Although *The Robber Bridegroom* is light and playful in comparison to
its companion tale "At the Landing," there are informing parallels. Both are
daughter's stories about motherless girls being raised problematically by male
surrogates. In *The Robber Bridegroom*, Rosamond's father, naively unaware,
is determinedly—though humorously—insensible of the menace his daugh-
ter faces from his second wife's jealous competition and threatening ill will.
He is also obliviously unmindful of Rosamond's coming of age; he comically

meets it with a misguided, naive, "protective" impulse to marry her randomly to a dubious potential defender of her "honor." In the other, darker story, Jenny's grandfather's protective guardianship is even more disturbing; he has confined the girl just as he previously restrained her mother (his daughter, seemingly dead from longing, whose desire to escape from the Landing he treated as a "raving"). In his house, "Jenny could go from room to room, and out the door. But at the door her grandfather would call her back, with his little murmur" (CS 242). He has educated Jenny to shyness treated as goodness ("the grandfather was too old, and the girl was too shy of the world, and they were both too good . . . to come out, and so they stayed inside"; 241). The result is that Jenny has developed a "touch that dared not break" (242). Drawn to beauty, she appreciates the crystal prisms that, throughout the house, give "off the faintest of musical notes" and radiate "rainbows," but obedient to a regimen of restriction, "it was her way not to touch them herself. . . . It might seem that nothing began in her own heart." Now, as her grandfather approaches death, "one awareness was always trembling about her: one day she would be free to come and go" (241).

In both texts, then, violation is presented as a change from befuddled protection, and both narratives interrogate the ability of women to transform old plots into liberating futures. Both fictions address the issue of female pleasure, of a womanly desire for flirtation, gaiety, romance, and sex (so do "Livvie," "Lily Daw," "A Piece of News," and other early Welty stories). Both tales picture a lover arriving astride a red horse—associated with animal sensuality— in the woods of female fantasy and pleasure. Linked as he is to that horse, Floyd fascinates Jenny when he gallops "at a racing speed. . . . he seemed somehow in his tattered shirt . . . to stream with the wind . . . with flying yellow hair" (CS 245). And both tales are concerned with the discovery in love of a threat of ineradicable separateness. Like and unlike Yeats's Aengus upon meeting the glimmering girl ("who called [him] by [his] name / And faded through the brightening air"), Jenny soon "said [Floyd's] name, for he was so close by. It was the first time. He stayed motionless and she knew he lived apart in delight. That could make a strange glow fall over the field where he was, and the world go black for her, left behind" (245). Ruth Vande Kieft writes, in a passage even more controversial now than when she first published it, that Floyd "brings [Jenny] into the world: not only by his sexual violation of her, but more quietly and surely through her adoring response to his wild beauty" (58). Floyd, like King associated with a community construction of mythological masculinity, has an effect on Jenny that may bring "her into the world," but is at best mixed: unsettling and damaging. Floyd's name is of course a homophone for flood, suggesting the overwhelming end he will bring to Jenny's own habitual drought during the actual flood that engulfs the Landing. Floyd, like a flood that problematically ends dry weather,

is an ambiguous figure even in Jenny's infatuated perception. In addition to beauty, there is also "something handled and used about Floyd, something strong as an odor" when she sees him indoors, confined by domestic space. And when Jenny looks into "his shining eyes," she sees that they hold "the whole flood, as the flood held its triumph in its whirlpools, and it was a vast and unsuspected thing" (CS 250).

The rape plots of the paired stories, so different in tone, both advance issues of a woman's control over her sexuality, herself, her autonomy, and her future. Daughters move on from and replace the problematic filial relationships that might condition them to respond to violation with love. Each is robbed of what she would have given freely if allowed, and each is jolted into a "shock of love" (CS 253). Welty uses violation of the sexual body to initiate emancipation from childhood and from ladyhood both, and an ensuing propulsion into womanhood. In women's narratives defining female independence through the discovery of the sexual body, rape is a particular vulnerability, dramatizing the loss of control over the self (Sabine Sielke's provocative discussion of 1970s feminism and the rape plot in the literature and film of that period is relevant here; see Sielke 166), and these Welty stories share elements from that pattern. In the fairy tale of *The Robber Bridegroom*, the heroine's induction into womanhood and awareness of her body as her self turns out well, while in the naturalism of "At the Landing," it does not.

As in *The Robber Bridegroom*, rape leads to thoughts of love and marriage in "At the Landing" when Jenny's voice temporarily takes on a fairy-tale quality in her oblique wishes: "I wish you and I could be far away. I wish for a little house" (CS 251). Rosamond and Jenny are both pictured dulling the "shock of love" in compulsive, ritual domestic cleaning as they attempt to regain self-control and normalcy after trauma.[6] Returning home after the flood has deposited its slime—a disturbing metaphoric sexual innuendo—Jenny "was into a whole new ecstasy, an ecstasy of cleaning, to wash the river out. . . . she forgot even love to clean . . . but the shock of love had brought a trembling to her fingers that made her drop what she touched. . . . at last the trembling left and dull strength came back, as if a wound had ceased to flow its blood" (253). Defense mechanisms characteristically activated by actual rape victims range from "splitting off, denial, regression, and suppression to autoaggression and guilt, introjection and identification" (Sielke 91), and Welty seems to know about these as Jenny unfolds her normalizing response.

The chiastic pair of stories are also both complicated by problematic advice given by older women. Salome hones and manipulates Rosamond's gradually alarmed recognition of her lover's separateness, and Jenny is guided by the porch "wisdom" of old ladies, who come by "to celebrate her ruin" (CS 254) as they ask, "Why don't you run after him?" (255), promoting her fixation on Floyd.

But these reversed stories, parallel as they are in these ways, develop differences appropriate to their distinct genres. Variations and divergence put "At the Landing" in the position of conversing with the previously published fairy-tale fantasy of a young woman's ability to revise old plots and put them right. *The Robber Bridegroom* optimistically resolves in a counterpoint equality of men and women. Jamie's desire violates Rosamond's privacy, but Rosamond's desire violates his. The fairy tale is similar to pulp romances that reconcile with an eventual balance of male and female: the rake is seduced toward some degree of reform by a beloved, and a single standard for men and women is negotiated. By contrast, "At the Landing" explores the subordinate status of women. As in Catharine MacKinnon's analysis of rape, in Jenny's story, unlike Rosamond's, gender is discovered as a system of dominance rather than of difference. MacKinnon writes: "It is her subordinate social status . . . not women's biological disposition, that makes her prone to sexual violation. The fact that men 'can be raped but women are the overwhelming numbers . . . in the rape victim population . . . expresses inequality, not biology'" (*Sex Equality* 383). "To be rapable, a position that is social, not biological, defines what a woman is" (MacKinnon, *Toward a Feminist Theory* 178). Floyd himself is more nature than he is patriarchy, but the joint effect of the two forces on and in Jenny dooms her.

What is most dissimilar between the two texts is that while each blurs the line between rape and consensual sex, "At the Landing" is so very disturbing in its inability to differentiate between the two acts. First there is the troubling quality of Jenny's history with obedience and how it informs even her attempted escape from it. Jenny, confined by her grandfather and the cultural gender attitudes he embodies, is circumscribed by indoor spaces and limiting images, and she is described with the language of passivity: "Jenny was obedient to her grandfather and would have been obedient to anybody, to a stranger in the street if there could be one" (*CS* 242–243). In her grandfather's house she lives submissively among objects; she is as bounded and secured as they are, suggesting a protected female role defined as a caretaker of commodities, a female life enclosed among objects. Patricia Yaeger has shown how the female world of Welty's "The Burning" (its plantation is culturally different from the house in "At the Landing" by several degrees) is defined by an overabundance of objects synonymous with the economy associated with slavery and the slave trade, the emerging topic of that story, and Yaeger describes it as the "most natural, most casual assumption . . . that . . . a white woman . . . should be surrounded by objects" ("Editor's Column" 14). Across Welty's work, time after time, women are revealed by the objects they live among. Jenny's relationship to the bits and pieces decorating her grandfather's strict house is especially disconcerting, because it is marked not only by her attraction and desire, but also by her obedient trepidation about reaching

for what gives her pleasure. In a house full of decorative prisms, Jenny herself contains shimmering longings that, like the crystals, reflect trapped, elusive, glimmering lights. Jenny has been taught not to reach for these. The implication is that the silencing obedience of Jenny's timid adolescence also defines her emerging sexuality.

The very heart of the contrast between Rosamond and Jenny is their voices. Rosamond has the power to sing aloud, to retell old stories, to make them hers in ways she wishes, reshaping them to yield her own story. From Rosamond's mouth, adventurous, authoritative lies fall "like diamonds and pearls" (*Robber Bridegroom* 39), while Jenny composes and sings a song "all silently" (*CS* 241). When she and Floyd walk together, they hold berries in their mouths, not words. We are repeatedly told that Jenny lives with the instruction not to speak to others (people in the town all nod at her, but "knew she was not supposed to speak to them," and especially "she was never to speak to Billy Floyd, by the order of her grandfather"; 247, 249). Jenny hardly speaks aloud, and in this tale her infrequent speech is characteristically reported, not heard.

A hallmark of Jenny's too-quiet discovery of sexuality is its alarming intersection of love and rape. When high water comes—with its overtones of passion, birth, and baptism inextricably bound with change, danger, and death—Floyd rescues Jenny. Then "when her eyes were open and clear upon him, he violated her" (*CS* 251). Floyd's rape of Jenny is blurred in the text by her desire to consent. Like Rosamond, Jenny has longed for her isolation to be breached; she has dreamed of Floyd and has been rehearsing to release her own sexuality. She has sought him out—even though in her fantasies, Jenny has already understood and admitted the extent of Floyd's otherness, like Rosamond discovering separateness in love. Jenny has respectfully acknowledged it: "she knew what she would find when she would come to him. She would find him equally real with herself—and could not touch him then. As she was living and inviolate, so of course was he. . . . at once she had the knowledge come to her that a fragile mystery was in everyone . . . and the secrecy of life was the terror of it" (245).

A feature of Jenny's discovery of love is that it is not entirely clear if her respect for Floyd's separateness indicates her tenderness, or if she is overwhelmed by a resigned and passive acceptance of isolation. Jenny refrains from reaching for Billy Floyd with a tacit recognition that to enclose him in domestic space would violate him. Nonetheless when Jenny finds herself taken by Floyd, she, like Rosamond in Welty's fairy tale, attempts to rewrite the story of her own violation and apartness with a retroactive consent. She tries to use the power of her imagination to revise the meaning of their encounter:

All she knew was that he would leave [the Landing] when his patience gave out, and that this little staving moment by the river would reach its limit and go

first. . . . Her words came a little louder and in shyness she changed them from words of love to words of wishing. . . . But ideas of any different thing from what was in his circle of fire might never have reached his ears, for all the attention he paid to her remarks. (CS 250)

Jenny's language of fairy-tale wishing ("I wish for a little house") is mocked not only by Floyd's reality but also by the timidity of her habitually silenced and now hopelessly indirect spoken request to and for Floyd.

The rhetoric of rape that the tale both plays on and radically critiques in Jenny's dire outcome is one in which the masculine is mythic, fertile, and divine while the feminine is mortal, incomplete, and vulnerable. Floyd's blend of mythic masculinity and rapist is as ambiguous as the blurriness between rape and consent in the tale. At the same time that Floyd is rude, wild (CS 243), and animal (245), an inappropriate prospect for Jenny's conventional domestic dreaming, Jenny's thoughts—and not, as in some readings, the story itself—present him as an embodiment of a masculine fertility associated with survival and renewal. This alluring masculinity is close to identical with the community mythology that Mattie Will flirts with, studies, and debunks in "Sir Rabbit." Echoing *The Robber Bridegroom* but in darker tones, Floyd embodies doubleness. Jenny—again, not the story itself—problematically makes Billy Floyd personify an antidote to her life of confinement. Floyd is associated with "the gleaming fish" he grasps (243)—recalling Yeats's wandering Aengus's silver trout that, caught, morphs into a vanishing "glimmering girl"—because Jenny constructs him as a longed-for, mythic river-country wanderer who counterbalances her captivity.

When three portentous old ladies articulate Jenny's dreams of Billy Floyd, their group construction of him is as contradictory as Jenny's own. These women are community storytellers, working on the semantics of a public narrative of masculinity (like the women in "Asphodel"), and the presence of this chorus of three in itself bolsters the mythic aspect of Billy Floyd, calling up mythology's assorted weird-sister triads. The story's interest in gender discourse and masculinity is clarified by their group construction. On the one hand, they call Floyd "wild," "Gipsy," "an animal" with "always . . . a long wet thing slung over his wrist when he went by, ugh!," "just like all men" (CS 254–255). On the other hand, they describe his glamour, with skin burned dark and "hair light, till he was golden in the road." And one of the trio, the one who "had books, though she was the one that was a little crazy . . . explained that Floyd had the blood of a Natchez Indian . . . the people from the lost Atlantis [who] took their pride in the escape from that flood, when the island went under . . . never letting the last spark of fire go out" (254–255). This orientalist construction of Floyd as the romantic, exotic, erotic, native other, as a giver of life, heat, and survival, makes him mythological, partly a

movie idol à la Valentino and partly an enduring ghost of a legendary people, a magical survivor who might initiate Jenny.[7] The women's narrative reconstruction highlights Welty's critique of the problematic transformation of a dangerously free masculinity into a fabulous mythic and redeeming one (a topic also seen in "Asphodel," "The Whole World Knows," and other Welty stories). Because Jenny's story is a rape fantasy gone wrong and become real. As in "Sir Rabbit," the mythic masculine is undercut by realism. Jenny is not saved by her encounter with Floyd, but further damaged by male entitlement, by Floyd's attractive but hazardous male freedom.

The final scene of "At the Landing" is powerfully disturbing: Jenny's quasi-consensual sexual experience with Floyd and her desire to transform it and to follow him lead her back to the water, where she is gang raped by river men. This unsettling ending perhaps parallels but immeasurably darkens the comical gang spanking that closes "Petrified Man," lightly destabilizing the idea of a woman's sexual "power" there. Jenny's gang rape, while unambiguously rape, again has a frighteningly consensual quality to it, continuing the story's interest in traumatic response and adding to Jenny's obsessive housecleaning a hint of autoaggression as a response to misguided guilt and emotional damage. When Jenny wanders among the community fishermen, asking for her lover, they put her inside a boathouse. One by one they come to her: "She actually spoke to the first one that entered between the dozing chickens. . . . When she called out she did not call any name; it was a cry with a rising sound, as if she said 'Go back,' or asked a question, and then at the last protested. A rude laugh covered her cry, and somehow both the harsh human sounds could easily have been heard as rejoicing" (CS 258).

Jenny's final cry is an inarticulate echo of her first words to Floyd, "go back," and her long silence is overwhelmed at the story's conclusion by the boatmen's callous laughter. Their rude noise, shades distinct from a joyful sound, conveys the ambiguity of Jenny's experience with Floyd: a missed celebration. Unlike Rosamond, Jenny does not unmask emotional violence to recognize it as a danger that she can nonetheless manage in a world where she hopes to escape guardedness. Unfortunately the world that Jenny's grandfather wanted her to fear and kept her withdrawn from proves to be worthy of dread. With no defenses other than evasion, Jenny extinguishes all the lights in the house of her mind and perhaps hopes the threat at its door will go away. In this state, Jenny "is waiting for Billy Floyd," her face hung with a smile "no matter what was done to her, like a bit of color that kindles in the sky after the light has gone" (CS 258). When a bright-eyed old woman asks, "Is she asleep? Is she in a spell? Or is she dead?" (258), her questions call up the transformative sleep of fairy-tale heroines such as Sleeping Beauty, but there is no reason to believe that Jenny will be awakened from this trance with a kiss. Where Rosamond, who exists in a fairy-tale universe, can transform

violation into deliverance, Jenny is overcome by the story of love with which she tries to shape her experience. And she is silenced. The sound that readers are left with is not Rosamond's voice assuring her father that her story, as she now authoritatively tells it, has become the truth and not a lie ("all true but the blue canopy"; 184). Instead, the inhuman, inarticulate "dull pit" (258) of boys' knives thrown at a tree reverberates as the sound of casual, unconcerned gendered violence.

The ambiguities around Billy Floyd, Jenny's consent, and this ending have produced very disparate readings. Some privilege the phrase "somehow both the harsh human sounds could easily have been heard as rejoicing" in their interpretations. Barbara Carson in *Eudora Welty: Two Pictures at Once in Her Frame* writes: "this violation is at least life. . . . Jenny and the rivermen . . . [e]qual and identical in their need for a fuller life . . . set off from The Landing, from their own individual emptiness, pursuing in their different ways their quest for life's wholeness" (39–40). Vande Kieft, Kreyling, Ann Romines, Carol Manning, and Colleen Warren emphasize the learning experience of Jenny's discovery of separateness; Romines writes, for example, that "what is happening in herself . . . is multiplicitous expansion" (208). Peter Schmidt, by contrast, notes the story's unsettling ambiguity and writes that "commentators . . . tend to argue that despite the violence done to her, Jenny experiences a mythic initiation" (128), but he concludes that the details of this ending suggest otherwise. Ruth Weston—calling on Rachel DuPlessis's *Writing Beyond the Ending*—discusses Welty's scripting of Jenny's "narrative death" as the familiar ending that punishes the unmarried sexual woman who escapes "marriage or valid romance" (DuPlessis quoted in Weston 41), which is "signified by her 'nonpossession' of the hero and non-access to marriage" (42). But rather than showing Jenny punished for a failure to conform to the too-familiar female plot, Welty's reworking of the rape narrative shows Jenny's acceptance of the traditional definition of womanhood (featuring obedience, silencing, and submission), which brings about her victimization. In this story, it is the old plot that is indicted, not Jenny's escape of it. Its revision shows a certain troubling "consensual" sexual experience to be as disturbing as rape, its synonymous double, and the text is more unruly and gender savvy than is usually acknowledged.

A quick glance from this vantage point to the dark notes of the rape plot in "The Whole World Knows" and in *Delta Wedding* helps to make clear a larger pattern in Welty's fictional carpet. "The Whole World Knows" is also about a community's construction of a masculine mythology, and Ran MacLain and Maideen Sojourner are both caught in it. Maideen—arguably again straddling a "consensual rape"—is the greater victim since Ran's culturally prescribed use and abuse of her (as a weapon against the wandering Ginny, as a source of comfort in his insecurity, as a wrinkle in the community

narrative being written by voices such as Perdita Mayo's) produces her sui-
cide. This interest in masculine mythologies applies too to Ellen and George's
discussion of his having taken sexual advantage of the underclass and vul-
nerable glimmering girl whom they both have recently found wandering in
the woods and treated so differently. The family vision of George as a male
paragon is momentarily disturbed by the discovery of his violation of the girl,
and then the discovery is passed over. The suggestion across these plots is
that, like modernism generally, Welty's fiction concerns masculine mytholo-
gies breaking down, though perhaps her focus is less on the male conundrum
of not living up to the male mythos and more on the problematic of women
cherishing and doubting that mythos. As a group Welty's stories make clear
the consequences for women of actions that the men seem heedless of and
that their communities overlook or look away from.

Race and Rape

Within American and in particular southern literature's narratives of rape,
plots involving race are a dominant strand. These tales of sexual violence
reproduce and interrogate national power dynamics in narratives that encode
cultural anxieties about both racial hierarchy and the historical commoditiza-
tion of humans. Conventionally the rape plots of southern literature develop
or question one of several recognizable formulas. One variety uncovers the
cultural fantasy of a black male threat to protected white womanhood—a
script that since Reconstruction has justified white control of black mascu-
linity. Another concerns white men's abuse of the black enslaved woman or
freedwoman, stories of women forced to consent or compelled to the position
of concubines, tales about legal rape and human property in a racist patri-
archy. A third familiar raced rape plot is the white woman's false accusation
across the color line. There is also in southern literature a predictable plot
that places sexual violence in the context of the Civil War; in the film ver-
sion of *Gone with the Wind* (1939), for example, a marauding Yankee soldier
attempts to violate Scarlett and Melanie, but the indomitable Confederate
women stop and kill him.

Welty's "The Burning" (1951) merges and reworks two of these familiar
rape plots. It writes over the traditional story of the sexual abuse of a slave and
over the story of the inviolable lady, recasting them tellingly as the story of a
black woman's rape at the hands of white ladies. Miss Myra and Miss Theo
are two emblematic ruins of southern womanhood; they are not indomitable
but are quite appallingly grotesque in their droll and caricatured adherence
to cultural prescriptions for a lady. The story of rape—of Delilah's multiple
levels of trauma—then becomes a story of the relationship between a woman
and the other woman.

"The Burning" is also a sort of mystery or detective story in that Welty does not presume to easily cross the color line to straightforwardly tell it from Delilah's point of view, but she nonetheless makes Delilah's consciousness the one we move with, struggle to clarify, and cloudily follow. Ultimately this rape plot varies from the usual tragic story of the sexual violation of an overpowered black female subject. Its protagonist, Delilah, is a victim of slavery, sexual abuse, and violated motherhood, and she suffers the casual collateral burning to death of her child and is disturbingly compelled to murder her mistresses in order to save them from further indignity or struggle. She nonetheless ultimately composes herself to collect the bones of her child along with assorted useful plunder, to find nourishment by chewing the comb of a dirt dauber, to drink from the Big Black River, and to wade toward her future—that is, to be the woman who survives.

The narrative of "The Burning" is complex, avant-garde, and oblique, as full of commotion and a chaos of details as the plunder and burning of a home during war; readers are confronted by this in the story's striking and initially cryptic opening lines. "Delilah was dancing up to the front with a message; that was how she happened to be the one to see. A horse was coming in the house, by the front door. The door had been shoved wide open" (CS 482). Delilah's eyes are also open, and what she and the reader see is bedlam: surreal, partial, random, interrupted chaos. In this setting, Welty evokes, parodies, but alters the familiar story of the lady as cultural emblem and authority, turning and queering the literary conventions of both the belle (Miss Myra) and the Confederate woman (Miss Theo). Consider what Welty accomplishes when the reader runs with Delilah's point of view into the parlor, disoriented, to find "they were standing up before the fireplace, their white sewing dropped over their feet, their backs turned, both ladies. Miss Theo had eyes in the back of her head" (482).

There are three women in the predictable parlor, the white ladies' expected dainty busywork emblematically hampering their feet and constraining their movement; their backs are turned on the cataclysmic events; they are "both ladies," with eyes averted from history. By implication they are attempting to cancel the disturbing realities that are entering the house. Nevertheless, "Miss Theo had eyes in the back of her head"; whatever else, she remains the vigilant domestic authority who sees and orders Delilah's movement. "'Back you go, Delilah,' [Theo] said. 'It ain't me, it's them,' cried Delilah, and now there were running feet to answer all over the downstairs" (CS 482). "Commotion" arrives with the white horse framed in the parlor's Venetian mirror, a framing that limits what can be seen but reflects the completely insane yet culturally inscribed and legible ladies' behaviors. "Then Miss Myra's racing speech interrupted everything. 'Will you take me on the horse? Please take me first.'" Miss Myra's inappropriate remarks here—and throughout—lampoon the

romantic imaginary of the southern belle. Myra demands attention and priv-
ilege, flirts as she is about to be raped, essentially asks to be "taken" first,
is dainty to the point of physical and mental handicap, and concocts sto-
ries of courtship and romance out of touch with the realities, including, and
above all, the looming actuality that has entered the room: "It was a towering,
sweating, grimacing, uneasy white horse. It had brought in two soldiers with
red eyes and clawed, mosquito-racked faces" (482).

While Myra is the belle, Theo is the ferocious, impervious Confederate
woman. The household inspection and rapes that follow are punctuated by
Miss Theo's affronted address of her rude company:

> "Is it shame that's stopping your inspection? . . . I'm afraid you found the la-
> dies of this house a trifle out of your element. My sister's the more delicate one, as
> you see. May I offer you this young kitchen Negro, as I've always understood—."
> That Northerner gave Miss Theo a serious, recording look as though she had
> given away what day the mail came in. (CS 484)

Welty's Theo is a parody of a familiar literary heroine described by Diane
Roberts in *Faulkner and Southern Womanhood*, the Confederate woman
who is part warrior—a steel magnolia envisioned to "[re-create] herself, to
accommodate, even valorize, hardship" (Roberts 3), to rejoice in it. While
her protecting men wage war on the battlefield, she is strengthened by her
bruising domestic combat with the offensive, bad-mannered invader, and she
defends the home property and by extension the economy in which "property
is all important" (3).

But as Theo proposes Delilah as a sexual stand-in, Welty turns her parody
of the conventional Confederate heroine sharply toward the grotesque, radi-
cally revising the more familiar rape plot. In the moment of ultimate grotes-
querie, after a Yankee soldier tells the women to leave by asserting "Burning
up *people's* further 'n I go yet" (CS 485), we hear Miss Theo's stare-down and
pivotal reply: "I see no degree." This remark at first is full of pathos: Theo
recognizes that torching the house will raze and demolish, burn and eradicate
the ladies' lives, since they are part and parcel of the house and their purpose
is tied to its domestic objects. But as the story progresses it becomes clear
that, monstrously, Theo's defense of Confederate culture absolutely "see[s]
no degree." To defend southern sexual and racial codes and to keep the black
child in the family "hidden," "shut up all upstairs" (489) in his liminal status
as a family member that is also family property, Theo causes the Yankees to
burn that young person alive. In the commotion, in the devastation, readers
find and gather the child's story—the boy generally referred to as Phinny but
by Delilah alone as Jonah.[8] Myra, insistently scripting herself as the charm-
ingly bad belle, at one point delusionally claims he is her child, fathered by
"an officer, no, one of our beaux . . . because I was always the impetuous

one, highstrung and so easily carried away" (489). Theo, willing to humor Myra in any fantasy of ladyhood except this one, which comes too close to breaking the taboo guarding the white lady, her body, and her social class's purity, responds, "don't you know he's black?," suggesting that the child is the offspring of their brother Benton and Delilah. Appallingly, startlingly, horrifyingly, Myra replies in a terrifying line of surreal comedy, "He was white. He's black now," pointing readers to the shock of his unseen charred body. Then Delilah urgently and wishfully responds, "Could be he got out. . . . He strong, he. . . . Could be Phinny's out," a rejoinder that Patricia Yaeger spotlights as revealing that Delilah humanely and maternally "worries about [the child's] fate instead of his color" ("Editor's Column" 19). Meanwhile Theo, Confederate heroine as grotesque, having caused the murder—"[i]t was a bellowing like a bull that came from inside" (486)—unsurprisingly but appallingly celebrates her own iciness, her valor in defending the home front. She, lampooned in this parody of the lady, brazenly brags: "I've proved . . . what I've always suspicioned: that I'm brave as a lion" (491).

The story's conclusion of course suggests that she is not "brave as a lion." Afraid of change, Theo, rather than enter the unknown, will command Delilah's help to kill first Myra and then herself. More accurately it is Delilah— though "down in the loud and lonesome grass . . . stung all over and wild to her hair's end" and watching Theo, neck broken, twist "like a dead snake until the sun went down" while asking, "What must she do?" and where must she go—who musters the fortitude to return to the burned house, claim her child's bones, wrap them like an infant swaddled, and enter the river (492). "Submerged to the waist, to the breast, stretching her throat like a sunflower stalk above the river's opaque skin, she kept on, her treasure stacked on the roof of her head, hands laced upon it. She had forgotten how or when she knew, and she did not know what day this was, but she knew—it would not rain, the river would not rise, until Saturday" (494).

Yaeger has discussed this ending as an act of competent "counter-conquest" in a story that is crowded with the "objects of conquest"—such as the silver jubilee cup that Delilah collects from the rubble and licks "now and then" to taste a memory of the sweetness that another drained, or the gilded mirror that features, in the bizarre but legible details of its ornate frame, "black men dressed in gold"—details that provide the reader with a "frame" on the "ornate pain" of southern history's rich colonial "traffic . . . in bodies and goods" ("Editor's Column" 16). My reading of "The Burning" here emphasizes plot since I am highlighting Welty's revisions of familiar rape narratives. But the overabundant detail emphasized by Yaeger, what she calls Welty's "neo-baroque" style—"a style that brims with too-muchness" of language and detail in a story "obsessed with things, what it means to have them, to leave them or burn them, to take them from others"—is central to the story's

subtlety and distinction (14). And Welty's accomplishment cannot be fully appreciated without emphasizing what she has technically risked, tried for, and successfully managed in a greatly underappreciated story that, working beyond the familiar rape plots, tells a tale that questions women's relationships across the plantation color line.

Race and Rape in "The Shadow Club"

Welty returns to the topic of rape and race in "The Shadow Club," a story she began in 1975 and worked on intermittently over at least the next decade of her life, producing revised versions of sections, changing character names, and reimagining structural boundaries. The tale extended into drafts for other stories, at times suggesting a story cycle along the lines of *The Golden Apples*, in this case pertaining to Observatory Street rather than Morgana, a place name suggesting the James Observatory on Jackson's Millsaps College campus, a local landmark, but also suggesting the "neighborly" monitoring of the lives shared and observed there.[9] The bits and pieces of the story's manuscript exist in eleven boxes (plus fifteen more boxes in which there are related portions in manuscripts developing other stories),[10] housed at the Mississippi Department of Archives and History; the various fragments, sections, and revisions of the changing text are arranged by the archival principle that the order and disorder of the author's found papers be kept intact. Working with these boxes, you discover that Welty wrote on anything: on the backs of deposit slips, advertisements, and envelopes, for example, as well as in and on typed drafts. And yet, the outline, plot, concerns, risks, and strengths of "The Shadow Club" come clear in a diligent reading of its extensive higgledy-piggledy fragments.

The story's plot first germinated from a newspaper clipping about a burglary in a schoolteacher's home, which Welty sent to her friend Nash Burger:

> Did you hear about poor Miss Annie Lester's terrible experience with a burglar? She is in the hospital with a broken arm—surprised a 21-year-old negro man at 2 or 3 o'clock in the morning, and I know nothing more except that there must have been a struggle—afterwards, she drove herself (he had cut the phone wire) to her brother's house. I can't really grasp how anybody could have done that to her, with her steady blue eyes direct and her innocent mathematical nature, and now old, too.

The "that" done to Annie Lester is not as clearly spelled out in this letter as in Welty's story—rape—but it is apparent from the news article and letter that there is a culturally familiar race crime plot embedded in the event that Welty's version will redirect in what I describe as an homage to Richard Wright in the genre and style of Ross Macdonald. "The Shadow Club," like

"The Demonstrators," reflects the influence of Macdonald's crime/mystery writing and, I argue, Wright's writing too.

Suzanne Marrs has told the story of Welty's relationship, begun in 1970 (six years after she published "The Demonstrators"), with Kenneth Millar—who published his popular crime fiction under the pen name Ross Macdonald. The two writers carried on an important epistolary infatuation throughout the 1970s until Alzheimer's disease ended Millar's side of the correspondence. These letters provided the literary intimacy that Welty had hoped for with John Robinson, fulfilled and consummated in mutual correspondence that Welty enjoyed through 1980 and that she then carried on solo until Millar's death in 1983.[11] The devastating effect of Millar's dementia, hospitalization, and eclipse—as well as the disturbing experience of feeling like the "other woman," especially from the perspective of Ken's wife, Margaret—would in the mid-1980s be starting points for new Welty efforts at stories in various ways tied to "The Shadow Club." Marrs pictures Welty attempting to transform this earlier manuscript into "Henry," "Affinities," and "The City of Light"—which respond to her loss of Millar through fiction. Another possibility is that Welty at one time considered a Shadow Club sequence, using its central characters in related stories.

"The Shadow Club" negotiates a balance between the mystery of a Millar-like detective fiction and a Weltian mystery of interiority. In this double mystery, the conventional Jim Crow raced rape plot of a black boy who is a lurking threat to a white woman is alluded to when the cast of characters, speaking callously and reductively, chat unselfconsciously with and about that racist mythology. When a group of white women, the victim's friends, discuss the history of rape in their neighborhood, their sweeping generalities expose their tendency to profile and mythologize: "on Observatory Street it couldn't have happened at all. This was a faculty neighborhood. . . . offenders were all black . . . or if they weren't black, they were all escapees from the penitentiary or mental institution."[12] Welty builds her plot in contrast to this dubious chatter by developing the narrative lesson she describes learning in *One Writer's Beginnings*: how one secret may reveal another. In this memoir she recalls as a child asking her mother about the secret of sex and unexpectedly provoking the revelation of a lost sibling, not "how babies could come but how they could die." Then she writes, "The future story writer in the child must have taken unconscious note and stored it away: one secret is liable to be revealed in the place of another harder to tell, and the substitute secret when nakedly exposed is often the more appalling" (17).

In a plot revealing the substitute secret discovered, a mystery leads to a forgotten crime, one committed neither by a black person nor a prison escapee. Nell Downing (also called Caroline, Cam, May, Justine, and Rachel in drafts),

raped in her home and left on the floor conked, concussed, exposed, and on display, returns to consciousness surrounded by friends—white women of a certain age, both frank and evasive on the topic of rape—with no memory whatsoever of what happened to her. Interrogated by a young woman, who is considered rude when she asks brusque questions about the assault but who argues that rape deterrence does not allow its victims "the right to expect privacy," Downing reflects, "If there is a 'message' in this for me, I'll get it. In my own way. . . . I believe messages come in their own time."

What comes is the unlocking of Downing's locked-up past. The violence she in time recalls is not her own rape story; that will emerge, but from the rapist's own altering point of view. Memory instead brings to Downing the repressed recollection of another supposed break-in at her house: as a child, she discovered her mother naked and shot, slowly bleeding out in her helpless daughter's presence, only feet from the bloody body of Downing's father, who had shot himself in the head after killing his wife. She suddenly recalls, after a lifetime of avoiding and repressing the secret, being tenderly and, as a child, unwittingly led by her mother's lover (a professor, neighbor, and father) to keep the secret of the murder-suicide and to instead accept and promote a cover-up story about a "robber" who allegedly entered the house—her house still—and killed her parents.[13] The memory has seemingly been shared by her friend and neighbor Ralph Ledbetter, the professor's son, a gay man, whose comfortable relationship with Downing seems temporarily thrown off-kilter by her exposure as a female body on display that he has failed to defend, an exhibition re-evoking an original discovery scene in which the two children, shocked and confused, stumbled onto their parents sexually involved.

The portrayal of violence and death in this manuscript is graphic and arresting, an indication of Welty's ongoing extension of herself as a writer. Downing unearths the memory of finding her parents in their death scene. Running with and trying not to spill a glass of water that her shot, naked, and perishing mother seems to want—although what the dying Hallie has begged for is water from Macready Wells, a place of family happiness—the child arrives in time to make some chilling observations:

> Her [mother's] hair looked dark and was hanging wet to her forehead and she was panting, as if she'd just been swimming in Paradise Pond.
> But as [she] held out the glass of water, her mother, with her thirsty lips, turned her head away. A dark stream poured out of her mouth. It looked like muddy water she had somehow come to swallow by mistake. [She] saw a muddy spot on the sheet where Mother's hand held it close to her breast, like a belonging.
> [She] bent over her mother and under the bed below her both Father's feet, the blue pajama legs were sticking straight up from the darkness on the floor. His big toes like signals.

Mother rolled on the wet pillow and then she crawled across the bed to the other side and lay down on her breast, with a wanting sound. The wanting sound was her breathing.

The graphic violence in this story, particularly in this account of Hallie's death, may have some relationship not only to Welty's interest in Macdonald's work and in noir as a genre but also to her recently lived horror: the 1975 murder of her close friend Frank Hains. Details of Ralph's portrait in the story also support the character's connection to Hains, suggesting that Welty's loss of her friend was one trigger for the story. Kevin Sessums's memoir *Mississippi Sissy*, which contains a factual account of both the man and the brutal murder, describes Hains's particular love of his 78-rpm record collection, and Ralph in Welty's story is closely and movingly connected to his vintage Red Seal record trove—"Tibaldi! Ponselle! Galli-Curci!"—which his disapproving, disrespectful mother contemptuously sells for a nickel apiece one day when he is in New York, for use in target practice at the county fair. This betrayal leads readers to understand Ralph's painfully conflicted desires: on the one hand, to escape his mother and their claustrophobic town and, on the other, to honor his unsettling filial obligations and loyalty to family and friends, who neither accept nor fully appreciate him.

The raced rape story of "The Shadow Club" thus opens into the film noir plot of adultery and murder. Its title calls up the popular radio hour named for its detective crime fighter, *The Shadow*. The show, which debuted in the 1930s, ran until 1954 and was serialized in pulp magazine spin-offs; it captivated audiences with its signature line emphasizing the noir of its plots: "Who knows what evil lurks in the hearts of men? The Shadow knows!" Critic Jacob Agner has discussed Welty's adaptation of film noir's chiaroscuro—light, dark, and shadow used to highlight moral "border-crossing"—in her 1965 story "The Demonstrators," techniques that "ink and illuminate the textual canvas in intentionally racial hues" to reveal the blackness of whiteness. Similarly in "The Shadow Club," the rumor of the black body is at first an associative marker for a tale exactly discovering the dark murkiness of whiteness, in this case darkening Downing's reckless, bright, and fair mother, Hallie. Her name recalls the comet that streaks the night sky with light: she is a woman associated with popularity, pleasure, country club success, and her bridesmaid girlfriends, the Shadow Club itself, the group representing a community in which relationships span generations, are full of secrets blurring moral boundaries, some shocking, some petty, some simply tragic.

The actual story of rape in this tale is uncovered not by Downing's memory but in a final section written from the perpetrator's point of view. More than Jim Crow's black violator rape plot, this section evokes the narratives of Richard Wright's black protagonists in his fictionalized autobiography and

in his version of "crime fiction" stories, *Native Son* and, especially, "The Man Who Was Almost a Man" and "The Man Who Killed a Shadow." Elroy Corum, escaping the Downing house, has gotten no farther than the ubiquitous town-dividing railroad tracks when he thinks, "if they were to find him and ask him what he'd done . . . , he'd say he couldn't remember." The account that follows is not exactly a memory, but rather is filled with Elroy's surprise as he discovers his own unraveling actions and feelings.

Elroy's narrative is the story of a boy, aimlessly and all night "walking . . . where his feet would carry him, waiting till it was safe to go home." Wandering into a white neighborhood at the end of his sanctuary-seeking sleepless night, he sees a door "standing wide open" and enters the house. After he boxes himself fearfully into a closet, Downing, a teacher preparing for the opening morning of the school year, opens the closet door to confront her intruder; she reads him correctly for what he is, "nothing but a child." Humiliated by her estimation of him as harmless, he tells her he has come for her purse; nevertheless she feels comfortable enough to command him to report with her to school. Then "before he knew it . . . he landed her a punch right in her thinker." While she is stretched out, reminding him of a church sister receiving "the holy spirit," with a face that "seemed to be granting permission to the whole world," he opens her refrigerator and eats plates of food—pickles, bread—and drinks sweet milk. Then he returns to find her eyes open although she is still out cold. In one manuscript draft, "her knee at a push showed its underside to him, yawned white as a cottonmouth moccasin opening to strike." Seemingly never before having been close to a woman, "before he knew what happened, he fell, as hard as she'd fallen, on top of her and his hands fought through the fumbled clothes. [H]e bolted into her. She didn't know. She lay as before, her eyes turned up at the clouds."

The keyed-up boy's erratic thoughts obscure his unpremeditated and precipitate act of rape; they are bound to a yearning for his bolstering but now-lost childhood home with an aunt who has died and to his dysfunctional current life with his father, his father's lady friend, her children by another man, and sometimes that other man as well. Elroy's thoughts wander and then lodge on a painfully childlike, simple, surreal aspiration, frankly felt as nonetheless unattainable: an ambition to grow up to be the exterminator man, to drill houses with "plenty of what it took to smoke [termites] out," and to drive the yellow truck with its "red and green termite as big as a full-grown hound, dressed up in a hat and gloves like wedding clothes and two pairs of high-topped shoes, riding the roof of the cab." The reader has a suspenseful and anxious moment when the boy—realizing the woman is hurt, tumbled like that dove that hit itself on the glass"—disturbingly worries that she is dangerous to him: "It was dangerous to pick up hurt things, hurt and still alive. They could hurt you. Maybe fly at you and try to put your eyes

out. Then he saw the little trail of blood moving on her forehead. . . . yes, it moved." But Elroy resists striking out at the wounded woman; rather, he takes "back his trust, as if it had been tricked out of him" and, frightened, stumbles away with her purse. Dumping the purse, which contains "no credit cards, no money, . . . no smokes," under a bridge in bushes that hold other dumped purses, he paradoxically thinks, "[o]ne sure thing I didn't need was no library card." As a train passes in the dark, Elroy impulsively jumps into an open boxcar, and rocks and sways with it into his future.

Elroy's story and its details repeatedly suggest an audacious homage to Richard Wright's portrait of the black boy too unaware of the forces that drive him to cope well with them, and nowhere are the allusions clearer than in this ending, which echoes the train hopping of "The Man Who Was Almost a Man." On one page of her drafts, Welty even considered the possibility of having Elroy find the hidden gun of the Downing murder-suicide, and she wrote at the top in red pen, "Elroy // He Rode Off Into The World With His Gun." This line could not more clearly echo the plot of Wright's Dave Saunders in "Almost a Man," just as the library card reference calls up Wright's different story in *Black Boy*, when with self-determining purpose Richard works to inveigle a card in order to borrow books. Jumping a freight car, like Dave before him, Elroy "rolled, was rolled halfway across the floor sometimes, and his head would bounce as [the train] ran along." Escaping but still without defense against forces that toss him, Elroy thinks that "the lady was gone, no more on the floor of his mind, glimmering no longer. . . . Out there, . . . stars had come out. . . . they danced like popcorn on the bottom of a black skillet." Welty's image of white popcorn stars moving on a black skillet pictures whiteness as explosive, unpredictable, and yet tantalizing, a detail that helps to reveal Elroy as at the mercy of exploding emotions and hungers, overwhelmed, and wishing for self-determination.

"The Shadow Club" is also replete with details that surprisingly evoke the less well-known Wright story "The Man Who Killed a Shadow," itself a turn on the Jim Crow rape plot. While Welty might certainly have seen the frequently anthologized "Almos' a Man," first published in 1940, in any number of locations other than Wright's collection *Eight Men* (where it emerged with its new title), she could only have known the later story from that 1961 volume. In it, the shadow referred to in the title is explicitly glossed as the "shadow of a [young black man's] fears" (*Eight Men* 193). Like Elroy, Wright's protagonist Saul Saunders is described as a boy who inhabits a "world split in two . . . the white one being separated from the black by a million psychological miles. Saul . . . saw the shadowy outlines of a white world that was unreal to him and not his own" (193–194). This unreal world is one where "things had names but not substance," suggesting the possibility that the boy's behaviors there also seem unreal to him. (I cannot help but think that Welty also knew

her close friend Ralph Ellison's 1964 essay collection, *Shadow and Act*, which also brings the idea of shadow—with the implication of living among those who see only shadows—to the story of race in America.) Like Elroy, Saul as a boy lived with and took comfort from not an aunt but a grandmother, who has "passed suddenly from his life," and as a result "the shadowlike quality of his world became terribly manifest" (*Eight Men* 195). While Elroy aspires to be an exterminator, Saul takes a job as one: "something in his nature . . . made him like going from house to house . . . putting down poison for rats and mice and roaches. He liked seeing the concrete evidence of his work and the dead bodies of rats [that] were not shadows" (197–198). At this point the stories diverge. Fired for defending himself against a slighting remark from his boss, Saul takes a job as a janitor in a library; there, cleaning, he is more than once bewildered by a virginal librarian, a "strange little shadow" of a white woman, who approaches him unexpectedly, crudely, and insultingly to fulfill her sexual fantasy. When he slaps her, she screams, and Saul, like Bigger Thomas in Wright's *Native Son*, manages his traumatic fear of being caught in and killed for physical contact with a white woman by killing the female shadow.

While the two stories are pointedly different in their revisions of the raced rape plot, they share attention to it and to the notion of a black boy traumatized by and at the mercy of forces he does not fully understand and cannot manage. I wonder about Welty's risk in authoring her story, and if she perhaps never published it because she or a publisher perceived the awkwardness of a southern white woman writing the story of a black boy as Richard Wright might. In another of Welty's unpublished manuscripts, "The Last of the Figs," discussed in chapter 6, an illustrator is dismayed when her publisher perceives her work as too problematic racially, too controversial to publish. Was Welty having that thought about her own work?

What I have shown in this chapter about Welty's uses of the rape plot is that she is certainly not writing a single storyline expressing a personal masochism or a longing for violence. Instead, she is responding to the literary history of the rape plot as a vehicle for expressing ideas about class, race, and power, as well as the tension between masculine mythology and masculine vulnerability, and a woman's relationship to all of the above. As usual, Welty performs a signifying element that reverberates throughout her fiction variously, but in ways that highlight her play with the literary and cultural history she challenges. Her versions of the rape plot call up an expanding list of adjectives: witty, playful, poetic, defiant, delicate, traumatic, brutal, experimental, satiric, risky, and, above all, aware.

The Body of the Other Woman and the Performance of Race

What Welty Knew

Many times in this book I have considered issues of race in Welty's work: in her girl stories' evocation of a world of whiteness problematically sheltering its daughters, in her portrayal of the dark night that comes to Nina and Easter, in her photography's representation of the black body, in her risking the interiority of Delilah, and in her treatment of the raced rape plot, to name a few. Here, I take one more slant on reading the body of the other woman as it beckoned Welty across her career. I examine her fictions that do not attempt to address the interiority of the black woman but rather focus on a black female body strongly present and called on to perform race—a familiar racial script.

My intention is to interrogate the messages sent by the black body in Welty's presentations of both central and marginalized characters—Phoenix Jackson in the early *Curtain of Green*, Partheny and Aunt Studney in *Delta Wedding*, and Twosie in *The Golden Apples*—before focusing freshly on Ruby Gaddy's withholding body in "The Demonstrators" and Esther's in the never-published or so far critically analyzed "The Last of the Figs," alternatively titled "Nicotiana."[1] The discussion will also enter the debates opened in the essays in my edited volume *Eudora Welty, Whiteness, and Race*.

In the introduction to that volume, I consider the question of what Welty knew about race based on what can be seen in her fiction. First, Welty's fiction makes visible both the color line and white privilege. She shows the ignored yet not successfully passed-over awkwardness of the gaping distances introduced between lives lived in shared space but separated by social structure. In addition, Welty clearly perceives the implications of whites' material advantage and recognizes blacks' deprivation. This understanding includes the relationship of that material advantage to U.S. economic history, to the cycle of race and poverty, to conflicts fostered between the black and white working classes, and to an uneasy hierarchy of white classes within the presumed

monolith of whiteness. Her fiction is attentive to the possession and nonpossession of goods but, as meaningfully, to the possession and nonpossession of the self as a racial issue. And in the observation that is most key to this chapter, I reason too that her fiction repeatedly shows that Welty understands race, like gender, to be a performance.

In Welty's "Powerhouse," the performance of more than music is one salient example: the protagonist simultaneously performs and is creative with his white audience's blackface expectations, riffing and burlesquing on the orientalist faces of the black jazzmen, which are expected as well as authorized by his white audience: "Asiatic, monkey, Jewish, Babylonian, Peruvian, fanatic, devil" (CS 131). This is a performative, an action that responds to and potentially transforms a familiar racial script. I describe this type of behavior in *Eudora Welty, Whiteness, and Race*:

> Resembling the living jazzmen Fats Waller and Louis Armstrong in their extraordinary moments of outrageous staginess, Powerhouse builds his performance of and on anticipated masks and materials in ways that yield an inventive and original response. . . . Like Louis Armstrong singing—with grin, grimace, and grace—"What Did I Do to Be So Black and Blue?" he creates and transcends an exaggerated performance of African American racial identity scripted by whiteness that may appeal to enthusiastic white consumption but is also powerfully subversive and expressive. That Welty emphasizes the performance of racial identities—black and white—is also clear in Shelley's journal in *Delta Wedding*. As Jean Griffith points out . . . , after Shelley names Troy's nonchalance with black men as a convincing performance mimicking and appropriating the white Deltan masculinity to which Troy has—by virtue of his lower class and outsider status—a probationary relationship, it worries Shelley that all her family's men are equally imitative performers of white masculinity: "Suppose a real Deltan only imitated another Deltan. Suppose the behavior of all men were actually no more than this—imitation of other men. But it had previously occurred to her that Troy was trying to imitate her father. (Suppose her father imitated . . . oh, not he!)" (10–11)

Contextualizing Welty's interest in racial identity as performance, I have argued that "from the earliest outset of her creative play, Welty's comedies are built on and emphasize her knowledge of gender, race, and power as social performances, a humor that perfectly anticipates Judith Butler's 1997 theoretical discussions of 'a politics of the performative'" in *Excitable Speech* (Pollack, *Eudora Welty, Whiteness, and Race* 11).

The connection to Judith Butler's work is one I made in this book's introduction, and it needs refreshing now. Butler has best articulated the body as constituted through an individual's (or character's) staged performance of a cultural script and as constructed "not only through conventions that sanction and proscribe how one acts one's body, the act or performance that one's

body is, but also in the tacit conventions that structure the way the body is culturally perceived" ("Performative Acts" 407). I reiterate this passage here because it is so relevant to demonstrating that Welty recurrently and variously over the course of her fictions shows her black women characters mediating an uncomprehending white audience's imposition of racial scripts and expectations. Like Powerhouse these women are shown asserting self-possession by adapting the performance—sometimes sly, sometimes comic—of the racial masks imposed on them in creative, resistant, and at times subversive enactments. And yet, at the same time that these performances can be read as informing, it is important to consider their opaque quality. In *Eudora Welty, Whiteness, and Race*, I note an emerging debate concerning the extent to which her marginalized or opaque black characters are allowed to become what David McWhirter has called "secret agents" both "withholding lives and obscuring emotional reactions while leaving readers in a position to understand how much white doesn't know and even prefers to leave underground" ("Secret Agents" 10).

My project here is to look closely at Welty's creation of black female bodies and to read them not as other characters in the texts read them but rather independently, as bodies that both keep their own counsel and yet speak, recognizing that the white gaze turned on them in the fictions is most often uninterested or unable to see or acknowledge them or their stories. To that end, I want to bring a number of bodies together as an informing group before approaching the two texts I am most interested in: first, "The Demonstrators," a story Welty wrote after her world in Mississippi had exploded in a way that would make increased racial awareness inevitable, and second, an unpublished story she very nearly finished, set in 1957 and tentatively titled "The Last of the Figs," which concerns the complexity of everyday interactions in the South in the year when President Dwight Eisenhower would send federal troops to defend the Little Rock Nine.

Arguably, the explosive events that marked the South throughout the 1950s and '60s created a defensiveness in a number of white liberal southern writers who had earlier attended to the topic of Mississippi apartheid carefully and impressively. This defensiveness caused them to cautiously back away from racial topics they had previously and powerfully explored, while Welty, by contrast, regardless of what she said in "Must the Novelist Crusade?" about the limitations of crusading fiction, homed in. To make the point with a case other than Welty's, I offer the example of Faulkner who, after finding his fuel in the racial reporting inherent to *Light in August*, *Absalom, Absalom!*, and *Go Down, Moses*, responds to the pressures developing in Mississippi after 1954 by halting his attention to black experience and to African American characters in favor of novels treating whiteness through its own gradations

and class divisions (*The Town*, 1957; *The Mansion*, 1959; *The Reivers*, 1962), a worthy topic that in those years was also significantly less combustible and perhaps less conflicted for the writer.

Reading the Black Female Body Performing Race

To begin at the beginning, I start with Phoenix Jackson in Welty's first volume, *A Curtain of Green* (1941), a collection that Susan Donaldson intriguingly describes as presenting "something very like a panoptic cellblock of human beings confined in separate stories and isolated from one another by a racially fissured society policed in the name of protecting idealized white southern womanhood" (49). That volume ends with two stories attending the color line, "Powerhouse" and "A Worn Path." These stories were originally published in June and February 1941, respectively, in the *Atlantic Monthly*, a fact that suggests that Welty, in her creative exploration of racial representation, wrote from Phoenix to Powerhouse rather than vice versa, as their order in the collection might seem to suggest. Along with Powerhouse, Phoenix Jackson is a central black figure developed in something that approaches interiority but is not exactly that. Rather, on the Natchez Trace and then in Natchez, readers meet Phoenix's physical, material body performing the ordeal of a taxing journey—a racially inflected struggle—and her voice commenting aloud on and in her performance. Insofar as this voice presents her talking to herself as often as to others, it displays a degree of interior reflection.

What Phoenix Jackson performs is resistance, durability, vulnerability, and strength. She is presented as "very old and small . . . in the dark pine shadows, moving a little from side to side in her steps, with the balanced heaviness and lightness of a pendulum in a grandfather clock. She carried a thin, small cane made from an umbrella, and with this she kept tapping the frozen earth in front of her" (*CS* 142). That is, her body is associated with civilization (the grandfather clock, the umbrella cane), not—as the black body often is in white literature—with nature, a force conquerable by civilization. Her physical description is riveting and detailed:

> She wore a dark striped dress reaching down to her shoe tops, and an equally long apron of bleached sugar sacks, with a full pocket: all neat and tidy, but every time she took a step she might have fallen over her shoelaces, which dragged from her unlaced shoes. She looked straight ahead. Her eyes were blue with age. Her skin had a pattern all its own of numberless branching wrinkles and as though a whole little tree stood in the middle of her forehead, but a golden color ran underneath, and the two knobs of her cheeks were illumined by a yellow burning under the dark. Under the red rag her hair came down on her neck in the frailest of ringlets, still black, and with an odor like copper. (142)

She is dressed in the clothing of an earlier time, clothing that conveys neatness, material deprivation, resourceful bricolage, and age. Her advanced years are associated both with a degree of physical frailty and with an emblem of wisdom (the wrinkle pattern of a tree on her forehead, also associated with lynching in her time and place). And of course she is Phoenix, a name carrying the mythological weight of regeneration, renewal, and survival.

Throughout, Phoenix is presented as a resistant body, making her way against obstacles and through ordeals. To herself she remarks, "Seem like there is chains about my feet, time I get this far. . . . Something always take a hold of me on this hill—pleads I should stay" (CS 143). The something may be aesthetic appreciation or it may be arthritic weariness or a combination of the two, but whatever it is, it is met with perseverance. She responds with a theatrical assault on the ordeals in the natural world: "Putting her right foot out, she mounted the log and shut her eyes. Lifting her skirt, leveling her cane fiercely before her like a festival figure in some parade, she began to march across. Then she opened her eyes and she was safe on the other side" (143). There she comments, "I wasn't as old as I thought." Leaving the tree-lined walk behind to assault a barbed-wire fence, she is aware of her material disadvantage: "she could not let her dress be torn now, so late in the day, and she could not pay for having her arm or her leg sawed off if she got caught fast where she was" (143).

As in much of African American literature rather than in the southern pastoral, the natural world of Phoenix's Natchez Trace is not primarily a romantic, spiritual space but a place crammed with lurking dangers. The worst of these are human; as Donnie McMahand carefully observes, the landscape echoes racial violence: "the path [Phoenix] follows winds through a wintry terrain that eerily reiterates the South's rhetoric of racialized violence: 'Big dead trees, like black men with one arm, were standing in the purple stalks of the withered cotton field. There sat a buzzard'" (182). The cotton in this field is "old" and the corn is "dead." The field, ghostly, "whispered and shook." This is the scene of Phoenix's encounter with a white small-game hunter, the first of two encounters with a white presence that imposes certain expectations for the performance of race.

The gentleman hunter at first may seem to be a benevolent figure in that he comes on Phoenix after she, "like a little puff of milkweed," has been knocked into a ditch by a large dog and found herself unable to rise (CS 145). Stuck on her back "like a June bug waiting to be turned over," she is found by the white hunter. But he is ambiguous and ultimately threatening; he carries a gun and is accompanied by another large dog in this landscape vaguely haunted with images of racial violence. Recognizing the threat he himself poses, he asks the elderly woman, "'Doesn't the gun scare you?' . . . still pointing it." Her response is careful as she holds "utterly still": "No, sir, I seen plenty go off

closer by, in my day, and for less than what I done" (146). The hunter responds to the black woman's stoicism with what a reader recognizes as a mask of, rather than the fact of, benevolence, because he is caught in a lie. While praising Phoenix as "scared of nothing," he tells her he would give her "a dime if [he] had any money with [him]." But the reader and Phoenix have seen a coin drop from his pocket, the shiny nickel much discussed in responses to the story. Phoenix rewrites the hunter's predictable racial script for her as an old auntie, tough but not too smart, and bests him by performing a parody of a trickster figure, enacting a darting opportunism, taking tiny advantage where she can find it and against the odds by snapping up his dropped coin. The encounter's closing is read by McMahand as a "verbal threat (disguised as advice)" when the hunter in the southern woods counsels, "stay home, and nothing will happen to you."

At the end of her journey in Natchez, Phoenix is once again asked to perform a familiar racial script, this time on the determining stage of a medical clinic offering "charity." There, a crisp-voiced and impatient nurse also condescends to Phoenix, peppering her with a rush of white exasperation toward what she inventories and disdains as a rural black charity case: "'Tell us quickly about your grandson, and get it over. He isn't dead, is he?' . . . 'Is his throat any better?' asked the nurse. 'Aunt Phoenix, don't you hear me? Is your grandson's throat any better since the last time you came for the medicine?'" (CS 148). The nurse is all annoyance over an injury that she clearly thinks would not befall a well-protected middle-class child: she is satisfied that she knows Phoenix's story when she locates "a card with something written on it." The medical note "Swallowed lye" categorically suggests to her a black child inadequately parented, and provides her with ready-made lines from a familiar racial script that emphasizes hopeless black misfortune and presumed-on white charity.

Phoenix's reply is also a racial response—to the script the nurse has read her as performing. There is a resistance about her: "With her hands on her knees, the old woman waited, silent, erect and motionless, just as if she were in armor." In Phoenix's moment in the clinic, there is a period of silence that might be read as a short stretch of "mindlessness," a word associated with Partheny in *Delta Wedding*; mindlessness might signify a spell when what is felt and thought cannot safely find expression or be expressed. In Phoenix's case, this pause is followed by "a flicker and then a flame of comprehension [coming] across her face, and [then] she spoke: 'My grandson. It was my memory had left me. There I sat and forgot why I made my long trip.' 'Forgot?' The nurse frowned. 'After you came so far?'" (CS 142). Of course another possible meaning of Phoenix's mindlessness is medical: she is an elderly woman who has come through a strenuous physical ordeal, and a truly concerned nurse might think that she is possibly dehydrated or might

be showing signs of age-related confusion. But rather than suggesting, "well now, let's have the doctor look at *you*," the nurse says, "[y]ou mustn't take up our time this way, Aunt Phoenix" (CS 148).

Recovering and remembering, Phoenix tells the story of a child's suffering and lasting, as well as of her own commitment. Welty wrote her essay "Is Phoenix Jackson's Grandson Really Dead?" in response to readers' questions that seemed to her to land exasperatingly far off the mark, but it is not unreasonable to think that readers have met the story with questions in part because Phoenix, like Powerhouse, keeps her own counsel in response to the clinic nurse's assumptions. While readers are sure that they know her as strong enough, enduring, and forbearing—as well as a vulnerable and at-risk body—they are caught outside certain entry into her life story, with more access to her resistance of the racial script that she knows she is seen as performing than access to details of her actual life.

Thinking back to my discussion in the introduction to this book of Jane Marcus's characterization of a strategic feminist aesthetic of "obstinacy and slyness," I suggest that Welty in her creation of Phoenix is attending to a similarly dexterous, sly, obstinate, and revisionary performance of race, given in response to the diminishing scripts that Phoenix's white audiences impose on her. Phoenix might then evoke the trickster folklore of Br'er Rabbit as much as the mythology of the self-renewing firebird. And in *Delta Wedding*, Welty again pays attention to dexterous or obstinate racial resistance. To illustrate that novel's interest in the performance of race, I now discuss a few central scenes involving first Partheny and then Aunt Studney.

Sarah Ford in "Laughing in the Dark: Race and Humor in *Delta Wedding*" tracks the comedy kindled by the performance of race in the novel. Ford's discussion liberates the laughter in scenes where black characters deride white behaviors and assumptions, even though no one in the novel is listening in a way that releases the potential laughter. I argue that what Ford reveals over and again as she attends to this subtle humor are satiric performances of race delivered in resistance. Consider, for example, the scene in which the white daughters Shelley, India, and Laura bring Partheny food, which is meant to express the family's concern for the black houseworker's recovery—and return to work—after her debilitating episode of "mindlessness," a state that can be read as an episode of psychological detachment responding to the trauma of living with a black identity. McMahand provocatively reads mindlessness as a suicidal dissociation in response to racial despair. The family's goal is to bring Partheny back to work without any inquiry into her episode of withdrawal, and the scene suggests what are likely both characteristic patterns of their white-black interactions and a coping mechanism that Partheny in this case successfully draws on. Shelley asks the houseworker if she has seen her mother, Ellen's, missing jewelry, and Ford analyzes the interaction

in which the white girls unselfconsciously impose a familiar racial script on a black woman. Partheny's response is a comic performance that invites the girls' self-correction:

> Partheny is expressing her regret that Ellen has lost such a treasure when India compliments her hat. Partheny exclaims, "It's a drawer-leg." . . . Shelley continues her patronizing by assuring her, "Yes, it's real pretty." Although the young girls attempt to humor this supposedly "mindless" domestic with their wedding invitation . . . and their silly compliments, she laughs right back at them. She humors their mother's absurd request to think about where her pin might be by looking around her own home, saying, "Don't suppose that pin could have flown down *here* anywhere, do you?" Laura then observes, "Partheny looked, patting the bed quilt and tapping the fireplace, and then disappearing into the other room where they could hear her making little sympathetic, sorrowful noises, and a noise like looking under the dishpan." Even the outsider Laura understands that Partheny was "playing-like looking for it." Partheny's performance makes their request look ridiculous; the humor does its job of subverting the power structure the girls assumed with their patronizing compliments. . . . Partheny's humor answers their inappropriate behavior by mocking their mock politeness, but if the girls can hear her, they do not respond. ("Laughing in the Dark" 139–140)

Similarly, Aunt Studney is another case of resistant (and dissociative) behavior. As is often pointed out, her name echoes her habitual response to any interaction: "Ain't studyin' you" (*Delta Wedding* 29). David McWhirter turns that phrase to reflect the woman's refusal to be studied, arguing the character's place in the pattern of "Welty's persistently withheld portrayals of withholding African Americans" ("Secret Agents" 120). He builds on Barbara Ladd's observation that the novel constantly makes readers aware of the lives of "black characters in this novel 'behind the veil' that separates them from the white characters" (quoted in "Secret Agents" 120), a consciousness brought home as readers repeatedly focus on the presence of black characters and overhear snippets from lives they do not fully understand.

Donnie McMahand characterizes Aunt Studney as a "most complex projection of the white gaze," giving a performance of race that escapes white expectations and yet does not. "In almost all aspects of her spectrographic figuration, Aunt Studney becomes a study of contrasts, her spectral identity merging at times with her ardent, bodily opposition to white dominance. . . . Aunt Studney sets her own itinerary, irrespective of property lines and racialized restrictions, challenging the controlling intent of the white gaze—but with marginal success" (174–175). McMahand reads the spectacle of her black body, which is seen by the acculturated child Laura as "coal-black, old as the hills, with her foot always in the road. In the child's eyes, Aunt Studney's skin color becomes an object of exhibition, one more detail in a canvas already crowded with oddities" (175). Although read by the Fairchild family

as performing a recognizable racial script, Studney also has some surprises for the white gaze in her repertoire:

> When the children are not looking, Aunt Studney opens [her] sack and releases a cloud of bees into the house. Setting the terms of Aunt Studney's otherness, the attack figures as the most fanciful act of black aggression in the novel. To be sure, the sudden swarm of bees leaves the children all the more confounded, with Roy laughing and asking, "Aunt Studney! Why have you let bees in my house?" Sphinx-like, Aunt Studney has no response for him; her actions stand alone, her strangeness multiplied within the mechanism of her control. (McMahand 175)

Arguably Welty's handling of these characters does not appropriate them nor claim to know them intimately, and as McWhirter suggests, this allows readers to know how much white people do not know. On the other hand, Welty reveals considerably more than nothing about these women. As Welty comments when asked about having crossed the color line to take photos of African American women and men, "Had I no shame as a white person for what message might lie in my pictures of black persons? No, I was too busy imagining myself into their lives" (*One Time, One Place* 10). In these stories, not at all contradictorily, there is a felt presence, considerable legibility, and an "imagining into" in her withholding fictional portraits of African American "other women."

In *The Golden Apples*, black characters are still more limited and marginalized than the black women in *Delta Wedding*. But they too are more complex in their performances of race than is generally acknowledged. In "Moon Lake," for example, Twosie speaks with a "high, helpless voice" (*CS* 348) and with a distracted and comical quality that for some calls up Butterfly McQueen's Prissy in David O. Selznick's *Gone with the Wind*. But that echo is a revoicing that yields a performance of race that is savvier than the film's. Welty habitually uses echo and allusion to emphasize her own narrative difference, something I have written about elsewhere and in chapter 5 on rape plots in this book. Unlike Prissy, who is portrayed as inept and in need of Scarlett's superior bravery and white woman competence, Twosie is portrayed as revealing aspects of Moon Lake's woods to the white girls, who have no similar awareness. While the camp girls are chattering, Twosie hears a ghost on the lake:

> "Hear him?" . . . "Know why? Know why, in de sky, he say 'Spirit Spirit.' And den he dive *boom* and say 'GHOST'? . . . Yawl sho ain't got yo' eyes opem good, yawl. Yawl don't know what's out here in woods wid you. . . . Yawl walk right by mans wid great big gun, could jump out at yawl. Yawl don't eem smellim." (*CS* 348)

As Christin Taylor points out in "The Boogie and the Bush: Racial Consciousness in Welty's Jim Crow–Era Short Fiction," Twosie links ghosts

with white southern men carrying guns in the woods and with their victims, informing the protected daughters of white Morgana of a racial landscape that they, unaware, have never noted, let alone gained competence in. When Jinny Love "with her switch indent[s] the thick mat of hair on Twosie's head and prod[s] and stir[s] it gently . . . [pretending] to fish in Twosie's woolly head" (*CS* 349), Taylor sees a fishing "for alternative epistemologies . . . that captivate the girls and suspend them in a moment of temporary reflection. The girls yearn to see through Twosie"—just as Nina yearns to enter Jinny Love's head when she bangs on it, hot as glass, while realizing you can never enter another *through* the head. Sharing Nina's impulse to enter other minds, Welty remarks that she "never doubted that imagining yourself into other people's lives is exactly what writing fiction is" ("Looking Back at the First Story" 755).

Ruby Gaddy's Body: "The Demonstrators" as Crime Fiction Investigating Reader Responses

All of this discussion has in a sense been a prelude to my reading, in "The Demonstrators," the body of Ruby Gaddy, approached and isolated as a black woman's body withholding secrets that the reader and her attending doctor ostensibly both want to access. Interpreting readers still have work to do on "The Demonstrators," although some trends toward consensus about the story are emerging. Like much of Welty's best work, it is complex, not at all straightforward, and even more than most can be and has been read variously. I argue that its complexity does not in the end make it an ambiguous work, but it is a risky, mysterious, and knotty one that, like Chesnutt's *Conjure Woman and Other Tales,* can reflect to readers their own views on race or—in its gaps and uncertainties—engage and possibly guide readers to reverie and to questioning their own racial assumptions. Eventually the story's satiric presentation of the *Sentinel*'s journalistic travesty makes it pretty clear both what the story is flatly not open to saying and its position on certain white narratives about race.

Like Rebecca Mark in "Ice Picks, Guinea Pigs, and Dead Birds," I have long understood this story as a murder mystery to be read by following clues. I recognize the plot structure to be one in which Welty would later become increasingly interested as a result of her relationship with Ross Macdonald/Kenneth Millar (this story was written in 1965, and Millar first sent a "fan letter" to Welty in 1970 upon the publication of *Losing Battles*). Her handling of the murder mystery genre in "The Demonstrators" is more modernist than typical and does not lead to easy resolution. But, I argue, it does lead to a "reveal." As always when reading Welty, following the clues embedded in the fiction's details can produce an evocative reverie that takes the place of a

conventional plot and is as informing as any traditional plot (see my "Photographic Convention and Story Composition").

It is helpful to trace the varied history of critical response to "The Demonstrators" in order to see where its indeterminacies have taken readers. It is true that some readers write conventional denouements into Welty's stories by working hard to privilege action or epiphany over detail, that is, they shape the plot that Welty's story pointedly avoids, as in those responses to "A Worn Path" that ask if Phoenix Jackson's grandson "is really dead." These interpretations favor more traditional plots than Welty writes. Consequently, attending to the history of published responses to "The Demonstrators" might be the same as tracking the record of a community of interpreters teaching itself, over time, how to read the story.

Early critical responses by and large were the most sympathetic to Dr. Strickland, seeing him as a well-intentioned medical authority justifiably at odds with the racial otherness of his patient and community, an otherness revealed in Ruby's and her community's performance of intractability when replying to the doctor's questions and in what he understands as their proximity or disposition to violence. At the same time these earliest responses already recognized some degree of the doctor's disturbing behavioral whiteness, particularly his startling failure to recognize and identify his patient as Ruby Gaddy, the woman who cleans his own office five days per week, but whose individual identity, we gather, has for him been obscured and erased by her status as invisible black labor. In these initial readings and in one more recent (Banecker), whiteness is assumed to be a frame of reference, the "normal" or a standard from which the black community is cut off.

Then, beginning with Noel Polk's 1986 essay, "Continuity and Change in Eudora Welty's 'Where Is the Voice Coming From?' and 'The Demonstrators,'" critics began to elaborate the story's attention to whiteness and to what it does not know. Polk argues that the story "is *about* the responses of the Holden community, the white community, to the murder; . . . Strickland carries with him into the black community all of the prejudices and blindnesses of white Holden" (9). Polk articulates this point of view as "a prejudice or blindness [not] of ill-will, but rather of indifference" to a community that lives "separately, enveloped [for the doctor] in a darkness darker than the color of their skin" (9–10).

With an interpretative disagreement emerging, a cluster of readings emphasized the ambiguity of the text—"ambiguity" resembling that disturbing word "ambivalent" in Dean Flower's misleading depiction of Welty on race, as in his comment, "it's no wonder that she felt ambivalent about racism" (33). Suzanne Ferguson, for example, reads the story as "controlled play with [stylistic] cognitive dissonances" that "on a first reading . . . seem to call up a muddle of responses," a "muddle" that Ferguson sorts out as asserting the

doctor's growth and indicative of Welty as "incorrigibly, mercilessly hopeful" about his improvement (53).

Suzan Harrison's influential reading in "Racial Content Espied" moved the critique away from textual uncertainty to seeing the text as being about interpretation.[2] This discussion puts compelling emphasis on the textuality of Ruby's black female body in "a story about reading and writing race and about resisting and obstructing racial readings" (Harrison, "Racial Content Espied" 94). It evaluates the interpretative framework that the doctor, who is a representative of cultural and medical authority, relies on as he bares and interrogates Ruby's wound. Uncovering the problems in the doctor's footing, Harrison notes the cross-examining quality of Ruby's community of black women, who withhold responses to Dr. Strickland and his condescending questions.

Mark in "Ice Picks, Guinea Pigs, and Dead Birds" offers more extreme resistance to interpreting Ruby and Dove through the doctor's perceptions and the *Sentinel*'s news story, a document that although consistently understood as a darkly comic exhibition of official whiteness, nonetheless in many readings is assumed to provide basic plot details as well as parody and confusion. Mark resists those details and as a result she asks if Ruby and Dove are perhaps not dead at all, a startling and provocative question in some ways prepared for by the bias, inaccuracy, and official racism of the *Sentinel* "report," which Mark argues cannot also be the source of trusted facts about what has happened between Ruby and Dove. Turning away from the *Sentinel*'s preoccupation with black-on-black violence, Mark uses the story's embedded details to open a discussion of cultural contexts, such as the black Baptist ceremony of "Easter Rock"; the nursery rhyme "Who Killed Cock Robin?"; the history of medical atrocities—lobotomies and sterilizations—performed on African Americans and poor whites under the banner of eugenics; 1960s racial murders; and finally the attention to mythic rebirth and resurrection in Robert Gardner's ethnographic film *Dead Birds*, which she provocatively connects to Ruby, Dove, and the birds appearing in the story's final paragraph. Attending to these details as suggestive contextualizations, Mark's reading refuses all easy assumptions about "who is really killing whom, and who is dead and who is alive" ("Ice Picks, Guinea Pigs, and Dead Birds" 209).

I take this sequence of critical responses as showing that, as Harrison argues, the story is precisely about reading and interpreting race, but also as suggesting that the reader's own stages of interpretation become part of the story. I briefly examine "The Demonstrators" against another short text that, while seeming to be about possible violence between a black man and a black woman, is actually about interpreting and misreading the performance of race: Faulkner's "That Evening Sun."

Faulkner's Nancy fears murder and Welty's Ruby is murdered, but I argue

that it is not these ill-defined "crimes" as much as readers' responses that are being investigated—and possibly opened to sentencing. Led by characters who guide readers' initial assumptions (on one hand, young Quentin Compson, reflecting the voices that surround him as a nine-year-old white child, and, on the other, Dr. Strickland, reflecting the assumptions of a white doctor practicing in the Jim Crow era), readers may initially accept the white suppositions built into the text, but then find them critiqued, guiding them to probe their own responses. These stories can pass as sharing white assumptions or be understood as undercutting them, precisely because it is up to the readers to self-correct or not. What's more, both stories refuse to answer the questions readers want most to ask—that is, what has happened to Nancy and to Ruby?—leaving them wanting to know more about the women than segregated knowledge allows. These several parallels and others—for example, Faulkner's and Welty's uses of the names Jesus and Dove as ironic markers, perhaps calling for an absent cultural salvation with the name Jesus and for an unavailable redemptive peace with the name Dove—may suggest that Welty is indirectly responding to Faulkner's text in her own parallel play. For these reasons, a closer juxtaposition of the two stories is informing.

"That Evening Sun" and "The Demonstrators": Reading and Misreading Race

"That Evening Sun," like "The Demonstrators," introduces the body of a black woman that is read and misread through racial stereotypes. Some readers settle for misreadings of Nancy promoted by voices in the text, which are overheard by the young Quentin Compson, while others gradually see how the text shows Faulkner's Nancy and Jesus (as Welty shows Ruby and Dove) caught in stock interpretations, living in a racist culture. Ralph Ellison, following a generation behind, described Faulkner as "more willing perhaps than any other artist to start with the stereotype, accept it as true, and then seek out the human truth which it hides," and then added, "[p]erhaps his is the example for our writers to follow" (43). This open-to-interpretation compliment, like Toni Morrison's for Welty (as neither "patronizing" nor "romanticizing" black characters, but writing them "the way they should be written about"),[3] invites thought and speculation about what Ellison as a writer of color appreciates in the white writer's handling of race. Ellison suggests that Faulkner evokes cultural stereotypes but takes them to places where they unravel, and in the process puts white readers in a position to interrogate how they misread race, inviting their propensity to accept racial clichés but also inviting their responses to evolve beyond that initial acceptance.

"That Evening Sun" offers a number of familiar racial misinterpretations of Nancy. Nancy's body is read with suppositions of drunkenness, prostitution,

and drug abuse, none of which, on consideration, are confirmed. Nevertheless these voices guide the child Quentin, who is reconsidering and interrogating those assumptions fifteen years later. Faulkner makes it possible for a reader to see first through the child's uncritical eyes, and then possibly beyond, to find whiteness brought to visibility by its ricochet off Nancy.

Mr. Compson's is one of the voices coloring Quentin's and the reader's view for a time. Quentin recalls being sent by his father with his siblings to fetch Nancy to cook breakfast when Dilsey was sick. The text says they would throw rocks at Nancy's house until she came to the door, without any clothes on, and leaned her head around it to say, "'What yawl mean, chunking my house. . . . What you little devils mean?' . . . 'Father says . . . you've got to come this minute'" (Faulkner 77). That is Caddy impressing on Nancy her father's assumption that racial etiquette requires Nancy to put the white family's needs before her own. She is their laundress, but if Dilsey is sick, Nancy needs to come to them right now. Although the Compsons' assumption is that she should obey immediately, she refuses, in violation of Yoknapatawpha's conventions of racial etiquette, replying, "I ain't studying no breakfast. . . . I going to get my sleep out" (78). Five-year-old Jason judges her: "I bet you're drunk. . . . Father says you're drunk. Are you drunk, Nancy?" (78). Later, Quentin reports that alcohol was not her problem when he says: "So we thought it was whisky until," and then readers hear the incident of Nancy who, while being taken to jail for an unnamed offense, calls out to Mr. Stovall, a church deacon, "white man . . . it's been three times now since you paid me a cent" (78). A reader's likely next response is that Faulkner has sketched Nancy into the literary cliché of the black jezebel, the hypersexualized, promiscuous black woman, the prostitute.

But a reader familiar with the culture of Yoknapatawpha may recognize that Nancy is not a prostitute as much as caught in racially determined sexual abuse. Nancy is saying what is universally known but collectively left unsaid, that white men like Mr. Stovall require black women like Nancy to come to their beds. In Yoknapatawpha, Mississippi, white ladies of a certain class, like Mrs. Compson, are ideally constrained from physicality, are prescriptively frail and "pure," guarded from labor and touch, kept from caring even for their children's bodies, protected along with the class and caste system of which their bodies are made emblematic. Meanwhile black women, by converse prescription, are expected to labor and to be warm caretakers of white women's children, are imagined to be physical as the white lady is not, and are understood to be sexually available. Exploited sexually, they are required to perform "race."

Answering the unaddressed question of why Nancy is going to jail, it might be that Nancy is accused of and maybe jailed not for being drunk, not for prostitution, but for resisting southern racial etiquette generally and for re-

peatedly breaking the rule of not speaking what everybody knows, but that racial etiquette requires no one to say: that black women are required to take care of white people's families on disruptively short notice and to provide sex on the demand of white men. Moreover Nancy speaks rowdily in a community that protects racial etiquette with power and violence, hence the barely noted kicking in of Nancy's teeth by Mr. Stovall.

So, a reader construing Nancy's story is preliminarily enmeshed in the stereotypes of a black woman going to jail for predictable offenses. For some readers, these prefabricated racial assumptions are counterbalanced by Quentin's childlike interrogation of events and assumptions, a questioning that is not quite skeptical, challenging, or incredulous, but also not yet settled into blind acceptance. A reader seeing through the false conclusions that surround Nancy going to jail may also infer that, despite the resistance expressed in Nancy's sass, she may be living with a black woman's racial despair, which—to borrow McMahand's language for Welty's Partheny—"bends inchoately between self-assertion and self-defeat," uncovering a tendency toward self-destruction (177). Nancy's resistance has an air of abjectness, also present in her frequent refrain "I aint nothing but a nigger," which implies living a life in which, despite swaggerful verbal challenges, she *has* despondently agreed to perform race (Faulkner 80, 85).

The impact of racism is also visible in this story in its effect on Nancy and Jesus's sexual relationship. Although her racist jailer, in yet another reductive white reading, attributes Nancy's suicide attempt to "cocaine and not whisky, because no nigger would try to commit suicide unless he was full of cocaine" (Faulkner 78), Nancy of course does not need to be on cocaine to want to kill herself. Her reasons are obvious as she swings naked with "her belly already swelling out a little, like a little balloon," a phrase that Faulkner was required to cut from the story along with the name Jesus for its first publication in *American Mercury*, details that he restored and stressed when he republished it later the same year (1931). Nancy is pregnant and not by her man, and as a result, Jesus is leaving her. As in Bessie Smith's black woman's blues to which the story's title alludes (the song "St. Louis Blues"), Nancy will "hate to see that evening sun go down" because, metaphorically at least, her "baby done left this town."[4] Nancy's story of being deserted is synonymous with being afraid of Jesus, who is outraged because, as he puts it, he "cant hang around white man's kitchen. . . . But white man can hang around" his (Faulkner 79). A white man has come into his "kitchen"—which now has a bun in the oven—and Jesus cannot stop him. Jesus is living in a culture where his sort of rage is silenced by the practice of lynching. So Nancy fears that his anger must be redirected at her (although the only violence confirmed in the story is Mr. Stovall's). Throughout, readers are seeing the effects of broadly institu-

tionalized racism on this couple's sexual relationship. The effect of their living in a racist culture is to make their partnership untenable.

I have taken the time to examine Faulkner's story before turning to "The Demonstrators" to point to how Welty's story is similarly about reading a black woman's body, about whiteness revealed by its response to a black woman's crisis, about that woman resisting the expectations that she perform race, and perhaps also about the damage inflicted by broadly institutionalized racism measured in its effects on a couple's relationship. Like Faulkner, Welty takes stereotypes to a place where they unravel; her story too invites readers to interrogate and discover themselves in their responses to reading the fiction, in their responses to Ruby's body as highlighted in the text, possibly recognizing themselves as one more audience both eliciting and embroiled in a performance of race. Reading the story here, I focus not only on Dr. Strickland's encounter with Ruby's house, body, and female community but on the practice of medicine in the segregated, Jim Crow South, exemplified in the role played by Holden's one doctor, and on the economic story of Ruby, Dove, and the Fairbrothers Cotton Seed Oil Mill, which appears in crucial moments of the murder mystery.

It is not new to say that, as he is led by a black child's demand to hurry to the other side of the railroad tracks racially dividing the town of Holden, Dr. Strickland travels into a power failure. He follows the youngster's directions that "could only tell him how to get there, an alley at a time, till they got around the cottonseed mill," where the "last electric light . . . [burned] in the vast shrouded cavern of the gin," the local economic power (CS 609). Coping with a "blackout," Strickland gropes and fumbles in the black community, experiencing strangeness while attempting to maintain his authority as a doctor. The power outage contributes to Welty's production of a surreal landscape, a stricken land in which the "water tank, pale as a balloon," emits "hollow, irregular knocking . . . from inside," a terrain not only unilluminated but arid in a way that calls up T. S. Eliot's spiritually barren "waste land" in need of rain, redemption, and renewal, a land in need of a healer (CS 618). Traveling this metaphorical geography of affliction, the doctor's car's white beams bring "into relief the dead goldenrod" and a sense of damage (609). This eerie, evaporating topography stands in for the desolate and damaged social terrain of Mississippi's reliefless civil rights landscape in the mid-1960s. That milieu is called up by the story's title and by numerous quick references to the events of the historical moment of publication, 1966: after the bodies of the murdered civil rights workers Andrew Goodman, James Earl Chaney, and Michael Schwerner were found, after black churches were repeatedly bombed in Mississippi and Alabama, and after Welty's friend the Reverend Ed King was disfigured in a car "accident" created by anti–civil

rights protestors and his jaw broken by police while he was beaten and jailed for demonstrating.

In an inversion nonetheless comparable to the theft of electric "power" that Ralph Ellison's nameless protagonist in *Invisible Man* (1952) uses to illuminate the story he tells from his underground retreat, Welty's atmospheric operational failure raises the question, "Who has the power?" This is background to Dr. Strickland's awkward white experience of being baffled when he enters a black Holden community composed of numerous individuals he knows, and is even beholden to, but whom now, outside of the daily contexts in which he more comfortably regards these individuals (as bodies providing service), he fails to recognize for much too long. Bewildered in a darkness that encodes the limits of his awareness, "at first his eyes could make out little but an assembly of white forms spaced in the air near a low roof—chickens roosting in a tree. Then he saw the reds of cigarettes." Still in need of guidance, he follows "a kerosene lamp . . . being held for him in the doorway. He stepped into a roomful of women" (CS 609).

Suzan Harrison calls attention to his following "a path of newspapers laid down . . . from the doorway to the bed" in a room where the walls are newspapered, a familiar image of poverty that also emphasizes the textuality of the body the doctor is deciphering. While disturbingly failing to identify Ruby, whom he knows, he "exposed the breast and then before her hand had pounced on his, the wound below the breast" (CS 609). Here is again the now-familiar scene of exposure of the other woman's body that I have traced across Welty's fiction, but in this case the othered woman resists rather than invites becoming a spectacle. The doctor's exposure of Ruby as "the breast, the wound," as Harrison points out, is suggestive of the stereotypical reduction of black female identity to sex and violence. But Ruby, with her gestures of withholding, like other black female characters in this chapter, defends against being cast into a performance of race and gender by and for a white audience.

The doctor asserts his status through abrupt, rebuking interrogations of the women in the room. He accuses them with a series of questions: "Too much excitement to send for the doctor a little earlier?"; "Have you touched her?"; "What the devil's running in here?"; "You got a fire on in here?"; "Can you ever hush that baby?" (CS 609, 611, 610, 613). In reaction, the women stand firm on Ruby's and their own behalf, in ways that suggest a community of resistance, something different and more than can be seen in Faulkner's story (where Nancy does not even have Dilsey come to her aid). Turning the tables on him, they demand: "'Don't you know her?' . . . as if he was never going to hit on the right question." Then, "[a]s if she had spoken, he recognized her," though merely as the woman who cleans his office. Turning to her, he demands, "Ruby, this is Dr. Strickland. What have you been up

to?" And the quick choral response from Ruby's encircling female network is "Nothin" (610, 611).

Ruby's Wound, Medicine, and the Murder Mystery Reveal

This aspect of the story frames and contributes to Welty's concern with medical practice in apartheid Mississippi. In the Jim Crow South certainly not every white doctor treated black patients, and hospitals at that time might or might not have had a black wing. In Mississippi, Taborian Hospital, located in the all-black municipality of Mound Bayou (the oldest in the country), was where African American staff treated the medical needs of black patients, and the sick and injured came from far and wide for care there. Since he is the only doctor in Holden, readers are relieved to learn that Dr. Strickland can be readily brought across the tracks to make a house call in the black community, but attention should be directed to what happens when he treats Ruby.

Lucille, sticking a "lamp hot" and her own cross-examination "into his . . . face," reverses the direction of the allegations with the clear suggestion that his medical treatment of Ruby is inadequate:

> "Remember Lucille? I'm Lucille. I was washing for your mother when you was born. Let me see you do something" she said with fury. "You aint even tied her up. You sure aint your daddy!"
>
> "Why, she's bleeding inside. . . . What do you think *she's* doing?"
>
> [The women] hushed. For a minute all he heard was the guinea pigs racing. He looked back at the girl. Her eyes were fixed with possession.
>
> "I gave her a shot. She'll just go to sleep. If she doesn't, call me back and I'll come give her another one." (CS 613–614)

Dr. Strickland successfully silences Lucille with the dire medical fact of Ruby's internal bleeding, reestablishing his medical authority. But Lucille has been right to speak out.

Judging from Strickland's remarks in combination with my consultation with a practicing physician, the doctor believes Ruby's heart is pierced. As he chastises the women for bringing Ruby her infant, perhaps with the intention to boost her will to live, and as Ruby's mother looks at her daughter's child and insists she will not raise the baby, perhaps challenging Ruby to rally, the doctor gives evidence of his diagnosis: "Get that baby out of here, and all the kids, I tell you. . . . This ain't going to be pretty. . . . I'd like a little peace and consideration to be shown. . . . Try to remember there's somebody in here with you that's going to be pumping mighty hard to breathe" (CS 612–613).

Dr. Strickland knows that if Ruby's heart is pierced, with every beat, blood is leaking into her pericardium. The medical prognosis in this sort of injury is that this accumulation will increasingly restrict the left ventricle's movement,

squeezing the heart so that it cannot expand after contraction. Simultaneously fluid backs up into the lungs. The called-for medical treatment for this dire situation, understood and performed since the eighteenth century, has an astonishingly positive success rate (75 percent today, although of course it was probably lower in a regional hospital in the 1960s) and involves draining the pericardium by inserting a needle into the heart. Draining the pericardium is an emergency department or even a field procedure, with the goal of transferring the patient to an operating room to suture the left ventricle if the bleeding does not stop. The palliative treatment is morphine to help with the feeling of suffocation.[5]

In her dire circumstance, Ruby needs treatment and care in a hospital. Later, in the *Sentinel* newspaper account of her death, which delivers Welty's caricature of the ludicrous travesties common in the white press's reporting of racial stories (a send-up all the more powerful because written from Welty's white Mississippian's insider point of view), readers are tellingly shown, through comparison with another weekend casualty, the look of urgent medical treatment that Ruby could not expect. The *Sentinel* (with its name that suggests the newspaper's role as a white sentry in the civil rights era's race conflict) reflects the white coverage of black lives, which are reported on only when crime or violence is involved. While the article makes Ruby's wound town news, it comically and appallingly interrupts and displaces her "demise," barely announced, when it straightaway digresses to the accidental death of a white boy, presented as if reasonably overriding the account of Ruby and Dove's story. This interposed story of Billy Lee Warrum's death is a complete and symptomatic non sequitur in Welty's parody of newspeak at its local worst. But its detail is very pertinent to Welty's account of Ruby's medical treatment. The interjection explicitly reveals what has not been done for Ruby: "Billy Lee Warrum Jr. died Sunday before reaching a hospital in Jackson where he was rushed after being thrown from his new motorcycle" (*CS* 619).

Ruby, however, was not hurried to any hospital, in either Jackson or black Mound Bayou. Rather, she was given a sedative to put her into a final sleep. Readings of this story, even those attending to the frame of Jim Crow medicine, have not adequately emphasized that the doctor's power failure is not just in his marriage or his inability to cure his daughter, afflicted at birth and dead at thirteen; it is in his absent expectations for saving Ruby. Welty's attention to the guinea pigs that the women hear racing as the doctor delivers his medical opinion rings a bell of negligence and malpractice toward black bodies that is not an aside; it is the visible solution to the murder mystery at hand.

The doctor's acceptance that Ruby's case is hopeless echoes a history told both at the Medgar Evers house tour and in the Hollywood film *For Us the Living: The Medgar Evers Story*, which, like Welty's "Where Is the Voice Coming From?," memorializes him. Evers's family hesitated to take him to

possibly available white doctors, for fear he would not be saved by them. While this may be—like the legend of Bessie Smith's having died after being turned away from a white Clarksdale, Mississippi, hospital following a car accident (she was actually taken to and died at a black facility)—an apocryphal story, it captures the black southern community's widespread and warranted concern about their medical treatment.

Would Ruby have died even if she had been rushed to a hospital? Very possibly, but it is also true that accurate diagnosis requires an X-ray and that the condition of a punctured heart is treatable with procedures available in a hospital. Instead Dr. Strickland prepares his "hypodermic," and while he does so, the room fills with other young black women: he is watched by "a row of them dressed in white with red banners like Ruby's . . . coming to fill up the corners" (CS 612). Ruby's treatment is representative and legion; the women's bodies, introduced to echo hers, suggest a multiplicity of black female bodies, which from white medicine's view are interchangeable and disposable (throwaway bodies too easily reduced to trash).

And Ruby's is not the only maimed body in the house. Dr. Strickland also recognizes Oree, whose "skirt is tucked in over the stumps of her knees," as "a figure of the Holden square for twenty years, whom he had inherited," who "still lives by the tracks where the train had cut off her legs" (CS 612, 614). Readers know no details of the maiming accident, but they do know that Welty rings the bell she also sounds in "A Worn Path": a recognition that terrible things happen to the poor (Phoenix Jackson's grandson's throat and esophagus scarred by accidentally drinking lye is a parallel to Oree's terrible accident). Welty connects this pattern to Jim Crow medical attitudes that blame the victim: think of the clinic nurse saying, "You mustn't take up our time this way, Aunt Phoenix. . . . Tell us quickly about your grandson, and get it over," a line that prefigures Dr. Strickland saying, "Ruby, . . . [w]hat have you up been up to?" (CS 148, 611).

Leaving Ruby and stepping into the moonlight, Dr. Strickland has an uncomfortable encounter with the row of dresses hung on the laundry line in front of the house. He recognizes the clothing as belonging to his own family: "his mother's gardening dress, his sister Annie's golf dress, his wife's favorite duster that she liked to wear to the breakfast table" (CS 615). These garments—like the familiar china cup he later finds himself drinking from—convey both the intimacy of and the distance between lives separated by the color line, emblems both of the interdependency of the houses (his and theirs) and of the differences in the lives lived in each. The garments disquietingly connect the black women he has left behind to cope and mourn with the white women in his own family, for whom he would expect to do better than he has for Ruby. At the same time he has failed to do better for his daughter Sylvia, injured at birth. The upshot is that his wife, Irene, who provided daily care for

their daughter (tending, lifting, feeding) beyond his medical attentions, has—since her loss—rededicated herself to the civil rights cause, which has become another tension between them. Now these dresses, laundered by black women like Lucille, who wash the clothing worn by white families such as his own, stand in for these women at odds with him and assault him "with sleeves spread wide, trying to scratch his forehead . . . flying around this house in the moonlight" (615). That angry imagery not only connects the black women of the story to Irene's trouble with her husband but also bonds the economic threads of the story to its medical raiment.

Intersections between the economic story of black Holden and its medical situation recur. Moving through the landscape of this neighborhood, Strickland passes a creek whose banks are depressingly littered, imagery again reminiscent of Eliot's "The Waste Land," where riverbanks are scattered with "empty bottles, sandwich papers, . . . cigarette butts" (lines 177–179), a picture of cultural illness and calamity. But Welty's creek banks are specifically strewn with evidence of medical catastrophes: narrow bottles empty of the sedative paregoric, "persistently sold under the name of Mother's Helper," a damaging narcotic "remedy" sold to and used among the poor throughout the 1960s, long after common recognition of its harm to children. Moreover, "telephone wires . . . hung with shreds of cotton" (CS 615) streak the atmosphere; this is a racial ghetto smudged by an industry that Rebecca Mark has connected to occupational brown lung disease—byssinosis—prevalent among mill workers exposed to cotton dust. This visible pollution hanging from trees and telephone wires in streamers of lint signals Strickland's drawing near to the "throbbing mill, working on its own generator" and emitting "a cooking smell . . . like a dish ordered by a man with an endless appetite" (615), suggesting voracious human consumption by a commercial enterprise.

This landscape leads to the railroad crossing that divides Holden by caste and class, "a grade crossing with a bad record," where the doctor notices another evocation of wasteland aridity, and Welty's language underlines her murder mystery's reveal. The doctor notes "the pillow-shaped glow of a grass fire," described so tellingly by Welty as "not to be confused with a burning church, but like anesthetic made visible" (CS 616). The startling reference once again underlines the anesthetic that Strickland has given Ruby to keep her sedate as she ebbs, comparing it to the more obviously malevolent murders enacted in the anti–civil rights church burnings of the period. Welty's word choice ("like an anesthetic made visible") makes "visible" Ruby as marginalized to death by white medicine's response to race, caste, and class, *as much as if* she had been murdered in a church bombing or burning. It is in this context that I understand the Reverend Jesse Jackson's comment on reading the story, made in a letter to the *New Yorker*, that "The Demonstrators" was

"so true and powerful," "it made me weep for my people" (quoted in Marrs, *EWAB* 328).

It is here in the story that there is a false epiphany from which a reader may, if so inclined, take suspect comfort: Dr. Strickland, though "tired, so sick and even bored with the bitterness, intractability that divided everybody and everything," experiences a "feeling of well-being [that] persisted [and] . . . increased until he had come to the point of tears" (*CS* 616). Brought a cup of water he has demanded, "suddenly tonight things had seemed just the way they used to seem. He had felt as though someone had stopped him on the street and offered to carry his load for a while—had insisted on it—some old, trusted, half-forgotten family friend that he had lost sight of since youth. Was it the sensation, now returning, that there was still allowed to everybody on earth a *self*—savage, death-defying, private? The pounding of his heart was like the assault of hope, throwing itself against him without a stop, merciless" (618).

If this were the story's end, it could suggest more reliably that, in an "assault of hope," the doctor has learned the importance of every self, an egalitarian lesson. But Strickland's short-lived shielding comfort, nostalgic and diminishing his sense of stress, is supplanted by Dove's dying body in an abrupt disarticulation parallel to the one in "A Memory"—that moment when the girl's contrived, suspect, and safeguarded recollection of a schoolboy is displaced by the exposed body of an other-class woman. Here, the shift is to the exposed body of an othered man. The doctor's feeling of comfort "gradually ebbed away, like nausea put down" (*CS* 618). As in the scene in Faulkner's *Light in August* when car lights expose Joe's white-black body emerging from the shadows of night, the moonlight and the lights of the doctor's car fasten on Dove, whose body is black and "golden yellow."[6]

> The man looked as if he had been sleeping all day in a bed of flowers and rolled in their pollen. . . . He was covered his length in cottonseed meal. . . . The man raised up on his hands and looked at him like a seal. Blood laced his head like a net through which he had broken. His wide tongue hung down out of his mouth. . . .
> "So you're alive, Dove, you're still alive?"
> Slowly, hardly moving his tongue, Dove said: "Hide me." Then he hemorrhaged through the mouth. (619)

Welty's golden seed imagery connects Dove's body, death, and secret to her continued use of "Waste Land" evocations, now calling up Eliot's ailing Fisher King, whose cure and health are needed to restore the land. And it connects Dove's body, entrapped in a web of blood that Harrison describes as "representing the repressive mythologies of racial identity, the myths of blood, by which white culture has sought to construct, control, and constrain

black Americans" ("Racial Content Espied" 105), to the specific economic story of the cottonseed oil mill. Dove's sudden appearance draws attention to the story's having circled him, having built interest in the mystery of his role in both Ruby's and Welty's tales. Responses to more of the doctor's accusing questions—"she married? Where's her husband? That where the trouble was?"—have led to Dove, who has left behind his guinea pigs. And when the doctor asks, "Is Dove who did it? . . . [S]omebody spit on the stove." Then a chorus of answers follows: "'It's Dove. . . . Dove.' 'Dove.' 'Dove'" (CS 611–612). The doctor readily fits that limited information into his prefabricated narrative: "Dove Collins? I believe you. I've had to sew him up enough times on Sunday morning. . . . Where'd he get to—Dove? Is the marshal out looking for him?" But in spite of the doctor's certainty, a reader may be aware of gaps in the story, gaps either filled in or widened by the confusing details of the *Sentinel* report, depending on a reader's disposition. Reviewing the details collecting around Dove, a number of questions emerge.

The *Sentinel*'s back-page headline reads: "TWO DEAD, ONE ICE PICK. FREAK EPISODE AT NEGRO CHURCH. No Racial Content Espied" (CS 619). The report is muddled and contradictory. There are frequent discrepancies in the account. Dove is reported to have died both of a chest wound and of a wound either to the ear or eye. He is called Dave, rather than Dove. Although he is purportedly wounded by Ruby after wounding her outside her church, the murder weapon is found on the far-off site of the new "Negro school," with no explanation for how the ice pick flew there.[7] (Was the community concerned for Dove? Or did it take part in his murder, perhaps delivering what they considered justice that would not be delivered by the law?) The opacity of Dove's story radically displaces the doctor's conclusion that "there was still allowed to everybody on earth a *self*." Moreover, one detail of the news report in particular raises disturbing unanswered questions that point not to "no racial content," nor to "no cause for the fracas," but to a possible economic story affecting a domestic one.

The mill has made its presence known repeatedly in the landscape of this story; now however the mill is a backstory that the *Sentinel* news article both acknowledges and denies and is also a clue in Welty's murder mystery. In and between the tabloid's lines, there are economic assumptions about white industry and black workers as well as a denied defensiveness about worker exploitation and simple facts about pay at the mill: "Mayor Fairbrothers stated that he had not heard of there being trouble of any description at the Mill. 'We are not trying to ruin our good reputation by inviting any, either. . . . If the weatherman stays on our side we expect to attain capacity production in the latter part of next month.' . . . Saturday had been pay day as usual" (CS 620).[8] One puzzling detail is that Dove comes to Ruby's church on payday, presumably "directly from his shift at the mill where he had been employed since

1959," since he was in work clothes, but "when Collins' body was searched by officers the pockets were empty."[9] Is there the hint that, just as Faulkner's Nancy and her lover, Jesus, were unable to withstand the institutionalized racism that complicated their relationship, Ruby and Dove have been unable to weather the tensions produced by whatever "trouble" has happened in Dove's job at the mill, an employer that expects "to attain capacity production" while its community of black workers lives in dire poverty?

The parallel then that I draw between Faulkner's and Welty's fictions is that they shape in their readers equivalent frustrations about what has not been told. Caught in white frameworks that direct the telling elsewhere, the black women's stories are displaced with race-based assumptions readers are invited to see through. These same fictions shape their readers, who want to know more about Nancy and Jesus and Ruby and Dove than the stories, with their limited white points of view, can tell.

Placing "The Last of the Figs" Among Welty's Civil Rights– Era Stories

"The Last of the Figs" (alternatively "Nicotiana") was never finalized for publication. "Figs," however, is largely accomplished, and it is a complex, provocative, and relevant conclusion to my reading of the bodies of Welty's othered women and the performance of race. Welty seemingly first drafted parts of the story between 1957 and 1964; she marked its first and major section as "Revised, '64."[10] She seems to have envisioned it being collected with "Where Is the Voice Coming From?" and "The Demonstrators," stories that she published in the *New Yorker* in 1963 and 1966, respectively, and then reprinted as the section "Uncollected Stories" in *The Collected Stories of Eudora Welty* (1980). Calling these "uncollected" stories was a misnomer indicative of her intention to eventually "collect" those two fictions not in *Collected Stories* but in a next volume, along with this third story, all three focused on the civil rights era. This intent is evident in her correspondence surrounding a dispute between Random House, which had her projected next collection under contract as of 1969, and Harcourt, which was shaping *Collected Stories* in 1979. John Ferrone, her editor at Harcourt, planned to (and did) include the two uncollected but published stories, a decision to which Albert Eskine, speaking for Random House, initially objected. Welty wrote to her agent, Timothy Seldes, on February 27, 1979, to say that the two stories predated her 1969 contract for a next collection, to outline her plans for the proposed volume, and to express her conflict:

> I would still like to hear from Mr. Ferrone and from you again, and from Random House too, in light of what the stories are. They are both about the "troubles" in

the Bad Sixties in Mississippi—the first deals with the Medgar Evers murder, the second obliquely but also, specifically. I had intended, all along, to complete some others I'd started and thought about, and to write some new ones, and group them for a separate book of stories. As you know, the novels intervened. So what I don't know now at this point: shall I give up the book of '60s stories by letting these two go in with the already collected stories for Harcourt? And this would put me back at [my] starting point with the book of stories I do owe Random House. . . . I wouldn't want to *not* express my appreciation to John Ferrone about *The Collected Stories* by holding back the new stories he would like to add, unless the reason were valid and proper. I wouldn't feel ready to give them up at all, if the new ones I'm working on weren't growing too long to go in a book with them too. Though it might not stay that way.[11]

The story that was getting too long seems to have been "Nicotiana/The Last of the Figs." Her thoughts about the project are also elucidated by a chart she made connecting three stories: "Grand Times," which she dated as set in 1936; "Nicotiana," which she dated on this outline as set in 1961; and "The Demonstrators," which she dated as set in 1965. The chart then traces characters from generations of the Strickland and Ewing families (among others) across all three proposed stories, again suggesting a plan for a story cycle resembling *The Golden Apples*. It is impossible to know when Welty made this chart, and so to know when she was entertaining this particular configuration, but some of the third section of the manuscript that I will discuss seems to have been written to fulfill the overarching plan, reaching back to the history and death of Mr. Ewing, described on the chart as from the Delta and otherwise not a character in the manuscript.

Although this preliminary chart suggests the date of this story was to be 1961, the actual manuscript's central historical allusion to the Little Rock Nine incident dates it as set in 1957. In this bit of civil rights history, the nine black students who integrated Central High School were initially blocked from entering the school building by ugly protests and by Arkansas governor Orval Faubus's decree, and then were defended by armed federal troops sent by President Eisenhower to enforce desegregation. Welty's use of the conflict clearly parallels her use of the murder of Medgar Evers in "Where Is the Voice Coming From?" and of Freedom Summer clashes in "The Demonstrators." Composed in three parts, the manuscript's first section concerns the domestic relationship between the two Ewing women—the elder Mrs. Ewing and her daughter Sarah, a children's book illustrator in her early forties—and their houseworker, Esther, which is developed in the context of both their personal histories and a background of remarks made by northern civil rights "agitators" talking to the local black community. The second section details a dinner party held for an opinionated northern visitor, Diana Cleveland, and records Sarah's friends' voices speaking on racial issues and on the tensions

between the North and the South. In the final section, the Ewing women go to Esther's house to confront her after she has without warning annoyingly quit them on the day of the dinner party, a visit whose goal is to recover Sarah's drawing of Esther's head, intended for use in a cover illustration for a new edition of *The Arabian Nights*. Esther unexpectedly has taken the drawing with her when she walked out on them, clearly thinking of it as her portrait and therefore hers, rather than as Sarah's intellectual property.

The story revolves around these three primary characters. Sarah Ewing is living in the South, where she now means to live permanently, with her seventy-five-year-old mother in their family home. When she was younger, she nearly married (or, in one draft, married and divorced) the painter Max Dawkins, who grew up in the neighborhood but is now a well-known artist in New York City. He is rumored to be gay and is still in touch, sending museum catalogs, a recent painting, but no letter. Mrs. Ewing has had a recent eye operation and is losing her vision, a plot component echoing Welty's semi-autobiographical *The Optimist's Daughter* by seemingly combining the elements of Judge McKelva's eye operation and Becky McKelva's prolonged illness at home. As a result of Mrs. Ewing's impairment, she can no longer drive or do housework easily. Esther, a black houseworker, has at the story's opening let herself into the Ewing house through the basement door and out of the blue pronounces herself "back," returning to a household where she has worked on and off for over seventeen years, but not for many years now. Arriving, she announces that they need her and that, for them, she has stopped working for the woman she jokingly calls "Mrs. Hog-eye," although later readers learn that Esther has kept her position with Mrs. Argyle and has added the Ewings' job. The Ewing women want help in the house so that Sarah will be freer to concentrate on her work—currently the illustration of *The Arabian Nights*—and Mrs. Ewing, reluctant to have someone new in the house, feels Esther is the only one she "could stand to put up with" ("Esther knows what we want and we know what little to expect of Esther").

"Figs" is remarkable in that it avoids any familiar formula for fictions about racial interactions current in the early 1960s, something that "Where Is the Voice Coming From?," as powerful as it is, does not do when it reveals the racist murderer, making racism a trait of a contemptible and mean underclass character. Showing racism as the practice of bad people can suggest that it is not a trait of better individuals. Here, however, it is exactly the habits of well-educated, professional, well-intentioned, middle-class characters, people with whom a reader might identify, that are explored. The fiction focuses on degrees of separation between the Ewings and Esther and on the difficulty these women have in forming a rapport across the color line. It is unblinking in that there is no dodging that Esther is a servant to the Ewing women, and at the same time it makes clear that this relationship of white employers to a black

maid in 1950s Mississippi provides a privileged, liminal space allowing the women their one opportunity to get acquainted, in an imprecise closeness negotiated over house chores and across the kitchen table and morning figs. Welty's portrait does not sentimentalize the relationship nor appropriate the black character by transforming her into a vehicle for white redemption, avoiding the familiar pattern established in such great American fictions as *Uncle Tom's Cabin, The Adventures of Huckleberry Finn,* and *To Kill a Mockingbird.* What emerges in "Figs" by comparison are unvarnished white behaviors and viewpoints that are at times insensitive, at times put upon, at times unsettling, and at times unsettled, but always complex. Later, Welty says about her intent in her civil rights era fictions: "it's not just a matter of cut and dried right and wrong—'We're right—You're wrong,' 'We're black, you're white.' You know, I wanted to show the complexity of it all" (Royals and Little 259). Unlike Kathryn Stockett's treatment of the white women of Jackson, Mississippi, and their black domestic workers in her popular (perhaps because unrealistically reassuring) novel *The Help,* there is no neat reconciliation or resolution at the fiction's end. Instead there are degrees of separation, increased disconnections, and grievances that create seemingly unbridgeable mysteries.

Following Esther's reappearance and reemployment, "Figs" shows the three women performing racial roles, strategizing and negotiating the tensions inherent in their economic interactions. Readers are privy to maneuvering and stage-managing: Mrs. Ewing, the white employer, attempts to calculate advantage along us-them lines in discourse filled with racially charged assumptions. She gauges that the family house is "too old and big and out-of-date for good ones [house helpers]. They'd take one look and turn tail," and she is cagey about needing Esther: "When you beg them and they're polite, they come, but they won't be good for a thing." Esther's bargaining strategy, by comparison, is to speak aloud to the walls and mutter to no one in particular to assert her standpoint that she cannot afford to work "no two days a week, needs to work every day. Six days a week." Soon after her arrangement is accepted, however, Esther attempts further, incremental negotiating progress by announcing that she is tired and "ain't gonna work every day for *nobody.*" Mrs. Ewing first comments on Esther's self-contradiction in a handling-the-help voice: "I'd be sorry to hear that." But Sarah presents the case for agreeing to give Esther a day off with pay, suggesting it saves them from Esther's taking her day "off when it comes over her, and pay[ing] her for it, and still never know when it'll be." Sarah launches this argument in part to arrange days without Esther "underfoot." Like her mother, Sarah thinks Esther is both needed help and an imperfect worker:

[Esther] didn't dust a lamp or a telephone or a fan because they were electric, or Mr. Ewing's photograph because he was dead. She didn't dust the windowsills or the baseboards because they were woodwork, and that belonged to

spring-cleaning and Sarah. . . . Esther looped the glass-curtains into one and dropped them in a pool down into the shades of the lamps to get them out of the way, and looped the cords of the lamps up off the floor and draped the arms of the chairs with them, and when she finished the room, left them all that way. She ran all the chairs and tables against the walls and left the rug a bare stage in the middle, with her footprints walking out of it. Her dust cloth moved along the surface of all things and around the objects on them in a continuous, indulgent, serpentine line—and Sarah had too many surfaces and too many objects—like one of those games where the point is to get from X to Y without touching an obstacle or retracing your path or taking your pencil up.

Sarah is critical of Esther but also sees the awkwardness of their hierarchy, the predicament of their divisions of labor, and the insensitivity of their interactions (as when her mother says, "'Oh, for the old days!' . . . , speaking in front of bending and stooping Esther").

Sarah perceives a performative quality in Esther's strategies for coping with the felt indignities of their routine. When Sarah tells her to change her dirty apron, Esther unexpectedly sobs at the insult suffered. "Her sobs were baritone and curiously jolly in their resonance, like the efforts of a civic Santa Claus in a pageant—Sarah had never before heard Esther perform this way. 'Ain't dirty! Ain't dirty! Ain't dirty!' . . . For the rest of the day she wore an apron dazzling enough to declare as if in electric lights . . . 'Who Has Hurt My Feelings?'" There is both awareness and comedy in Welty's attention to the women's performances, tolerated on all sides as strategies for playing their respective parts on either side of the color line.

In the midst of their divide, a love of figs in season is a pleasure that Esther and Sarah share. Every morning, Esther gathers and helps devour the limited supply of late figs ripening in the Ewing garden. Esther laughs, "Almost couldn't get rid of all them figs this morning. . . . Had to crowd." Eating figs appreciatively is a punctuating gesture in Esther's portrait: "she opened her mouth for a smile, spread her tongue, and laid a peeled fig on it." When Esther enjoys figs and cream at the kitchen table, she goes barefoot, a liberty that Mrs. Ewing objects to. But the baring excites Sarah to inspiration: she is all of a sudden stirred to take Esther as a model and to draw her head and feet. Again in a Welty fiction, the other woman displays herself "inappropriately," and for the first time this story is explicitly concerned with the middle-class woman's artistic capture of the other woman's self-exposure and bared body part. While preferring not to listen too well to Esther's conversation about northern "agitators," who assert that "white folks hate people," Sarah—attending to her own purposes—suddenly commands: "Hold still."

> Esther was instantly devoid of motion. She could stand still without a flicker of a muscle, she could just wait and be, or else imitate waiting and being. . . . Esther continued to hold up [Sarah's] dress, but her past and future had been

dropped like a tray with a white lady's tea-glass on it, and she was shed of it. . . .
The skin of her arm had the polish that marble has, and following the line of the
bone to the elbow, with its dead-black elbow patch, ran a lance-shaped streak of
purple. . . . The skin of her face was opaque, the color of lava, lava that might
still flow, but not now—its eyelids as thick as its nostrils, its lips like two of her
own fingers laid curving over her mouth: a face that was lightless but listening,
closed down but peeping out. . . . The suspension from thinking that came over
her when she drew, her hand absorbing to itself all she had of precision and daring
and mobility was like a song that an anonymous voice was singing to keep every-
thing else away. She turned a page. Now she was drawing the feet.

Archless, sexless, matte, flat under their weight and burden. . . . She thought of
Atlas. As she drew she saw as well as she was seeing the bones in Esther's ankle,
the Atlas Mountains of Africa as she'd seen them the one time in her life—across
the water from the deck of a smooth ship at evening, coal-black lumps, upheavals
into the hibiscus-colored sky, and over them the crescent moon and a single throb-
bing star dangling from it. She drew the moon and star on their chain around the
ankle of Esther's foot. She lost herself in the horny landscape of the toenails, like
snail shells or gritty pearls from the sea, their convolutions and excrescences like
flowers, like barnacles, like precious stones.

"All right" said Sarah, offhand. "You can get back to work."

She had got the feet.

Drawing Esther's face, Sarah recalls the phrase "as if bereaved of light"[12]
from William Blake's "The Little Black Boy" in *Songs of Innocence*. The
phrase floats in a stream through Sarah's head as she draws and then plays
throughout the text as Yeats's "The Song of Wandering Aengus" played
throughout "June Recital." The allusion calls up several aspects of Blake's
antislavery verse and the interpretative issues it has raised for readers: its
probing of inequality between the black and white children pictured; its ques-
tioning of the mother's teaching and Christian counsel to accept suffering
in earthly life and look ahead to heaven for consolation and reward; and its
interrogation of binary thinking, which creates contrasts between body and
soul, between black child and white child, between penitent endurance and
liberating salvation—oppositions that fracture what might alternatively be
understood as unities. Moreover Blake's possible intentions are understood
through reference to his illustrations, relevant here in a story about an illus-
trator, her model, and her illustration.[13]

Welty's description of Sarah the illustrator in some ways calls up Marie
Atkinson Hull (1890–1980), a Jackson, Mississippi, artist who dominated
the local art scene for much of Welty's life. She left Mississippi to study and
show her art and work—affiliating with the Art Students League of New
York and showing and painting in Europe in the late 1920s—but returned to
Jackson to live in Welty's own Belhaven neighborhood. In 1930 Hull painted
Melissa, using her black housekeeper as a model. Hull was Welty's own art

teacher, and Welty repeatedly references her when discussing her story "A Memory": "When I took art from [Marie Hull, Jackson painter and teacher], she taught us that device: framing with your fingers. Studying drawing and painting made me aware in writing a story of framing your *vision*, as a way toward capturing it" (Cole and Srinivasan 193). Moreover, Hull began her professional life as a piano teacher, when Welty was a young child,[14] a history causing me to wonder if she could also have been any sort of model for Miss Eckhart or even the early piano teacher of the Courtney manuscript.

In the scene where Sarah draws Esther, the illustrator's appropriation of the maid for her model cuts short one of Esther's several accounts of northern civil rights workers attempting to raise the black community's consciousness and sense of racial anger to effect needed change. The northerners' recounted rhetoric resonates throughout the story as inadequate, a vocabulary failing to precisely address the very real troubles, complexities, and complications in the relationships that these women are mediating. The civil rights workers' campaigning discourse oversimplifies, reducing the relationship between black and white in the South to hate, while readers see more nuanced factors: economic disparity, interdependence and an unequal division of labor, shared lives and emotional separation—all on display in a culture that divides spheres of action, influence, and privilege along the color line. In the mix of clumsy, multifaceted, good-spirited, and painful interactions between the women, Esther reports her daughter-in-law's frightening reflection of a recently instigated public discussion:

> "one 'f these days people going to start carrying ice-picks in their purses riding to work on the bus. Tellin' that one o' these days when that bus driver pass up somebody, like he don't mind doing, people's going to all take out their ice-picks and light one after the other on that bus driver's back. Them mens says so. . . . Hope when that happens I ain't on *that* bus. Hope I on the next one," she said then, and laughed indulgently at the Ewings.

Mrs. Ewing's joking reply is abruptly if comically dismissive: "You generally are."

Readers consider these public and private conversations as they mull over the story's central mystery: Esther's disappearance from work at the Ewings'. Esther reports the advice of the northern organizers, "Mrs. Ewing, men say if y'all don't give us no trouble, how come us don't give y'all some." Esther attempts to interrogate these sorts of instructions in conversations with her disconcerted employers. They receive Esther's debriefings as speech acts that may be inviting advice or may be staging vague threats, and they vacillate between not listening too well and commenting between themselves. Esther specifically reports the heard suggestion: "Pick a day. Wait till they needs you bad, and then you ain't show up." And that is of course what Esther will do

on the day of Sarah's book deadline and dinner party. But although Mrs. Ewing would like to attribute Esther's behavior to "those men," a reader does not. In one way, Esther's sudden disappearance is part of a long-term pattern that began when she first came to Mrs. Ewing as a girl, announced her willingness to work for her, but later, without giving warning, went off during harvest season to other labor, presumably to earn better money. She would then reappear on a rainy day to cook "a real good feeling dinner. [Then] when the dry weather came back, [she] would disappear again. After it was all over she'd come back looking thin . . . [and] never referred to having been gone. She never wondered about her welcome. Here she was back, that was all." Esther's earlier employment had seasonal cycles that introduced a certain behavioral coming and going, routinely left unexplained, undefended, and self-evident. But as relevant as that history is, Esther's departure on this occasion is more palpably a reaction to an incident that flared between Sarah and Esther. The story gives a portrait of a relationship developed in spite of the women's daily performance of racial roles but also of tension and hurt feelings building to a crisis.

Moments after Sarah has audaciously turned Esther's head and feet into her artistic property, the women clash when Esther, equally presumptuous, fixes Sarah's dinner dress to suit Esther's personal idea of what is party appropriate. While "Esther was frozen still under the raised professional eye," Sarah suddenly recognizes in the worker's immobilized hand the dress she has "let" Esther wash for the dinner party, forgetting Esther's love of starch. Sarah, infuriated, reacts by exclaiming her irritation and indignation, and the two women raise their voices:

> Esther broke out, "Only way it gonna look like a party! Make all that lace stand up on your shoulders! Ain't a wrinkle now can inch in on that skirt!"
> "It's stiff as a board. I couldn't hope to sit down in it. All right, Esther, you came in knowing what I'd say. Take it back and wash it over, wash out the starch and tomorrow iron it again. You knew as well as you knew my name I wouldn't wear a dress like that."

The next day Esther does not come to work, an act the Ewings understand she has prepared for as they realize she has "paid herself" by asking for "ten dollars to give the burial society" and fifty cents for "washing powder to wash her dirty apron." From this we gather the size of Esther's wages as well as her preparation to depart. Moreover, Esther has left a signifying response to Sarah's annoyance over the starched dress. Sarah finds it on the laundry line:

> There hung tonight's tablecloth and napkins, her mother's white batiste nightgowns, and her party dress that Esther had washed over again—all alike stuck back-to-front as with glue, stiff as board. They creaked in one piece, like a long

gate, when she touched them—a napkin hung solid in her grasp as an elephant tusk. Her party dress gave a crack like the split of kindling when she pried it off the line and bent it over her arm.

She raised up the tablecloth with a thrust of her arm—it stayed in shape, like a hat; she put it over her head, where it shot out on both sides from its fold and reached down to her knees. It was like putting on the summerhouse. Carrying the rest of the things she enjoyed a creaking, snuffed-out walk . . . back to the house. The scent of nicotiana was in there with her.

Eventually it becomes clear that the unwarned departure is a repeat performance of something unforgiven between Mrs. Ewing and Esther, providing readers with still more to understand about the feelings of the women involved. But before the third and final section, which concerns Esther and Mrs. Ewing, the second section treats the dinner party for Diana Cleveland (originally Pippa Iverson), an opinionated northerner. This segment further contextualizes the historical moment of the women's interaction and the regional tensions developing over the issue of Jim Crow. In this less finalized section of the draft, Welty writes conversation demonstrating the national friction and northern condescension about southern racism while at the same time letting her southern characters reveal their blindness toward their behaviors about race. This section also shows Sarah's continued interest in Max Dawkins, who turns out to be her visitor's cousin. Diana's comparative remarks about Dawkins's career versus Sarah's require her to defend her identity as a woman attempting to take her art seriously while choosing to live in the South rather than in New York and while being an illustrator rather than a painter, just as Welty choose to remain in Jackson and to be a writer of short stories rather than a novelist.

Sarah's dinner party is planned to host the visiting northerner, who plays the role of a questioning, challenging outsider, smug in her sense of difference and regional superiority. A caricature of a New York intellectual, her name, Diana, perhaps calls up Welty's embattled history with Diana Trilling's 1946 accusatory remarks misinterpreting *Delta Wedding* as prototypically southern and regressive on the topic of race.[15] This traveler is not an easy dinner guest. She brings her own gin, suspecting she will be offered bourbon. Concerned about the effect of southern cooking on her diet, she unexpectedly asks, "Could I simply have a lamb chop," to which Sarah, who has creatively arranged and painstakingly labored over the meal's preparation, replies, flushing: "I haven't a lamb chop to my name. . . . [The meal's] nothing all that rich and splendid." Unremitting and uncompromising, Diana proposes: "You won't mind if I leave most of it on my plate?" Comically her diet and her suspicion of southern food do not impede her consumption, especially of the frozen tomato aspic.

The story's title in one sense refers to Diana Cleveland's rejection of the

"purely local" figs that Sarah prizes and prepares, too tender and perishable to be well known in the Northeast. Hoping to make some elaborate, new, hard, and special dish for her guests, Sarah has with Esther collected and guarded the last of the season's figs for a "floating island" dessert. Finishing its preparation during the party, Sarah thinks with irony, "Who gets the last of the figs? She does." And Cleveland's response to the labor-intensive dish is rejection: "'Figs? Is that what I've been given, little cold, clammy things?' There they all were, left on her plate, a little orderly pile of discards." The title equally refers to Esther's staying with the Ewings only through the fruit's season, until their tree no longer provides the figs that she and Sarah enjoy together. The title comments too on Sarah's ironic choice to deprive Esther, who would have savored the last of the figs with her, while serving them to a guest who not only does not appreciate them but discards them as repulsive.

If Cleveland is a vexing diner, she is equally grating as a conversationalist. Her sense of northern superiority is clear as she asks how her hosts are "getting on with your integration down here . . . ? Having a little trouble?" She remarks to the journalist Warnie Foley, an editor of the local paper and fellow dinner guest: "I suppose there's lots of dreadful stuff to print . . . with your social situation and what not." At another moment, she quips, with no sense of irony, "After all, who's running the country, you or us?"

Sarah's other guests respond to Cleveland with a variety of performances on the topic of race. Some stories they tell emphasize the history and concern and community shared across the color line. Jenny Raglund's older children are being watched that night by her grandmother's sewing woman, eighty-two-year-old Bernice ("'Now is that a Negro?' asked Diana"—modeling her difference), and Jenny's rendition of the situation captures the comedy of her equally old grandmother, concerned that Bernice might fall asleep, sitting up to watch the sitter: "they're all three watching each other, and all eating ice cream. I imagine they have enough history to holler back and forth to each other to keep 'em both awake a good while." Jenny (also spelled Jennie by Welty) asserts an endearing but suspiciously proverbial narrative of black and white women working together, but the general conversation simultaneously confronts the rising anxieties coming with change and guaranteeing violence. Warnie Foley has been watching the letters to the editor on the subject: "Some letters come in to the paper that would fairly delight your soul or discourage you one. . . . Rednecks from the hills that never had a thing to do with a Negro, ready to help us all start killing 'em." Preston Raglund tells the story of his employer, a bank president who "[g]ave us all subscriptions to the . . . White Citizen's Council for Christmas last year . . . instead of a bonus. . . . And you know what he laughs to see at home? His little boy jitterbugging in the living room with the cook. Yet come one day if ever it got started, he'd

mount a machine gun in every corner." Hal, recently returned from studying abroad, argues for global northern and southern temperaments as well as climates: "[t]he more separate and different the parts, the richer the harmony." Later, in response to Diana's arguments for the virtue of sameness, he asks: "Are you trying to get us to protect ourselves against you?" and refers to the Book of Esther and in it Jews' defense against their countrymen, the Medes and Persians ("There was bloodshed"). Sarah herself thinks of Esther from time to time as "Queen Esther," seemingly both as a representative of an othered people and as imperious in having her way. The allusion also calls up the mythic Esther's righteous and successful mediation in favor of her disparaged and condemned people.

Before the evening is over, attention turns exactly to controversial mediation. Mrs. Ewing interrupts the dinner party to share her shock at President Eisenhower's sending "paratroopers" to Little Rock's Central High. Although she has left the party conversation to those younger than herself, she now interrupts with alarm in defense of the South:

> I didn't believe Pres. Eisenhower would send troops. . . . the North wants the worst to happen. . . . And the chances are ever so good tonight they'll get it. . . . I'm mortally sick of both sides of this thing, if you want to know the truth of it. I'm ashamed. And I'm getting scared. . . . As long as it's turned against the South, that justifies any weapon they want to use. . . . They're not ashamed . . . they're morally proud. . . . The North and South will have to go to work and hate each other again for another hundred years, and I'm not equal to it.

Throughout the voices of other women are heard in response:

> "Paratroopers? With guns?" said Anne. "Against little children? Going after sixth-graders with fixed bayonets? . . . It never entered my head. Like a bunch of barbarians. . . . "You think they'd really shoot?" cried out Jennie.

Mrs. Ewing responds: "Of course not, just point at them." [She] spoke it harshly to her favorite young friend. Both their faces were white.

"That's all anybody with a loaded gun ever says he's going to do. Just wait another moment. The next thing will be for the guns to go off." She stood wavering.

Hal tries to add perspective, telling Sarah: "Your mother's needlessly upsetting herself. . . . All people her age are. Talking almost unlike themselves."

Welty's portrait of white response to national troops defending the law and the black students shows, on the one hand, Mrs. Ewing's shortsightedness, which fails to see any urgency to integrating schools, and, on the other, a reasonable dread that civil rights conflict is going to be resolved not by putting adults on the line, but children. This scene, like many in the fic-

tion, underlines the sense of Welty's interview remark that she thought she "would write some stories to show what it was really like here, how it was so complicated and how motives were so mixed" (White 240). Welty's portrait of Mrs. Ewing is of a lack of sympathy for racial change, which was not at all specific to mean or underclass or reprehensible people but rather understood as a tangle of habit and point of view in an era of segregation and entrenched entitlements.

Of equal weight with these performances on the topic of race are the performances of racial identity that develop during interactions with Junior, the African American gardener who, apparently understanding perfectly that Esther has quit while the Ewings are at first uncertain, kindly compensates for Esther's absence by generously staying to serve dinner. He is talked to, around, and about in ways that delineate the individual characters and the state of racial affairs. In particular, dinner guest Preston Raglund's voice is jocular and provokingly white, though Sarah thinks he is performing southern in response to Diana, and at one point she finds herself doing "what Preston had done at the table when he exaggerated his thick country speech and his clumsy ideas. . . . They'd both caricatured themselves for the benefit of a stranger." But whatever sets Raglund off, his performance is boorish, churlish, and at Junior's expense. Junior is also engaged in a racially determined performance: it is assumed that—because he is racially appropriate in this time and place to the subservient role—he can switch between the assignments of helping in the garden, in the kitchen, and in the dining room. Preston mocks Junior's role-play as butler, rendered to lend a hand to the Ewing women, by repeatedly calling attention to it as a costumed performance: "'Look at the ice cream coat,' said Preston. "Hey, boy, I bet you're going to make a mistake somewhere tonight, inside a house instead of out grubbing." "It's like having Charlie Chaplin wait on you. Those killing shoes." Welty shows that Junior, "like a steady swimmer, moved on through [the laughter]" breaking over the dining room. Irksome as Preston is for Junior, Preston is not alone in speaking about Junior in his presence. Sarah grouses about his gardening help for a moment: "You try to keep him out of the beds but he gets in behind your back. You can't let him out of your sight. . . . And then if you can ever get the flowers to bloom in spite of him, he's the one that admires them! And praises himself so." But her story, in contrast to Preston's, ultimately becomes an appreciation of Junior's artistic sense: "What he really has is a sense of the beautiful," she says, conveying their collaboration in the shared pleasure of producing the garden.

Late in the story readers learn that Diana is not only opinionated about northern moral superiority, she is equally convinced of northern artistic superiority. On a tour of the house, she discovers that Sarah (like Welty herself) uses her bedroom as a workplace; Cleveland's criticism of that as unprofes-

sional behavior reminds Sarah that Max had a similar view of her habit. Soon Sarah is following the topic of Max: "He's the more clearly talented one, if it comes to that." But she is surprised by Diana's reply: "You're the cut-off one." Sarah replies that she's not ("I'm right inside the heart of work at what I love"), and Diana challenges her: "In Mississippi. Of course you are." And Diana elaborates her sense of regional difference and its impact on creativity: "Suppose I'd been brought up down here . . . like you . . . well, I might've been quite different from the person I am. I'd have had a wildly different girlhood. Sluggish, that's the sort of climate it is. I'd be used to not having much to do, or much money, to being bored and left to my own ideas." The gist of Diana's presumptions is that she sees Sarah as a local artist who "should work a little harder and graduate from children's books." Does this grating conversation address Welty's own life decisions to work in Jackson, to stay in her family home, not to move to New York, and not to shift from writing short stories, treated at times as a lesser genre in a literary market prizing the novel? Does this self-reflexive aspect of the story reveal the obstacles Welty faces as a southern woman artist, clearing a path of her own?

The final section of "The Last of the Figs" begins with a professional surprise. Sarah receives a letter in a business envelope, but she hides it "as if it had been a love letter—[running] to her room to read it again, lying on the bed, [giving] way to tears." This letter from her publisher drops the project of her illustrations for *The Arabian Nights*, citing concern for the political problem of her use of Esther as a model for the genie. Referencing the political situation between the United States and the Middle East, the publisher objects to Sarah's choice to portray an *Arabian Nights* character "as ethnically different than the average American citizen and especially the portrayal on the finished jacket and cover drawing of the Genie as a Negro, as the Genie is a slave." It ends with a reference to the illustrator being southern and accordingly best suited to the sort of book she has in the past won awards illustrating, where "the story was, of course, about Mississippians."

In shock at having her work rejected "sight unseen" and at being told that her southern location limits what she can portray, Sarah initially puts some of her drawings in the trash. But she gradually recovers and goes to the library table to reassess her cover art. To her surprise she discovers that her drawing of Esther's head is missing. Sarah and her mother come to understand that Esther has left with her portrait, and the scene of their realization is comic: "Why did she leave me the feet?," Sarah cries, laughing. Mrs. Ewing, who has throughout objected to Esther's barefoot ways, teases: "Perhaps she doesn't like her feet. I don't." Comedy gives way to an earnest consideration of entitlement to intellectual property based on another individual. Seemingly Welty is exploring this issue at around the same time she is publishing *One Time, One Place*,[16] with its captured images of people on the street; she

seems here to recognize and explore ahead of its time a vexed creative issue—complicated by the relationship of white artist to black photographic subject. (As is traditional in so much photography, the individual subject—who is not a professional model—is unidentified, unacknowledged, and uncompensated while the artist earns economic and other rewards.) Sarah understands that Esther thought the drawing "belonged to her. . . . She was just gathering up her things." Mrs. Ewing, on the other hand, perhaps seeking an opportunity to confront Esther or at least to solve the mystery of her departure, is adamant that they visit her at home to get the drawing back. Sarah seems at first to be having absolutely none of that, but when her vision-impaired mother announces plans to take the car, Sarah yields, concerned both for her mother's safety and for Esther, and hoping perhaps to be able to better address the conflict between Esther and herself.

Driving across the railroad tracks, Sarah contemplates the cotton fields from which Esther has emerged, a young, pregnant black woman forced to make her way. Sarah wonders about the other woman's early life and, behind that, slavery and, behind that, Africa. She wonders if Esther has gotten over those histories, and "Will she get over us? Or does she even know, except when she's in our house, that we exist?" And, probing herself, Sarah thinks, "I haven't any proof, any proof in my heart, that she exists." Bottle trees in yards recall the genie theme, the idea of "trapped unfriendly spirits . . . kept prisoner forever." Sarah realizes that although she has often driven Esther home in bad weather, she has never before exited the car at Esther's house.

There she finds a fig tree and smells nicotiana, as she would in her own yard, but the disrepair of Esther's unsound two-room rental house, with its water closet and no bath, is quite different from her own. While Mrs. Ewing knocks, Sarah looks through the glass pane of the door and realizes she is looking though curtains that she discarded, as well as at "the bed of her school days, now scuffed like an old shoe." Moreover she sees, set alongside pictures of Jesus and a young black man, "one of Mrs. Ewing as a young lady sitting bemused and hatted for her husband in a fan-backed chair" and "a homemade paper heart faded to pale orange, saying Sarah loved [Hugo] A valentine thirty years old, not at its destination." She also sees her sketch, "smaller and paler than she remembered. . . . Esther's head, wrapped in the Genie's gauzy turban with the clouds around it . . . with the Genie's jeweled eyes and the lips like two fingers laid together over what the mouth might speak—for an instant Sarah's skin pricked, as though magic had drawn it—transported it here all in an instant." Scanning the room she sees assorted familiar objects, all from the Ewing house, including an out-of-joint pencil sharpener once left in the trash, a kewpie doll, and plates broken and discarded, one of them the "heart dish" that, like the valentine heart, cryptically answers Sarah's thought

about whether these women "exist" for one another "in the heart." Surprised by and considering the meaning of these things, she thinks:

> [D]omestic objects—which had been presents, and which had been discards, which had been lost, could no longer be told now. . . . She thought, Esther had to crowd. They were the great majority, the things that had passed from one human being to another without any status, without being either gift or theft. There had been no real exchange, and they had made no memory, but perhaps there had been a helpless and unspoken connivance, a mutual amusement . . . and playful deceit. A communication that was in itself incommunicable, and now that too was ended.

These transferred objects announce and testify to shared lives and different circumstances and to intimacy, connection, and distance all.

While the Ewings are rapping at Esther's door, another white woman arrives: Mrs. Argyle has come on a similar mission. She reveals that Esther has both been "all-along" working for her and has abruptly quit her: "It's the NAACP put her up to this!" Skeptical, Mrs. Ewing says she has "no notion" why Esther quit, but she thinks she'll "ask her." Mrs. Argyle's voice is more blatantly and unashamedly racist than any voices heard before in this story. She recounts with pleasure how her husband, in a Chicago department store, identified a light-skinned salesgirl as "Negro" and succeeded in having her fired as inappropriate, and Mrs. Ewing calls it "a wretched story."

As Sarah laughs at the three of them banging on the unanswered door, calling the episode "hopeless," Mrs. Argyle announces that she wants Dollsie and is "going to get her." She is referring to Esther by this other name, also used by a child on the street, which causes the reader again to feel how limited the Ewings' knowledge of their worker is. Giving the door handle "a good wrench," Mrs. Argyle breaks the insubstantial lock, and the three white women barge in and see Esther:

> Sarah didn't at first recognize her. . . . Gone was the starch. Gone was the oiled hair-crown. Esther's hair stuck out in low-flying points all around her round face. Sarah looked for her feet, and there they were. . . .
> Esther looked at the white faces—one, two, three—and didn't speak. Her mouth twitched, and a little saliva tracked down her chin. She rocked on her hips, as she used to do standing on the corner waiting for the bus to come by and let her get on, only she did not look ready for transport at all, now. In the crowded dimness of the room, airless, clockless, lightless, she didn't speak, she didn't come out, she didn't go back—she was just there.
> "I'll get you for this," said Mrs. Argyle.

In an assault both out of the blue and perhaps inevitable, Mrs. Ewing suddenly and vehemently lets loose a barrage of pent-up feelings. Silencing even the brash Mrs. Argyle, she vents the resentment that readers now discover she

has harbored against Esther for several years. Her outburst at first seems self-absorbed and unjustified, but it narrows to a troubling source: her memory of Esther having previously left her job at the Ewing house without warning at a time that was more than inconvenient. That was a day of family grief and loss, the day when Sarah's father died. Mrs. Ewing's hurt, anger, and denunciation catch the history of interdependence between these women, their intimacy and its abrupt limits, their unbridged difference and yet Mrs. Ewing's sense of connection betrayed.

> After all we've done for you. After all the times my husband protected you, kept you from trouble and debt—stood up for your miserable son in court—a son you ought never to have had—spent his last Christmas Eve on earth with *you* maneuvering that boy into the hospital. . . .
> [Y]ou asked me what "the men" meant when they told you-all to pick a day. As if you ever needed any influx of hoodlums to tell you. The knowledge is born right in you. In your black heart that's always been completely without friendship, memory, or gratitude, and you can't have one without the other. The day my husband died, you deserted me. Gay as a lark, you walked out of my house to the cottonfields on the day of his death. *That* was the day those men meant, Esther. They were talking about the past, that day, the saddest day of my life. The day when I was the most betrayed by life, you took the opportunity of betraying me too. . . . I thought I forgave you because of your ignorance and color and since I could never hold you responsible, I took you back. . . . But I've never forgiven you, Esther. I let you come six days a week but I never have forgiven you and I never will and now that you're no longer putting forth . . . [any] claim on me, I want you to know it.

This subterranean anger in Sarah's mother's relationship with Esther, previously unknown to readers and yet perhaps visible throughout, is clarified as a sense of abandonment and betrayal more bottomless than petty, the result of the widow's misjudgment of the nature of her association with Esther. The tirade exposes a hierarchical, unstable, and explosive connection between women who are in a sense close but are unable to construct a stable emotional bond to take them beyond the unspoken rules dictating the interactions between white employer and black employee in a segregated world.

When at last Mrs. Argyle finds an opening in Mrs. Ewing's torrent of accusations, the callous other woman picks up the assault but changes its direction: "'Listen: you ain't worth killing and . . . still I've got to have you!' screamed Mrs. Argyle. 'You come with me and get in that car, you hear?'" Esther's response to this dual battering is matter-of-fact: "I don't mess with Esther's folks' business. How come they want to mess with mine?" As if in ironic commentary on the older white women—who while wanting to have their way with Esther are not remotely interested in Esther's business, her reasons, or her state—Sarah, "to make Esther know who she was," asks: "Esther, what are you going to do for yourself? Esther, what'll become of you?"

As the white women make their way back to their cars, Mrs. Argyle, reading race in a way that recalls Mr. Compson's reading of Nancy in "That Evening Sun," demands, "Was she drunk? . . . I'd like you to tell me. Was the nigger drunk? . . . Well, she needn't think this is the end of it. It's far, far from the end of it." Once in their car, Sarah makes a comment to her mother that suggests that only Sarah among the visitors has been studying Esther during the hopeless interchange, looking for her own explanations for Esther's departure: "there was a brown stain in Esther's mouth, a stain, all satiny brown inside her lips and on her tongue." "'Well, it doesn't matter,' said Mrs. Ewing indifferently. 'Could have been snuff. Or she could have been trying to bring something about by witchcraft. Or drugs. Whatever it was, I want you to take me home.'"

The first point to make about this conclusion to the story is that it is entirely cryptic. Welty is again using the mystery form, but adapting it, not to show a pat reveal but rather to make public how much white does not know. Let me suggest some of the questions called up by this tentative conclusion, indeterminacies perhaps left to be settled by individual readers reading race.

How is one to understand Mrs. Ewing's outburst? Do readers think, as Sarah says to comfort her mother in the car, without wholly seeming to believe it herself, "Esther had it coming"?[17] Mrs. Ewing has evidently harbored genuine pain that now finds unfortunate expression in a self-relieving harangue. Do readers think her rant is completely uncalled for, or is she making a deeply felt and pertinent point? Is her pain a foreseeable product in a relationship both created and limited by the color line hierarchy, which she wanted to believe (and maybe should believe) is also an intimate personal relationship? In a bit of added draft, which seems more about Welty exploring motive than writing something that would fit and work, Mrs. Ewing corrects Sarah, admitting that "I ought to be ashamed of myself," as they are both ashamed of Mrs. Argyle, while nevertheless feeling it unjust that Esther admits to "no difference" between her two employers.

Why has Esther left? Do readers in the end think it is a matter of the starch in Sarah's dress? Or is it a question of Esther's building anger at having had her ways of doing constantly challenged by women who leave their housework to her but have too many opinions about it? Does evidence that she planned for her departure and quit both her jobs simultaneously suggest that her behavior is not about them, but about her? Did the public civil rights conversation about the need for black people's anger play a role in her decision? Sarah in Welty's postscript pages asks, "[s]uppose you'd reached a point where everything you felt could be expressed in only one way—quitting?" Had Esther reached that point?

What are readers to make of the brown mouth stain that Sarah takes note of in the last lines? Is the discoloration a possible sign of illness? Brown tongue

can result from antibiotic use or radiation therapy. The text has had an undercurrent of attention to the issue of race and medicine, which perhaps supplements the development of that topic in "The Demonstrators." The storyline here concerning Esther's son Brady repeatedly suggests how dependent black families are on white intercession for help with medical care in this time and place. Not only have the Ewings arranged Brady's past surgeries but, when Brady is "cut" on a Saturday night and in the hospital as a result, Esther is both so worried and confused about the medical terminology surrounding his situation that it is impossible for a reader to decipher his situation. Esther turns to Mrs. Ewing to call for information because, as she puts it, "Sometime when it's colored people, they don't always tell you. They loses patience with people." Or is that brown stain possibly connected to the story's other title, "Nicotiana," more commonly known as tobacco plant, which chewed or taken as tea is a home remedy relied on to overcome fatigue or pain, an analgesic also used as a relaxant. Its use leaves a brown stain in the mouth. Think back to the description of Esther during the confrontation scene: "Her mouth twitched, and a little saliva tracked down her chin." Is Esther numb throughout the final scene, and if so why? Certainly no one is asking, although Sarah seems to have noticed something, without being able to identify what.

Welty's manuscript, unusual and innovative in its time in its focus on white and black women negotiating more than housework in their domestic economic relationships, invites comparison with two more recent texts, all three coming out of this era in Jackson, Mississippi. *Can't Quit You, Baby* (1988) is Ellen Douglas's (the pen name of Josephine Haxton) novel about Cornelia, a white, middle-class woman, and Julia, her African American, working-class house helper, nicknamed Tweet, who together have made conversation for fifteen years in the 1960s and '70s, "across the kitchen table from each other, shelling peas, peeling apples, polishing silver" (4). Unavoidable inequality marks their connection, which is too easily considered a friendship by Cornelia, who will better confront Tweet's point of view over the course of the novel. Even though the terrain of the Douglas novel's relationship is the seemingly sheltered atmosphere of a middle-class house, as with Welty's "Figs" its interracial interactions are complex, emotionally fraught, revealing, and burdened with the stress of the period and the legacy of separation that is the by-product of a cultural history of segregation and economic hierarchy. Kathyrn Stockett's 2009 novel *The Help* is similarly concerned with African American maids working in white households in Jackson, Mississippi, during the early 1960s. Her heroine, Skeeter, is a naive, ambitious, well-meaning, young white woman who during the civil rights movement decides to write a book detailing the maids' point of view on the white families for which they work and the hardships, affronts, abuses, and disasters they experience on a daily basis. Unlike Welty's manuscript, *The Help* comes to a controversial

"feel-good" conclusion: the story, as Janet Maslin writes in her *New York Times* review, "purports to value the maids' lives while subordinating them to Skeeter and her writing ambitions" in a cultural critique that arguably too much resembles a white coming-of-age narrative.[18] Skeeter's success in selling the black women's stories, portrayed as giving them voice, is presented in a way that largely simplifies the complexity of her earning career advancement and a very profitable living by marketing the stories that are theirs. As Suzanne Jones writes in "The Divided Reception of *The Help*," Stockett attempts to neutralize the complexity of the issue of intellectual property based on another's life by having Skeeter "bring up this concern to Aibileen. But the issue became a real-life problem for Stockett when her brother's maid Ablene Cooper brought a lawsuit, charging that Stockett's novel had stolen her story and her name" (11).

The comparison of Welty's draft with these two fictions helps to highlight the choices Welty makes in her manuscript and to suggest a few reasons that Welty, perhaps for reasons other than health, did not finish and publish her story in the 1960s or '70s. Unlike Stockett's novel and to a greater degree than Douglas's, "Figs" contains no confidence about bridging the color line and no suggestion that personal transformation is a simple path to social change. By comparison the story suggests a realistic understanding of structural racism, including the racism of "good" white people, and boldly explores a woman who resembles Welty. There is no vision of Sarah as a person who saves Esther nor as a person saved by her own action, though readers get a sense of her thoughtfully caught in complexity, encounters, and observations.

"Figs," like "The Demonstrators," presents white points of view, but makes one want to better understand a black woman's story. Because Esther's story is an unsolved mystery, Welty's tale of the other woman may be either (reductively) appropriated for an individual reader's racial/political purposes or recognized as a story withheld. Welty again leads her readers to ponder the body of the other woman: first, Esther's exposed and freedom-seeking feet, and then, her satiny brown tongue that is not speaking. Esther, like Ruby and like Phoenix, Partheny, Aunt Studney, and even Twosie before them, keeps her secrets in the midst of a compulsory performance of race and yet informs readers. Obligatory performance can also work as a protecting mask; it allows the subaltern a privacy that in fact works to protect her from appropriation. As David McWhirter, quoting Dipesh Chakrabarty's analysis of modernism's depiction of the subaltern in *Habitations of Modernity*, has written, "Welty models a way of writing about subaltern lives that acknowledges the 'parts of society,' and of history 'that remain opaque. . . . We cannot see into them, not everywhere.' Practitioner of the 'fragmentary' and the 'episodic,' . . . of reticences and withholdings and secrets that will not be unlocked, Welty refuses to represent what she does not know, even as she reaches for the 'posi-

tive danger' of encounter, for the possibility of other 'knowledge forms' that might resist the totalizations of a racist society and history" (McWhirter, "Secret Agents" 127).

Did Welty hesitate to share a narrative full of risk in this period? Would readers have brought to it the response that caught Kathryn Stockett off-guard: that is, would they have found this domestication of the heroic civil rights struggle reductive? Or does the domestic plot enacted on the stage of women's history—that is, in the household—validate the importance of understanding how the political plays in personal as well as in public arenas? Note too, the response to William Styron's *The Confessions of Nat Turner*, published in 1967, which questioned *who* could write a black character as much as it questioned how they wrote it,[19] and which made the publishing industry generally hesitant to accept white writers representing black characters or racial conflict, a hesitation Welty seems to be treating in her manuscript when Sarah's book cover is rejected sight unseen as too controversial (Stockett's character Elaine Stein, a fiction editor at Harper and Row, to the contrary).

Welty's albeit unfinished manuscript is less conventionally tidy than Douglas's novel and in no way reaches the feel-good ending of Stockett's, which brings Eugenia "Skeeter" Phelan to white redemption. If she had finished the story, it is unlikely that Welty would have tried for a neat resolution. Once again, I am reminded of Welty's statement: "You know, I wanted to show the complexity of it all" (Royals and Little 259). Welty's treatments of race performed by her black female characters, and readers' awareness of their guarded, unrevealed selves behind those performances, repeatedly do that.

A Last Word on Continuity and Change in Welty's Career

As I weigh, chart, and get ready to close this book, looking backward to now look ahead, this investigation takes its place among my other work on Welty. In my earliest readings, my interest was in her modernist techniques, her play with literary convention, her location of pleasure in surprising expectations, and her understanding and advantageous control of readers' processes in her narrative interactions. Then my edited volumes on Welty's fiction—*Eudora Welty and Politics: Did the Writer Crusade?* (coedited with Suzanne Marrs) and *Eudora Welty, Whiteness, and Race*—both attempted to forward and enhance critical response to her by focusing on topics that had been largely and for too long passed over. Elsewhere, considering her photography, I argued the connections between her work in that medium, her experience with photographic conventions, and her penchant for risky details and minimal plots in her short story composition.

Now, in this book, I have emphasized a narrative pattern visible across her remarkable career and asked about the puzzle inherent in the repetition of other women's bodies exposed. The pattern as it morphs and develops reveals an implied artistic biography (a story about the risk of self-exposure) that intersects with a life biography and that contours her canon. Noting and making sense of this pattern of the other woman has several outcomes. It helps immensely to clarify Welty's treatments of the issue of class. It also elucidates a continuity between the projects of her early photography and her later writing. What is more, it turns out that her portrayals of the other woman's body have triggered three central critical controversies in her reception, and the pattern is itself the thread that, when pulled, helps considerably to unravel the bunches in those debates. All in all, to read Welty's work without seeing this dominant pattern and its variations is potentially to miss much.

As I close this book I am brought back to my start, returning to thinking

about Welty as a stylist, this time across the span of her career and additionally throughout her late unpublished manuscripts, while knowing more about her fiction, her life, and her development. Increasingly I think of her as a writer whose work unfolded in two major periods that—like Picasso in his rose and cubist phases—show stylistic changes that suggest evolution, but all bear a characteristic artistic signature. Across the change, there is the continuity of her attention to scenes of exposure, to what is written on the body, and to acts of reading the body.

Eudora Welty was originally a modernist who took tall artistic risks in her short stories. Technically astonishing and wryly intelligent in her early accomplishments, Welty's first period developed through *A Curtain of Green* and *The Wide Net*, and later came to certain maturity in *The Golden Apples* and *The Bride of the Innisfallen*. Welty's work as a pioneering high modernist is evident and foundational to her identity and contribution as a writer. Critical response to this work increasingly liberates her from the pigeonholes of regionalist or comic writer and recognizes her as a technical innovator whose modernism changed the look and possibilities of the short story. Then, perhaps beginning with *The Ponder Heart* (1954) and throughout much of the 1960s and '70s, a stylistic shift moved her toward performativity, dramatization, and accessibility, anticipating American literature's broad turn away from modernism, not exactly into the realism of John Updike and John Cheever (she often harbors a greater strain of the surreal in her realism), but closer to them than before. Her modes of change show her continuing to interact with developments in twentieth-century technology and media (film and even television genres in this later period) as she earlier had with photography, radio, and theater.

In this stylistic period, I note the straightforward directness of her 1963 story "Where Is the Voice Coming From?," which I understand in terms of her need to speak clearly to a large audience on a pressing subject but also recognize as part of an ongoing development in her style of presentation. This change is evident in her endeavor to deliver the novel *Losing Battles* (1970) predominantly through speech, a technique she prepared for in "Why I Live at the P.O." and "Keela, the Outcast Indian Maiden," but now sustained in her longest work. I observe too the relative narrative simplicity of her novella *The Optimist's Daughter* (1972), in which risk-taking has more to do with treating some very personal issues than with inventive technique. Next, I see the clarity of her essays collected and revised for publication in *The Eye of the Story* (1978), the documentary clear voice of her public lecture series (at Harvard in 1983), published as the memoir *One Writer's Beginnings* (1984), and the visual work of assembling *Photographs* (1989).

These late career projects all suggest her stylistic shift, which arguably reflects a desire to speak in new ways to broader audiences than she had in

her subtle, clever, modernist, and supremely literary early short stories. An exception of the later era might be "The Demonstrators," where Welty arguably balanced noirish realism with her signature complexity as she spoke on the slant to those who would follow her. Some suggest that her indirectness there reflects wariness in addressing a topic that was causing her state of Mississippi to rock with violence. I argue, by contrast, that the story is bolder than even "Where Is the Voice Coming From?," since "The Demonstrators" dramatizes a black woman marginalized to death by a white doctor not at all motivated by racial hatred but who is the obliviously unaware agent of institutionalized medical racism.

In this period, Welty's decelerated work on *Losing Battles* created a fifteen-year gap in publication that reflected not only her caretaking of her ailing mother and loss of her brothers but, as I have argued elsewhere ("Words Between Strangers"), a pause in her relationship with an audience that had received the interiority and technical experimentation of *The Bride of the Innisfallen* with less enthusiasm than it welcomed the comparatively less ambitious *The Ponder Heart*, winner of the 1954 William Dean Howells Medal for fiction. In this hiatus of fifteen years, Welty outlived her grief over insufficient communication with John Robinson, endured an increasing awareness of lost human connection coming to her through the illnesses and deaths of so many family members and friends, and was worried and disturbed by the violent division of Mississippi, the South, and the country on the topic of race. It was in the context of these combined events that an amplified interest in speaking more directly entered her work.

From the outset Welty's fiction had modeled stylistic variety, hinting at her having set for herself specific technical challenges (I think of the chiasmus of *The Robber Bridegroom* and "At the Landing" performing one plot in different genres). With *Losing Battles*, she seems to have negotiated a form that reconciled the extreme differences in the narrative strategies developed for the spoken and accessible *The Ponder Heart* and the complex, slowly unfolding interior dramas of *The Bride of the Innisfallen*. In her unpublished, late-period manuscript "The Shadow Club" too, she continued to navigate balance, this time between the mystery of detective fiction and the mystery of interiority, pairing the talkiness that suits film with a novelist's interest in who gets to narrate what and how. On one page of a draft, Welty charted shifts in point of view, showing her inclination, in moments of revelation and climax, to slip out of talk and into a particular character's private experience. Moreover, in this period, her increasing interest in the mystery genre plainly reflected her relationship with Ken Millar and his Ross Macdonald fiction. His influence was also felt both in her project to collect her essays (she dedicated *The Eye of the Story* to him and took his advice in assembling the collection) and in her choices about how to shape a memoir (certainly her reference to

"transit" memory in *One Writer's Beginnings* poignantly although surreptitiously refers to his losses to Alzheimer's disease and then to her loss of him to death from the disease).

To drive home both the changes and the continuity evident in Welty's late career, I want to pair my last words with some of hers and to discuss the revelations of her notes for "The Alterations," another story she began but never fully drafted (the Mississippi Department of Archives and History sets its date as 1987).[1] At the story's center are two bodies, one female and one dead, both "exposed." These notes of hers are intriguing because they display both the transformations of her late work and her evolving continuity. Moreover, they make Welty's precomposition process instructively visible. Her notes consist of jottings on two unlined letter tablets and one unlined notepad, eventually followed by some pages of more fixed and cleaner draft, still handwritten but labeled "to be typed" following her extensive markings. Throughout the notes one can see Welty return persistently to her idea, writing it again, varying the dialogue completely, seemingly looking for a best line or version to make itself apparent. Her pre-draft process is a revelation: she repeatedly rewrites the scene but with no particular reference to notes that came before; she is not culling but exploring the episode anew, letting herself see another version of it, time after time, before allowing it to take the form of an arranged draft.

These notes are fascinating in part because their topic is so unexpected for a Welty story. Alternately tentatively titled "It's a Lost Art," "A World of Patience Is What It Takes," and "Peau de Soie" (referencing the silk—literally, "silk skin"—frequently used in wedding gowns), the story concerns a dressmaker who kills her long-endured abusive husband by literally undertaking to make "alterations" to him. As the character is interviewed by the police, her voice seems to cross Welty's Edna Earle Ponder with the mad narrator from Poe's "The Tell-Tale Heart" to create a woman ripped from the pages of the *National Enquirer*, as fantastic as Lorena Bobbitt (infamous in 1993) but more inventive and idiosyncratic in the bizarre logic of a battered wife's sensational personal solution. The protagonist, alternately named Frieda, Doris, Willy Mae, and Evelyn, but perhaps emerging best as Genrose Hopper, is at work over the body of her husband when police respond to a report of trouble from a client who, expecting to pick up her completed job, has seen a body on the living room floor. This murder mystery's plot and form, I argue, adapts and parodies the television police procedural. Recall *Dragnet* (and the countless descendants of that series), its prototype of gritty detail, its attention to ethical dilemmas in the story of justice, and its cops, who request but are rarely able to keep informants to "just the facts, ma'am" and who act as straight men to quirky wrongdoers.

In Welty's manuscript, the police, at first bewildered by marks on the victim's body, interrogate the dressmaker, asking if "something stung him" to

make "these ugly risings." In one version, the policeman notes "fresh super-ficial needle punctures" that are not drug tracks. Gradually the seamstress identifies the neat mending she has done, after using her stork scissors to repeatedly prick and stick her husband. Grotesquely but comically she has treated each wound with "invisible darning" and mostly covered them by using up the contents of "a box full of Ouchless 3-inch bandages." "You were sewing on him?," they ask. "'Looks like you been vaccinating him for the smallpox,' said the old policeman, 'and here it took.'" When the officers ask if her husband had objected to her efforts, she explains earnestly that, drunk, he snored until, without her at first noticing, he stopped. "Sometimes he puffed out a little sound and once his lips made a little pop, like somebody that's just made a mistake. I stuck my needle back in my collar and my thought turned to Band-Aids." "He was bleeding a little faster than my fingers. It was something I hadn't thought of."

Over the pages of these unlined notepads the couple's history comes clear. Saturdays were both the husband's day off and his wife's "busiest day. . . . All her alterations were promised and there was a stream of chattering women and final fittings." The women's activity infuriated Mr. Hopper (alternately named Bud, Floyd, Earl, and Mr. Hobbs). In one version the police note the wife's "black eye." In a few crossed-out lines, the wife reports her husband asking, "'Did I hit a tender place?' I'd say, 'Well women are tender all over, did you ever think of that?'" The police remember a previous incident when "neighbors called us. . . . Sure. You was the one that got hit. He put a wrench to your head and a wonder you ever got up."

On this particular Saturday, sodden with liquor, naked to the waist, and behaving badly, her husband slipped or fell in his stupor. "He was weaving. Waxing. Then he just went over." The police question her role in his fall, asking if she did "more than touch him . . . just a little bit?" Their exchange might recall Welty's description of how Exum gave Easter's "heel the ten-derest, obscurest little brush," causing her plunge into Moon Lake. Genrose describes it: "I put out my finger, just to shame him, poked him one little push. . . . he was ripe to fall. . . . I don't think he knew what hit him. . . . it was my hard clean floor." Leaving him where he has rolled to "sleep it off on the living room rug," she begins to work on him. "I completely forgot about myself. That's what a wife is good for." Contemplatively she ruminates that "some wives might have kept on once they got started—might have cut on deeper down when they got to where his heart is and cut it out. I never even thought of doing that. I swear I never. That's just when I stopped, and went back and got my soap and water, and my Band-Aids. He looks in good shape, all neat now. Except for his eyes. I'm not responsible for them." Happy enough with her job she credits herself with his transformation: "how peace-ful his wife had made him. . . . He's a credit to both of us. . . . My husband this very minute is in heaven. I'd made him an angel." The dark comedy of the

murderer's self-justifying self-presentation, of her obsessive tendencies and pride in her work, and of her belief in her innocent intention is underscored. A possible trigger for her unexpected assault is perhaps the wedding dress worn by her dressmaker's dummy: ironically, "just on the other side of the curtain . . . in the shadows" of her parlor, it signals "through its glimmer. . . . It was there as if in the wings, as if awaiting its cue to enter on its squeaky little wheels [for its day on center stage]" (Welty's brackets).

Notwithstanding the Welty signatures of humor, surprise, and homage to literary history (here an assured wink toward the voice and situation of Poe's "The Tell-Tale Heart"), and despite her characteristic reflection of and on popular culture and her recognizable feminist concerns (now astonishingly overt), who would have expected Welty to write this police procedural of sensational murder? I do note an inkling of sustained interest in violent abuse beginning as early as "The Night of the Little House" and "Flowers for Marjorie," but in this late period it emerges energetically. Abuse is central in *Losing Battles* in the caretaking "marriage" between Lexie and Julia Mortimer, is climatic in *The Optimist's Daughter* in Fay's slapping of Judge McKelva, and is exposed in Hallie's betrayal of Merritt and his murder of her in "The Shadow Club." Welty's attention to the topic perhaps culminates in three related, unpublished drafts—"Henry," "Affinities," and "The City of Light"— perhaps expressing, as Suzanne Marrs and Tom Nolan's *Meanwhile There Are Letters* suggests, resentment toward Kenneth Millar's wife's treatment of him before and during his illness and death. "Alterations," like others in this late period, is a talky drama, adapting and parodying a television genre as much as literary history. These notes show Welty still experimenting and evolving as a writer even in advanced age and even after she had contentedly or regretfully lost the disposition to finish and publish her fiction. Her topic though still brings to readers the exposed body—of the woman abused, of the man revealed.

The issue of a writer's retirement, of how to stop writing after an epoch of imaginative life, was addressed by Philip Roth's announcement that at the age of eighty he determined to stop writing. In 2012, he claimed to rise in the mornings to see on his keyboard a sticky note reading: "The struggle with writing is over" (McGrath). The *New York Times* quoted him as saying, "I look at that note every morning . . . and it gives me such strength." Now I cannot help but wonder if one day his admiring readers will nonetheless find a few pads of notes for an unfinished story, begun and indulged as Welty's were. What is clear is that for Eudora Welty the imaginative urge died hard, and even after she lost the ability to type, to comfortably (or even uncomfortably) sit and work, she was still interacting with narrative forms and inventing. Even in this late and unexpected work, where a dead man's corpse is investigated, it is a woman's unprotected body that is exposed.

Notes

Introduction. Written on the Symbolic Body

1. The "angel in the house," a phrase introduced in Coventry Patmore's 1854 narrative poem, has become a useful catch phrase in feminist analysis following the work of the feminist historian Carroll Smith-Rosenberg.

2. The autobiographical roots of "June Recital" are made evident by passages in her memoir, *One Writer's Beginnings*. Elsewhere, Welty more explicitly acknowledged the other texts as also having autobiographical roots.

3. Alison Arant also notes the story's "critique of the eugenic rhetoric of human improvement" (70). Arant's emphasis is on "dysgenic" marriages and "the marriage of a woman who, from a eugenic standpoint, lacks 'moral intelligence'" (70).

4. The bad girls of nineteenth- and twentieth-century literature choose suicide or madness rather than marriage: think of Charlotte Perkins Gilman's *The Yellow Wallpaper*, Kate Chopin's *The Awakening*, Edith Wharton's *The House of Mirth*.

5. Hereafter, *The Collected Stories of Eudora Welty* will be cited in the text as *CS*.

6. The exception would be Troy's construction of his cabin-bound, quilt-making mother in *Delta Wedding*, who stands in contrast to Robbie, the underclass seductress, and Ellen, the complex mother.

7. Charity is frequently satirized in Welty's plots; I think for example of her portrayals of suspect charity in "A Visit of Charity," "A Worn Path," "Kin," and *Losing Battles*.

8. McWhirter encapsulates and pointedly comments on the plot of *The Sheik*: "Before venturing off into the desert alone in the company of native guides, Lady Diana refuses a proposal from an Englishman of her own class, claiming 'marriage is captivity—the end of independence.' Her subsequent kidnapping and seduction—or is it rape?—by Ahmed—'when an Arab sees a woman he wants, he takes her' . . . suggest how *The Sheik* intermingles questions of ethnicity, masculinity, and female sexuality during a period when all three were highly controversial topics. . . . Hansen, surveying the debates that raged around Valentino after the success of *The Sheik*,

similarly argues that 'the projection of the ethnic and racially male other as sexually potent, uncontrollable, and predatory,' was also linked to the emergence of, and anxieties about, the New Woman, 'with her alleged economic independence, liberalized life-style, and new public presence . . . which seemed to advance the articulation of female desire, of erotic initiative and choice'" (McWhirter, "Eudora Welty Goes to the Movies" 78, quoting Hansen 258).

Chapter 1. Other Women's Bodies in Welty's "Girl Stories"

1. Katherine Anne Porter in her preface to *A Curtain of Green* describes the story as having "something of early personal history" about it (xxii), a comment in which she is pointing to the *künstlerroman* (portrait of the artist) quality of the story.

2. One autobiographical aspect of the story is that young Eudora was, like Loch Morrison, confined to bed for a prolonged period when at the age of seven she was diagnosed with a "fast-beating heart."

3. There are a few exceptions to this rule that occur to me, such as the satirical "Delegate" and "Hello and Goodbye," both published in *Photographs*.

4. Thanks to Forrest Galey, the director of the Eudora Welty Collection at the Mississippi Department of Archives and History, who traced and verified these details.

5. The quoted passages in this section all refer to the Courtney manuscript held in the Eudora Welty Collection at the Mississippi Department of Archives and History, box 247, folders 1–3. The story is discussed and passages reprinted by permission both of the Mississippi Department of Archives and History, and of Russell and Volkening as agents for the author. Copyright © by Eudora Welty, renewed by Eudora Welty LLC.

6. The baby is alternately named "Loradia."

7. Hereafter, *Eudora Welty: A Biography* will be cited in the text as *EWAB*.

8. Important treatments of this story include those by Ruth M. Vande Kieft (27–29), Ruth Ann Lief, Elaine Ginsberg, Alfred Appel (3–8, 99–101), Merrill Maguire Skaggs, Louise Westling (*Eudora Welty* 65–66), W. U. McDonald Jr., Gail L. Mortimer (54–56), Patricia Yaeger ("Beyond the Hummingbird: Southern Women Writers and the Southern Gargantua" and, in a variation, *Dirt and Desire* 117, 129–140), Stephen M. Fuller, and Lionel Kelly. Mortimer's and Westling's pieces are important for their attention to the girl's sheltering, and Yaeger's reading is the most helpful and relevant to my own.

9. Yaeger, thinking about this, pointedly asks, "[C]an a Southern female child . . . represent the power structure?" And she answers: "what a child thinks at the beach may be as telling as a trip to the statehouse; she may give us access to . . . the insane politics of everyday southern life" (*Dirt and Desire* 135, 131).

10. From the draft of "A Memory," held in the Eudora Welty Collection at the Mississippi Department of Archives and History, cited by permission of both the Mississippi Department of Archives and History and Russell and Volkening as agents for the author. Copyright © by Eudora Welty, renewed by Eudora Welty LLC.

11. Suzanne Marrs dates the manuscript of "The Night of the Little House" in *EWAB* 626. It is here discussed and lines reprinted with the permission of both Russell and Volkening as agents for the author, copyright © by Eudora Welty, renewed by Eu-

dora Welty LLC, and the Manuscripts and Archives Division, New York Public Library, Astor, Lenox, and Tilden Foundations.

12. At Victory's post office the narrator asks if she has received a letter and is told that the only one unaccounted for is for a man who has not come: M. Galen. Once she identifies herself as Martha Galen, the narrator interprets the glance directed at her: "For a woman to be addressed by her initial, her marital status unstated, was another crazy idea, I understood. I could not help feeling, in this conversation after a long trip, that everything I had done was unbecoming." Galen's comments might suggest modeling on such 1930s feminist cinematic heroines as Katharine Hepburn, since the story generally has a filmic feel.

13. The manuscript "Beautiful Ohio" is discussed and passages reprinted by permission of the Mississippi Department of Archives and History and of Russell and Volkening as agents for the author. Copyright © by Eudora Welty, renewed by Eudora Welty LLC.

14. Gail L. Mortimer in *Daughter of the Swan: Love and Knowledge in Eudora Welty's Fiction* and Michael Kreyling in "History and Imagination: Writing 'The Winds'" provide two other careful readings of the story.

15. Passages quoted in this section all refer to the manuscript of "Beautiful Ohio" held at the Mississippi Department of Archives and History, box 244.

16. I note with interest that Chestina Welty played the trumpet, a fact brought to my attention by Suzanne Marrs.

17. The rabbit reference strikes me as an allusion to Katherine Anne Porter's "The Grave," first published in *Virginia Quarterly Review* in 1935, though better known from its 1944 republication in *The Leaning Tower and Other Stories*. Welty in 1935 valued Porter as a mentor as well as a friend and would have read it. Like Porter's story, Welty's is about an early encounter with female sexuality.

18. Allusions to Perseus throughout *The Golden Apples* culminate in "The Wanderers" when Virgie "must believe in the Medusa equally with Perseus" (CS 260).

19. Danielle Pitavy-Souques, "Watchers and Watching: Point of View in Eudora Welty's 'June Recital,'" is perhaps the earliest reading that carefully attends to point of view.

20. Suzanne Jones, writing about Porter's Miranda in "Reading the Endings: Katherine Anne Porter's 'Old Mortality,'" argues along similar lines.

21. The story cycle's name itself has its source in the poem. The allusion underscores the characters' wandering search for satisfaction.

22. Is "stuck-up" a pun that points to a class position as well as a head position?

23. Cassie's uneasiness might recall my introduction's discussion of southern culture's demand for strictly defined identities and of the sheltered daughter of southern literature living in a space shaped by the omitted backdrop of whiteness, even when sheltering parents are entirely unaware of the cultural caste system's role in standardizing protective behaviors and female education to constraint.

24. Hereafter, references to *The Optimist's Daughter* will be cited in the text as *OD*.

25. Laurel remembers that, after her mother's death, her father invited her to "knock off, invite a friend for company, and all go to see England and Scotland in the spring," writing "there was never anything wrong with keeping up a little optimism

over the Flood." His daughter makes no plans with him, and then "she heard he was about to marry Fay" (OD 143).

26. These three unfinished manuscripts are quite different, but their shared background is the Millar relationship. I discuss them and reprint lines of manuscript with the permission of both the Mississippi Department of Archives and History and Russell and Volkening as agents for the author. Copyright © by Eudora Welty, renewed by Eudora Welty LLC.

27. I am grateful to Suzanne Marrs for sharing this informing work with me in draft.

Chapter 2. Welty's Photography and the Other Woman

In this book, all photographs by Eudora Welty are reproduced from her negatives without cropping or reversal. For that reason, the images of "Hello and Goodbye," of "Sideshow, State Fair (Junie Alive)," and of "Sideshow, State Fair (Amazing Wonderful Siamese Calves)" differ from the images published in the 1989 volume *Photographs*.

1. Welty had enrolled in the Mississippi State College for Women at the age of sixteen and then in 1927, after two years there, she transferred to attend the University of Wisconsin. And so after spending her college years in Columbus, Mississippi, and Madison, Wisconsin, it was a plan for graduate work at Columbia that took her to New York in 1930, a plan that changed when her father died in 1931.

2. Welty reports that when she "took art from Mrs. Hull [Marie Hull, a Jackson painter and teacher]," she learned "that device: framing with your fingers. Studying drawing and painting made me aware in writing a story of framing your *vision*, as a way toward capturing it" (Cole and Srinivasan 193).

3. Patti Carr Black cites Welty's 1935 letter to Bernice Abbott, inquiring about Abbott's photography class at the New School for Social Research: "I have photographed everything within reason or unreason around here, having lately made particular studies of negroes, with an idea of making a book since I do not like Doris Ulman's [*sic*] pictures" (Black, "Back Home In Jackson" 35).

4. In her interview with Cole and Srinivasan, she describes the role Sam Robbins played: "He supplied me with a lot of stuff that I never knew about—better paper, chemicals, and things like that. He was helpful too—he marked on each one what was wrong, like not enough contrast, too much, and so on. And so I printed up a collection of the best ones for him and he did exhibit them" (189).

5. Her photograph "Delegate," of a member of the Daughters of the American Revolution, is a good example of this sort of comic revoicing.

6. Welty discusses her feelings about this in her interviews with Hermione Lee (151) and with Hunter Cole and Seetha Srinivasan (207).

7. This all seems related to Welty's late unpublished manuscript "The Last of the Figs" in which Sarah draws her houseworker Esther's feet, one of many occasions in which the vocabulary of Welty's photos, taken in the 1930s but assembled for publication in 1980, seems to reverberate in her late fiction.

8. Here I am quoting Welty's first version of "The Pageant of Birds," published in the *New Republic*, 565–566, rather than the revision she prepared for *The Eye of the Story*.

Chapter 3. *Silence, Sheltering, and Exposure in "Music from Spain" and* The Bride of the Innisfallen and Other Stories

1. Suzanne Marrs writes of the Welty-Robinson relationship: "Between 1945 and 1951, their romance would ebb and flow. Between 1946 and 1947, Eudora would twice journey to San Francisco and spend several months living there near John. In 1950, John would follow Eudora to Europe, where they would share good times on the Cote d'Azur and in Florence. But there were long periods of separation between these meetings, and by the end of 1951 their relationship seemed doomed. Like Lorenzo Dow in 'A Still Moment,' though her concerns were earthly rather than divine, Eudora would know 'Love first and then Separateness,' not the reverse" (*EWAB* 138–139).

2. All of the manuscripts and all of the correspondence referred to in this chapter, unless otherwise noted, are discussed and lines reprinted by permission of the Eudora Welty Collection at the Mississippi Department of Archives and History, and of Russell and Volkening as agents for the author. Copyright © by Eudora Welty and renewed by Eudora Welty LLC. All of John Robinson's manuscripts and correspondence are discussed and quoted with the additional permission of Michael Robinson.

3. I mean here that Robinson exited the closet by choosing another relationship, not by explicitly coming out as a gay man.

4. Correspondence was exchanged between Welty and others on the topic of Robinson's stories, and here is one response in which John Palmer deliberates over what seems to be "All This Juice and All This Joy":

> 24 Feb 1948
> I can say that Mr. R looks like a right newcomer. But I'm not convinced that this is the best piece he could offer for his first Sewanee showing. For one thing, the deliberately loose construction strikes me as being on the arty side; for another, the underlying thematic unity which holds these little groups of strangers together seems a little too pat for conviction and I think the moment of violence is a very real defect as being "unlikely" and unacceptably sensational. And I very much hope that Mr. Robinson will not be turned away by my comments here. You know that I could have been vaguer and politer if I'd chosen to be, but what's the use if you're really interested? A man who has this control of tone and detail is capable of managing a whole unblemished story and it's that I shall hold out for from him.

What Palmer felt was "unlikely," Cyril Connolly would soon enthusiastically publish.

5. Marrs writes: "Though John may well have discussed his emotional state in post-war letters to friends, few of these letters are extant. Those he sent to Eudora—perhaps more than two hundred written between 1946 and 1951—she destroyed sometime in the 1970s so as to protect his privacy. But in 1983, John's nephew discovered a hoard of Eudora's letters to John stored under the old family home, and John quickly decided they should be returned to her. By giving them back, he gave his blessing to their preservation. The surviving correspondence, though one-sided, clearly indicates that John was in turmoil about his future—he did not want to resume his career as an insurance adjustor, he thought longingly of permanent residence in Italy, he was moody and often depressed" (*EWAB* 139–140).

6. This letter is simply headed "Monday." It is not otherwise dated, but clearly was written in 1948. Eudora Welty's letters to John Robinson, cited throughout this chapter, are held in the Robinson sections of the Eudora Welty Collection and the John F. Robinson Papers, all at the Mississippi Department of Archives and History.

7. This is the same "Monday" letter from 1948.

8. This is again the "Monday" 1948 letter.

9. This letter is headed "Friday." Not otherwise dated, it was likely written in 1948–1949.

10. The Mississippi Department of Archives and History holds eighty-five pages of notes for and scenes of a collaboratively written screenplay and a different sixty-two-page draft of the screenplay, composed in 1948–1949, with John writing in San Francisco and Eudora in Jackson. About the screenplay, Robinson writes, "Hollywood will never take it, maybe Cocteau."

11. A different but related approach to the pleasure of their relationship is taken by Julia Eichelberger in her collection of Welty's gardening letters, *Tell About Night Flowers*, which excerpts Welty's decade of correspondence to Robinson and to her beloved agent, Diarmuid Russell, with whom she shared a remarkably close friendship and a productive and relied-on "first reader" relationship. Eichelberger makes clear that Welty's gardening letters, while detailing her horticultural hobby, say much more: her letters consistently use gardening as a metaphor for progress in her writing, her affections, and her spiritual health. Moreover Eichelberger powerfully uses the letters to chart a decade of biography and, in particular, the narrative of the Welty-Robinson relationship.

12. Robinson to Nancy and Alice Farley, January 29, 1949, Farley Papers, Alderman Library, University of Virginia, Charlottesville.

13. Diarmuid Russell seems to be making a similar judgment when he writes "If [John] wishes to write, really wishes, then that would be good but if it is merely a half-longing, a sort of medicine it doesn't help much (February 13, 1947; reprinted in Eichelberger, *Tell About Night Flowers* 196).

14. In collections housed at the University of Virginia in Charlottesville and Washington University in St. Louis, respectively.

15. This letter is headed "Friday Morning." No date is given, but by deduction the year was likely 1948.

16. Elements of this chapter have been reworked from my essay "Reading John Robinson," published in 2003, before the 2005 Marrs biography of Welty made clear so much about the relationship and before additional correspondence, now available at the Mississippi Department of Archives and History, was processed and released beginning in 2008. This chapter therefore draws on my earlier work but supersedes it.

17. Another interesting detail relevant to a Welty reader thinking about the richness of the Lands End site: just above where Playland operated, to the side of the Cliff House, a full-scale, room-size camera obscura was installed in 1946 and opened to the public, based on a fifteenth-century design by Leonardo da Vinci. Light from the Seal Rock area of the bay passes through a hole and strikes the optical device's surface, where it is reproduced, upside down but with color and perspective preserved. It is impossible to imagine that Eudora, with her interest in cameras, did not enter

and enjoy this tourist attraction, which has earned a spot in the National Register of Historic Places.

18. Hereafter, this story will be cited in the text as JJ.

19. Anyone familiar with Lands End will recognize the phenomenon of these pines that, continuously buffeted by ocean bluster, have grown to one side, making the wind-swept look their permanent physical form.

20. Eichelberger, like Marrs, discusses Welty's destruction of these letters in *Tell About Night Flowers*, xxviii–xxix.

21. The habit seems to have ended after Robinson's sabbatical at Yaddo in 1952, which Welty had arranged, and her reaction to his story "The Beach Fire."

22. The manuscripts of "Pickups," "House of Mirth," and "The Black Cat" are held in the John F. Robinson Papers at the Mississippi Department of Archives and History. Copyright © by Eudora Welty, renewed by Eudora Welty LLC.

23. On the draft of the story there is a handwritten marginal comment alongside the first of the two paragraphs that I quoted above. The comment is "but more—willing," an observation that Welty elaborates in her letter.

24. The manuscript "The Flower and the Rock" is held in the Eudora Welty Collection at the Mississippi Department of Archives and History. Copyright © by Eudora Welty, renewed by Eudora Welty LLC.

25. "Open the Door, Richard" is a comic and widely varied performance about a man locked out and calling for his roommate to let him in. Its best-known version was performed by Count Basie and His Orchestra. Words by Dusty Fletcher and John Mason; music by Jack McVea and Don Howell.

26. This oddly calls up the details of Welty's early story "The Purple Hat."

27. Hubert Creekmore (1907–1966) also published *The Chain in the Heart*, *Daffodils Are Dangerous*, *Purgative*, *Cotton Candy*, and *The Fingers of Night*. Welty in several interviews credits her friend, neighbor, mentor, and relative-by-marriage Hubert with the suggestion that she send "Death of a Traveling Salesman" to *Manuscript*— the small, Ohio-based magazine that surprised them both in 1936 by accepting that first story of hers. He was throughout their lives a close friend.

28. See, for example, the Chicago Public Library's gay and lesbian fiction list, compiled by the librarians at the Harold Washington Library Center.

29. The Mississippi Department of Archives and History houses one of John's parodies of Faulkner, written and given as a present for Eudora on a birthday.

30. John, unlike Don, troubled Eudora more with his anxieties about and avoidance of intimacy than with having entertained the thought of marrying in order to better belong. Yet I think it is clear that, in his relationship with Eudora, John considered these sorts of choices and that the emotional cloud that she in her letters recurrently worries over likely has to do with a period of reluctance to give up "belonging" and "counting" in traditional ways.

31. Katherine Anne Porter Collection, University of Maryland at College Park Libraries.

32. I offer no certainty that Eudora used this word in its current sense of describing an affirmed homosexual identity.

33. These letters are discussed and lines reprinted with the permission of the Wash-

ington University Library, and Russell and Volkening as agents for the author. Copyright © by Eudora Welty, renewed by Eudora Welty LLC.

34. Perhaps the most intriguing letter of the period is Welty's to Robinson in May 1951, when she is writing of her close friend Mary Louise Aswell's fear of her husband, Fritz Peters. The language almost suggests that Welty is displacing an outing conversation she wants to have with Robinson onto the story of their friends: "What chance the boy ever had I don't know—brought up out of the Middle West with Lesbians, Gurdjief [sic], the army & war of course, homosexuals, South of France[']s beaches of nudist colonies, Truman [Capote]—what others have done to him! So now he's paying us all back through the dear and loving ML" (*EWAB* 203). Does her discussion of Aswell's partner's abuse, blamed on homosexuality seen as an illness, displace questions she has about her relationship with John? Is she remarkably unaware that the subject is sensitive for him, or is she now testing for, or possibly inviting, a reaction?

35. Rood's letters are in "Select Correspondence" of the Welty Collection at the Mississippi Department of Archives and History.

Chapter 4. Was Welty a Feminist?

1. So many of Welty's stories focus on women's bodies that I assert it as a predominant pattern from her first published story, "Death of a Traveling Salesman," throughout her career. I think of the moment in "The Whistle" when Sara pulls off her dress to use it to protect a tomato crop from the cold, or when Lily Daw chooses a pink brassiere. I think also of Keela when he is a maiden, of Clytie when she drowns herself in her reflection, of pregnant Hazel when she does not, of Miss Sabina "painted to be beautiful and terrible in the face," of Livvie discovering lipstick in Miss Baby Marie's trunk, and so on.

2. Discouraged when Robert Penn Warren and Cleanth Brooks, the editors of the newly established *Southern Review*, returned "Petrified Man" in 1937 without accepting it, Welty destroyed the only copy. When Warren wrote later to express his second thoughts about the rejection, she rewrote it from memory; it was later included in the *O. Henry Prize Stories of 1939*. Years later, when she met Warren in person, she confessed her worry that it had not been ethical for her to rewrite the story and resubmit it. Warren's comment, reported in a letter to John Robinson, was amused: "but you wrote it, didn't you?"

3. Both Peter Schmidt in *The Heart of the Story* and Lauren Berlant in "Re-writing the Medusa: Welty's *Petrified Man*" present wonderful discussions of the Medusa in this story.

4. In keeping with my attention to the controversial debates in Welty studies, I refer here to Sally Wolff's reading of "Petrified Man" as being—along with "Death of a Traveling Salesman"—"for the author a self-referential, bleak contemplation of her empty cradle" ("Eudora Welty's Children of the Dark Cradle" 256–257).

5. Welty's comments on her acquaintance with McCullers generally express irritation. The two young writers seemingly first met at Breadloaf in the summer of 1940, and as she writes in a letter to Frank Lyell, Welty found McCullers to be "an odd

little 22 year old with long hair, bangs, a cigarette cough, [and] boy's clothes." Her comments about McCullers in letters repeatedly express the strain of her annoyance.

6. In addition to Fiedler's groundbreaking book, I recommend and am indebted to Rachel Adams's *Sideshow U.S.A.: Freaks and the American Cultural Imagination* and Rosemarie Garland Thomson's *Freakery: Cultural Spectacles of the Extraordinary Body*, particularly the essay by Elizabeth Grosz, "Intolerable Ambiguity: Freaks as/at the Limit."

7. Lois Welch makes this observation in her analysis of Welty's humor, "Wild but Not Savage: Eudora Welty and Humor in Native American Writers."

8. When Welty incorporates Clyde Morton into her 1938 unpublished novel, he is guilty of domestic violence, and the narrating character's desire to help his abused daughter and to have her community register domestic violence as a crime structures much of the plot.

9. In letters to Diarmuid Russell, she considers writing a "magical surprise" (September 1948) and distinguishes between writing "magic things" and writing "clever" ones, letting the magic "come through": "I am not magic but my heart lives in that country" (June 8, 1942). Letters reprinted in Eichelberger, *Tell About Night Flowers*.

Chapter 5. *"Before the Indifferent Beak Could Let Her Drop"*

1. Presented here in the order of their initial publication, not their order in *The Golden Apples*.

2. The quotations here are from D. L. Ashliman's online translation of the Grimms' "Der Räuberbräutigam."

3. This letter and her letter to Nash Burger (discussed below) are quoted by permission of the Eudora Welty Collection at the Mississippi Department of Archives and History and of Russell and Volkening as agents for the author.

4. Yaeger's 1984 "'Because a Fire Was in My Head': Eudora Welty and the Dialogic Imagination" broke ground by discussing the female act of revoicing, which opens language to another point of view, but she also argues that "Mattie Will's fantasy represents the limited scope of creativity that Morgana society confers—even on women of strong imagination" (962), a position I find both helpful and not.

5. "At the Landing" grew from a draft called "The Children," which is dated 1934. Rape, however, was not a part of the early draft; rape was introduced in the version written more or less simultaneously with *The Robber Bridegroom*.

6. Ann Romines in *The Home Plot: Women, Writing, and Domestic Ritual* writes well and extensively on the issue of housecleaning in this story, concluding that "the compulsive pull of housekeeping . . . is only temporary. . . . the history of women in her family and her place—the shutting up and the trimming down—cannot coexist with all [Jenny] has learned of love" (208–209).

7. Here I am extending points David McWhirter makes about the sheik in "Eudora Welty Goes to the Movies" by bringing them to "At the Landing." And while Annette Trefzer does not specifically discuss the women's creation of Billy Floyd's native roots, her analysis of the native presence and absence in Welty's work in *Disturbing Indians:*

The Archaeology of Southern Fiction is very useful in relationship to this aspect of the story.

8. Readers do not know Phinny's age, and some entertain images of a grown and hidden son in what seems to be a revision of Jim Bond's story from Faulkner's *Absalom, Absalom!*

9. The model of Sherwood Anderson's *Winesburg, Ohio* seems relevant here.

10. I refer to "The Wells" and to the sequence of Henry stories, in which "Affinities" and "The City of Light" seem to be very different approaches to a single project, restarted.

11. Marrs tells of the letters exchanged by the two and of Millar's confession to Reynolds Price that he loved Eudora (*EWAB* 387). Marrs and Nolan, *Meanwhile There Are Letters: The Correspondence of Eudora Welty and Ross Macdonald*, traces the relationship through the letters and also excerpts one of Welty's unpublished stories refracting the friendship.

12. Welty's unpublished manuscript is discussed and lines reprinted here by permission of the Eudora Welty Collection at the Mississippi Department of Archives and History and of Russell and Volkening as agents for the author. Copyright © by Eudora Welty, renewed by Eudora Welty LLC.

13. If the Observatory Street project bears some resemblance to the story cycle of *The Golden Apples*, played out in a different genre, Professor Ledbetter at moments seems to echo the philanderer King MacLain, rung in a crime novel register. At his death, there is community speculation that the professor is Downing's father and that the tenderness he has shown toward her is in recognition of that secret. Similarly, in "The Wanderers," at another funeral, there is a suggestion that King is Virgie Rainey's father, a conjecture that gives their exchange there a tender nuance.

Chapter 6. The Body of the Other Woman and the Performance of Race

1. This extremely interesting and provocative manuscript has at this point only been described briefly in Marrs's biography, but it deserves more attention. Like all of the late unpublished manuscripts, assembling the story as envisioned by Welty is a challenge since its parts exist among many folders in the Mississippi Department of Archives and History in Jackson. The story is here discussed and lines reprinted by permission of the Mississippi Department of Archives and History and of Russell and Volkening as agents for the author. Copyright © by Eudora Welty, renewed by Eudora Welty LLC.

2. Harrison writes, "Strickland approaches her along 'a path of newspapers laid down on the floor from the doorway to the bed' (*CS* 609); the walls of the room are 'newspapered' (*CS* 610); and Ruby's son sits 'on a clean newspaper' laid on [the] floor (*CS* 611). While the surrounding of Ruby by newspapers prefigures her entrapment in the newspaper article later in the story, it also points to the significance of reading; the scene calls to mind an earlier Welty story in which newspapers are the vehicle for another of Ruby's encounter[s] with language" ("Racial Content Espied" 96).

3. Morrison, as I discussed earlier, praised Welty in an interview with Mel Watkins in 1977.

4. Bessie Smith performed "St. Louis Blues" (1914) by W. C. Handy throughout the 1920s and sang: "Hate to see the ev'nin' sun go down, / 'cause my baby, he done left this town."

5. Thanks to Dr. Sally Bergwerk for her help in researching Ruby's medical condition and this explanation.

6. Notice that Dove, black and gold, echoes those "black men dressed in gold" from "The Burning."

7. Was it taken by Ruby's young brother, who both carried and "found" it there? Was there someone else who retaliated for the strike against Ruby? The testimony that community members "would not have gone off and left [Dove] if [they] had known he was able to subsequently crawl up the hill" (*CS* 621) is ambiguous in its meaning when the report is also that they chased the wounded Collins "in the direction of Snake Creek. . . . then he fell to the ground and rolled approximately ten feet down the bank, rolling over six or seven times" (620). They "stood there a while and flipped some bottle caps down at him and threw his cap down after him right over his face and didn't get a stir out of him." The remark quoted is: "The way he acted, we figured he was dead" (621).

8. Although the reference to "the weatherman" calls up the Weather Underground, that title was not used by the SDS until 1969. Its source was Bob Dylan's lyric "You don't need a weatherman to know which way the wind blows" from the 1965 "Subterranean Homesick Blues," which was released while Welty was completing her story, published in 1966.

9. Has Dove been robbed? Has he lost his job?

10. Welty attached to this revised section three gummed labels: the first reads "The Last of the Figs," and a third (completely obscuring the second) reads "A 60's story can be extricated from this." Below this remark, but on the same label, is a title written in another pen, "Nicotiana / revised '64 / Part I / to copy." Copyright © by Eudora Welty, renewed by Eudora Welty LLC.

11. Russell and Volkening records, Manuscripts and Archives Division, New York Public Library, Astor, Lenox, and Tilden Foundations. This letter is discussed and lines reprinted with the permission of the New York Public Library, and of Russell and Volkening as agents for the author.

12. The full stanza that the phrase calls up is "My mother bore me in the southern wild / And I am black, but O, my soul is white! / White as an angel is the English child / But I am black as if bereav'd of light."

13. I draw on these critical explorations of the poem: Hazard Adams, *William Blake: A Reading of the Shorter Poems* (Seattle: University of Washington Press, 1963); Harold Bloom, *Blake's Apocalypse: A Study in Poetic Argument* (Ithaca, N.Y.: Cornell University Press, 1963); E. D. Hirsch, *Innocence and Experience: An Introduction to Blake* (New Haven, Conn.: Yale University Press, 1964); Zachery Leader, *Reading Blake's Songs* (London: Routledge and Kegan Paul, 1981); Howard H. Hinkel, "From Pivotal Idea to Poetic Ideal: Blake's Theory of Contraries and 'The Little Black Boy,'" *Papers on Language and Literature: A Journal for Scholars and Critics of Language and Literature* 11 (1975): 39–45; Myra Glazer, "Blake's Little Black Boys: On the Dynamics of Blake's Composite Art," *Colby Literary Quarterly* 16 (1980): 220–236.

14. As a child, of course, Welty lived on Congress Street, in another neighborhood.

15. Taking Welty and the South to task and conflating the two, Trilling wrote, "It is difficult to determine how much of [my] distaste for Eudora Welty's new book . . . is resistance to the culture out of which it grows." Assuming that Welty was "so fondly" describing Mississippi Delta culture, Trilling essentially oversimplified the novel. Misinterpreting the fiction as without "criticism of the Fairchild way of life" and believing that Welty cherished "the parochialism and snobbery of the Fairchild clan," Trilling felt she must "deeply oppose its values" (60–61).

16. This section of the manuscript was clearly drafted after the 1964 revision.

17. This car conversation appears in what might be an exploratory draft. While the predominant segment of the third section of the manuscript is assembled under the title "*The Last of the Figs* Part 3 New Typed. *Original* Sept," other assorted pages of manuscript experiment with presenting the material this way or that. My reference here is to one of those scraps. It explores the characters, adds information, and has the feel of a postscript, but does not have the feel of closure. Starting as early as her work on *Losing Battles* (and I think particularly of the Phil section of *The Optimist's Daughter*), Welty sometimes wrote out sections of a story in manuscript to explore ideas and characters, without intending to use them.

18. It has been suggested that Eugenia "Skeeter" Phelan, the daughter of a respectable white family, home from college with dreams of becoming a writer and at odds with her mother's dream for her to be conventionally married, was loosely inspired by Welty herself, and Welty appears in the novel as someone Skeeter is reading. Sarah Ford discusses this in an unpublished paper, "Reimagining 'Eudora Welty' Through the Eyes of the Artists."

19. Most visibly, there was the publication of *William Styron's Nat Turner: Ten Black Writers Respond*, ed. John Henrik Clarke (Boston: Beacon, 1968).

Postscript. A Last Word on Continuity and Change in Welty's Career

1. This manuscript is discussed and lines reprinted by permission of the Mississippi Department of Archives and History and of Russell and Volkening as agents for the author. Copyright © by Eudora Welty, renewed by Eudora Welty LLC.

Bibliography

Archives and Unpublished Works

Brackets around a manuscript date for items from the Welty (Eudora) Collection at the Mississippi Department of Archives and History indicate a year attributed by an archivist or a scholar. Parentheses indicate a date clearly associated with at least a portion of the manuscript, although drafting may have begun before and continued after that date.

Nash Burger correspondence. Select Correspondence, Welty (Eudora) Collection. Mississippi Department of Archives and History, Jackson.

Farley Papers, Alderman Library, University of Virginia, Charlottesville.

Frank Lyell correspondence. Select correspondence. Welty (Eudora) Collection. Mississippi Department of Archives and History, Jackson.

John F. Robinson correspondence. Select correspondence. Welty (Eudora) Collection. Mississippi Department of Archives and History, Jackson.

John F. Robinson Papers. Mississippi Department of Archives and History, Jackson.

John Rood correspondence. Select Correspondence, Welty (Eudora) Collection. Mississippi Department of Archives and History, Jackson.

Tim Seldes correspondence. Russell and Volkening Records. Manuscripts and Archives Division, New York Public Library, Astor, Lenox, and Tilden Foundations, New York City.

William Jay Smith correspondence. William Jay Smith Papers. Washington University Special Collections, St. Louis, Missouri.

Welty, Eudora. "The Alterations" [1987]. Welty (Eudora) Collection. Mississippi Department of Archives and History, Jackson.*

———. "Beautiful Ohio" (ca. 1936). Welty (Eudora) Collection. Mississippi Department of Archives and History, Jackson.

———. Courtney story, untitled (ca. 1925). Welty (Eudora) Collection. Mississippi Department of Archives and History, Jackson.

———. "The Flower and the Rock" (ca. 1947). Welty (Eudora) Collection. Mississippi Department of Archives and History, Jackson.

———. "Henry," "Part 1 and Part 2 Affinities," "The City of Light" [1980s]. Welty (Eudora) Collection. Mississippi Department of Archives and History, Jackson.

———. "The Last of the Figs" (alternately "Nicotania"), Parts 1, 2, and 3 (ca. 1964). Welty (Eudora) Collection. Mississippi Department of Archives and History, Jackson.

———. "The Night of the Little House" (1938). Russell and Volkening Records. Manuscripts and Archives Division, New York Public Library, Astor, Lenox, and Tilden Foundations, New York City.

———. "The Shadow Club" [1970s]. Welty (Eudora) Collection. Mississippi Department of Archives and History, Jackson.

Published Works

Adams, Rachel. "'A Mixture of Delicious and Freak': The Queer Fiction of Carson McCullers." *American Literature* 71, no. 3 (1998): 551–584.

———. *Sideshow U.S.A.: Freaks and the American Cultural Imagination*. Chicago: University of Chicago Press, 2001.

Adams, Timothy Dow. *Light Writing and Life Writing: Photography in Autobiography*. Chapel Hill: University of North Carolina Press, 2000.

Agner, Jacob. "Welty's Moonlighting Detective: Racial Chiaroscuro and Traces of Noir in 'The Demonstrators.'" Paper presented at "'Everybody To Their Own Visioning': Eudora Welty in the Twenty-First Century: An International Conference of the Eudora Welty Society," Texas A&M University, April 2012.

Allred, Jeff. *American Modernism and Depression Documentary*. Oxford: Oxford University Press, 2010.

Anderson, James Cletus. *Roy Stryker: The Humane Propagandist*. Louisville, Ky.: University of Louisville, 1977.

Anreus, Alexander. *The Social and the Real: Political Art of the 1930s in the Western Hemisphere*. University Park: Pennsylvania State University Press, 2006.

Appel, Alfred. *A Season of Dreams*. Baton Rouge: Louisiana State University Press, 1975.

Arant, Alison. "'A Moral Intelligence': Mental Disability and Eugenic Resistance in Welty's 'Lily Daw and the Three Ladies' and O'Connor's 'The Life You Save May Be Your Own.'" *Southern Literary Journal* 44, no. 2 (2012): 69–87.

Babb, Valerie Melissa. *Whiteness Visible: The Meaning of Whiteness in American Literature*. New York: New York University Press, 1998.

Bailey, Rebecca. "Clothes Encounters of the Gynecological Kind." In *Dress and Gender: Making and Meaning in Cultural Contexts*, ed. Ruth Barnes and Joanne B. Eicher, 248–265. New York: St. Martin's, 1992.

Bakhtin, M. M. *The Dialogic Imagination: Four Essays*. Edited by Michael Holquist. Translated by Caryl Emerson and Michael Holquist. Austin: University of Texas Press, 1981.

Banecker, Andrew. "'No Cause Was Cited for the Fracas': Ambivalent Racism in Eu-

dora Welty's 'Where Is the Voice Coming From?' and 'The Demonstrators.'" In *Turning Points and Transformations: Essays on Language, Literature, and Culture*, ed. Christine DeVine and Marie Hendry, 125–140. Newcastle, England: Cambridge Scholars, 2011.

Barilleaux, René Paul, ed. *Passionate Observer: Eudora Welty among Artists of the Thirties*. Jackson: Mississippi Museum of Art, 2002.

Barnes, Djuna. *Ryder*. 1928. Reprint, Champaign, Ill.: Dalkey Archive Press, 1990.

Bartky, Sandra Lee. "Foucault, Femininity, and the Modernization of Patriarchal Power." In *Writing on the Body: Female Embodiment and Feminist Theory*, ed. Katie Conboy, Nadia Medina, and Sarah Stanbury, 129–154. New York: Columbia University Press, 1997.

Beauvoir, Simone de. *The Second Sex*. 1949. Reprint, New York: Knopf, 1953.

Berlant, Lauren. "Re-writing the Medusa: Welty's *Petrified Man*." *Studies in Short Fiction* 26, no. 1 (1989): 59–70.

Bernstein, Matthew. *Visions of the East: Orientalism in Film*. New Brunswick, N.J.: Rutgers University Press, 1997.

Bhaba, Homi K. *The Location of Culture*. London: Routledge, 1994.

Black, Patti Carr. "Back Home in Jackson." In *Passionate Observer: Eudora Welty among Artists of the Thirties*, ed. René Paul Barilleaux, 33–55. Jackson: Mississippi Museum of Art, 2002.

———. *Early Escapades: Eudora Welty*. Jackson: University Press of Mississippi, 2005.

———. *Eudora*. Jackson: Mississippi Department of Archives and History, 1984.

Blair, Sara. "Against Trauma: Documentary and Modern Times on the Lower East Side." In *Trauma and Documentary Photography of the FSA* by Sara Blair and Eric Rosenberg. Berkeley: University of California Press, 2012.

———. *Harlem Crossroads: Black Writers and the Photograph in the Twentieth Century*. Princeton, N.J.: Princeton University Press, 2007.

———. *Henry James and the Writing of Race and Nation*. Cambridge: Cambridge University Press, 1996.

Blum, Joanne. *Transcending Gender: The Male/Female Double in Women's Fiction*. Ann Arbor, Mich.: UMI Research Press, 1988.

Booth, Alison, ed. *Famous Last Words: Changes in Gender and Narrative Closure*. Charlottesville: University of Virginia Press, 1993.

Bordo, Susan. *Unbearable Weight: Feminism, Western Culture, and the Body*. Berkeley: University of California Press, 1993.

Bourdieu, Pierre. *Outline of a Theory of Practice*. Cambridge: Cambridge University Press, 1977.

Brinkmeyer, Robert H., Jr. "New Orleans, Mardi Gras, and Eudora Welty's *The Optimist's Daughter*." *Mississippi Quarterly* 44, no. 4 (1991): 429–441.

Brooks, Peter. *Body Work: Objects of Desire in Modern Narrative*. Cambridge, Mass.: Harvard University Press, 1993.

Butler, Judith. *Excitable Speech: A Politics of the Performative*. New York: Routledge, 1997.

———. "Performative Acts and Gender Constitution: An Essay in Phenomenology

and Feminist Theory." In *Writing on the Body: Female Embodiment and Feminist Theory*, ed. Katie Conboy, Nadia Medina, and Sarah Stanbury, 401–418. New York: Columbia University Press, 1997.

Caron, Simone M. *Who Chooses?: American Reproductive History Since 1830*. Gainesville: University Press of Florida, 2008.

Carson, Barbara. *Eudora Welty: Two Pictures at Once in Her Frame*. Albany, N.Y.: Whitston, 1992.

Chakrabarty, Dipesh. *Habitations of Modernity: Essays in the Wake of Subaltern Studies*. Chicago: University of Chicago Press, 2002.

Chesnutt, Charles W. *The Conjure Woman and Other Tales*. 1899. Reprint, Durham, N.C.: Duke University Press, 1993.

Child, Francis James. *The English and Scottish Popular Ballads*. New York: Folklore Press, 1956.

Chopin, Kate. *The Awakening*. 1899. Reprint, New York: Norton, 1976.

Claxton, Mae Miller. "'The Little Store' in the Segregated South: Race and Consumer Culture in Eudora Welty's Writing and Photography." In Pollack, *Eudora Welty, Whiteness, and Race*, 95–113.

Cole, Hunter, and Seetha Srinivasan. "Eudora Welty and Photography: An Interview." In Prenshaw, *More Conversations with Eudora Welty*, 188–213.

Conboy, Katie, Nadia Medina, and Sarah Stanbury, eds. *Writing on the Body: Female Embodiment and Feminist Theory*. New York: Columbia University Press, 1997.

Cortese, Anthony J. *Provocateur: Images of Women and Minorities in Advertising*. Oxford: Rowman and Littlefield, 1999.

Craton, Lillian. *The Victorian Freak Show: The Significance of Disability and Physical Differences in 19th-Century Fiction*. Amherst, N.Y.: Cambria, 2009.

Creekmore, Hubert. *The Welcome*. New York: Appleton-Century-Crofts, 1948.

Davidov, Judith F. *Women's Camera Work: Self/Body/Other in American Visual Culture*. Durham, N.C.: Duke University Press, 1998.

de Lauretis, Teresa D. *Technologies of Gender*. Bloomington: Indiana University Press, 1987.

Diamond, Irene. *Feminism and Foucault: Reflections and Resistance*. Boston: Northeastern University Press, 1988.

DiBattista, Maria. *Fast-Talking Dames*. New Haven, Conn.: Yale University Press, 2003.

Dollard, John. *Caste and Class in a Southern Town*. New Haven, Conn.: Published for the Institute of Human Relations by Yale University Press, 1937.

Donaldson, Susan. "Making a Spectacle: Welty, Faulkner, and Southern Gothic." *Mississippi Quarterly* 50.4 (1997) : 567–583.

———. "Parting the Veil: Eudora Welty, Richard Wright, and the Crying Wounds of Jim Crow." In Pollack, *Eudora Welty, Whiteness, and Race*, 48–72.

———. Recovering Otherness in *The Golden Apples*. *American Literature*, 63.3 (1991) : 489–506.

Douglas, Ellen. *Can't Quit You, Baby*. New York: Atheneum, 1988.

Douglas, Mary. *Purity and Danger: An Analysis of the Concepts of Pollution and Taboo*. London: Routledge, 1966.

DuPlessis, Rachel Blau. *Writing Beyond the Ending: Narrative Strategies of Twentieth-Century Women Writers*. Bloomington: Indiana University Press, 1985.

Dyer, Richard. *White*. New York: Routledge, 1997.

Eagleton, Terry. *The Rape of Clarissa: Writing, Sexuality, and Class Struggle in Samuel Richardson*. Minneapolis: University of Minnesota Press, 1982.

Ebersole, Lucinda. *Coming to Terms: A Literary Response to Abortion*. New York: New Press, 1994.

Eichelberger, Julia. *Prophets of Recognition: Ideology and the Individual in Novels by Ralph Ellison, Toni Morrison, Saul Bellow, and Eudora Welty*. Baton Rouge: Louisiana State University Press, 1999.

Eichelberger, Julia, ed. *Tell About Night Flowers: Eudora Welty's Gardening Letters 1940–49*. Jackson: University Press of Mississippi, 2013.

Eliot, T. S. "The Love Song of J. Alfred Prufrock." 1915. Reprinted in his *The Waste Land, Prufrock, and Other Poems*, 9–15. Mineola, N.Y.: Dover, 1998.

———. "The Waste Land." 1922. Reprinted in his *The Waste Land, Prufrock, and Other Poems*, 53–70. Mineola, N.Y.: Dover, 1998.

Ellison, Ralph. "Twentieth-Century Fiction and the Black Mask of Humanity." In his *Shadow and Act*, 24–59. New York: Vintage International, 1964.

Entzminger, Betina. *The Belle Gone Bad: White Southern Women Writers and the Dark Seductress*. Baton Rouge: Louisiana State University Press, 2002.

Evans, Elizabeth. *Eudora Welty*. New York: Ungar, 1981.

———. "Eudora Welty and the Dutiful Daughter." In Trouard, *Eudora Welty: Eye of the Storyteller*, 57–68.

Faulkner, William. *Selected Stories*. New York: Modern Library, 1983.

Federal Writers' Project of the Works Progress Administration (Miss.). *Mississippi: A Guide to the Magnolia State*. New York: Viking, 1938.

Ferguson, Frances. "Rape and the Rise of the Novel." *Misogyny, Misandry, and Misanthropy*. Special issue of *Representations* 20 (Autumn 1987): 88–112.

Ferguson, Suzanne. "'The Assault of Hope': Style's Substance in Welty's 'The Demonstrators.'" In Trouard, *Eudora Welty: Eye of the Storyteller*, 44–53.

Ferris, Bill. "A Visit with Eudora Welty." In Prenshaw, *Conversations with Eudora Welty*, 154–171.

Fiedler, Leslie. *Freaks*. Garden City, N.Y.: Doubleday, 1993.

———. *The Tyranny of the Normal*. Boston: Godine, 1996.

Filene, Peter G. *Him/Her/Self: Gender Identities in Modern America*. Baltimore, Md.: Johns Hopkins University Press, 1998.

Fleischhauer, Carl, Beverly W. Brannan, Lawrence W. Levine, and Alan Trachtenberg. *Documenting America, 1935–1943*. Berkeley: University of California Press in association with the Library of Congress, 1988.

Flower, Dean. "Eudora Welty and Racism." *Hudson Review* 60, no. 2 (2007): 325–332.

Ford, Sarah. "Laughing in the Dark: Race and Humor in *Delta Wedding*." In Pollack, *Eudora Welty, Whiteness, and Race*, 131–147.

———. "Reimagining 'Eudora Welty' Through the Eyes of the Artists: Kathryn Stockett's *The Help*, Edward P. Jones' *The Known World*, and Kate Campbell's 'The Yellow Guitar.'" Presentation at the American Literature Association meeting, San Francisco, May 2010.

Foucault, Michel. *Discipline and Punish: The Birth of the Prison.* New York: Vintage, 1995.

———. "Friendship as a Way of Life." In *The Essential Works of Foucault 1954–1984,* vol. 1: *Ethics: Subjectivity and Truth,* ed. Paul Rabinow and trans. Robert Hurley, 135–140. New York: New Press, 1997.

———. *The History of Sexuality.* Vol. 1. Translated by Robert Hurley. New York: Pantheon, 1978.

———. *Power/Knowledge: Selected Interviews and Other Writings, 1972–1977.* Edited by Colin Gordon. New York: Pantheon, 1980.

Freeman, Jean Todd. "An Interview with Eudora Welty." In Prenshaw, *Conversations with Eudora Welty,* 172–199.

Frost, Linda. *Never One Nation: Freaks, Savages and Whiteness in U.S. Popular Culture.* Minneapolis: University of Minnesota Press, 2005.

Fuller, Stephen M. "Memory's Narrative Gossamer: Configurations of Desire in Eudora Welty's 'A Memory.'" *Studies in Short Fiction* 35, no. 4 (Fall 1998): 331–337.

Gamson, Joshua. *Freaks Talk Back: Tabloid Talk Shows and Sexual Nonconformity.* Chicago: University of Chicago Press, 1998.

Garrow, David J. *Liberty and Sexuality: The Right to Privacy and the Making of Roe v. Wade.* Berkeley: University of California Press, 1994.

Gilbert, Sandra M., and Susan Gubar. *The Madwoman in the Attic: The Woman Writer and the Nineteenth-Century Literary Imagination.* New Haven, Conn.: Yale University Press, 1979.

Gilman, Charlotte P. *The Yellow Wallpaper.* Boston: Bedford, 1998.

Gilman, Sander L. "Black Bodies, White Bodies: Toward an Iconography of Female Sexuality in Late Nineteenth-Century Art, Medicine, and Literature." *Critical Inquiry* 12 (1985): 204–242.

Ginsberg, Elaine. "The Female Initiation Theme in American Fiction." *Studies in American Fiction* 3 (1975): 27–37.

Gleeson-White, Sarah. "A Peculiarly Southern Form of Ugliness: Eudora Welty, Carson McCullers, and Flannery O'Connor." *Southern Literary Journal* 36, no. 1 (Fall 2003): 46–57.

———. *Strange Bodies: Gender and Identity in the Novels of Carson McCullers.* Tuscaloosa: University of Alabama Press, 2003.

Goldstein, Laurence. *The Male Body: Features, Destiny, Exposures.* Ann Arbor: University of Michigan Press, 1994.

Graham-Brown, Sarah. *Images of Women: The Portrayal of Women in Photography of the Middle East 1860–1950.* London: Quartet, 1988.

Griffin, Larry J. *The South as an American Problem.* Athens: University of Georgia Press, 1995.

Griffith, Jean C. "'I Knowed Him Then Like I Know Me Now': Whiteness, Violence, and Interracial Male Intimacy in *Delta Wedding* and 'Where Is the Voice Coming From?'" In Pollack, *Eudora Welty, Whiteness, and Race,* 148–164.

Grimm, Jacob, and Wilhelm Grimm. "Der Räuberbräutigam." *Kinder- und Hausmärchen* 40 (Berlin, 1857). Translated by D. L. Ashliman. http://www.pitt.edu/~dash/grimm040.html (accessed December 2014).

Gross, Seymour Lee. *Images of the Negro in American Literature*. Chicago: University of Chicago Press, 1966.

Grosz, Elizabeth. "Intolerable Ambiguity: Freaks as/at the Limit." In Thomson, *Freakery: Cultural Spectacles of the Extraordinary Body*, 55–68.

Guerard, Albert J. "Concepts of the Double." In *Stories of the Double*, ed. Albert J. Guerard, 1–14. New York: Lippincott, 1967.

Gwin, Minrose. *The Woman in the Red Dress: Gender, Space, and Reading*. Urbana: University of Illinois Press, 2002.

Hansen, Miriam. *Babel and Babylon: Spectatorship in American Silent Film*. Cambridge, Mass.: Harvard University Press, 1991.

Hariman, Robert, and John L. Lucaites. *No Caption Needed: Iconic Photographs, Public Culture, and Liberal Democracy*. Chicago: University of Chicago Press, 2007.

Harrison, Suzan. *Eudora Welty and Virginia Woolf: Gender, Genre, and Influence*. Baton Rouge: Louisiana State University Press, 1997.

———. "'It's Still a Free Country': Constructing Race, Identity, and History in Eudora Welty's 'Where Is the Voice Coming From?'" *Mississippi Quarterly* 50, no. 4 (1997): 631–646.

———. "Playing with Fire: Women's Sexuality and Artistry in Virginia Woolf's *Mrs. Dalloway* and Eudora Welty's *The Golden Apples*." *Mississippi Quarterly* 56, no. 2 (2003): 289–314.

———. "'Racial Content Espied': Modernist Politics, Textuality, and Race in Eudora Welty's 'The Demonstrators.'" In Pollack and Marrs, *Eudora Welty and Politics: Did the Writer Crusade?*, 89–108.

Haskell, Molly. *From Rape to Reverence: The Treatment of Women in the Movies*. Chicago: University of Chicago Press, 1987.

———. "The 2,000-Year-Old Misunderstanding: Rape Fantasy." In her *Holding My Own in No Man's Land: Women and Men and Film and Feminists*, 127–137. New York: Oxford University Press, 1997.

Henninger, Katherine. *Ordering the Façade: Photography and Contemporary Southern Women's Writing*. Chapel Hill: University of North Carolina Press, 2007.

Hill, Daniel D. *Advertising to the American Woman, 1900–1999*. Columbus: Ohio State University Press, 2002.

hooks, bell. *Black Looks: Race and Representation*. Boston, Mass.: South End Press, 1992.

Huf, Linda. *Portrait of the Artist as a Young Woman*. New York: Ungar, 1983.

Hurley, F. Jack. *Portrait of a Decade: Roy Stryker and the Development of Documentary Photography in the Thirties*. Baton Rouge: Louisiana State University Press, 1972.

Jacobson, Matthew Frye. *Whiteness of a Different Color: European Immigration and the Alchemy of Race*. Cambridge, Mass.: Harvard University Press, 1998.

Johnson, Randy, Johnny Meah, Jim Secreto, and Teddy Varndell. *Freaks, Geeks, and Strange Girls: Sideshow Banners of the Great American Midway*. San Francisco, Calif.: Last Gasp, 2004.

Jones, Anne Goodwyn. *Tomorrow Is Another Day: The Woman Writer in the South, 1859–1936*. Baton Rouge: Louisiana State University Press, 1981.

Jones, Anne Goodwyn, and Susan Donaldson, eds. *Haunted Bodies: Gender and Southern Texts.* Charlottesville: University of Virginia Press, 1997.

Jones, Suzanne. "The Divided Reception of *The Help.*" *Southern Cultures: "The Help" Special Issue* 20, no. 1 (Spring 2014): 7–25.

———. "Reading the Endings: Katherine Anne Porter's 'Old Mortality.'" In Booth, *Famous Last Words: Changes in Gender and Narrative Closure,* 280–299.

Karlyn, Kathleen Rowe. *The Unruly Woman: Gender and the Genres of Laughter.* Austin: University of Texas Press, 1995.

Kelly, Lionel. "American Fat: Obesity and the Short Story." *Yearbook of English Studies* 31 (2001): 218–229.

Kidd, Stuart. "Eudora Welty's Unsuccessful Application to Become a Resettlement Administration Photographer." *Eudora Welty Newsletter* 26 (Summer 1992): 6–8.

Kreyling, Michael. *Author and Agent: Eudora Welty and Diarmuid Russell.* New York: Farrar, Straus and Giroux, 1991.

———. "History and Imagination: Writing 'The Winds.'" *Mississippi Quarterly* 50 (1997): 585–599.

———. "Welty and the Biographer." *Mississippi Quarterly* 52, no. 1 (1999): 131–137.

Kuehl, Linda. "The Art of Fiction XLVII: Eudora Welty." In Prenshaw, *Conversations with Eudora Welty,* 74–91.

Ladd, Barbara. "'Coming Through': The Black Initiate in *Delta Wedding.*" *Mississippi Quarterly* 41, no. 4 (1988): 541–551.

———. *Resisting History: Gender, Modernity, and Authorship in William Faulkner, Zora Neale Hurston, and Eudora Welty.* Baton Rouge: Louisiana State University Press, 2007.

———. "'Writing against Death': Totalitarianism and the Nonfiction of Eudora Welty at Midcentury." In Pollack and Marrs, *Eudora Welty and Politics: Did the Writer Crusade?*, 155–178.

Lancaster, Ashley Craig. *The Angelic Mother and the Predatory Seductress: Poor White Women in Southern Literature of the Great Depression.* Baton Rouge: Louisiana State University Press, 2012.

Lange, Dorothea, and Paul S. Taylor. *An American Exodus: A Record of Human Erosion in the Thirties.* New Haven, Conn.: Published for the Oakland Museum by Yale University Press, 1969.

Lee, Anthony. "Introduction." In *Trauma and Documentary Photography of the FSA* by Sara Blair and Eric Rosenberg. Berkeley: University of California Press, 2012.

Lee, Hermione. "Eudora Welty." In Prenshaw, *More Conversations with Eudora Welty,* 146–153.

Levenson, Michael H. *The Cambridge Companion to Modernism.* Cambridge: Cambridge University Press, 1999.

Lief, Ruth Ann. "A Progression of Answers." *Studies in Short Fiction* 2 (1965): 343–350.

Lisitz, George. *The Possessive Investment in Whiteness: How White People Profit from Identity Politics.* Philadelphia: Temple University Press, 1998.

López, Alfred J. *Postcolonial Whiteness: A Critical Reader on Race and Empire.* Albany: State University of New York Press, 2005.

Maclay, Joanna. "A Conversation with Eudora Welty." In Prenshaw, *Conversations with Eudora Welty,* 268–287.

MacKethan, Lucinda. *Daughters of Time: Creating Woman's Voice in Southern Story.* Athens: University of Georgia Press, 1990.

MacKinnon, Catharine. *Feminism Unmodified: Discourses on Life and Law.* Cambridge, Mass.: Harvard University Press, 1987.

———. *Sex Equality.* New York: Foundation Press, 2001.

———. *Toward a Feminist Theory of the State.* Cambridge, Mass.: Harvard University Press, 1989.

Manning, Carol S. *With Ears Opening Like Morning Glories: Eudora Welty and the Love of Storytelling.* Westport, Conn.: Greenwood, 1985.

Marcus, Jane. "Still Practice: A/Wrested Alphabet: Toward a Feminist Aesthetic." In *Feminist Issues in Literary Scholarship,* ed. Shari Benstock, 79–97. Bloomington: Indiana University Press, 1987.

MariAnna, Cara J. *Abortion: A Collective Story.* Westport, Conn.: Praeger, 2002.

Mark, Rebecca. *The Dragon's Blood: Feminist Intertextuality in Eudora Welty's "The Golden Apples."* Jackson: University Press of Mississippi, 1993.

———. "Ice Picks, Guinea Pigs, and Dead Birds: Dramatic Weltian Possibilities in 'The Demonstrators.'" In Pollack, *Eudora Welty, Whiteness, and Race,* 199–223.

———. "Pierced with Pleasure for the Girls: Eudora Welty's 'The Winds.'" *Journal of Contemporary Thought* 7 (1997): 107–133.

———. "Wild Strawberries, Cataracts, and Climbing Roses: Clitoral and Seminal Imagery in *The Optimist's Daughter.*" *Mississippi Quarterly* 56, no. 2 (Spring 2003): 331.

Marrs, Suzanne. *Eudora Welty: A Biography.* Orlando, Fla.: Harcourt, 2005.

———. *Eudora Welty: One Writer's Imagination.* Baton Rouge: Louisiana State University Press, 2002.

———. *The Welty Collection.* Jackson: University Press of Mississippi, 1988.

———. *What There Is to Say We Have Said: The Correspondence of Eudora Welty and William Maxwell.* New York: Houghton Mifflin Harcourt, 2012.

Marrs, Suzanne, and Tom Nolan, eds. *Meanwhile There Are Letters: The Correspondence of Eudora Welty and Ross Macdonald.* New York: Skyhorse, 2015.

Martin, Matthew R. "Vision and Revelation in Eudora Welty's Early Fiction and Photography." *Southern Quarterly* 38, no. 4 (Summer 2000): 17–26.

Maslin, Janet. "Racial Insults and Quiet Bravery in 1960s Mississippi." Rev. of *The Help* by Kathyrn Stockett. *New York Times,* February 18, 2009.

McAllister, Marvin Edward. *Whiting Up: Whiteface Minstrels and Stage Europeans in African American Performance.* Chapel Hill: University of North Carolina Press, 2011.

McBride, Dorothy E. *Abortion in the United States: A Reference Handbook.* Santa Barbara, Calif.: ABC-CLIO, 2008.

McCullers, Carson. *The Member of the Wedding.* 1946. Reprint, Boston: Houghton Mifflin, 2004.

McDonald, W. U., Jr. "Textual Variants in 'A Memory.'" *Eudora Welty Newsletter* 15 (1991): 9–11.

McGrath, Charles. "Goodbye, Frustration: Pen Put Aside, Roth Talks." *New York Times,* November 17, 2012. http://www.nytimes.com/2012/11/18/books/struggle-over-philip-roth-reflects-on-putting-down-his-pen.html?pagewanted=all&_r=0.

McHaney, Pearl A. *A Tyrannous Eye: Eudora Welty's Nonfiction and Photographs*. Jackson: University Press of Mississippi, 2014.

McHaney, Pearl, ed. *Eudora Welty as Photographer*. Jackson: University Press of Mississippi, 2009.

———. *Eudora Welty: Occasions: Selected Writings*. Jackson: University Press of Mississippi, 2009.

———. *Eudora Welty: The Contemporary Reviews*. New York: Cambridge University Press, 2005.

McMahand, Donnie. "Bodies on the Brink: Vision, Violence, and Self-Destruction in *Delta Wedding*." In Pollack, *Eudora Welty, Whiteness, and Race*, 165–184.

McPherson, Tara. *Reconstructing Dixie: Race, Gender, and Nostalgia in the Imagined South*. Durham, N.C.: Duke University Press, 2003.

McWhirter, David Bruce. "Eudora Welty Goes to the Movies: Modernism, Regionalism, Global Media." *Modern Fiction Studies* 55, no. 1 (2009): 68–91.

———. "Secret Agents: Welty's African Americans." In Pollack, *Eudora Welty, Whiteness, and Race*, 114–130.

Millstein, Barbara Head, and Sarah M. Lowe. *Consuelo Kanaga: An American Photographer*. Seattle: Brooklyn Museum and University of Washington Press, 1988.

Morris, Christopher. *Southern Writers and Their Worlds*. College Station: Published for the University of Texas at Arlington by Texas A&M University Press, 1996.

Morrison, Toni. *The Bluest Eye*. 1970. Reprint, Garden City, N.Y.: Knopf Doubleday, 2007.

———. "Interview with Mel Watkins." *New York Times Book Review*, September 11, 1977, 48–50.

———. *Playing in the Dark: Whiteness and the Literary Imagination*. Cambridge, Mass.: Harvard University Press, 1992.

Mortimer, Gail L. *Daughter of the Swan: Love and Knowledge in Eudora Welty's Fiction*. Athens: University of Georgia Press, 1994.

Mulvey, Laura. *Visual and Other Pleasures*. New York: Palgrave Macmillan, 2009.

Natanson, Nicholas. *The Black Image in the New Deal: The Politics of FSA Photography*. Knoxville: University of Tennessee Press, 1992.

Needham, George. "Manet, *Olympia*, and Pornographic Photography." In *Woman as Sex Object*, ed. Thomas Hess and Linda Nochlin, 81–89. New York: Newsweek Books, 1972.

O'Grady, Lorraine. "Olympia's Maid: Reclaiming Black Feminist Subjectivity." *Afterimage* 20, no. 1 (1992): 14–15.

Olasky, Marvin N. *Abortion Rites: A Social History of Abortion in America*. Washington, D.C.: Regnery, 1995.

Peterkin, Julia Mood. *Roll, Jordan, Roll*. New York: Ballou, 1933.

Peters, Sarah. "Something She Had Always Heard Of: Storytelling, Sexuality, and Community in Eudora Welty's *The Golden Apples*." In *Narratives of Community: Women's Short Story Sequences*, ed. Roxanne Harde, 94–113. Newcastle, England: Cambridge Scholars, 2007.

Petersen, Kerry Anne. *Abortion Regimes*. Hanover, N.H.: Dartmouth College Press, 1993.

Peterson, Nancy J. *Against Amnesia: Contemporary Women Writers and the Crises of Historical Memory*. Philadelphia: University of Pennsylvania Press, 2001.

Petty, Jane Reid. "The Town and the Writer: An Interview with Eudora Welty." In Prenshaw, *Conversations with Eudora Welty*, 200–210.

Pierpont, Claudia Roth. "A Perfect Lady." *New Yorker* (5 October) 1998, 94–104. Revised for *Passionate Minds: Women Rewriting the World*, 155–173. New York: Knopf, 2000.

Pitavy-Souques, Danielle. "Watchers and Watching: Point of View in Eudora Welty's 'June Recital.'" *Southern Review* 19 (Summer 1983): 483–509.

Plath, Sylvia. *The Bell Jar*. 1963. Reprint, New York: Knopf, 1998.

———. *The Unabridged Journals of Sylvia Plath*. Edited by Karen V. Kukil. New York: Anchor, 2000.

Poe, Edgar A. "The Philosophy of Composition." In *The Selected Writings of Edgar Allan Poe: Authoritative Texts, Backgrounds and Contexts, Criticism*, 675–684. Edited by Gary R. Thompson. New York: Norton.

Pojman, Louis P., and Francis Beckwith. *The Abortion Controversy: A Reader*. Boston: Jones and Bartlett, 1994.

Polk, Noel. "Continuity and Change in Eudora Welty's 'Where Is the Voice Coming From?' and 'The Demonstrators.'" In *Turning Points, Mississippi Mindscape*, ed. John Ray Skates, 7–12. Jackson: Mississippi Committee for the Humanities, 1986.

Pollack, Harriet. "On Welty's Use of Allusion: Expectations and Their Revision in Welty's 'The Wide Net,' *The Robber Bridegroom*, and 'At the Landing.'" *Southern Quarterly* 29, no. 1 (Fall 1990): 5–31.

———. "Photographic Convention and Story Composition: Eudora Welty's Use of Detail, Plot, Genre, and Expectation from 'A Worn Path' Through 'Bride of the Innisfallen.'" *South Central Review* 14, no. 2 (Summer 1997): 15–33.

———. "Reading John Robinson." *Mississippi Quarterly* 56, no. 2 (2003): 175–208.

———. "Story-Making in *The Golden Apples*: Point of View, Gender, and the Importance of Cassie Morrison." *Southern Quarterly* 34, no. 2 (Winter 1996): 75–80.

———. "Words Between Strangers: On Welty Her Style, and Her Audience." *Mississippi Quarterly* (Fall 1986): 481–507.

Pollack, Harriet, ed. *Eudora Welty, Whiteness, and Race*. Athens: University of Georgia Press, 2013.

Pollack, Harriet, and Suzanne Marrs, eds. *Eudora Welty and Politics: Did the Writer Crusade?* Baton Rouge: Louisiana State University Press, 1996.

Porter, Katherine Anne. "Introduction." In Welty, *A Curtain of Green*. Garden City, N.Y.: Doubleday, Doran, 1941.

Prenshaw, Peggy. "Welty's Transformations of the Public, the Private, and the Political." In Pollack and Marrs, *Eudora Welty and Politics: Did the Writer Crusade?*, 19–46.

Prenshaw, Peggy, ed. *Conversations with Eudora Welty*. Jackson: University Press of Mississippi, 1984.

———. *Eudora Welty: Critical Essays*. Jackson: University Press of Mississippi, 1979.

―――. *More Conversations with Eudora Welty.* Jackson: University Press of Mississippi, 1995.

―――. *Women Writers of the Contemporary South.* Jackson: University Press of Mississippi, 1984.

Rafter, Nicole Hahn. *White Trash: The Eugenic Family Studies, 1877–1919.* Boston: Northeastern University Press, 1988.

Raper, Arthur F. *Tenants of the Almighty.* New York: Macmillan, 1943.

Riesman, David. "Styles of Response to Social Change." *Journal of Social Issues* 1 (1961): 81.

Roberts, Diane. *Faulkner and Southern Womanhood.* Athens: University of Georgia Press, 1994.

Robinson, John. "All This Juice and All This Joy." *Horizon* 18 (November 1948): 341–347.

Rogers, Robert. *A Psychoanalytic Study of the Double in Literature.* Detroit, Mich.: Wayne State University Press, 1970.

Romines, Ann. *The Home Plot: Women, Writing, and Domestic Ritual.* Amherst: University of Massachusetts Press, 1992.

Royals, Tom, and John Little. "A Conversation with Eudora Welty." In Prenshaw, *Conversations with Eudora Welty,* 252–267.

Russo, Mary. *The Female Grotesque: Risk, Excess, and Modernity.* New York: Routledge, 1995.

Savitt, Todd Lee. *Race and Medicine in Nineteenth and Early Twentieth-Century America.* Kent, Ohio: Kent State University Press, 2007.

Scarry, Elaine. *Literature and the Body: Essays on Populations and Persons.* Baltimore, Md.: Johns Hopkins University Press, 1988.

Schmidt, Peter. *The Heart of the Story: Eudora Welty's Short Fiction.* Jackson: University Press of Mississippi, 1991.

Sedgwick, Eve Kosofsky. *Between Men: English Literature and Male Homosexual Desire.* New York: Columbia University Press, 1985.

―――. *Epistemology of the Closet.* Berkeley: University of California Press, 1990.

Sessums, Kevin. *Mississippi Sissy.* New York: St. Martin's, 2007.

Sharpe, Christina Elizabeth. *Monstrous Intimacies: Making Post-Slavery Subjects.* Durham, N.C.: Duke University Press, 2010.

Sielke, Sabine. *Reading Rape: The Rhetoric of Sexual Violence in American Literature and Culture, 1790–1990.* Princeton, N.J.: Princeton University Press, 2002.

Sivulka, Juliann. *Soap, Sex, and Cigarettes: A Cultural History of American Advertising.* Belmont, Calif.: Wadsworth, 1998.

Skaggs, Merrill Maguire. "Eudora Welty's 'I' of Memory." In *Critical Essays on Eudora Welty,* ed. W. Craig Turner and Lee Emling Harding, 153–165. Boston: Hall, 1989.

Slethaug, Gordon E. *The Play of the Double in Postmodern American Fiction.* Carbondale: Southern Illinois University Press, 1993.

Smith-Rosenberg, Carroll. *Disorderly Conduct: Visions of Gender in Victorian America.* New York: Knopf, 1985.

Spacks, Patricia Meyer. *Gossip.* Chicago: University of Chicago Press, 1985.

Staiger, Janet. *Bad Women: Regulating Sexuality in Early American Cinema*. Minneapolis: University of Minnesota Press, 1995.

Stockett, Kathryn. *The Help*. New York: Einhorn/Putnam's, 2009.

Stockton, Sharon. *The Economics of Fantasy: Rape in Twentieth-Century Literature*. Columbus: Ohio State University Press, 2006.

Stott, William. *Documentary Expression and Thirties America*. New York: Oxford University Press, 1973.

Stout, Janis P. "Miranda's Guarded Speech: Porter and the Problem of Truth-Telling." *Philological Quarterly* 66, no. 2 (Spring 1987): 259–278.

Taylor, Christin. "The Boogie and the Bush: Racial Consciousness in Welty's Jim Crow–Era Short Fiction." Paper presented at the conference of the Society for the Study of Southern Literature, Vanderbilt University, Nashville, Tenn., March 2012.

Thomson, Rosemarie Garland, ed. *Freakery: Cultural Spectacles of the Extraordinary Body*. New York: New York University Press, 1996.

Trachtenberg, Alan. *Reading American Photographs: Images as History, Mathew Brady to Walker Evans*. New York: Hill and Wang, 1989.

Trefzer, Annette. *Disturbing Indians: The Archaeology of Southern Fiction*. Tuscaloosa: University of Alabama Press, 2007.

Trilling, Diana. "Fiction in Review." *Nation*, May 11, 1946, 578. Reprinted in *Eudora Welty: The Contemporary Reviews*, ed. Pearl McHaney, 60–61. New York: Cambridge University Press, 2005.

Trouard, Dawn. "Burying Below Sea Level: The Erotics of Sex and Death in Welty's *The Optimist's Daughter*." *Mississippi Quarterly* 52 (2003): 231–251.

———. "Diverting Swine: Magical Relevancies of Eudora Welty's Ruby Fisher and Circe." In *The Critical Response to Eudora Welty*, ed. Laurie Champion, 335–355. Westport, Conn.: Greenwood, 1994.

———. "Welty's Anti-Ode to Nightingales: Gabriella's Southern Passage." *Mississippi Quarterly* 50, no. 4 (1997): 669–688.

Trouard, Dawn, ed. *Eudora Welty: Eye of the Storyteller*. Kent, Ohio: Kent State University Press, 1989.

Turner, Bryan S. *Routledge Handbook of Body Studies*. Abingdon, England: Routledge, 2012.

Turner, W. C., and Lee E. Harding. *Critical Essays on Eudora Welty*. Boston, Mass.: Hall, 1989.

Ussher, Jane M. *Managing the Monstrous Feminine: Regulating the Reproductive Body*. New York: Routledge, 2006.

Vande Kieft, Ruth M. *Eudora Welty*. Boston: Twayne, 1962.

Waldron, Ann. *Eudora Welty: A Writer's Life*. New York: Random House, 1998.

Walker, Alice. "Eudora Welty: An Interview." In Prenshaw, *Conversations with Eudora Welty*, 131–140.

Warren, Colleen. "(R)evolutions of Change: Female Alterability in 'The Children' and 'At the Landing.'" *Southern Quarterly* 36, no. 1 (Fall 1997): 51–63.

Watson, Jay. *Reading for the Body: The Recalcitrant Materiality of Southern Fiction, 1893–1985*. Athens: University of Georgia Press, 2012.

Welch, Lois. "Wild but Not Savage: Eudora Welty and Humor in Native American Writers." *Eudora Welty Newsletter* 31, no. 1 (Winter 2007): 18–24.

Welty, Eudora. *The Collected Stories of Eudora Welty.* New York: Harcourt Brace Jovanovich, 1980.

———. *Country Churchyards.* Jackson: University Press of Mississippi, 2000.

———. *A Curtain of Green.* Garden City, N.Y.: Doubleday, Doran, 1941.

———. *Delta Wedding.* 1946. Reprint, San Diego, Calif.: Harcourt Brace Jovanovich, 1991.

———. *The Eye of the Story: Selected Essays and Reviews.* New York: Random House, 1978.

———. "Hello and Goodbye." *Atlantic* (July 1947): 37–40.

———. "How I Write." *Virginia Quarterly Review* 31 (1955): 249.

———. *In Black and White.* Northridge, Calif.: Lord John Press, 1985.

———. "Is Phoenix Jackson's Grandson Really Dead?" 1974. In her *The Eye of the Story: Selected Essays and Reviews*, 159–162. New York: Random House, 1978.

———. "Looking Back at the First Story." *Georgia Review* 33 (1979): 755.

———. *Losing Battles.* New York: Random House, 1970.

———. *One Time, One Place: Mississippi in the Depression: A Snapshot Album.* 1971. Reprint, Jackson: University Press of Mississippi, 1996.

———. *One Writer's Beginnings.* Cambridge, Mass.: Harvard University Press, 1984.

———. *The Optimist's Daughter.* 1972. Reprint, New York: Vintage, 1978.

———. *Photographs.* Jackson: University Press of Mississippi, 1989.

———. *The Robber Bridegroom.* New York: Doubleday, 1942.

———. *Twenty Photographs.* Winston-Salem, N.C.: Palaemon, 1980.

Westling, Louise. *Eudora Welty.* Totowa, N.J.: Barnes and Noble Books, 1989.

———. *The Green Breast of the New World: Landscape, Gender and American Fiction.* Athens: University of Georgia Press, 1998.

———. *Sacred Groves and Ravaged Gardens: The Fiction of Eudora Welty, Carson McCullers, and Flannery O'Connor.* Athens: University of Georgia Press, 1986.

Weston, Ruth. "The Feminine and Feminist Texts of Eudora Welty's *The Optimist's Daughter*." *South Central Review* 4, no. 4 (1987): 74–91.

———. *Gothic Traditions and Narrative Techniques in the Fiction of Eudora Welty.* Baton Rouge: LSU Press, 1994.

Wharton, Edith. *The House of Mirth.* 1905. Reprint, Mineola, N.Y.: Dover, 2002.

White, Clyde S. "An Interview with Eudora Welty." In Prenshaw, *More Conversations with Eudora Welty*, 231–242.

Wiegman, Robyn. *American Anatomies: Theorizing Race and Gender.* Durham, N.C.: Duke University Press, 1995.

Williamson, Judith. "Woman Is an Island." In *Studies in Entertainment: Critical Approaches to Mass Culture*, ed. Tania Modleski, 99–118. Bloomington: Indiana University Press, 1990.

Willis, Deborah. "Eudora Welty: The Intrepid Observer." In *Eudora Welty as Photographer*, ed. Pearl McHaney, 81–84. Jackson: University Press of Mississippi, 2009.

Willis, Deborah, and Carla Williams. *The Black Female Body: A Photographic History*. Philadelphia: Temple University Press, 2002.

Wolff, Sally. "'Among Those Missing': Phil Hand's Disappearance from *The Optimist's Daughter*." *Southern Literary Journal* 25, no. 1 (1992): 74–88.

———. "Eudora Welty's Children of the Dark Cradle." *Mississippi Quarterly* 56, no. 1 (2003): 251–267.

Wray, Matt. *White Trash: Race and Class in America*. New York: Routledge, 1997.

Wright, Richard. *Black Boy: A Record of Childhood and Youth*. New York: Harper, 1945.

———. *Eight Men*. 1961. Reprint, New York: Thunder's Mouth Press, 1987.

Wright, Richard, and Edwin Rosskam. *12 Million Black Voices*. 1941. Reprint, New York: Thunder's Mouth, 1988.

Yaeger, Patricia. "'Because a Fire Was in My Head': Eudora Welty and the Dialogic Imagination." *Publications of the Modern Language Association* 99, no. 5 (October 1984): 955–973.

———. "Beyond the Hummingbird: Southern Women Writers and the Southern Gargantua." In *Haunted Bodies: Gender and Southern Texts*, ed. Anne Goodwyn Jones and Susan V. Donaldson, 287–318. Charlottesville: University of Virginia Press, 1997.

———. "'Black Men Dressed in Gold': Racial Violence in Eudora Welty's 'The Burning.'" In Pollack, *Eudora Welty, Whiteness, and Race*, 185–198.

———. *Dirt and Desire: Reconstructing Southern Women's Writing, 1930–1990*. Chicago: University of Chicago Press, 2000.

———. "Editor's Column: 'Black Men Dressed in Gold': Eudora Welty, Empty Objects, and the Neobaroque." *Publications of the Modern Language Association* 124 (January 2009): 11–24.

Yardley, Jonathan. "A Quiet Lady in the Limelight." In Prenshaw, *More Conversations with Eudora Welty*, 3–13.

Yates, Gayle Graham. "My Visit with Eudora Welty." In Prenshaw, *More Conversations with Eudora Welty*, 87–99.

Živković, Milica. "The Double as the 'Unseen' of Culture: Toward a Definition of Doppelganger." *Facta Universitatis: Linguistics and Literature* 2, no. 7 (2000): 121–128.

Index

Page numbers in italics refer to figures. Figures 2.1–2.36 follow page 114; figures 4.9–5.5 follow page 178.

medical treatment (Jim Crow inequality of), 202–3, 215–21, 237–38

"Memory, A," 37–44; class, 40; critical controversy, 38; exposure, girl's response, 40–41; exposure through story-telling, 42–43; flashers, 40; romantic love, 39–40; sheltering, 38–42; use of framing, 72

Millar, Kenneth (Ross Macdonald), 69, 192, 243–44, 246

"Moon Lake," 12–16

Morrison, Toni, 87, 210

Moulin, Félix-Jacques-Antoine, *L'Odalisque et son esclave*, fig. 2.2, 77–79

M'Toy, Ida, 94–95

"Music from Spain," 113–18; early draft "The Flower and the Rock," 113; and Eliot's "Love Song of J. Alfred Prufrock," 114–15; and exposure, 114–15, 116; girl story, gender reversal, 116; and homoeroticism, 115–16; from male point of view, 101; response to Robinson's "House of Mirth," 101; Robinson's stories, influence of, 118

"Must the Novelist Crusade?," 200

Natanson, Nicholas, 82, 83–84

"Night of the Little House, The," 42–43

"No Place for You, My Love," 101, 126–27, 150

One Time, One Place, 37, 72–76, 86, 95, 115, 206

One Writer's Beginnings, 9, 30–31, 61, 62–63, 74, 115–17, 192, 242, 243–44

Optimist's Daughter, The, 62–69; autobiographical elements, 62–63, 64–65, 67, 69; bird imagery, 66–67; and class, 62, 64; critical controversy, 62–63; early drafts, 68–69; exposure, 63, 65; Laurel's selfishness, 63, 65–66; and Kenneth Millar, 69; and mother-daughter relationship,

66; other-woman in, 63; Phil Hand addition, 68–69; and John Robinson, 69; sheltered girl, 66, 67–68; sheltered wife, 66

other-woman: "The Bride of the Innisfallen," 127–28; "common," 33, 40; as double, 8–9; exposure, 6, 24–25, 25–26, 40, 47–51, 59–60, 65; flashers, 6, 25–26; as grotesque, 1, 8, 24–25, 25–26, 38, 41–42, 48, 62, 63, 65, 66; not lady, 64; rape plot, 187; restrictions, 59–60; sheltered girl's fascination with, 12–16, 34–35, 40–41, 51, 53–55, 56, 57, 59–61, 63, 65–66, 67; sideshow bodies, *figs. 4.10–4.13*, 151–55; and spectacle, 1–2, 5–6, 69, 154–55, 205, 214. *See also* exposure; girl stories; sheltered daughters

"Pageant of Birds, A," 44, 95–96

Parks, Gordon, "Washington D.C. Government Charwoman," *fig. 2.7*, 82

Peterkin, Julia, *Roll, Jordan, Roll*, 72–73

Peters, Sarah, 161

"Petrified Man," 133–56; abortion, 139; beauty, 135, 136, 138–39; body studies, 137, 138–39, 145; cultural study, 140–50; female power, 135, 137; female vulnerability, 136; and Carson McCullers, *The Member of the Wedding*, 150–52, 155; and Sylvia Plath, *The Bell Jar*, 133–34, 134–35, 139; power over other sex, 136–38, 149; pregnancy, 137–38, 139–40, 147, 149; rape plot, 136, 137, 161; sideshow bodies, 152; spousal relationships, 135, 137–38; subversive, 155–56; teeniniest men, 152–53

photography: alternative documentary photography, 82, 84, 86, 87–89, 95, 98; black female body in apartheid society, *figs. 2.11, 2.12*, 83; black female body in ethnographic and pseudo-scientific images, *fig. 2.1*, 76–

Roth, Philip, 246
Russell, Diarmuid, 44, 103, 104, 140, 252n11, 255n13; represents Robinson, 102
Russo, Mary, 5–6

satire of feminism, 137–38
Schmidt, Peter, 8, 44, 49, 161, 186
Sedgwick, Eve, 18, 99–100, 106
"Shadow Club, The," 191–97; and *Golden Apples*, 256n13; Millar's influence, 192, 194; as noir genre, 194; origins of plot, 191, 194; race and rape plot, 191–97; and Richard Wright, 191, 192, 194–97
Shahn, Ben: "Cotton Pickers," *fig. 2.6*, 82; "Sharecropper's Family," *fig. 2.8*, 82–83
sheltered daughters, 3–4; anxiety of authorship, 24–25; miniature bodies, 25–26; sheltering as beneficial, 50; and southern lady, 25; whiteness, 4, 6, 12–13, 15–16, 25, 64. *See also* exposure; girl stories; other-woman
"Shower of Gold," 149, 162, 170, 174
sideshow banners, *figs. 4.9–4.13, 153*, 153–55
sideshow bodies, *figs. 4.14, 4.15, 153*, 154–55
Sielke, Sabine, 164–65, 166, 169, 178, 181
"Sir Rabbit," 165, 169–77; comic rape, 165, 169–75; critical controversy, 171–73; and female desire, 172–73, 175–77; and masculinity, 169, 174, 175–77; and Yeats's "Leda and the Swan," 169, 171, 174–77; and Yeats's "The Song of Wandering Aengus," 173, 177
Skaggs, Merrill Maguire, 248n8
Snap, Wyatt, "Oh My! But *She* Is Fat," 152, *153*
spousal relationships, 66, 68–69, 156–60
Srinivasan, Seetha, 73, 86, 90, 91, 96–98, 226–27, 250n2, 250n4, 250n6

"Still Moment, A," 250n1
Stockett, Kathryn, *The Help*, 238–39
Stockton, Sharon, 166, 175
Stout, Janis P., 9
Stryker, Roy, 80–82, 83–84, 98

Taylor, Christin, 206–7
Thomson, Rosemary Garland, 151, 254n6
Trouard, Dawn, 62–63, 126–27, 157–58, 160
Twenty Photographs, 74

Ulmann, Doris, 72–73
Uncollected Stories, 221–22; "The Demonstrators," 207–21 (*see also* "Demonstrators, The"); "Where Is the Voice Coming From?," 216, 222, 223, 242–43
Untitled (Woman with Attendant), *fig. 2.4*, 78–79

"Visit of Charity, A," 44, 247n7

"Wanderers, The," 55–56, 57–58, 169–70, 177–78, 179
Welch, Lois, 255n7 (chap. 4)
Welty, Chestina, 26–30, 36, 45; death of, 62–63, 80–81; trumpet player, 249n16. *See also* Courtney manuscript
Welty, Eudora: anxiety over authorship, 6, 9, 12, 24, 37, 42–43, 63, 78, 241; and Judith Butler, 199–200; drafting process, 244; on female beauty, 89–91; "Helena Arden," *fig. 2.22*, 90, 141; literary intimacy, 109–10; Millar (Ross Macdonald), relationship with, 69, 192, 243–44, 246; as modernist, 7, 12, 38, 42–44, 242; mother-daughter relationships, 36–37 (*see also* Courtney manuscript); on *Optimist's Daughter*, 64, 67; and Katherine Anne Porter, 249n17; racial awareness, 198–201; rape plots, 136; as realist,

whiteness, 4–5, 194, 196, 198–99. *See also under* sheltered daughters

"Whole World Knows, The," 185, 186–87

"Why I Live at the P.O.," 242

Wide Net, The, 242; "Asphodel," 184–85; "At the Landing," 179–87 (*see also* "At the Landing"); "First Love," 178; "Livvie," 134, 180, 254n1; "The Purple Hat," 253n26; "A Still Moment," 250n1; "The Wide Net," 44, 73, 102, 149, 156–57; "The Winds," 44–51 (*see also* "Winds, The")

"Wide Net, The," 44, 73, 102, 149; dedicated to Robinson, 102, 156; pregnancy, 156–57

Williams, Carla, *Black Female Body,* 76–77, 78

Willis, Deborah, *Black Female Body,* 76–77, 78

"Winds, The," 44–51; and "Beautiful Ohio," 44; class-based interactions, 48; cornetist, 49–50; flasher, 47–51; girls' maturation, 50–51; mother-daughter relationship, 46–47; other woman, 48

Wolcott, Marion Post, 98; "Jitterbugging in a Negro Juke Joint Saturday Evening," *fig. 2.36,* 98

Wolff, Sally, 68–69, 254n4

"Worn Path, A," 1, 83, 134, 198, 208, 217, 247n7; description of Phoenix Jackson, 201–2; race as performance, 202–4, 239; segregated medical treatment, 202–3

Wright, Richard, 5; *Black Boy,* 88, 196; "The Man Who Killed a Shadow," 194–95, 196–97; "The Man Who Was Almost a Man," 194–95, 196; *Native Son,* 197; "The Shadow Club" as homage to, 191–92, 194–97; *12 Million Black Voices,* 83–84

Yaeger, Patricia, xiii, 25–26, 38, 41, 152, 182–83, 190–91

Yeats, William Butler, 50, 54–55, 156, 159, 166, 169–78, 180, 184, 187

The New Southern Studies

*The Nation's Region: Southern Modernism, Segregation, and
U.S. Nationalism*
by Leigh Anne Duck

Black Masculinity and the U.S. South: From Uncle Tom to Gangsta
by Riché Richardson

Grounded Globalism: How the U.S. South Embraces the World
by James L. Peacock

*Disturbing Calculations: The Economics of Identity in Postcolonial
Southern Literature, 1912–2002*
by Melanie R. Benson

American Cinema and the Southern Imaginary
edited by Deborah E. Barker and Kathryn McKee

*Southern Civil Religions: Imagining the Good Society in the
Post-Reconstruction Era*
by Arthur Remillard

*Reconstructing the Native South: American Indian Literature and the
Lost Cause*
by Melanie Benson Taylor

*Apples and Ashes: Literature, Nationalism, and the Confederate States
of America*
by Coleman Hutchison

*Reading for the Body: The Recalcitrant Materiality of Southern Fiction,
1893–1985*
by Jay Watson

*Latining America: Black-Brown Passages and the Coloring of
Latino/a Studies*
by Claudia Milian

Finding Purple America: The South and the Future of American Cultural Studies
by Jon Smith

The Signifying Eye: Seeing Faulkner's Art
by Candace Waid

Sacral Grooves, Limbo Gateways: Travels in Deep Southern Time, Circum-Caribbean Space, Afro-Creole Authority
by Keith Cartwright

Jim Crow, Literature, and the Legacy of Sutton E. Griggs
edited by Tess Chakkalakal and Kenneth W. Warren

Sounding the Color Line: Music and Race in the Southern Imagination
by Erich Nunn

Borges's Poe: The Influence and Reinvention of Edgar Allan Poe in Spanish America
by Emron Esplin

Eudora Welty's Fiction and Photography: The Body of the Other Woman
by Harriet Pollack

Keywords for Southern Studies
edited by Scott Romine and Jennifer Greeson